Digital Still Life Photography

Digital Still Life Photography
Art, Business & Style

Steve Sint

pixiq
www.pixiq.com

Editor: Rebecca Shipkosky
Interior Design: Tom Metcalf
Illustrations: Sandy Knight, Hoopskirt Studio
Cover Design: Thom Gaines, Electron Graphics

Library of Congress Cataloging-in-Publication Data

Sint, Steve, 1947-
 Digital still life photography : art, business & style / Steve Sint. -- 1st ed.
 p. cm.
 Includes index.
 ISBN 978-1-4547-0327-3 (pbk.)
 1. Still-life photography. 2. Photography--Digital techniques. I. Title.
 TR656.5.S56 2013
 771--dc23

 2012014065

10 9 8 7 6 5 4 3 2 1

First Edition

Published by Pixiq
An Imprint of Sterling Publishing Co., Inc.
387 Park Avenue South, New York, N.Y. 10016

Text © 2013 Steve Sint
Photographs © 2013 Steve Sint

Distributed in Canada by Sterling Publishing,
c/o Canadian Manda Group, 165 Dufferin Street
Toronto, Ontario, Canada M6K 3H6

Distributed in the United Kingdom by GMC Distribution Services,
Castle Place, 166 High Street, Lewes, East Sussex, England BN7 1XU

Distributed in Australia by Capricorn Link (Australia) Pty Ltd.,
P.O. Box 704, Windsor, NSW 2756 Australia

If you have questions or comments about this book, please contact:
Pixiq
67 Broadway
Asheville, NC 28801
(828) 253-0467

Manufactured in China

ISBN 13: 978-1-4547-0327-3

For information about custom editions, special sales, premium and corporate purchases, please contact Sterling Special Sales Department at 800-805-5489 or specialsales@sterlingpub.com. For information about desk and examination copies available to college and university professors, requests must be submitted to academic@larkbooks.com. Our complete policy can be found at www.larkcrafts.com.

Dedication: For three Js, an M, and my Aunt Blanche.

Acknowledgements

Although I created the words and images in this book, I have to acknowledge many people who helped me discover my style or added to the file cabinet of photographic knowledge that floats around in my head. Some are living, and some have passed, but all are important.

Spending time in countless cafes, bistros, studios, lofts, apartments, and bookshops, many people explained the difference between an f/stop and a bus stop to me. I owe them all a debt of gratitude. In alphabetical order, some of them are:

Ansel Adams
Eugene Atget
Martin Bough
Chris Collins
David Friend
Cy Gross
Joe Lorentz
Jim Macammon
Peter Moore
Irving Penn
Henry Sandbank
E. Fred Sher
Michael Zide

Menachem Adelman
Peter Bittner
Harry Callahan
Jack Elness
Elizabeth Greenberg
Bert Keppler
Ned Matura
Arnie Michael
Arnold Newman
Charles Reynolds
Ernest Scarfone
Edward Weston
Harvey Zucker

A call out and thank you to:

GO-Studios
212.564.4084
http://go-studios.com/

Dutch House of Photography
646.606.2141
www.dutchhouseofphotography.com/

And a special thanks to my first assistant Radek, who always makes sure there's a fresh card in my camera and a whole lot more.

contents

Foreword

What follows is a joke so old it has a beard.

Question: How many photographers does it take to change a light bulb?

Answer: 100—one to change the bulb, and 99 others to tell you how they could have done it better.

A professional photographer and old friend of mine, Martin Bough, once told me that every time a new freelance assistant came to work in his studio, he would ask the new assistant to set up a Plexiglas® sweep. For the uninitiated, a sweep is a table whose surface is made from a 4x8-foot sheet of translucent Plexiglas® flexed into a curve (see pages 102-111 for instructions on making one for yourself). Knowing full well that Martin already knew how to set up a sweep, I asked him why he had each new assistant set one up for him. I found his answer interesting. He told me that since freelance assistants "worked around" (for different photographers), he was interested in seeing how those other photographers taught their assistants how to construct a sweep!

While the old joke and the anecdote cited above might seem unconnected, they are in fact both true and, more importantly, very similar in the context of this book. Studying still life photography will eventually prove to you that there are often many ways to accomplish the same thing! This simple fact means this book can be useful to both the new photographer just starting out and the established professional. For the newbie, many of the techniques illustrated in this book might be the only ones they will know for accomplishing certain techniques, tasks, or types of photographs. For established pros, who already have a bag full of tricks up their sleeves, some of the techniques illustrated in this book might be used to augment, improve, streamline, or simplify techniques, tasks, or concepts they already know about and currently use.

So, regardless of which type of photographer you categorize yourself as, don't fall into the trap of thinking the techniques described in this book are the end of the story. Instead, consider them a list of individual tools you can mix, match, and use depending upon the subject you are photographing and where your own creativity takes you.

Finally, realize that the idea for this book you are holding was conceived before my last two books were even written, and that means it has been simmering in my head for a long time. While it was simmering, and I was writing the first two books in this series, I came to the conclusion about what it is *not*. It's *not* about workflow. A Google search for "books on workflow" returns over three and a half million hits. And, it's *not* about using Photoshop. A Google search for "books on Photoshop" gets close to one hundred million hits!

But, if the first word in the book's title is "digital," and it's not about workflow and it's not about using Photoshop, then what is it about? Actually, I think it is exactly about what one reviewer said my portrait book is about:

"The book concentrates on taking portraits rather than post processing...for everything up until you take the card out of the camera, this book will provide you with the practical information you need for portraits with which your subjects will be happy."

Of course you can't make still life subjects happy, but this book will provide the tools you need to make your clients happy. Furthermore, you will find in these pages a lot of what I know about using a digital camera to take still life photographs and making money while doing it.

Now, it's time for the big reveal: Truthfully, I get angry with myself every time I have to use Photoshop to correct something that I could have corrected earlier in the image-creating process.

I hate using Photoshop to correct my mistakes because I feel the time required to do so is both unproductive and unprofitable. Nobody pays me anything extra to correct my mistakes! This does not mean I hate Photoshop. In fact, I love it. But, what I really love more than Photoshop (almost more than anything else) is taking pictures. Not fixing pictures after I've taken them, not creating images using Photoshop or some other image-manipulation program, but actually *taking* pictures! In truth, one of the biggest highs in my life is downloading pictures that I find pretty close to perfect the moment I open the image's file. By "perfect," I mean pictures that come out of my DSLR just the way I envisioned they would be when I took them. Because, what lights my fire, what floats my boat, what I live for, is taking pictures and not fixing pictures!

Photoshop (and other image manipulation programs) are powerful creative entities unto themselves, but I prefer using Photoshop as a secondary tool instead of the primary one to achieve the image I want. If you were to imagine a timeline spanning how a still life photograph is made, it might look like this: First you'd think about what the subject is and how you want to portray it, decide on a background, construct the set in which you would place the subject. Next, you would position and light the subject, choose the camera and lens you'd need to make the photograph, take the photograph, download the photograph, and finally use a computer and an imaging program to process and correct the photograph. Interestingly, at any point along this timeline, you could make changes and corrections. Because I have a pretty complete bag of photography skills, I prefer to make my changes and corrections as early in the process as possible, because it gives me a second chance at getting exactly what I want (instead of the only chance), and it saves time.

I have no negative feelings directed at those who find fulfillment in using post processing as their primary tool to make corrections or adjustments in their photographs. However, I love the feeling of a camera in my hand much more than the feel of a mouse in my hand because I'm passionate about taking pictures! If you find your passion with a mouse in your hand, I can only say that's great too, because I think using Photoshop creatively is an art form, and creating anything makes for a satisfying, fulfilling life. That said, I think some photographers, especially those who started out in the digital era, don't become as passionate about taking pictures as those photographers who started out in the pre-digital age. For many of them, taking photographs is often an anxiety-filled experience. Maybe it's because they might not be happy with the results they are getting, and they can't identify what to change to make things better. Or, maybe they don't understand exactly how to change the thing they don't like even if they could identify what it is. Therefore, even if you prefer the feel of a mouse in your hand, you might want to read this book to expand your understanding (and hopefully your passion) to other parts of the timeline that comprises the entire image-making process. Getting it right in the camera does not mean you can't then massage the image in Photoshop to your heart's content if that's your primary passion or if you just want to add another layer of creativity to the image-making process.

So, if you want to take perfectly beautiful pictures, pictures that come out of the camera just the way you envisioned them, then this book is definitely for you! Stop reading it as you stand in the bookstore aisle, head for the checkout counter, and buy it. Let's go!

1

Common Subjects

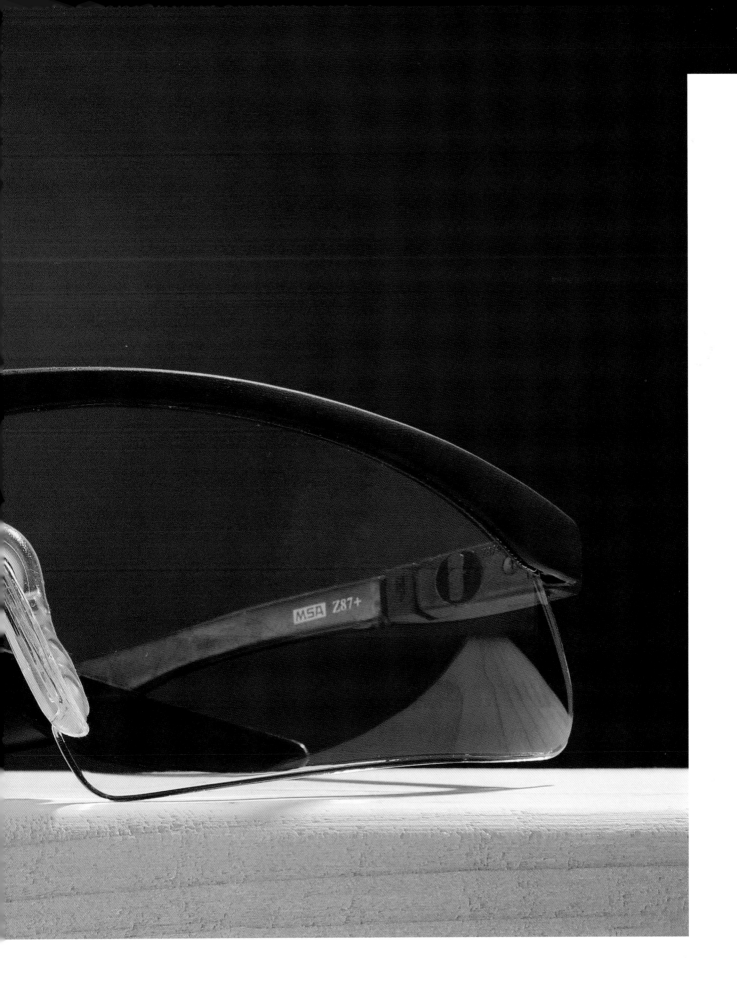

Decisions, Decisions

We live in a world where we are inundated with images—a barrage of images. Still images and moving images are constantly passing before our eyes. There are too many images to remember many of them, because there's always the next image to focus on. I've accepted this fact and lowered my expectations of what I want viewers to do when they see an image I've created. I've decided that my goal when making images is to stop the viewer for just a few seconds. A few seconds before they turn the page, click on their mouse, or pass by an image hanging on a wall. I've also learned that there are tools I can use to gain that few seconds. I can use color to gain those few seconds. I can use shape and perspective, or even confuse the viewer. I can create an emotional reaction in the viewer to gain those few seconds, or I can tap into a collective memory of mankind. I'm sure there are many more, but the first thing I think about when envisioning an image I'm about to make is which tool or tools I'm going to use to stop the viewer for those few seconds.

When faced with shooting an inanimate object, the first thing a photographer must decide is what kind of photograph he or she is trying to make and take. If the photograph is for a client, then many of the decisions about what kind of photograph to take can be determined beforehand by considering the client's budget, the useful life of the photograph, and the time allotted for the assignment. While some photographers might prefer taking a still life photograph (such as a portfolio piece) when they are in complete control of all the elements in the composition and the production of the image, there can be comfort in getting direction from a client. The world of still life photography is very broad, and limiting that world by satisfying a client's list of requirements for the type, budget, use, and deadline of the photograph can be helpful in producing a successful image.

The second step is looking at the widget (the object you intend to photograph) in a critical light and deciding what makes it unique or interesting. Do you want to show the widget's surface texture (think fur, leather, and lace)? Does the widget have a reflective surface (think jewelry, silverware, chrome, gold, or glassware)? Is the widget transparent or translucent? Is it wet (think liquor, beer, and certain foods like soup or sliced fruit)? Is it an electronic item that contains light sources as part of it (think LEDs or LCDs)? Is the widget ephemeral and decaying from the moment it was created (think food and flowers)? Each of these categories brings to my mind specific techniques that will accentuate the characteristics I want to feature. Illustrating and explaining these techniques for you is my primary purpose in this book.

Types of Still Life Photographs

When faced with taking a photograph of still life subject, whether for a catalog on the web or in print, for selling it on eBay, or to be used in a national advertisement on a page of a glossy magazine, the first step, as I have said, is to spend a moment thinking about what kind of photograph you are trying to create. After spending a lot of my life making more still life images than I care to remember, I have sorted all the kinds of widget photographs I've made into three basic categories. They are as follows:

The Drop-and-Shoot Photograph

As the name implies, you light a background, drop (OK, OK, "place") your widget on the background and take a picture of it. Whether you are shooting 100 widgets for a client or a single one of your mom's unique, antique curios to auction off on a buy/sell website, the goal of this type of photograph is to shoot a clean, sharp, centered, image that shows the item in an understandable and visually appealing way. Because these photographs are relatively simple, when speaking about this type of shoot as a professional assignment, a number of other factors can be as important as the photographer's photographic ability: price per picture, speed of production, the photographer's ability to organize and accomplish the assignment on time and on budget.

In truth, and in part because of the photographic automation available today, the drop-and-shoot photograph is no longer the realm of only professionals, but can also be accomplished by almost anyone interested in learning just a little about how to do it. On the flip side, when there are a large number of different-sized items to photograph (to me, this most often means 50 or more) by a specific deadline, these assignments are usually assigned to a professional. I mention "different-sized" items because if, for example, you have to photograph 5000 buttons that are all about the same size, that type of assignment can be so automated that you need more of a camera operator than a

photographer, and the button manufacturer can set up that process themselves. On the other hand, if the assignment is to shoot, for example, 500 small but different-sized kitchen accessories, the items are probably different enough to make it worthwhile to commission a professional photographer, even if it is for their organizational abilities instead of their photographic abilities.

Here are some ideas that can you use to help you accomplish this type of assignment:

Feel the Need...the Need for Speed: Because of the low price per image and the fixed pricing inherent to drop-and-shoot jobs, you can't waste time. So, while it might take you an hour or so to nail down the set construction, lighting, and technical bits, such as lens choice and exposure, once that first image is approved (see page 17), the idea is to work fast. If you can do 50 images at $25 each in a day, that's $1250, but if you make only 20 images in that time, you're looking at only $500 for your hard day of work. Considering that every shooting day actually requires 2.5 to 3 days of work (see Chapter 11 for more on this), you could make better money (and have better benefits) as a manager at Mickey D's!

Even at this early stage in the book, this careful management of your time is so important that I'd like to elaborate on it a bit. There are photographers who will tweak the lighting design of a photograph for days! They'll place one light and study its effect on the subject, and then walk away, then come back to the set and look some more, then walk away, and then come back to the set, on and on, until they finally decide where to put their second light. While this is all well and good when you are learning your craft, there just isn't the time for such luxuries when you're trying to make a living. In Chapter 11, you'll discover that the expenses (not profit, not your salary, just expenses!) required to open a useable—but not luxurious—photography studio are over $5500 per month, or about $1300 per week.

Likewise, these same photographers will then spend a few days perfecting their image using Photoshop. And again, while this is all well and good when you're learning how to use Photoshop, there just isn't time for that when you're trying to make a living. While it's OK to invest a week of your time on a portfolio piece at your beginnings, if you do that sort of thing once you're in the thick of your career, and then decide to price that image at $750, you just threw $550 out the window. (Remember, it costs $1300 per week to keep your studio open.)

I have a friend and former studio mate, named Menachem, who is an excellent still-life photographer. While interviewing young photographers who were looking for a few days of work as a second photographer, Menachem looked at a really clean image in one photographer's portfolio, lowered his reading glasses to the bridge of his nose, set his gaze on the prospective second shooter, and asked: "How long did it take you to create this image?" Not understanding the import of Menachem's question, the young photographer puffed up his chest and proudly said: "It took me four days to make this image." Menachem then said to the young photographer, "I'll get back to you."

Late one night as we sat around his studio exchanging war stories, Menachem told me about that interview: "I saw this young photographer's portfolio the other day, and the kid showed me images that took him four days to pull off. I wish he had shown me what he could do in 20 minutes." Why would Menachem seem to arbitrarily choose 20 minutes per image? Read on.

If he is selling clean, high-quality catalog images for $100 apiece (a likely price), then 20 minutes per image translates to three images per hour, which translates to 24 – 30 images in an 8 – 10 hour day, which allows Menachem to pay the second shooter $50 – 75 per hour and still make enough to keep the studio open. Two things should be mentioned: 1. At the prices and times I just listed, Menachem wasn't getting rich off the second photographer's

images, and 2. While the second shooter was working, Menachem was matching him image-for-image on a second set in the studio. For better or for worse, that is the reality of studio photography. You've got to love it to do it, and even then, you've got to be fast at it!

Even though this is the first chapter in this book, I am writing this section last—on the very day that I will submit the book to my publisher. I am finishing it last because, until today, I didn't have the information necessary to write it. There are approximately 400 images on these pages (I just counted them) that I created specifically for this book. My first assistant Rad, plus two other assistants and I created them in approximately 30 days of shooting (I just counted them) over a ten-month time span on days when I wasn't doing my other assignments.

The images are a mix of easy images, hard-to-make images, involved-setup images, portfolio images, frustrating images that made me cry or had me cursing (mostly to myself), gnashing my teeth and pulling my hair out, and images that made me smile with both joy and satisfaction, plus about a dozen or so illustrations. All the Photoshop work needed (which was relatively minor) was done immediately after each image was created—not a week later, not a month later, but right after the image was created. Even though I made lists of the images needed and gathered the subjects and props required before each day of shooting, my assistant and I did all the required photography, downloading, editing, and Photoshop work at the rate of about 15 to 20 images per day. If we are talking about professional photography (which I am), and if we are talking about making a profit while doing it (which I am), then the story of this book's creation is the reality of shooting a big project.

So, in reality, shooting the images for this book was not exactly a drop-and-shoot assignment, because each one is meant to illustrate a totally different lighting technique. Therefore, they cannot all be lit the same way, so I couldn't just pull off 40 or 50 of them in an 8-hour day. However, with any type of assignment, you really should learn to feel the need, the need for speed!

Be Prepared: It is important to have all the widgets available before you start to shoot. If you're building your set at your client's warehouse (for instance), having all the products available is a piece of cake. On the other hand, if the products are delivered to your studio, it is a huge drag (and can kill the profit in the assignment!) to have the widgets delivered in dribs and drabs or to find yourself missing one item that is to be included in a group shot with six others that were already delivered! You can often avoid this hassle by planning ahead and making lists whenever possible and keeping in touch with your client so you know how many items are being shipped. Furthermore, when you're planning how much studio space you need to have available for the shoot, you have to consider how much space is required for unpacking, storing, preparing, and repacking the specific products.

Make a Plan Before You Dive In: Have a plan on how to do all the assignment's photographs efficiently. For example, this might include grouping the items by their size or their surface texture, or how many items are to be included in each photograph. This planning might even extend to your lighting style. It has been said that still photographers light the subject, while cinema and video photographers light an area, because they expect their subjects to be moving around or through that space.

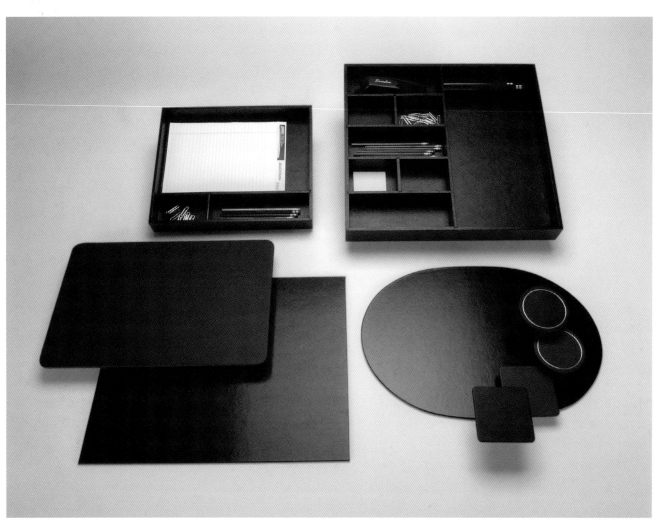

It is a big anchor on a drop-and-shoot assignment needing to shoot an image of nine items (with props) and only having eight of them available!

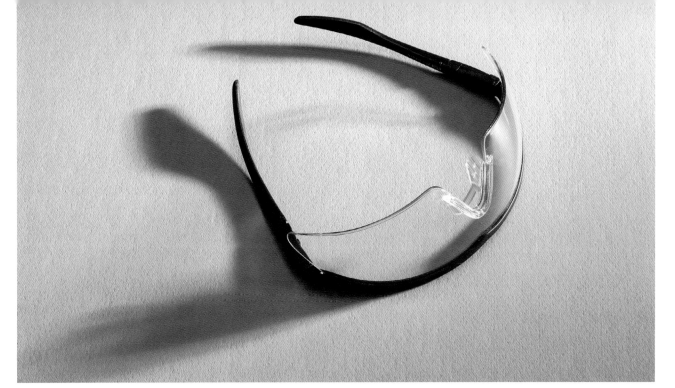

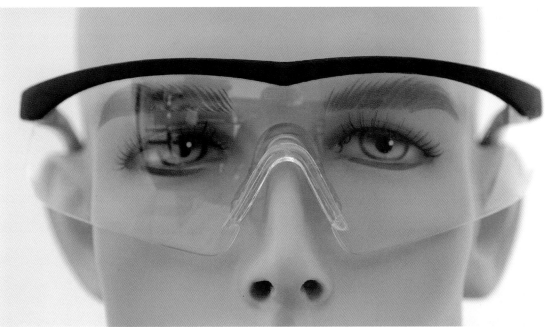

Two versions of safety glasses shot in a drop-and-shoot style. While the image of the glasses on the manikin head might seem to make that image more involved, the truth is, it was illuminated by naturally occurring window light (and a fill card), while the image of the glasses alone was shot using a studio flash unit. Sometimes, for drop-and-shoot images, window light is the fastest way to go.

Maybe for large drop-and-shoot assignments, you can borrow the lighting style of cinema and video photographers and light the set as an area that you can move subjects into and out of quickly. Doing this might decrease the amount of time you use to light each subject. As an example, instead of using a narrow-beamed, carefully aimed small source such as a hairlight on your subject, you might use a larger source that places a hairlight over the entire set (see the section on "Making a Scoop," pages 161-163). This is a great way to save time, but such an increase in productivity will never happen if you don't plan for it ahead of time.

Get Approval: Have a representative of the client present to keep track of and approve each photograph as it is taken. The importance of this cannot be underestimated: Just consider how much time it requires to re-shoot half of the photographs you created for an assignment because you didn't know what the important or unique feature of the product was before you shot it.

Don't Underestimate the Value of Drop-and-Shoot: This type of assignment garners a low price per picture (usually $20 to $30 per image), but if you do it right, you can still make a good profit. Say you shoot 100 or more similar products at a fast rate (a minimum of 50 images per 8-hour work day) using a similar lighting style and background; this type of marathon assignment can be more profitable than shooting one photograph in the next category that takes you three or four days to produce!

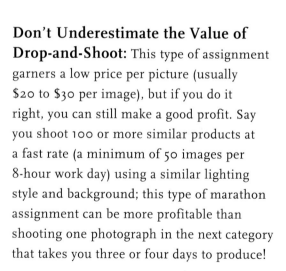

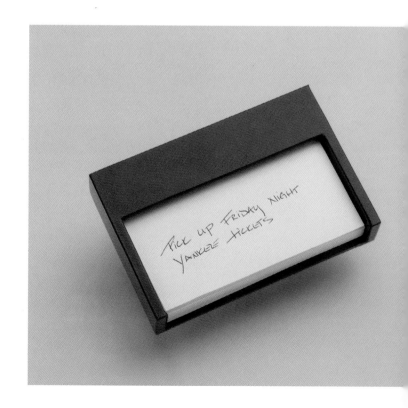

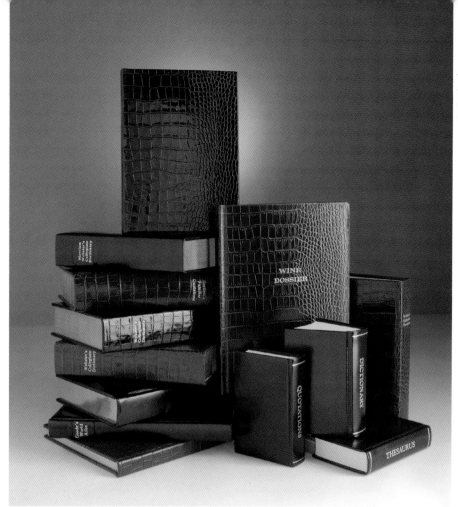

Thirteen books as a group for the cover of a catalog can be important enough to qualify for a beauty shot.

The Beauty Shot

As the name implies, the goal of this type of photograph is to make the subject as beautiful as possible. But, before we can continue, I must mention a related point. First off, even though it is called a "beauty shot," the goal might be to make the item look as grotesque or as ugly as possible. How can that be, you ask? Well. Whether you're tasked with making whatever widget you're photographing beautiful or ugly, the real goal of the beauty shot is to stop the viewer from turning the page or clicking their mouse for a few extra seconds—just those few extra measly seconds.

This means you might bring a huge bag of photographic tricks to bear that will create greater impact in the final image. These may be as simple as choosing a unique camera position relative to the subject, accentuating interesting points about the subject with light, or cloaking some parts of the subject in shadow to accentuate other attributes. Regardless of these three examples and everything else that could possibly go into creating a beauty-shot, the lighting for a beauty shot should always be tailored to the specific product you are photographing, unlike the lighting-an-area concept I described for the drop-and-shoot style. Unlike the drop-and-shoot type of picture, a beauty shot demands more thought, more time, and commands a higher price if a client is paying the tab for the picture (as opposed to a portfolio piece). Don't think catalog picture, think magazine advertisement instead, and you've got the idea. Sometimes, when you're tasked with shooting 100 widgets of the drop-and-shoot type mentioned above, there might be a few beauty shots thrown into the mix. These might be the front, back, and inside cover shots for a paper catalog, the opening page of a web catalog, or even a grouping of related products shown as a whole or in use.

Before getting to the description of the illustrative photograph that follows, note that there are always more assignments for a beauty shot than there are for illustrative photographs. That's because, while there are ads that sometimes show only a beauty shot, there are very few ads that contain only an illustrative image. Usually, whether in either the lower corner of the illustrative image or plopped right on top of it is—you guessed it—a beauty shot! Finally, and important to those who dislike traveling, almost all beauty shots can be done in a photography studio where the most control of creating the image can be achieved.

The Illustrative Photograph

This type of photograph is probably the most difficult kind of picture to create, because you are trying to get the viewer to feel some intangible attribute about the subject. Often the subject,

product, or widget isn't even included in the photograph, because it will be featured as a second, superimposed beauty shot. For example, you might be photographing some chocolate pudding but, instead of shooting the pudding's box, you might be tasked with photographing a cup of the prepared pudding, and your goal might be to illustrate the concept of "creamy and delicious!" Examples of other concepts might be: expensive, exclusive, high-tech, family, love, fun, safety, security, sex appeal or sexual prowess, or even a holiday such as Christmas or Thanksgiving. Without a doubt, non-concrete, nebulous concepts can be difficult to portray in a photograph of a product. As mentioned previously, a beauty shot of a widget is often combined with an illustrative photograph of a related concept or feeling. This means, even if you nail the concept of "creamy and delicious" for the pudding, you still might have to produce a beauty shot of the pudding box too!

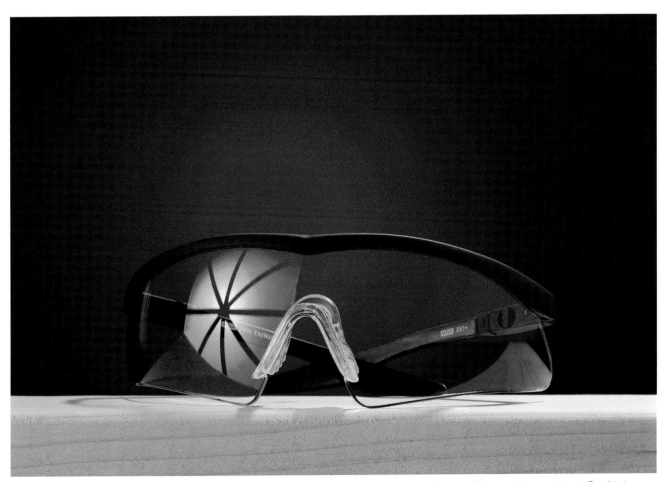

Trying to mix a beauty shot and a concept in one photograph is both difficult and fun, so sometimes I like to take a crack at it. For this image of safety glasses, I placed four strips of tape over a diffusion screen to create the reflection in the right lens, portraying an eye seeing "stars." Hopefully, it conveys what can happen if you don't wear eye protection when necessary.

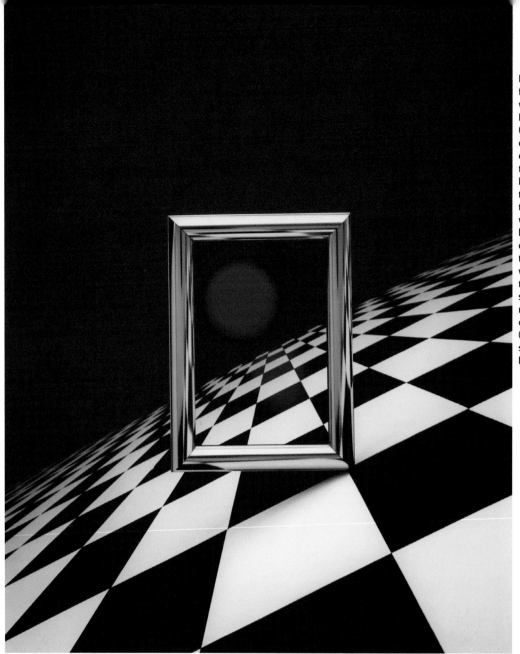

I did this image for a picture frame manufacturer. It wasn't what he asked for, but I hated his more traditional concept (boring!) so I did this one on a lark, in addition to what he asked for. I had previously made the forced-perspective checkerboard for a different client using three different-sized chess sets to foster the illusion of a different world. That being the case, since I already had the background available, creating the image for the picture frame manufacturer was an easy leap. The result was that the client loved my rendition so much, he immediately gave me another assignment, asking only that I continued with his (ha ha!) checkerboard theme. To see the next step in my checkerboard series, see page 189.

So, if a drop-and-shoot photo of a coffee pot is just an image of a coffee pot, and a beauty shot of that coffee pot might make the viewer think the coffee pot is the most beautiful coffee pot they have ever seen, then an illustrative shot of a coffee pot should make the viewer smell the coffee brewing. For instance, it might invoke a feeling in the viewer of that first cup of coffee in the late morning when they don't have to work, have nary a worry in the world, and can lounge around the house all day. Or, maybe it's that same coffee pot surrounded by such perfect accessories, in such a perfect kitchen setting, that the viewer would feel as though their life would be perfect if all the items in that scene were theirs. OK, maybe that's a bit of an exaggeration, but all the same, it is a goal I would be willing to try for!

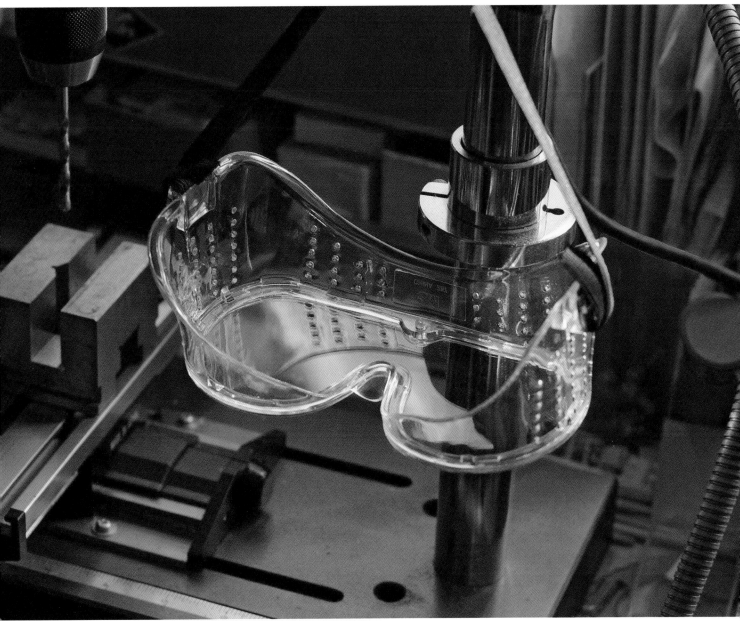

As another example, illustrative shot of a bottle of perfume should be an image that makes the bottle look like such a visage of perfection that your viewer will think buying it and applying its contents would make them irresistible to the opposite sex! To use a well-worn cliché, the drop-and-shoot shot is a picture of the steak, and the illustrative shot is a picture of the sizzle!

Now that I've covered the three very broad categories of what kind of photographs to take, let's look at what kind of subjects you might be asked to shoot.

This illustrative photo of a pair of safety goggles makes the fourth image of safety eyewear in this chapter. They cover a range of differing difficulties and purposes. This means the images should all be priced differently, with the last two being more expensive than the first two.

Types of Still Life Subjects

Even if you ignore food and beverages (both non-alcoholic and alcoholic ones), which can be considered stand-alone specialties, product photography and still life subjects surround us. Nearly everything that is handmade or manufactured, or even just sold by one person to another person, needs a picture of it for advertising purposes. That means just about every inanimate object in the world can be the subject of a still life photograph! So, if every product or thing for sale on the planet needs a picture taken of it, then what is there left to say about typical still life subjects? Quite a lot, actually!

Since this book (along with my other books) is about how to make a living taking pictures, then we should be most interested in which types of products command the highest fees to have great pictures taken of them. This can be broken down in a few different ways. Either products that appeal to the largest number of potential buyers, or products that have the highest price tags, or products that have the highest margin of profit built into their price, might be likely places to start. This means a product that has mass appeal, a high price, and a high margin of profit might be considered a still life photographer's dream subject. Another way to break it down would be how much does the media that the product will be featured in cost? Expensive media real estate leads to higher prices paid for images to fill that real estate. Lastly, things that are sold at wholesale prices (to become part of another product) and simple things that are sold by the hundred count or the yard are often very low-margin items. That means the photos of them are worth less than a dime a dozen!

If you look through magazines, catalogs (both paper and web versions), point-of-purchase posters, billboards, and every other form of product advertising, you'll start to see the same kind of products featured over and over again. But interestingly, paper catalog and web catalog widgets are different from the ones pictured in full-page magazine advertisements. Generally speaking, magazine ads feature higher-ticket items or those with wide appeal; paper catalogs feature items that are less expensive and appeal to a smaller audience; and web catalogs feature products that are less expensive still, or if they are expensive, they have a very limited appeal to a small, specific audience. Part of the reason for this is that a single page of magazine advertising, whose rates are based on the magazine's circulation, can cost as much as a smaller-run paper catalog that is sent to a targeted audience. Web-based catalogs, with no paper, printing, or mailing costs can include even less expensive products.

While this information might seem superfluous, thinking about it from a cost perspective—how much it costs to advertise each product, per view—will help you understand it. The photography budget to shoot a product for a national magazine ad will be larger than the photography budget for a limited-run paper catalog, which in turn will be larger than the photography budget for a web-only catalog. This means, if professional product photography is your chosen field, eventually, you will have a pretty good idea of how much you can charge for taking a picture of that product. Today, there are also a multitude of small special-interest magazines that cater to a specific, tightly targeted audience, but their circulations are relatively small, and many of their advertisers take their own images or use ones supplied by their customers. All that being said, let's look at what typical products are placed in high-end, high-circulation magazines.

Who is Your Client's Client?

Men's large-circulation magazines: liquor, beer, cars, boats, RVs, motorcycles, stereo systems, watches, cameras, computers and electronic gadgets, gifts for women

Women's large-circulation magazines: cosmetics, jewelry, high-end fashion, fashion accessories (bags, shoes, etc.)

Gender-neutral magazines: health and beauty items

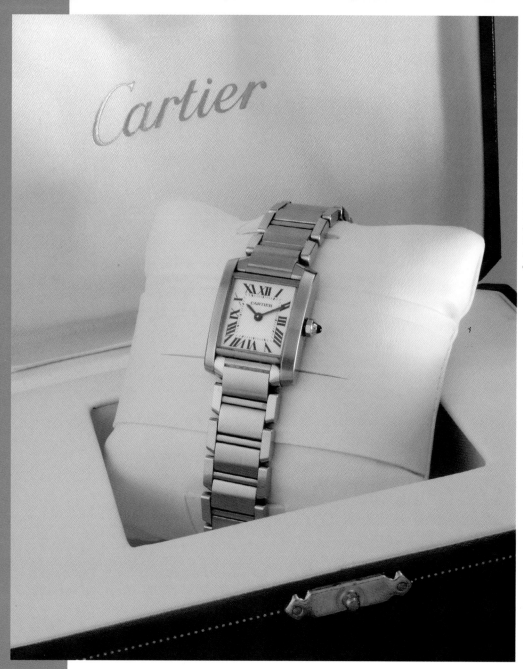

Instead of showing a portfolio full of drop-and-shoot images, start adding beauty shots to your portfolio. For every beauty shot you add, remove one drop-and-shoot sample. Eventually, your entire portfolio will be beauty shots, and clients will start to get the idea that you can produce more difficult, higher-paying assignments.

The Paradox

Young, inexperienced photographers rarely land assignments to photograph mass-appeal, high-priced, high-margin products that appear in high-priced advertising real estate. Photographing these items is the highest-paying, most profitable assignment a photographer can get. Instead, young photographers get assignments photographing limited-appeal items that appear in lower-priced advertising real estate that are less profitable. Some art directors and art buyers say this is a good way to "separate the wheat from the chaff" (the more talented photographers from the less talented photographers), while other members of the image-making and buying community will say that if you establish yourself as a maker of low-priced images, you will always be a maker of low-priced images.

But if young, inexperienced photographers can only get lower-paying, less profitable assignments, and once they become established as a creator of low-priced images they will always be a creator of low-priced images, how can they ever expect to break through to become one of the photographers who is considered for the higher-paying, more profitable assignments? There is no doubt this is difficult to do, and doing it requires more than just perseverance. If you want to be "the wheat" (instead of the chaff) but still want to make your living doing photography while you're waiting to be discovered, here are some suggestions that might help you make the transition.

Revamp your portfolio! Shoot a high-end liquor bottle, a beer, an expensive watch. Shoot a high-priced pair of shoes, a cosmetic, a mouthwash, an expensive leather pocketbook. String together a few images of any of the products just mentioned. Pick the subject you like best and would enjoy shooting the most for your series. Slowly eliminate drop-and-shoot images from your portfolio. Buy some high-end magazines and study the images in their advertisements. Then, don't copy them exactly, but copy the style of the photography instead. Choose difficult subjects. Think about exciting images instead of more mundane ones. Don't shoot a steak— shoot the sizzle! Illustrate a concept. Try not to use Photoshop gimmicks; anyone can do those with a mouse click. This is not easy, and your new portfolio won't be created overnight, but don't stop until you have at least a dozen images that are unlike whatever you've done before. Once you get to that first dozen images, shoot one more, and then don't show your drop-and-shoot images anymore. If the images in your new portfolio are exciting and fresh, don't worry about showing it to potential drop-and-shoot clients. They will know you can do the easy stuff.

Continually update your portfolio with higher-priced types of images. When the day comes that a potential client says (without you saying anything about your pricing structure): "Wow, your images are great, but I think you're too good for what I can afford!" At that moment, you'll know you're on the right track. Then, if you want the assignment, you can adjust your prices down to the client's affordability level and book it easily because you know they love and want your images!

2

Finding A Space

If studio or product photography is your thing, the first point to consider is getting a studio space. And, since your professional photography is a creative endeavor, you should apply that same kind of creative energy to finding and outfitting your workspace. Many neophytes think that all it takes to be successful in this game is to have a set of very creative "stopper" images, and the world will beat a path to their door. But, although I would love to be a harbinger of happiness, I have to tell you that there are thousands (maybe millions) of photographers in the US alone, that have portfolios of very creative "stopper" images and many of them are willing to make those images for little or no profit because their understanding of good business practices are—how can I say this gently—horrendous! In fact, if you don't believe me, do a Google search under the word "photographer" as a sobering reminder of the competition you will be facing. Let me save you the time; I just did that search and got over 43 million hits. So, regardless of how creative you are, there are some things that you must always keep in mind to ensure your success when looking for a studio specifically and being a successful commercial photographer in general. As a start, here is a simple list:

The single most important thing that determines whether you are a successful professional photographer is getting assignments!

The single most important thing that determines whether you are a successful professional photographer is getting assignments!

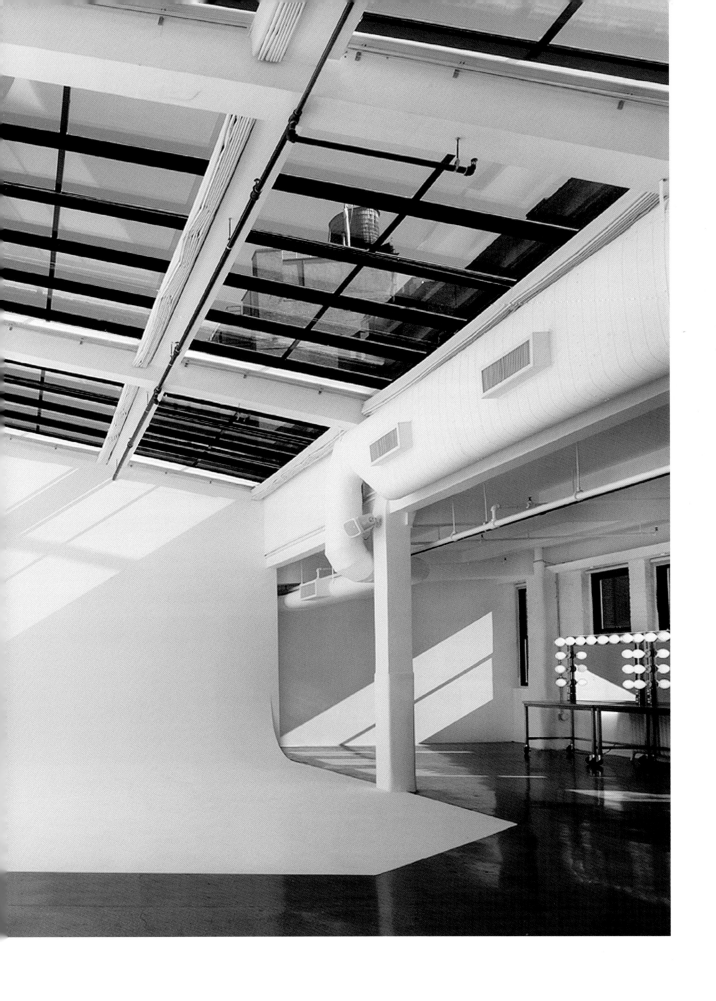

What? Yes, I typed it twice, so no, you don't have double vision! But you thought this chapter was about finding and setting up a studio. Well it is, but without assignments, even the most expensive and beautiful studio in the world is nothing more than a big money pit. So much so, my fist mentor once asked me what was the most important thing I should be thinking about after finishing an assignment. I, not really understanding the gravity of the question, tried to make up an answer off the cuff: "Getting the film to the lab!" He said no. I guessed again: "Putting everything away that I used to shoot the assignment?" He said, "Because?" I said, "Because it's important to put everything away so the studio doesn't look like a bomb went off in it!" He said, "No. The most important thing is getting the next assignment."

In my years of experience since then, I have found that being totally focused on my client's assignment is extremely important in getting repeat business. I want each and every client to feel like the shoot I'm doing for them is the most important thing in my life at that moment. And, it is! But, almost equally true, over the years, I have also trained myself to be capable of multi-tasking. Taking my mentor's words to heart, my reality is that I'm always thinking about the next assignment—even while I'm shooting the one I'm currently working on. I mention all this here because finding and outfitting a successful studio is totally dependent upon getting assignments to support it (there, I just said it a third time!). But, since this chapter is all about finding a studio, let's get back to the matter at hand; just always keep the next assignment in mind!

Newbie photographers—probably with visions of Antonioni's *Blow Up* in their heads—might imagine a fabulous converted carriage house in a fashionable, upscale part of town complete with indoor, off-street parking for their hot sports car and equally hot SUV, a 50x70-foot shooting floor complete with glossy, polyurethane-covered hardwood floors, 18-foot ceilings, skylights, a gourmet kitchen, a leather-couched client lounge complete with an antique pool table, and a beautifully decorated loft with a choir of softly backlit golden-haired angels singing. Well, maybe not the choir. Others have pipe dreams about models prancing around in front of the camera, giant wind machines whipping the gyrating models' hair, music pumping out a primal beat, and assistants, stylists, and make-up artists scurrying on and off the set. Phooey to most of these ideas! At your beginnings, they are just a fantasy.

Sure, a studio like that might be possible if you are billing big bucks (like over $250,000 a year), but you're going to take and sell a lot of less glamorous pictures before you get there! While all these luxury items are certainly nice and will no doubt impress your clients, you still have to get the assignment based on your images before you get them in the door. Furthermore, the only kind of clients who can support these luxuries have deep pockets, and they are the type who commission national ads—realistically, something no startup photography studio is going to get in the beginning. In today's competition-based economy—and remembering those 43 million Google hits I mentioned earlier—almost any client would be willing to trade 20-25% off your fee for not having a leather couch to sit on or an antique pool table in your client lounge. Also realize that your studio's location is not particularly important, nor does it matter much how your studio is decorated just beyond the edge of your camera's frame!

When you're first starting out, almost everything just past the edge of your camera's frame is really unimportant. While you'll want your studio space to be a very clean, efficient, and easy place to work, a lot of expensive cosmetic attributes are nothing more than expensive fluff—fluff that you really don't need and likely can't afford. This is a very important concept, because truthfully, it can be said about still life photography that the world in which you live, work, and create is both defined and confined by the edges of your camera's frame. (The only time something outside your camera's frame is important is when it's reflecting light onto something in the frame!) The reasons behind separating the space within your camera's frame from the space outside your camera's frame can be summed up with the sections that follow, so let's start there.

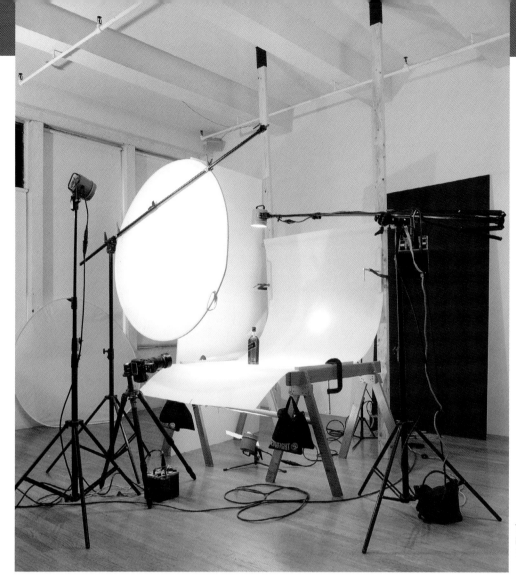

What you basically need is a big white room with high ceilings!

Keep Your Overhead Low!

You'll need a big space, one that must include a small office, a shooting room, a storage area for products, props, and equipment, some kind of conference area, a make-up room / bathroom, and possibly a kitchen; but even while considering all of these requirements, you must remember not to bite off more than you can chew!

Think of it as a place of business, and at your beginnings, forget the frills. You're better off always shopping wisely and saving a few pennies on everything you buy or rent, because those pennies add up. Being that frugal might even help you pay a few months' rent when times are lean and your phone doesn't ring.

I want to tell you about my first studio, just to give you an idea of how little you really need. During college, I shared a four-room apartment with two buds. Each of us had a room, and mine was 14x18 feet. In that entire space (a hair more than 250 square feet), I had three pieces of furniture: a regular-sized twin bed (footprint of 20 square feet), a six-drawer highboy dresser (4.5 square feet), and a small nightstand (2.5 square feet). The other 225 square feet of space was my photography studio. The furniture, what there was

of it, was arranged along the two long walls at one end of my room, which left me space to back up from the 14-foot wall I tacked my background to. I often used the nightstand as a tabletop for subjects. My closet, which was in the hallway outside my room held my wardrobe, and well, let's just say my wardrobe was meager—it contained a tuxedo and a dark suit (both for weddings), plus two pairs of jeans and two pairs of chinos. I used the rest of the closet space to store my growing collection of light stands, wooden poles, and lengths of 1x2 and 1x3 lumber.

While some might consider my life at that time a bit monastic, it was simple, and I loved it. My share of the rent was 50 bucks (which was also my pay for shooting just one wedding for a wedding studio at the time), my phone bill was less than $20 a month, and the landlord supplied heat, electricity, and water as part of the rent. While this story reminds me of my grandfather telling me that milk was a nickel in his day, and he had to walk six miles to school (barefoot, in the snow, and uphill both ways), it does lend credence to my assertion that, when you start out, you really, really should do everything you can to keep your overhead low. In that studio / bedroom, I created my first portfolio and started my professional photography career!

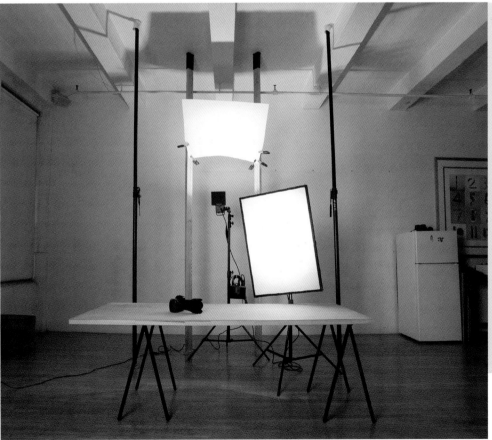

It's amazing how little equipment you actually need to get started on your career as a still life photographer:

• A pair of saw horses with a hollow-core door on top of them (which makes a great tabletop)
• A pair of 2X4 floor-to-ceiling beams with a pair of Set Shop Timber Toppers (pages 107-108) or a pair of Autopoles
• A simple diffusion frame (pages 94-101)
• A couple of fill cards
• A couple of spring clips
• A few light stands
• A few inexpensive or more expensive lights
• Your DSLR

That's all you need to get started! Even counting the cost of printing up business cards, compared to stocking a candy store or buying a taxicab, the start-up expenses are minimal.

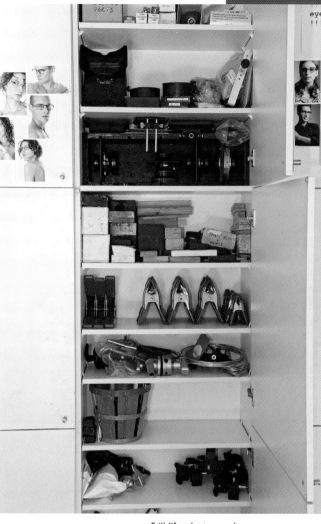

Still life photographers use so many backgrounds, surfaces, diffusion frames, and props that it is important to be as organized as possible so you can easily access the items you need, especially in a small space. These two images show how one photographer organized part of his space to have everything available, while still keeping things neatly stowed away when not in use. On the left is a rack he built for his 4x8-foot flats and acrylic sheets, plus two other areas for smaller flats, surfaces, and diffusers. The image on the right shows part of a wall with kitchen-type cabinets where he can neatly store his photographic accessories.

What Kind of Space Do You Need?

Think about what kind of products you are likely to be photographing to decide what size space you might need. You can shoot tabletop, small product photographs, and even portraits all day long on a 10x15-foot (3.1 x 4.6 m) shooting floor. Add 100 square feet (9.6 square meters) for a 10x10-foot office, another 100 square feet for storage (products, props, and equipment), and another 30 to 40 square feet (2.7 to 3.6 square meters) for a make-up room / bathroom, and you can get by with a 400-square-foot (37.2-square-meter) space!

Are you going to shoot cars? If not, you don't need a drive-in floor! What about furniture? Are you going to shoot furniture? If not, then the place you're renting doesn't need a freight elevator! Are you thinking of doing full-length fashion shots in your studio? If not, then you don't need a shooting floor that's 30 to 40 feet (9.1 x 12.2 m) long!

Owning a Studio

Can you afford to buy a space? While renting a space is the way to go for the least amount of cash outlay when you're starting out, if you can scrape together enough money to put a down payment on a place you'll own, there are tremendous advantages to doing so. In the first place, any improvements you make to the space (electric service, flooring, a kitchen) increase the value of the property for you instead of the landlord. More importantly, property (historically speaking) almost always increases in value. Furthermore, because the entire space will be used for business purposes, you can depreciate the entire cost of the space over its useful lifespan. Lastly, every time you make a mortgage payment on a space you own, you are establishing equity, as opposed to rent that is just a monthly outflow of cash akin to throwing it into the wind! One of my earliest mentors pointed out that, at the end of a long career, a photographer who hasn't been exactly super successful in the photography business can often find the money to secure a comfortable retirement by selling their space. If you are in a position to buy a property, you should consider it—it may secure your future even if you aren't such a great photographer.

The Home Studio

In the spirit of keeping your overhead low, you might be able to use a part of your home as a studio when you're first starting out. There are tax advantages to doing this, but only if the area of your home used for your business is not also used as living quarters. You can break down the area of your home used only for your business by square footage and then, by comparing it to the total square footage of your home, you can deduct a portion of your house expenses as business expenses. For example, if 1/3 of you house is used only for business purposes, you can deduct 1/3 of your heating expenses, 1/3 of your electricity and water expenses, 1/3 of house repairs (a new roof?), and

you can even depreciate 1/3 of the cost of the house (over time) from your income! I am in no position to give true and accurate advice on your tax liability, so please don't accept these words as gospel, but your accountant should be able to help out here. If you go this route, I suggest you do not cheat at all, keep scrupulous records by way of bills and receipts in case you are ever questioned about your deductions, and even take panoramic photographs of the rooms you are using for business.

Sharing a Studio

Although this next item will be covered in greater detail in "The Biz" chapter, I thought I should mention it here too. Even the busiest self-employed still life photographer will find it difficult to shoot more than 100 days per year. While I'll prove this in the business chapter, just take my word for it right now, and let's think this through starting from there. Why carry the expense of a huge shooting space if you are only going to use it less than a third of the time? Why indeed! Maybe you should consider joining forces with another photographer and sharing a studio space.

Don't just jump at this idea as a panacea and start looking for a studio mate, though. In truth, a bad studio mate relationship can be as horrible as a bad marriage, and you should think long and hard about whom you are willing to partner with. Although doing so can halve your expenses, and double available tools and equipment, you really have to trust someone you're going to share a space with. And, even if you trust your studio mate implicitly, it's still your responsibility to protect yourself. What was it President Reagan said? "Trust, but verify." Here are some rules that I think are necessary for a great, long-term studio-mate relationship:

• Follow the Golden Rule: Treat your studio mate(s) as you would like them to treat you.

• In a perfect world, you should have different specialties. A fashion photographer and a still life photographer could make perfect mates.

• No matter what, never ever try to get work from one of your mate's clients. This does not mean that when one of you is really busy you can't hire the other to work as a freelance photographer.

• While my studio mate and I shared one open office space, it is advisable that each of you has a private office with a lockable door. Furthermore, each one's computer should be password protected. When assignments get few and far between, a struggling photographer will do anything to find work, so it's as important to protect your business paperwork and contacts as it is to protect your photography equipment.

Speaking of equipment, there are two types to consider. One is your cameras, lenses, a light meter (or two), one favorite tripod, and other essentials. The other is lights, light modifiers, clamps, tools, clips, sawhorses, plywood flats (tabletops), and general studio stuff. The first should go into a locking steel cabinet or a safe, and the second should have some identifying mark so you know whose stuff is whose in case you two decide to separate. For my studio mate and me, he used a band of red plastic tape on his stuff, and I used a squirt of yellow paint from a spray can on everything of mine.

Hang a big wall calendar in a prominent place in your studio and make it a rule that you have to write down which day or days you are booking the shooting space beforehand so there's less chance of a conflict.

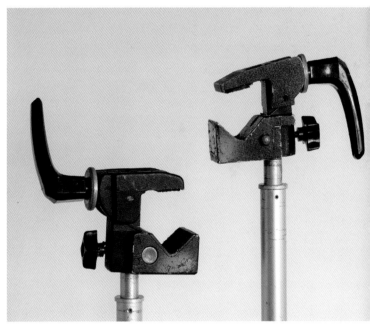

Consider having a written agreement between you. Make sure it covers how to dissolve the partner situation as well as listing what all the partners' responsibilities are in regard to costs that must be shared. I mention this because it doesn't necessarily have to be an equal partnership. For example, consider the photographer who is an industrial specialist that works primarily on location but needs a full-time office and a shooting space one or two days per month.

Always treat each other respectfully. Remember that your good name and reputation will be with you forever and that the world of professional photographers in almost any area of the country (even in a hot bed of photography like New York City) is very, very small.

Cooperatives

Another possibility might be for a group of photographers to band together and form a collective. It would take a lot of organizational work, but the group could build a few (typically three to seven) private offices surrounding one large shooting area. Each member, after buying into the collective for a fee to cover initial construction costs, could pay rent on their own office and then pay a per-day fee to use the shooting space. Done fairly and carefully—and possibly renting out the space by the day to other photographers who don't have an office in the space—it could reduce the costs to all the photographers involved and maybe even be a profitable enterprise. It has been said that getting photographers to work together towards a common goal is like herding cats, but through careful selection of the group's members, it might be possible and a good deal for all involved! This is just an idea to keep in the back of your mind.

Day-Rental Spaces

Consider whether or not you need a full time studio at all. A while ago, a photographer friend of mine who shoots in Paris was flown into New York for a fashion shoot. He arrived with just his camera case, lenses, light meters, and his favorite tripod. Everything else he needed when he got here, from a studio, to lights, to light stands, to assistants, he rented. We had dinner together when he was here, and I asked him why he did it that way. His answer was that everything he rented was a billable expense instead of just overhead!

A year later, I had to cover a trade show in Germany as a magazine columnist, and I spread the word to my clients before I went that I was going to be in Europe and asked if they needed anything covered. One ad agency had gotten an assignment to advertise the introduction of a Swedish company's furniture line in the US. The agency was sending over their art director and wanted to control the shoot by using a US photographer. Since the magazine was picking up the tab for my flight, the agency asked if I could shoot for them at the factory in Sweden. Of course I could! I rented all the lights, stands, light modifiers, and everything else I needed except my cameras, lenses, meters, and tripod. I billed all the rental equipment (plus my standard 20% markup) and didn't have to drag a single light along with me. The point is this; if you live in a metropolitan area, you might be able to rent studio space by the day only when you need it. You're still going to need to create a portfolio, and it's unrealistic to think you can pull off billing for studio rental by the day when you're first starting out, but it may be possible as your career progresses if you can figure out some way to get a legitimate office space.

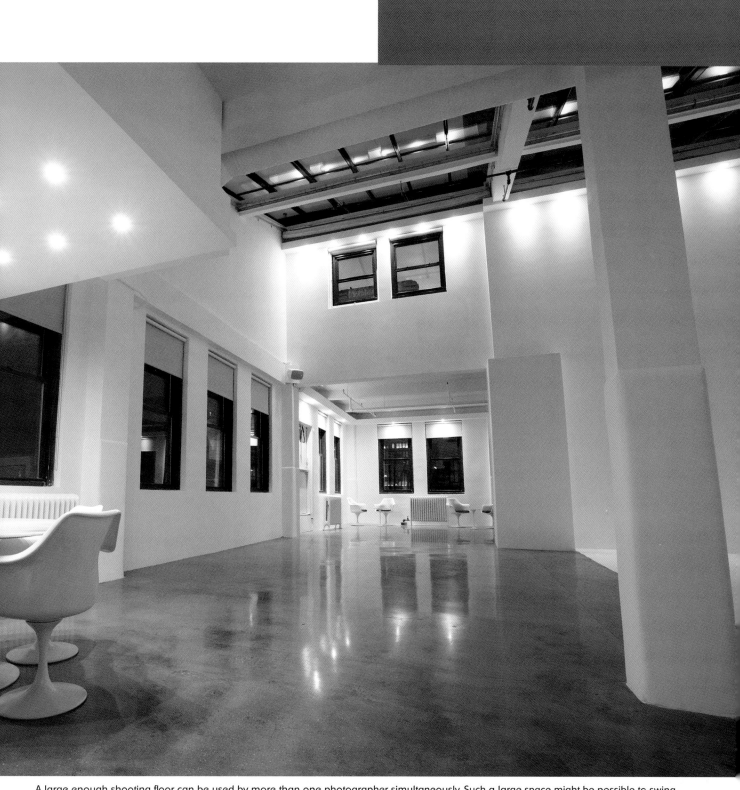

A large enough shooting floor can be used by more than one photographer simultaneously. Such a large space might be possible to swing for a collective of photographers. Photo Courtesy of GoStudios NYC (www.go-studios.com/)

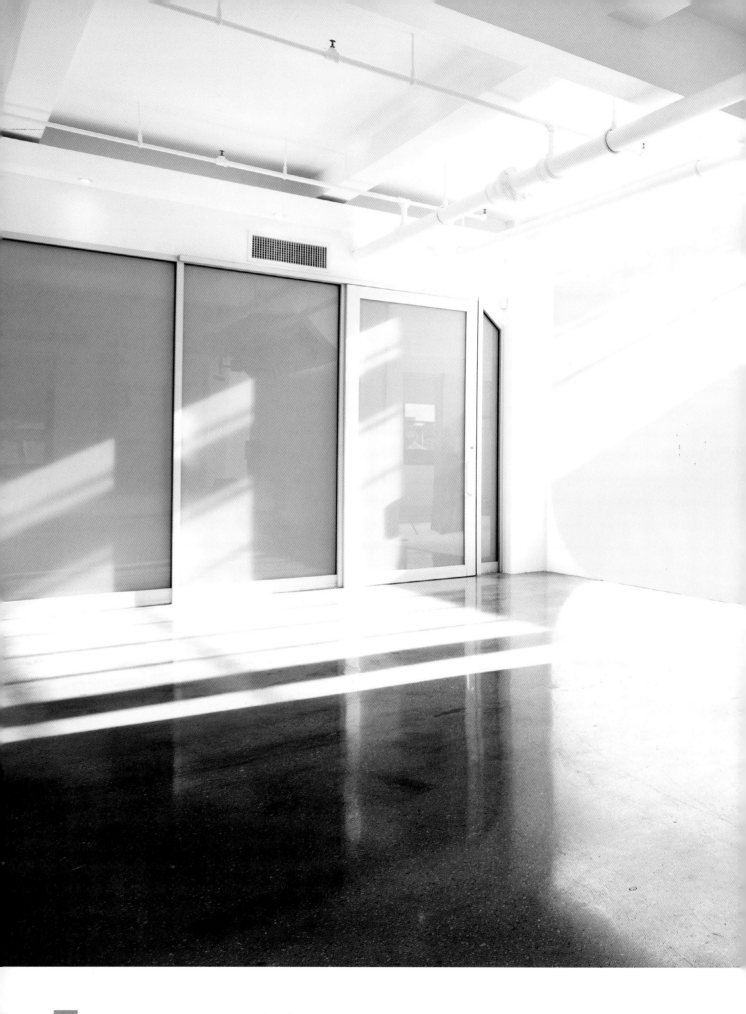

Rental studios in big cities can be so impressive that they can be used to actually augment your reputation! The very fact that you know where to find such a beautiful studio for a one-day shoot can be enough to cement your reputation as a professional.

In this multi-purpose penthouse studio in New York, some or all of the conference-style furniture is moved out every time there's a shoot. What's unseen in this picture is an adjoining area that's filled with photo equipment where the furniture is placed when the photo equipment is in the shooting area. If you were to look behind the couches, though, you'd see some of the broken-down photo equipment carefully tucked into little corners of the space.

Studio Features

There are some things you really need, some things that would be nice to have, and then there are wastes of money. What should your first studio offer, realistically?

Cheap Rent!

Commercial real estate is rented on a per-square-foot, per-year basis. As an example, if you were to rent 1000 square feet (92 square meters) at $12 per square foot, the rental would be $12,000 per year, or $1000 per month. (Commercial space costs more than that, but I chose $12 per square foot so the math would be easy.)

But, if you rent 1000 square feet, you don't necessarily get 1000 useable square feet. That's because most commercial real estate is rented on a gross square-foot basis, as opposed to net square feet. What do I mean by gross and net square feet? Once again, as an example, in my city, there

are many commercially zoned building lots that are 20 feet (6.1 m) wide by 100 feet (30.5 m) deep, and because building code does not require external alleyways or setbacks between the buildings on a block, the building's footprint is often the full size of the lot.

When you rent a floor in such a building, you pay rent on 2000 square feet (185 square meters), but you end up with only about 1400 to 1500 square feet. How can this be, you wonder? Where does that extra 500 – 600 square feet go? Well, you pay rent on the outside dimensions of the building, but the walls are a foot thick, so in this example, you are paying rent on 236 square feet of brick wall. In the example I'm citing, you also pay rent on elevator shafts, stairwells, and even bathrooms outside your studio's space. If there is more than one tenant on the building floor, you pay rent on common areas also, such as the hallways from the elevator to your studio door. Keep these things in mind as you scour the internet or newspapers for rental space.

Location, Location, Location!

Since you're looking for a commercial studio (as opposed to a portrait or a wedding studio), it's not exactly paramount to be in a busy shopping mall. In fact, it might be great to be in an industrial park surrounded by widget manufacturers! What better location to be than in a place surrounded by your clientele?

At one time, there was a place called The Gift Building in New York City. It was filled with showrooms of gift items that buyers from all over the country came to see when they were looking for things to sell in their stores. The rent for a showroom was always high, but the flow of buyers made it worthwhile for the gift manufacturers. One smart photographer, realizing that all the building's tenants were potential clients, bit the bullet and rented a space for his studio in the building, even though the rent was high. For years, he ran a very successful still life studio taking pictures for the building's tenants. In fact, he once joked to me that

he never had to leave the building to do business. Imagine a life of shooting salt and pepper shakers, picture frames, crystal vases, attaché cases, leather backgammon sets, fountain pens, and little ceramic statues, while never leaving the building except to go to lunch and go home. So, while location, location, and location are important, it's not like when you're shopping for a home or retail location. You don't have to be near schools, houses of worship, shopping centers, or places with heavy consumer traffic, but it is important to be easily accessible for your clients!

Even in rural areas (although clients can be few and far between in such places), your studio's location should be easily accessible by car and delivery truck. Telling a client they have to travel 15 miles on a main drag, then 22 miles on a secondary road, and then 9 miles on a dirt road to get to your studio, for example, will give many potential clients reason to pause.

On the other hand, keeping your business rent low may mean looking for studio space that is less than prime, especially if you work in a big city. You don't need a storefront for a commercial photography studio, and many commercial buildings have huge basement rooms with cement floors and high ceilings that can be rented for a song.

Accessibility

Speaking of looking for a basement, if that's your plan—and it's a good one—access to some basements in smaller commercial buildings is very limited. Sometimes it's a narrow stairway leading to a standard doorway down below street level, with concrete walls on either side of it. But have you ever thought of getting a 4x8 foot sheet of plywood or a 12-foot length of 2x4 through such a doorway? You should!

In one of my past studios, located on the fifth floor of a commercial building, there's a small passenger elevator and a narrow winding staircase. We could never figure out how to get the 4x8 sheet of plywood or the 12-foot length of 2x4 up to our studio using

Since you are willing to commit to paying the rent on a studio and signing a lease on the space you find, don't be afraid to ask the landlord to make modifications that may make it more useful to you. Look at the photo on the left. The photographer who rented this basement space demanded the landlord install a ramp so the he could use his carts to get things into and out of the basement studio space. Guess what? The landlord complied, feeling it was better to make the modifications so he could rent out the unused basement space. While it might be that all the space you're interested in needs is a coat of white paint, if you don't ask for what you need, you'll never know what's possible! Now, look at the photo on the right. This type of basement access should be a deal breaker—there's no way to get 4x8-foot sheets of plywood in there!

the elevator, so we had to use the stairs. This meant unbelievable extra effort, bruised fingers, and amazing streams of curse words as we muscled the items up the winding staircase. Then one day, there was construction being done on the floor below us, and my studio mate and I watched in amazement as the construction workers popped the emergency hatch open in the elevator's ceiling and threaded 16-foot 2x4 studs into the elevator with the long end of the studs extending up into the shaft through the hatch! Then, as if to rub our noses in our own stupidity, they brought 4x8-foot sheets of plasterboard up to the fourth floor by taking the elevator to the basement, opening the door in the lobby, and putting the 4x8-foot sheets of board on top of the elevator cab! Another construction worker got into the cab in the basement, pushed the button for the third floor, and when the elevator got there, they opened the door on the fourth floor and unloaded the 4x8 sheets off the top of the cab. We couldn't believe we didn't think of this ourselves. So, if a basement or an upper floor is the perfect spot for your commercial studio, but the access is difficult, don't give up on the idea without first thinking it through.

Beware of steel support beams that can ruin the space for photography use. In my city, New York, while many building plots are 20 feet wide and 100 feet deep, others are much larger. The building codes in New York City state that the largest span you can have in a multi-story building without an intermediate support beam is 30 feet (9.1 m). Knowing this beforehand, my studio mate and I searched out 30-foot-wide buildings when we were looking for a space. We ended up renting a 30x100-foot floor in which we placed a 28x50-foot shooting space. This allowed us to shoot across the space's narrow dimension. Often, we were able to squeeze in five or six small still life sets simultaneously. Do you know the building codes in the area you are looking for a studio space in? You should.

Natural Light

Windows and skylights are nice, but you do not absolutely need them. In fact, the light they give you is governed by the weather and the time of day you're shooting, so that kind of light is hard to control. Further, if the place you're looking at has lots of windows, and you really want to control your lighting, you might find you'll need blackout curtains a lot of the time. When I started out, I didn't get this. My second studio, even though it was on the second floor, had a 15x8-foot, three-pane glass wall at its front.

My third studio had a single-sloped ceiling, but the vertical wall at the ceiling's high end had a southeast-facing, 20-foot span of 3-foot high windows that varying amounts of direct sunlight or skylight streamed in through. On both occasions, the realtor told me how great the light was, and each time I fell for it. Those windows cost me over a thousand dollars to cover with black velvet curtains, even though I was lucky enough to have a friend with a sewing machine who sewed the panels of velvet together for free! But, until I came up with the money, I can't tell you how many product shots I did after dark.

Finally, my fourth studio (3000 square feet, 30x100) had no windows along the two 100-foot walls. It did have wall of glass along the front and one small window at the very rear of the space, which was required by the building code. My studio mate and I placed our offices and conference area up against the wall of windows, and we painted the glass panes of the back window black so no natural light got to our 30x50-foot shooting floor. I can tell you from experience, that last studio was the easiest to be productive in. It wasn't ideal, however, because it didn't offer the option of natural light—it is nice to have that option too.

The fact is, windows and skylights may be a requirement for your style of shooting. What? Didn't I just say the opposite of this? Well yes, I did! While most photographers feel (rightly so) that a photography studio is a sacred sanctum in which the photographer should have total control of all the light that will be used to illuminate any subject, there is no reason you shouldn't be able to use a more organic, available-light look on some assignments, when you want to.

Neither type of lighting style is better than the other. It is just a matter of taste. And, it's not necessarily going to be about your taste; it will often be your client's taste. Similarly, some clients prefer a total sharpness, a crispness, from the front of the set to the back, while other clients might prefer a shallow depth of field, where the background is intentionally left out of focus. The point is, you want to offer them options. And, if you feel (as I do) that a good studio is that sacred sanctum where you control the light, then shouldn't that include being able to use an organic, large-aperture, window-light style too? As long as you can afford to cover those windows when needed, it absolutely should!

While the choice of looking for a studio with or without windows is yours, I will tell you that photographers everywhere often prefer a window-lit location assignment over laboring tirelessly in a studio without windows to create the look of window light.

Today, you can order carefully fitted opaque roller window shades from many window treatment or drapery stores. Importantly, because you'll sometimes want to eliminate the naturally occurring window light altogether, the operative word is opaque!

Finally, it is important to always remember that all photographic styles go through cycles and what's popular today will not be popular tomorrow, while what was popular yesterday will be popular again at some time in the future. It's the nature of the beast, and while no photographer has a crystal ball to foresee what the future will hold, a perfect studio space offers the photographer as many lighting options as possible!

Security

Don't forget security for your studio. Some studios, especially those in big cities near a wealth of potential clients, are located in industrial areas that are deserted at night. Other studios, located in less densely populated areas, are single story buildings. Or, maybe you're considering a ground-floor studio in a big commercial building. All of these studios are prime targets for low-life thieves. While it is ideal to have an alarm system, window gates, and video surveillance, if you can't afford that at your beginnings, you should at least find the money to invest in a steel equipment locker or burglarproof safe. Consider having your locker or safe bolted to the floor with a heavy-duty bolt that goes through the bottom of the inside of it. That way, would-be creeps planning to rip you off won't be able to remove the entire locker or safe so they can work on cracking it in some other location at their leisure. How many of these security measures you can afford should inform your decisions about the location of your studio too. A fourth floor studio is much harder to break into than a ground-floor one.

Regardless of how great a safe you find, it still won't protect your equipment from the threat of fire. This being a very important issue, don't forget fire insurance in addition to your standard liability and theft policies.

Flooring

Hardwood floors are nice to have in a studio, but cement floors (painted with grey deck paint to keep the cement dust down) are just as serviceable (maybe even more so) although they are harder on your feet. However, you can buy dozens, maybe hundreds, of pairs of crepe-soled shoes for less than the cost of a polyurethane-covered hardwood floor! If a place you're looking at has ratty hardwood floors, it might be a lot cheaper to cover them with sheets of 3/4-inch plywood (painted with grey deck paint, of course) than it is to have them sanded and sealed.

Thinking about this a bit more, while carpeting might be nice (not to mention quieter and warmer) in your office and conference areas, it has no place on a shooting room floor! Seamless backgrounds get creased, torn, or otherwise ruined the moment someone or something is placed on paper laid over a carpet, and stuff is always being spilled or dripped onto a working studio's floor anyway.

One thing you will need is a solid floor. Imagine the studio you rent has creaky old wooden floors instead of solid wood or concrete ones. You are doing a photograph that requires a double exposure in which it is absolutely imperative that the camera does not move even a millimeter between exposures. Your camera is mounted on tripod that is weighted down with sand bags (or other weights; see page 83), and you move your feet or shift your body weight between exposures. This, in turn, causes a board under the tripod to shift ever so slightly, and your double exposure is ruined. Solid floors—enough said.

Ceilings

You'll need high, flat, solid ceilings, unencumbered by vents or ductwork. Drop ceilings are a drag. You'll want to be able to wedge poles between the ceiling and the floor to hang backgrounds from or to support the rear of a translucent acrylic sweep (see pages 107-109)—flimsy ceiling tiles held on a tin-foil framework just won't cut it! Besides, some landlords charge you extra for that drop ceiling! Think 10-foot to 12-foot ceilings, and you're on the right track. And, if you think that low-hanging, 2-foot-wide HVAC duct running along the ceiling of a possible studio won't be a problem, I can promise you there will be many days when a boom's counter-weight arm will be banging into the $#@%ˆ thing every time you try to position your soft box!

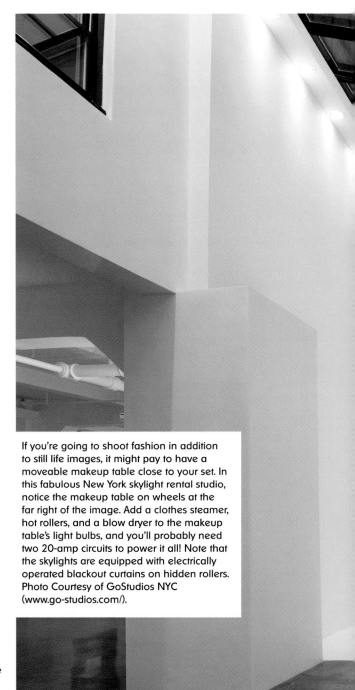

If you're going to shoot fashion in addition to still life images, it might pay to have a moveable makeup table close to your set. In this fabulous New York skylight rental studio, notice the makeup table on wheels at the far right of the image. Add a clothes steamer, hot rollers, and a blow dryer to the makeup table's light bulbs, and you'll probably need two 20-amp circuits to power it all! Note that the skylights are equipped with electrically operated blackout curtains on hidden rollers. Photo Courtesy of GoStudios NYC (www.go-studios.com/).

Power

You will need electricity. What's that old joke? Oh yeah: the Chicken Delight factory has moved to a new location that has electricity, and now, not only do they have De-Chicken, but they also have De-Light! Sorry, I couldn't resist. Getting back to the topic at hand, you're going to need electricity—and probably more that you think. Your shooting floor will be the most electricity-hungry beast you'll have to satisfy. Just how much power you'll need will vary depending upon many factors including (but not limited to), which types of lights you decide to use, how many sets you will have going simultaneously, the size of the products you plan to photograph, the f/stop you want to use, the format of your camera, and how fast you want to shoot (flash recycle time). Throughout this chapter I've suggested being frugal, but in this instance, it is wise to have a licensed electrician install as much power as you can afford. Like RAM in your computer, you can't have too much of it (within reason)!

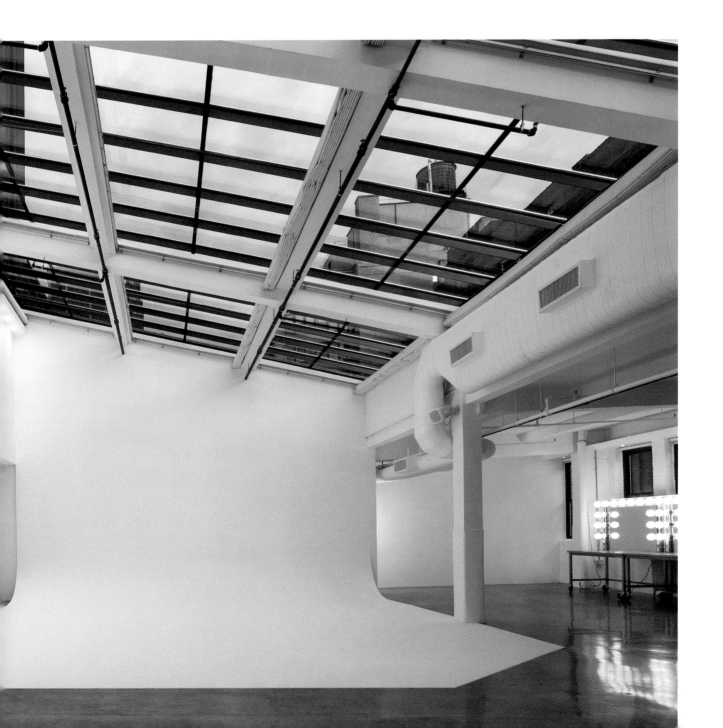

Let's get specific. As a rule of thumb, depending upon everything mentioned above, you'll need between 100 and 200 amps of electrical service just for your shooting floor. While that breaks down to five to ten 20-amp circuits, you might find you'll need an additional 30-amp circuit (or two) for amp hogs such as air conditioners or big, fast-recycling flash units. Some photographers might argue that if you decide on low-wattage florescent lighting as your light source for photography, you can get by with much less power. I strongly disagree. Have you ever seen a florescent spotlight that you could really use to create dramatic lighting? I haven't.

While you probably need one or two 20-amp lines for your office and computer equipment, you'll also need another two 20-amp lines if you can swing a kitchen. A dressing room mirror surrounded by low wattage bulbs can easily be powered by a single 20-amp line, but plug in a clothing steamer, a set of heated hair rollers, and a blow dryer, and you will stretch that single 20-amp line to its limits.

Knowing all this, it's a safe bet you're going to need an absolute minimum of 100 amps of electric service (five 20-amp circuits, each with its own circuit breaker), plus possibly even the extra one or two 30-amp lines I mentioned if you want to power big flash units, a kitchen, and air conditioners.

Extras

In my opinion, if you can afford about 100 – 150 extra square feet (9.6 – 14.3 square meters) of space, a small kitchen equipped with beautiful appliances and set along one wall of your shooting floor opens up the possibility of shooting food and using the appliances as backgrounds and supporting props (e.g., liquid soap or cleaning products by the sink; a pan of some beautiful food on the stove top, shot from above to see the burners; small kitchen appliances on a decorative stone countertop; dishes in a sink, dishwasher, or draining rack; or products on a refrigerator shelf or door rack). If your budget can in fact support a compact (but beautiful) kitchen and some nice appliances, be sure to keep them spotlessly clean.

Although this might sound weird, a small workshop (maybe 10x10 or 10x15 feet) that has a workbench with a vise and is equipped with a few portable hand and power tools can be really useful (see pages 58-69). Here, you can construct and paint accessories, props, and flats. It should be convenient to your shooting area, but not too close as to allow dust and debris to contaminate your shooting area.

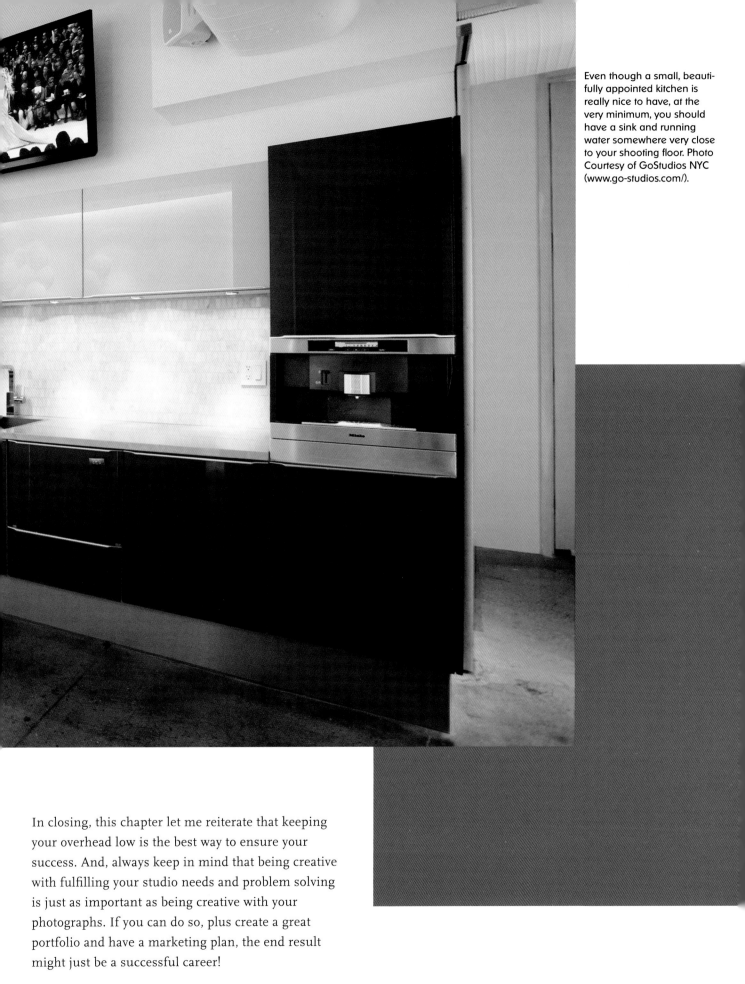

Even though a small, beautifully appointed kitchen is really nice to have, at the very minimum, you should have a sink and running water somewhere very close to your shooting floor. Photo Courtesy of GoStudios NYC (www.go-studios.com/).

In closing, this chapter let me reiterate that keeping your overhead low is the best way to ensure your success. And, always keep in mind that being creative with fulfilling your studio needs and problem solving is just as important as being creative with your photographs. If you can do so, plus create a great portfolio and have a marketing plan, the end result might just be a successful career!

3

Construction Tools For the Set

If you're serious about still life photography, you'll find you'll need some tools to help you create your photographs. But, while beginners will assume I'm talking about the photographic tools they'll need, the list of tools you'll really need is much more encompassing. Making and creating still life and product photographs will find you wearing many different hats. To name but a few, some days you'll be a carpenter, other days you'll be a product unpacker (or repacker), some days you'll be a product assembler, or a even a set designer. Sometimes you'll be an engineer, a draftsman, a businessperson or a salesperson, and finally, there will be those days when you're the photographer you dreamed of being.

But, regardless of which hat you're wearing, each and every day, your primary goal is to be creative. To create photographs, you'll find that you have to be creative not only with traditional photographic tools (camera and lighting equipment), but with other tools too. You wouldn't believe how many products you shoot might have to be assembled—from bicycles to furniture to Christmas trees! Furthermore, not only will you have to buy or construct other permanent things for your own use, but you'll also need things that are semi-permanent (which can collapse to be stored in a smaller area), and things that are non-permanent (which can then be broken down into their components after being used once so the components can be used for something else). While some of this might sound cryptic, I can assure you that it will make more sense to you as we continue. But, before we move along, let me give you three axioms about still life and product photography:

As I mentioned in the last chapter, everything outside of the photograph's frame is irrelevant. It doesn't matter where your studio is, what your studio looks like, how it's decorated, or whether you are using a big flash unit or a flashlight to illuminate your subjects. (I've used both!) The actual world we work in is both defined and confined by the edges of the photograph. (Of course, there are instances in which this isn't strictly the case: For example, if something is projected onto or reflected in any part of the subject, that projection or reflection is within the photograph's frame and is therefore relevant.)

The last (yes, last) thing you need to do when making a still life or product photograph is to place the camera between what you are seeing with your naked eye and the subject. Everything up until the point of capturing the actual photograph can be done without looking through the camera. At most, all you might need until that point is a small black mat board with a rectangle cut out of its center that matches the proportions of your final image. Note: not the proportions of your camera's format, the final image's proportions!

Like many kinds of professional photographs, the goal of still life or product photography is to create an emotional reaction in the viewer. You want to stop the viewer for a few extra seconds while they are looking at your photograph of the product. Just

a few extra seconds before they turn the page, click to view another page in their browser, or push the channel selector on their TV's remote. Personally, I often think of it as magic: making the ordinary look extraordinary! But, creating these kinds of images is often a game of smoke and mirrors. Accentuating what you want the viewer to see, shrouding what you don't want the viewer to see, and little things like defying gravity are everyday occurrences.

Before we start, I must mention that many times in this book, I will expand on ideas that use inexpensive solutions yet still allow you to create fresh and exciting images. There are thousands of photographers who will drop big bucks on things that are sold specifically as photographic equipment when something that is the same, but not marked

as "photographic," can be bought for a pittance compared to the photographic item! I have nothing against photographic equipment manufacturers, and I will recommend those things when a less expensive alternative is not available. I have every desire that the photographic equipment manufacturers succeed in their businesses, but my first desire is that you succeed in yours! There are photographers in New York City who will spend tens of thousands of dollars on nothing but the highest-end photographic equipment, but until you are going after national clients with huge budgets, who are impressed by such displays, these types of things just aren't that important. I have always felt—and proven over a long career—that my images should stand out more than the tools I use to create them and the facility I work in. This little rant does not mean that you'll find me on a $5000 CEO portrait shoot in jeans and love beads, nor does it mean that I won't drop a lot of money on a lens I must have to create the images I want. However, it does mean that if I can save a buck without sacrificing anything within my photograph's frame, I'll be the first to jump at doing it. That said, let's begin.

The Supplies You'll Need

When it comes to finding a source for the tools you'll need, you might find that the best places to look don't specialize in photo equipment! Instead, you might find yourself browsing the aisles of hardware stores, home improvement super stores, lumberyards, hobby shops, and art supply stores. Thankfully, the tasks involved no longer require as much brawn as they do brains—it is most often a matter of knowing what tool can accomplish a specific task, knowing how to use that tool, and having that tool available. The real trick is to realize that the very best still life and product photographers often have abilities in many different fields and use them all in combination to craft a photographic solution. These photographers work at developing their imaginations and curiosity, while keeping that curiosity directed, as opposed to aimless. If you keep an open mind, it's amazing how often an item designed for one purpose can be used for something else totally unrelated to its original purpose!

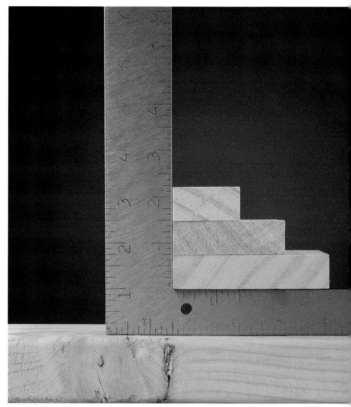

Here a 1x4 (2.5 x 10.2 cm), a 1x3 (2.5 x 7.6 cm), and a 1x2 (2.5 x 5.1 cm) are resting in the corner of my carpenter square. Note that each piece of lumber is smaller than its stated dimensions.

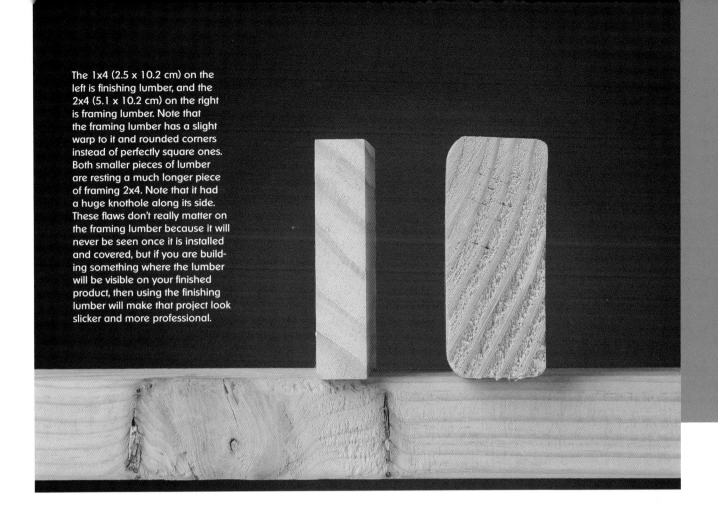

The 1x4 (2.5 x 10.2 cm) on the left is finishing lumber, and the 2x4 (5.1 x 10.2 cm) on the right is framing lumber. Note that the framing lumber has a slight warp to it and rounded corners instead of perfectly square ones. Both smaller pieces of lumber are resting a much longer piece of framing 2x4. Note that it had a huge knothole along its side. These flaws don't really matter on the framing lumber because it will never be seen once it is installed and covered, but if you are building something where the lumber will be visible on your finished product, then using the finishing lumber will make that project look slicker and more professional.

Wood

Walk through any cinema or video studio and you'll find they have a carpentry shop. Walk through any large still photography catalog studio, and you'll find they have a carpentry shop. It's simple really: To make films, videos, and still life or product photographs, you often need to build things, and it just so happens that wood is often the best choice as the building material. Unlike metal, wood can be cut and joined easily, it is non-conductive, and when you clamp something to wood, it compresses a bit, and its natural springiness makes the clamp hold better. Best of all, almost every task required to work with wood can be done with either hand tools or small, lightweight power tools. Lastly, wood is an organic product and it smells pleasant!

Dimensional Lumber

Because of this, before we get to the tools you'll need, let's start off with a short primer about lumber, since that's the building material you'll most often use. Basically, when it comes to lengths of wood (often called dimensional lumber) as opposed to sheets of wood (like plywood or particleboard), there are two types that will work. The first is used by construction crews for framing and is always covered from view in the final product; it is coarse, it often has knots, and it is not pretty. This is called framing lumber.

The second type is called finishing lumber, and in its final use, it is usually visible. It usually costs more, comes in smaller dimensions, has nicer finished edges, and can be bought "clear," meaning it has no visible knots. Since some of the things you might be constructing will be visible to your clients on your set, I have found that using finishing

NOMINAL SIZE	ACTUAL SIZE
1 x 1 inch (2.5 x 2.5 cm)	3/4 x 3/4 inch (1.9 x 1.9 cm)
1 x 3 inch (2.5 x 7.6 cm)	3/4 x 2-1/2 inch (1.9 x 6.4 cm)
1 x 4 inch (2.5 x 10.2 cm)	3/4 x 3-1/2 (1.9 x 8.9 cm)
1 x 6 inch (2.5 x 15.2 cm)	3/4 x 5-1/2 inch (1.9 x 14 cm)
1 x 8 inch (2.5 x 20.3 cm)	3/4 x 7-1/4 inch (1.9 x 18.4 cm)
1 x 10 inch (2.5 x 25.4 cm)	3/4 x 9-1/4 inch (1.9 x 23.5 cm)
1 x 12 inch (2.5 x 30.5 cm)	3/4 x 11-1/4 (1.9 x 28.6 cm)
2 x 2 inch (5.1 x 5.1 cm)	1-1/2 x 1-1/2 inch (3.8 x 3.8 cm)
2 x 3 inch (5.1 x 7.6 cm)	1-1/2 x 2-1/2 inch (3.8 x 6.4 cm)
2 x 4 inch (5.1 x 10.2 cm)	1-1/2 x 3-1/2 inch (3.8 x 8.9 cm)
2 x 6 inch (5.1 x 15.2 cm)	1-1/2 x 5-1/2 inch (3.8 x 14 cm)
2 x 8 inch (5.1 x 20.3 cm)	1-1/2 x 7-1/4 inch (3.8 x 18.4 cm)
2 x 10 inch (5.1 x 25.4 cm)	1-1/2 x 9-1/4 inch (3.8 x 23.5 cm)
2 x 12 inch (5.1 x 30.5 cm)	1-1/2 x 11-1/4 inch (3.8 x 28.6 cm)
4 x 4 inch (10.2 x 10.2 cm)	3-1/2 x 3-1/2 inch (8.9 x 8.9 cm)
4 x 6 inch (10.2 x 15.2 cm)	3-1/2 x 5-1/2 inch (8.9 x 14 cm)
6 x 6 inch (15.2 x 15.2 cm)	5-1/2 x 5-1/2 inch (14 x 14 cm)
8 x 8 inch (20.3 x 20.3 cm)	7-1/4 x 7-1/4 inch (18.4 x 18.4 cm)

lumber presents itself in a more professional-looking way. Although some photographers do, I find there's no need to paint it because it is never visible within my picture's frame (see the first axiom at the beginning of this chapter), but it should still look like a finished product with a sense of purpose and a clean design. It is also very important to note that when a piece of lumber is marked as 1x4 inches (2.5 x 10.2 cm), its actual dimensions are smaller than that. (See the table above.) Finally, and worth noting, dimensional lumber (of either the framing or the finishing type) is usually available in 8, 10, 12, and 16-foot lengths (2.4, 3, 3.7, and 4.9 m).

In addition to dimensional lumber, you may also need to use wooden dowels at times for hanging seamless paper or fabric backdrops, or even for storing things like clothing and backdrops. They are available in a wide variety of diameters and lengths, although "standard" closet poles are about 1.5 inches (3.8 cm) in diameter and are available in the longest lengths.

Engineered Wood

You'll also need sheets of wood to use as tabletops. There is a wide variety of engineered "sheet" wood, but there are only a couple you'll need to concern yourself with.

Plywood: Plywood is one type of sheet wood, and it is made from thin sheets of wood laminated together using glue and pressure. Because of the way it's constructed, it is extremely strong but somewhat flexible. The strength part is great, but the flexibility can create problems when it is used for tabletops—it just requires more support than a more rigid sheet would.

Plywood is generally sold in 4x8-foot (1.2 x 2.4 m) sheets of varying thicknesses, and the thicker it is, the more expensive it is. Plywood can be purchased with no perfect sides, one perfect side, or two perfect sides. Although it is more expensive, I prefer two perfect sides, because I'm often putting paper over it, and I don't want a knothole under the paper that can cause a crease in my paper or keep a product from standing up straight.

A piece of plywood set upon two sawhorses can create a work table for props or a shooting surface on which to put a background beneath a subject. While many photographers use a piece of 1/2-inch (1.3 cm) plywood for this, I find that it starts to sag at lengths over 3 feet (0.9 m). Naturally, the longer the distance the plywood has to span between the two sawhorses, the more it sags, which can be a real problem if you are setting up an 8-foot (2.4 m) table using a full sheet of 1/2-inch (1.3 cm) plywood.

There are two ways around this problem. One is to use a third sawhorse to support the middle of the span, and the other is to use two or three stringers that run the length of the span and are either clamped or screwed to the sheet of plywood. My choice for stringers are made from lengths of 1x2 (2.5 x 5.1 cm) lumber set on their narrow end but you can use larger dimensional lumber if you feel the need (1x3 or even 1x4). The plywood, with the stringers beneath them, is laid across two sawhorses and you end up with a sag-free tabletop. Generally speaking, and because of the sagging problem, I much prefer to use 3/4-inch (1.9 cm) plywood for my smaller tabletops (about 4 feet / 1.2 m or less) because its thickness obviates the need for stringers or a third sawhorse. However, since I find I need the stringers or the third sawhorse for 8-foot (2.4 m) wide tables when using 3/4-inch plywood anyway, I always use 1/2-inch plywood for those situations.

Particleboard: There is also a material called particleboard that is made from tiny wood chips mixed with resin glue and pressed into boards while the glue dries. It is often used as a substrate under Formica® kitchen countertops and for kitchen shelving because it doesn't sag much over time like plywood does. While 3/4-inch (1.9 cm) particleboard is better than 3/4-inch plywood for photography studio tabletops, it is also heavier than plywood and more difficult to cut because of all the glue in it.

Whether you use plywood or particleboard as your tabletops, you can have the 4x8 (1.2 x 2.4 m) sheet you buy at the lumberyard or store cut into smaller pieces that make it easier to transport. Furthermore, the cost of cutting it (typically $1 – 3 per cut) is often offset by the delivery charges involved when buying full sheets, because the smaller pieces can often fit into your car. For most photographers starting out (and for most tabletop subjects) you'll need one 36x48-inch (91.4 x 121.9 cm) and two 30x48-inch (76.2 x 121.9 cm) tabletops, so one 4x8-foot sheet of material can be cut into all three with only two cuts.

This brings me to an interesting point. I recommend always buying your lumber at the same place and becoming friendly with the saw man there. Say you need a small piece of 1/4-inch (0.6 cm) plywood to cut into pads for protecting the surface of some finished wood when you have to C-clamp it to something else. Well, yards or stores that cut lumber usually have a scrap box. If somebody walks in, buys a sheet of 1/4-inch plywood, has it cut to the size they need, and decides that they don't want what's left, the ever-frugal saw man will throw the small piece of scrap into a box. When you're having the wood you just bought cut and you need a little extra piece, ask the saw man if he has what you need in his scrap box. Most likely, the small piece of 1/4-inch ply you need is in the scrap box, and it's often free, or sometimes it's a buck or two, but you'll never know what's in there if you don't ask. Now that you have some knowledge about the materials I'm suggesting you use, let's look at the tools you'll need to work with it.

Power Tools

Just a short time ago, basic carpentry meant using hand tools, and that meant hard work, and blister city! Power tools started off requiring a power cord, and they gave way to battery-powered tools. For the kind of construction you'll be doing in a photography studio, you will need a few traditional hand tools, but the majority of the construction you'll be doing can be done with just two inexpensive power tools: a drill and a jigsaw.

Since I always do my construction in the studio and there is always an electrical outlet close at hand, I prefer corded (as opposed to battery-powered) tools because they are usually less expensive, they are always lighter-weight, and using a wall outlet to power the tool means there is one less battery to worry about charging!

Also, there is no need to get suckered into buying a super-duper, expensive contractor's model—you're not going to use it to build houses! If it ever breaks, you should just throw it out and buy another, as long as you can find another cheap one that has the features you need. In my 40-year career, I've worn out two drills, but the cost of the three drills I've purchased adds up to less than one of the more expensive alternatives!

figure 1

Your toolbox should, at the minimum, include the following power tools and accessories:

• A variable-speed jigsaw with an adjustable blade angle. (See figure 1.) A package of spare blades for the saw that are designed to cut wood.

• A variable-speed, reversible electric drill with a 3/8-inch chuck (the part of the drill the drill bits fit into). (See figure 2.)

• A set of drill bits and screwdriver bits for your electric drill—I use a DeWalt set that includes 16 drill bits ranging from 1/16 to 1/2 inch, plus 8 screwdriver bits. (See figure 3.)

• A set of hole saws that fit your drill's chuck. (See figure 4.)

• A few pilot-hole drill bits for wood screws. Using a pilot-hole bit will stop your piece of lumber from splitting when you drive a wood screw into it. (See figure 5.)

• A pair of safety glasses or goggles! I cannot stress the importance of this enough. Photographers make their living with their eyes, so always protect yours when using power tools! (See figure 6.)

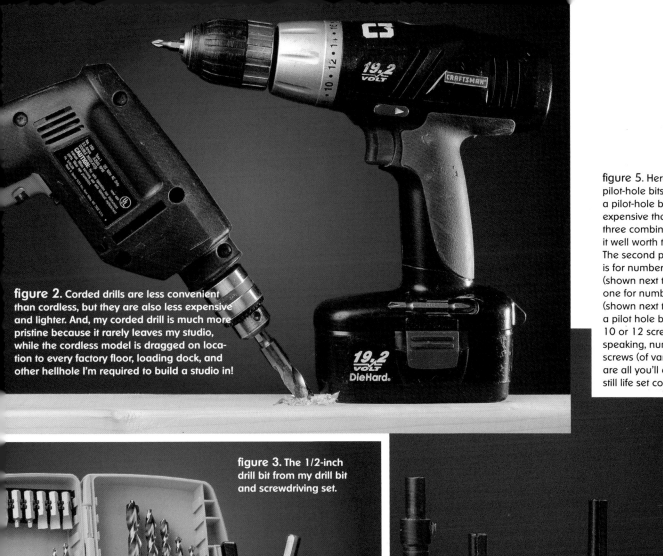

figure 2. Corded drills are less convenient than cordless, but they are also less expensive and lighter. And, my corded drill is much more pristine because it rarely leaves my studio, while the cordless model is dragged on location to every factory floor, loading dock, and other hellhole I'm required to build a studio in!

figure 5. Here are some pilot-hole bits. On the left is a pilot-hole bit that is more expensive than the other three combined, but I find it well worth the extra cost. The second pilot-hole drill bit is for number 4 or 5 screws (shown next to it), followed by one for number 8 or 9 screws (shown next to it), and finally, a pilot hole bit for number 10 or 12 screws. Generally speaking, number 5 or 6 screws (of various lengths) are all you'll ever need for still life set construction.

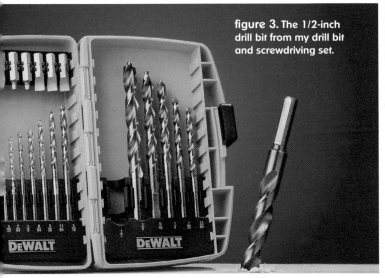

figure 3. The 1/2-inch drill bit from my drill bit and screwdriving set.

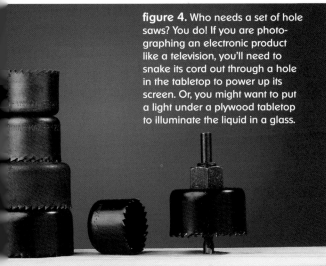

figure 4. Who needs a set of hole saws? You do! If you are photo-graphing an electronic product like a television, you'll need to snake its cord out through a hole in the tabletop to power up its screen. Or, you might want to put a light under a plywood tabletop to illuminate the liquid in a glass.

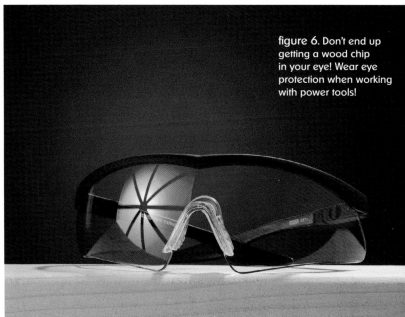

figure 6. Don't end up getting a wood chip in your eye! Wear eye protection when working with power tools!

If you get really into carpentry (and you might!), it is nice to have a few other power tools. These are other power tools I use quite often:

An electric screwdriver. In reality, what I'm talking about is a second drill. This one can be a corded or battery powered one—the power source doesn't matter. It is just important that you have two reversible, variable-speed drills. The reason you need two is so you can use one to drill pilot holes for screws and the other for driving the screws into whatever you are building. Without two, you have to drill a pilot hole and then exchange the drill bit for a screwdriver bit, which can slow your construction project to a snail's pace. For proof of just how important the second drill really is, skip ahead to chapter 4 and look over the process for constructing a diffusion frame. Between screwing the pieces of wood together, you'll need to drill a minimum of 16 pilot holes and drive home a minimum of 16 screws. That means changing your single drill's bit over a dozen more times! It's your time and your tool budget, so you decide.

• A small handheld rotary tool such as a Dremel tool or the more powerful RotoZip for cutting, grinding, shaping, and sanding things. I have and use both— my Dremel for lightweight jobs, and my RotoZip when I need more muscle. (See figure 7.)

• A selection of various bits and attachments for your rotary tool.

• A pair of safety goggles! Photographers make their living with their eyes, so always protect yours when using power tools! Yes, I mentioned this before, but it's really important! (See figure 8.)

• A circular saw is also a power tool worth having, because it's much easier to cut a straight line with one (as opposed to a jigsaw). However, I consider it a luxury option because there is a way to cut a straight line with a jigsaw using a straight edge and two C-clamps.

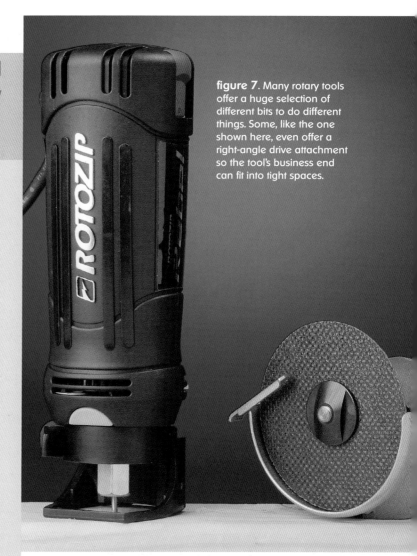

figure 7. Many rotary tools offer a huge selection of different bits to do different things. Some, like the one shown here, even offer a right-angle drive attachment so the tool's business end can fit into tight spaces.

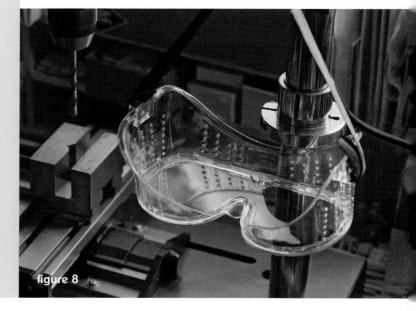

figure 8

Shop Vac

A small canister wet/dry vacuum cleaner is a really nice thing to have. If you are going to shoot products, you have to be able to control the dust in your studio, and the best way to do that is with a vacuum cleaner! Once again, you don't need a super-duper industrial sized one, but a 6 – 12 gallon (24 – 49 liter) one can be purchased at a home center store for under $100. They all come with a hose and accessory kit and can suck up liquids as well as dust. Don't think you'll ever have to suck up liquids? See the paragraph in Chapter 8 about using water as a surface (page 200). If (or when) you buy yours, be sure to purchase at least two spare filters with it—you'll need them eventually.

Air Compressor

One more thing I have always found helpful is a source of clean, dry compressed air. The last thing you want to spend your time doing is retouching dust spots off your subjects in post-production! For example, cleaning dust spots off reflective surfaces in images, like cosmetic containers or glassware, is especially difficult, because not only do you have to remove the dust spot, but you also have to get the dust spot's reflection. A squiggly wisp of cotton stuck in the prong on a ring that holds the gemstone in position is another nightmare! Regardless of how good the current version of Photoshop is, these scenarios present challenges (and they waste your time).

At my beginnings, I bought aerosol cans of compressed air by the half dozen. The cans would sometimes spit propellant that would ruin my subject's finish, and when it wasn't spitting, the intensity of the airflow was more like a gale-force wind instead of the gentle zephyr I needed! After years of using too many cans of this stuff, I attended an illustrator's demonstration where the presenter was using an airbrush. I was most intrigued by the compressor he was using to power the airbrush and spent a few moments at the end asking questions about it. It was virtually silent (none of that gas station hissing and banging), had a reservoir tank so it could deliver a consistent airflow, a moisture trap (so no spitting), and a regulator gauge to allow control of the airflow intensity. I ended up at a big art supply store and bought a compressor with all the features I just

mentioned and the cheapest airbrush I could find. My little shopping spree was not cheap! While my airbrush was a simple, single-action one that cost about $30, the Medea compressor I decided upon was over $300. That purchase was about 25 years ago, so I've saved a lot of money over the years not buying canned air.

Today, partly because of hobbyists who paint their models, beauticians who paint people's nails, and make-up artists who paint people's skin, there are many lightweight and inexpensive compressors on the market. Furthermore, you can often add a moisture trap to an inexpensive compressor that doesn't come with one and avoid that spitting problem I mentioned. (When you compress air, water vapor in the air condenses into droplets of water, and those droplets can mess up a pristine background in a second.)

Some of you might be saying, "I'm just starting out, I can't afford food to eat, let alone a $300 compressor! What? Is Steve crazy? And, I've got to buy an airbrush too?" OK, you've got a point. So, for those of you on the proverbial shoestring budget, I suggest a Giotto Rocket Air Blaster. The medium-sized version (6.6 inches / 16.8 cm) is about $15, but interestingly, both the larger one (7.5 inches / 19 cm) and the smaller one (5.3 inches / 13.5 cm) are under $10.

Lastly, consider this: Instead of buying an expensive air compressor and airbrush, you can use the vacuum cleaner I mentioned to suck dust off a product instead of just blowing it off (so the dust doesn't just resettle onto it). However, beware that a shop vacuum is strong enough to suck a small product right off your tabletop! One way to avoid having that ruby ring you're photographing sucked into your shop vacuum is to rubber band a scrap of nylon stocking over the vacuum's tube when you're using it as a dust remover. It'll still suck strong enough to ruin the arrangement of your small subjects, but at least they won't disappear up the vacuum's tube.

Hand Tools: If I Had a Hammer...

In the Stone Age, the first tool invented was probably the hammer. While a hammer is perfect for breaking rocks, I'm going to go out on a limb here and say that having a hammer isn't really as necessary as it once was. Of course, if you want to be able to hang a picture in your studio, you'll still need one! You'll also need a few other hand tools:

Three Interchangeable-Bit Screwdrivers

I know, I know, how many screwdrivers can you use at one time? Well, what happens if you and an assistant are building something together? Do you pass that one screwdriver back and forth between you? I think not! There are two new improvements in screwdriver design that are worth investigating. One is a screwdriver with interchangeable bits. The simplest of these have two double-sided bits that

fit into two ends of a tube and the tube fits into the screwdriver's handle. This means one of these newer screwdrivers can take the place of four of the traditional, single-bit screwdrivers.

The second design breakthrough is a ratcheting handle that means you can drive the screw in to the limit of your wrist's movement and then rotate the screwdriver backwards, because the screwdriver exerts force in only one direction. You select which direction the screw is turned with force by a selector ring on the screwdriver's handle. The ratchet design allows you to keep the bit in the screw for the entire operation, making things go much faster. These same screwdrivers also come with a selection of bits, stored either in the handle or in a small plastic case. Although I still use traditional screwdrivers most of the time, I do like the ratcheted ones.

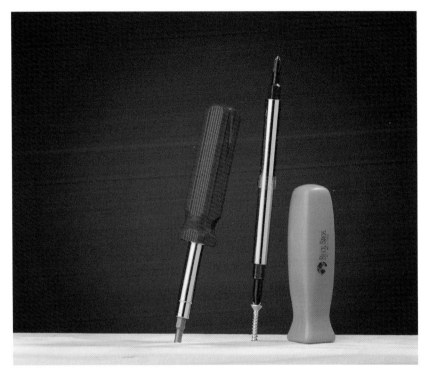

Adjustable Wrench

Adjustable wrenches are handy to have around because they don't chew up the edges of a bolt or nut that needs tightening like a pair of pliers or vise grips do. After all, you don't want the pristine bolts on a product you've just assembled to look anything less than perfect when you photograph it.

Various Pliers

You'll need a pair of regular slip-joint pliers, a few pairs of needle-nose pliers, and maybe even a pair of vise-grip pliers (not shown). Although not a perfect substitute, a pair of vise-grip pliers can take the place of an adjustable wrench.

Every so often, you'll need a pair of BIG pliers, not only to tighten a headset on a bicycle that you have to assemble to shoot, but maybe to grip a broken knob on a piece of grip equipment. Mine is old, it was relatively inexpensive when I bought it new, and I find it is quite worth having.

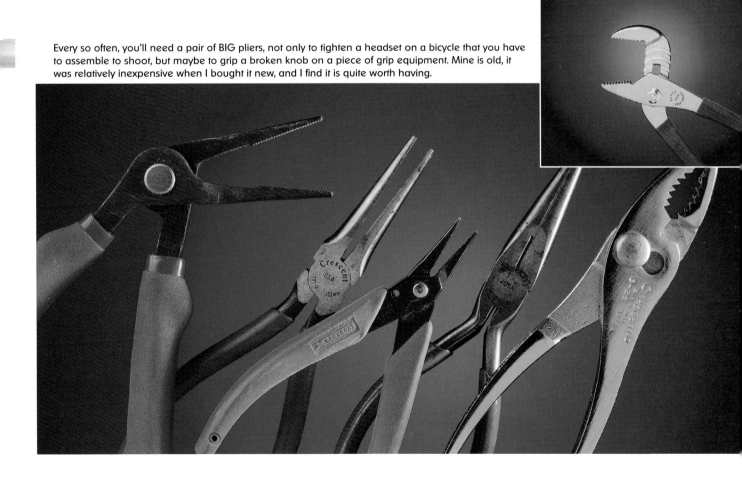

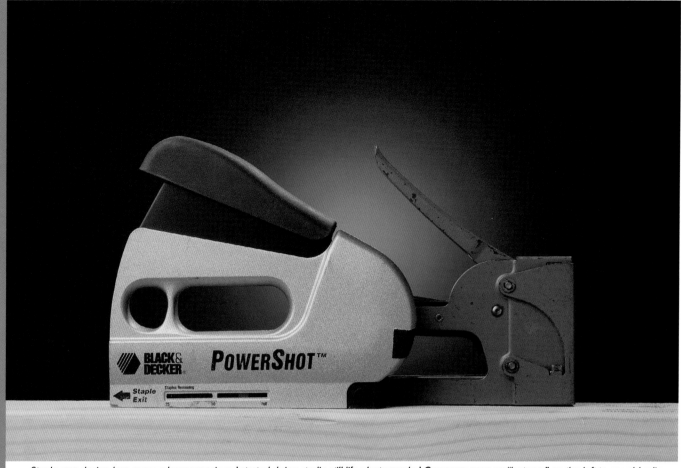

Staple gun design has come a long way since I started doing studio still life photography! Compare my new "hotness" on the left to my old relic on the right. The old relic still works fine, but we needed a second staple gun in my studio, and I decided to try out one of the newer designs. It was more expensive than the older design and, in honesty, I'm still not sure if it was worth it!

A Staple Gun

If you want to drape material, tack a piece of diffusion material to a wood frame (pages 94-101), or stop a seamless paper from rolling off a tabletop, nothing beats a few quick, strategically placed staples. And, of course, don't forget to always have a box of staples for your staple gun.

Hint: A single staple—or even a few of them—won't stop a roll of seamless from curling up, because the paper will just tear around the staple. But, if you put a small square of gaffer tape down on the seamless paper where you plan to put the staple, it provides enough reinforcement to keep the paper from tearing or rolling up for a millennium (OK, that's an exaggeration, but only a slight one)!

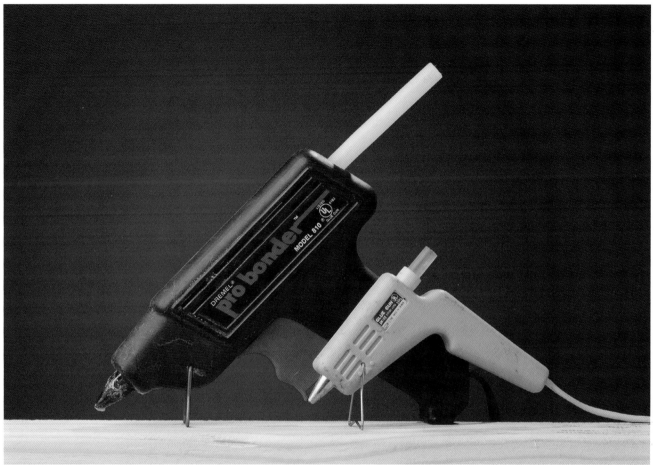

Mommy and baby hot glue guns! Both are definitely worth having. Caution: Hot glue (as the name implies) is very, very hot! Hot enough to badly burn your skin (badly!) if a blob of the molten glue gets on it. Be careful, and don't ever touch a hot glue joint with your finger to see if the glue has set.

A Hot Glue Gun... Actually Two

Nothing is more frustrating than perfectly positioning a product (like a lipstick tube and cap) and then accidentally bumping the tabletop it's resting on as you place a fill card, knocking the product out of position! I used a lipstick as my example because the cap usually has the brand's logo on it and when the tube falls over the cap (with the logo on it) rolls away also. Arggggh! Worse, when the lipstick tube falls over, it almost always damages the perfectly chiseled edge of the lipstick itself! Arggggh! Two little droplets of hot glue will keep this kind of calamity from happening. Glue guns come in two sizes, and while the larger size is sold in hardware stores, the tiny-sized one is usually found in craft, hobby, or art supply shops. Both sizes are worth having. Obviously, you'll also need some glue sticks to use in your glue gun.

Hint: When you first plug in your hot glue gun, as it heats up, some of the glue will dribble out the end of the gun. That being the case, put a small piece of mat board or corrugated cardboard under the business end of the gun so you don't get a blob of glue on your tabletop as the gun is warming up to operating temperature.

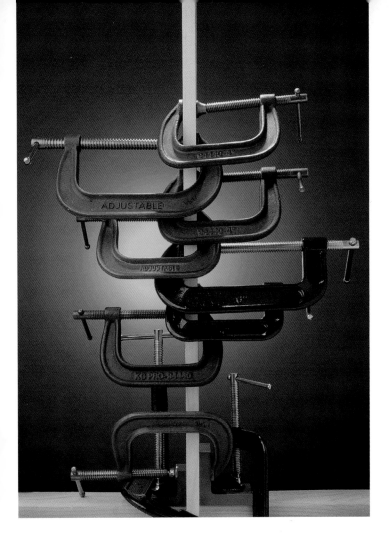

The possible uses for a C-clamp or two are only limited by your imagination but, on the negative side of the ledger, good C-clamps are pricey. Keep in mind, though, you don't need the biggest, strongest, or heaviest-duty one available. Why spend $125 on a single C-clamp that can support 2500 pounds (1134 kg) when a $10 one that supports 200 pounds (91 kg) will more than satisfy your needs? For the record, I have five 6-inch (15.2 cm) ones and eight 4-inch (10.2 cm) ones that have served me well for many years. The "C" part of a good C-clamp is usually made of cast iron, and the screw should be made of steel—one like that will last forever. In my opinion, you should stay away from lighter-weight ones in which the "C" casting is made from aluminum. By shopping wisely, you should be able to find the price you need—try your local hardware store, Lowes, Home Depot, or Harbor Freight Tools on the web or in-store.

C-Clamps

C-clamps offer a wide variety of applications. Off the top of my head:

• Holding two things in alignment as you drill them for a more permanent, screwed-together connection

• Clamping together two wooden frames covered with diffusion material to create a huge light source

• Clamping a tabletop to a pair of sawhorses

• Attaching wall flats together to form a background

• If you have to drill a hole through a piece of translucent acrylic, sandwiching it between two pieces of wood so it won't shatter when the drill bit bites into it

• You can even have a stud from a photographic super clamp (see pages 150-151) welded to a C-clamp for custom way to mount a camera or a light in a unique position

Spring Clamps

If C-clamps are your battleships in the clamping wars, then spring clips are your cruiser ships. I have and use ratchet clamps, spring clamps, weird little wire paper clip ones, and even large binder clips I found in the office supply store. As long as a spring clip can open at least one inch wide, I'm a sucker for it. Why one inch, you ask? Well, if I'm working on a 3/4-inch (1.9 cm) plywood table top, and I want to clip a seamless to the table's edge—oh heck, you get the idea! I can't tell you how many different layers of surfaces might be piled one atop the other in a complicated still life, nor can I tell you how frustrating it is when the layers are moving around on one another instead of staying in alignment. So, whenever I'm laying down layer over layer of backgrounds, I end up clipping each layer to the surface I'm using as a tabletop.

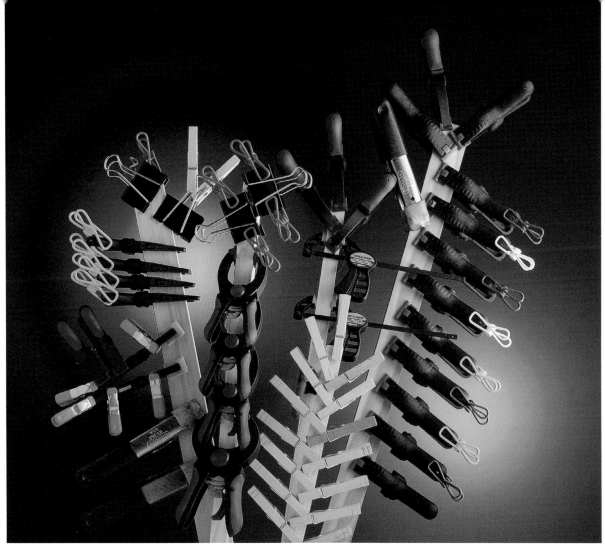

On Zanthar, a planet with two suns, one a hot yellow and the other a cooler blue, all photographers are happy because spring clamps sprout like weeds! Seriously though, this image shows off only part of my collection of spring clamps, and every one of them gets used on one assignment or another.

Utility Knife

The original utility knife stored extra blades in its handle, but the blade in use was always exposed. Considering that this was basically an exposed razor blade, you can understand why it could be a bit dangerous if you weren't careful. However, current ones have a mechanism for retracting the blade when it's not in use, and that's the kind I recommend looking for. Utility knives are great for cutting mat boards, fill cards, and even seamless paper. (Beware of terrible paper cuts from the edge of seamless paper—do not slide your fingers along its edge!)

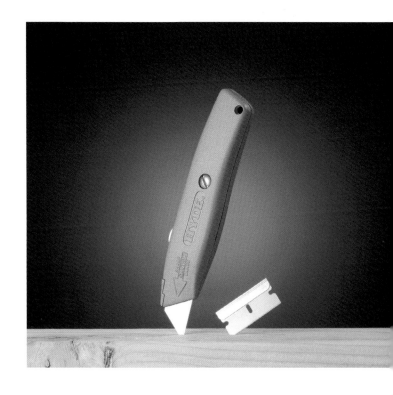

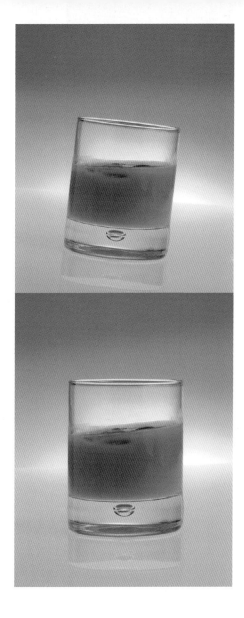

If your tabletop is not level, you can put a shim under the low side (between a sawhorse and the tabletop) made of a layer or two of mat board or whatever else you have handy. The two-axis hot shoe level is inexpensive (usually less than $20) and the 24-inch carpenter's level is maybe twice as much, but my advice is to buy both of them and use them! Want another reason why you should get into the habit of leveling your tabletop? If you shoot any transparent container (a glass or a bottle for example) with liquid in it, and your tabletop is not perfectly level, the liquid in the container will be level. This means that if you adjust your camera's tilt so that the container's sides are parallel to the image's sides, the liquid in the container will appear crooked in the image. If you tilt the camera so that the liquid's surface is parallel to the top and bottom of your frame, then the container's sides will not be straight. As a mentor once told me (and now I'm telling you): The surface of a liquid is always level—not sometimes, always!

Safety Goggles

Did I mention safety goggles? Photographers make their living with their eyes, so always protect yours when using tools!

Bubble Level

Landscape photographers often use a two-axis bubble level (a double bubble level) that fits into their camera's hot shoe to make sure the horizon line is level. Likewise, a studio photographer who is shooting a box of cornflakes, for example, should level his or her camera too so the sides of the box are vertical. But, I have to ask you this: What good is it to level your camera if the tabletop the product is resting on is not level? The answer is none! They both have to be level. So that the camera and the subject start off on a level playing field, you need a way of leveling your tabletop, and for that, I use a 24-inch (61 cm) I-beam carpenter's bubble level. The longer the level you use, the more accurate the level will be (home builders often use 72-inch levels!) but I find a 24-inch one is fine for most tabletop photography.

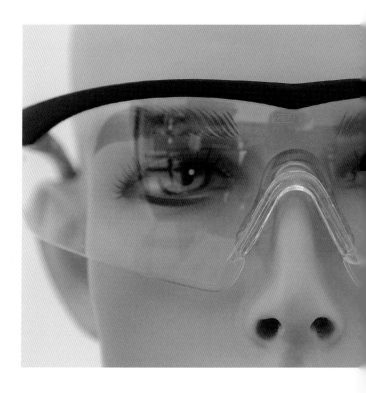

Now, before I continue, a word from this chapter's sponsor: SAFETY!

I just mentioned for the third time the importance of wearing safety glasses or goggles when working with tools, but that's just the half of it. I have also mentioned using hammers, hot glue guns, sharp, pointy drill bits, and saw blades with teeth as sharp as a Piranha's. And, after this announcement, I'm going to suggest using mat knives, pointy X-ACTO® blades, and even single-edged razor blades! Plus, don't forget that the world's worst paper cuts can come from the edge of a piece of seamless paper, and the edged of polyester diffusion film is no joke either! Oh my, this is serious stuff. You can slice off a finger or crush a toe in the blink of an eye. (Hint: No bare feet or flip-flops when you're working in the studio!) You can start a fire in a New York minute. When the tool you buy says anything on it like, "safety precautions" or "caution" or "danger," read what it says, and then follow the rules! I implore you, your mother implores you, Be Careful!

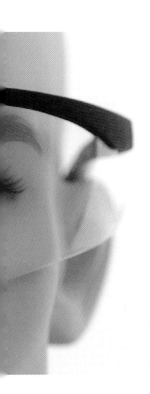

Please...please... don't be a dummy— wear safety glasses when working with power tools or sharp tools, or when doing any construction work!

Later on, I am going to talk about using gigawatts (a slight exaggeration) of electricity and lights so hot...well, forget the old analogy, "you can fry an egg on it," and substitute, "you can melt metal on it," and you'll get the idea! If I just added an ice pick and a meat hook to the items I'm suggesting you use in this book, we would have every murder mystery weapon known to man on the list! But, instead of adding picks and hooks to the list, I'm going to suggest that you get a...fire extinguisher! Yes, a fire extinguisher. You should get one that can put out electrical fires as well as paper fires. And, even with the fire extinguisher right by your side, you should still Be Careful! Forgive my meager attempts at comedy here but it is often how I react to very serious stuff, and this is very serious stuff, so Be Careful!

Thank you, this has been a public service announcement, and now we will rejoin our program already in progress. Let's check out what helpful tools you might find at an art supply store.

Tools From Your Local Art Supply Store

Small towns don't always have an art supply store, while bigger cities often have a few. College towns usually have one, probably because of all the art students needing supplies. Regardless, the Internet can help you find all the art supplies a photographer will ever need. In fact, a Google search of the term "art supplies" gets over 23 million hits. I point this out because you shouldn't limit your selections to the 8 feet of art supply shelf space in even the biggest Staples! So, without further ado, lets look at what you'll need from an art supply store.

The first three tools I'm going to highlight are not only used on the set, but also when I want to draw something I plan to build or shoot. Drawing something may sound like something you never want to do (that's why you chose to be a photographer) but I promise you that working out something on paper (whether it's set construction or lighting design) is often faster and easier than experimenting in real life. Plus, if you sketch or draw it first, you can give the sketch to an accomplished assistant and say: "Here, build me this."

Rulers

First off, you're going to need some sort of straight edge. I have a 48-inch (121.9 cm) aluminum ruler and a 36-inch (91.4 cm) steel ruler. The aluminum ruler is the thicker of the two, and the bottom of the steel rule has a layer of rubbery cork on it. Both features are helpful in different situations. I also use an 18-inch (45.7 cm) steel machinist's ruler (actually called a "blade") that I find is both extremely accurate and beautiful, but honestly, is expensive and a bit of a luxury. To me, it's a small indulgence I find worthwhile.

While both of the first two rulers I mentioned can help me draw a straight line, the thicker aluminum one can also help me cut a straight line with my jigsaw. Try cutting a dead straight line with your jigsaw and you will find it is no easy feat! If the saw blade hits a knot or a denser part of the lumber you're trying to cut, instead of a straight line, you may end up with a cut that resembles a drunk's stagger!

So, to get a straight cut, I use two C-clamps to clamp the ends of my 4-foot (1.2 m) aluminum ruler to a piece of plywood so that the edge of the ruler is parallel to the line I want to cut and offset by the distance between my saw's blade and the edge of the saw's shoe. I can then use the ruler as a guide, pressing the outside edge of my running saw's shoe against the side of it, and the resulting cut will be as straight as my ruler is. No fooling, it really works! Likewise, if I have to cut a straight line with a knife blade into a piece of paper, placing my 3-foot (0.9 m) ruler on the paper with the cork side down stops it from slipping as I make my cut.

Finally, since we are talking about rulers, I also use a wooden yardstick (that I got for free a little over 100 years ago), and I have drilled holes through it at almost every inch marker. By putting a pushpin through one hole and putting a pencil or marker through some other hole I can use it as a large radius compass and draw circles (or curves) with diameters from about 6 inches (15.2 cm) to 68 inches (172.7 cm). The resulting circle or arc can be cut out of the mat board or paper I'm tracing on, and then it can be used to create a spotlight or other lighting effect.

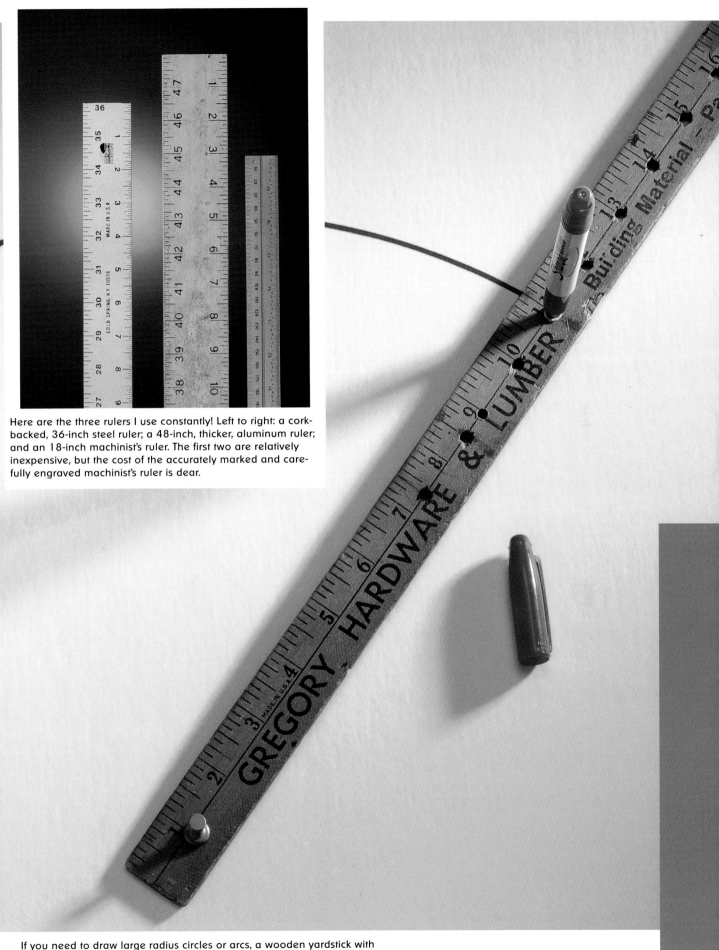

Here are the three rulers I use constantly! Left to right: a cork-backed, 36-inch steel ruler; a 48-inch, thicker, aluminum ruler; and an 18-inch machinist's ruler. The first two are relatively inexpensive, but the cost of the accurately marked and carefully engraved machinist's ruler is dear.

If you need to draw large radius circles or arcs, a wooden yardstick with holes drilled in it, a pushpin, and a Sharpie® marker are your ticket to ride!

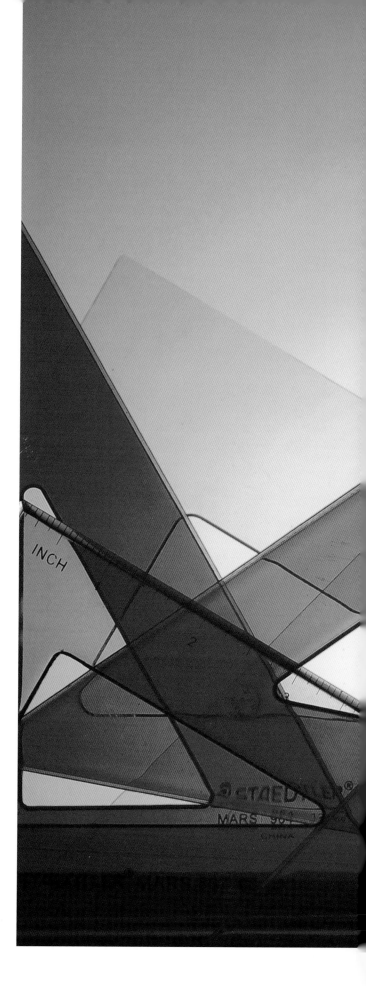

Triangles

You'll also need two acrylic drafting triangles: a 90/45/45 and a 90/60/30. Those numbers refer to the degrees of the angles at the triangle's corners, and they always add up to 180. Bigger acrylic triangles are more accurate, but over the years, I've collected a few of each in different sizes. Using one of my triangles pressed against one of my straight edges I can draw a two perpendicular lines. Actually, I have switched to using a machinist's square set that I bought a few years ago instead of my two triangles because it offers more possibilities for setting angle measurements, but it takes much longer to set up and, in truth, when I want to save time and don't need the machinist square's adjustability, I grab one of my trusty triangles.

Carpenter Square

You might want to include a carpenter square on your tool list too. Basically, it's a metal "L" with a 90-degree corner and 1/8-inch markings along both sides. Like the triangles, it can also take the place of a machinist square. So, between the carpenter squares, the machinist squares, and the triangles, I've just offered three different ways of measuring for a 90-degree angle. It is often important to have two adjacent edges of a piece of wood form a 90-degree angle. Among other reasons, someday you might want to build an apple box (a short riser your "talent" can stand on), and to do that, accuracy counts! Check out the photo of dimensional lumber on page 54 to see what a carpenter square looks like.

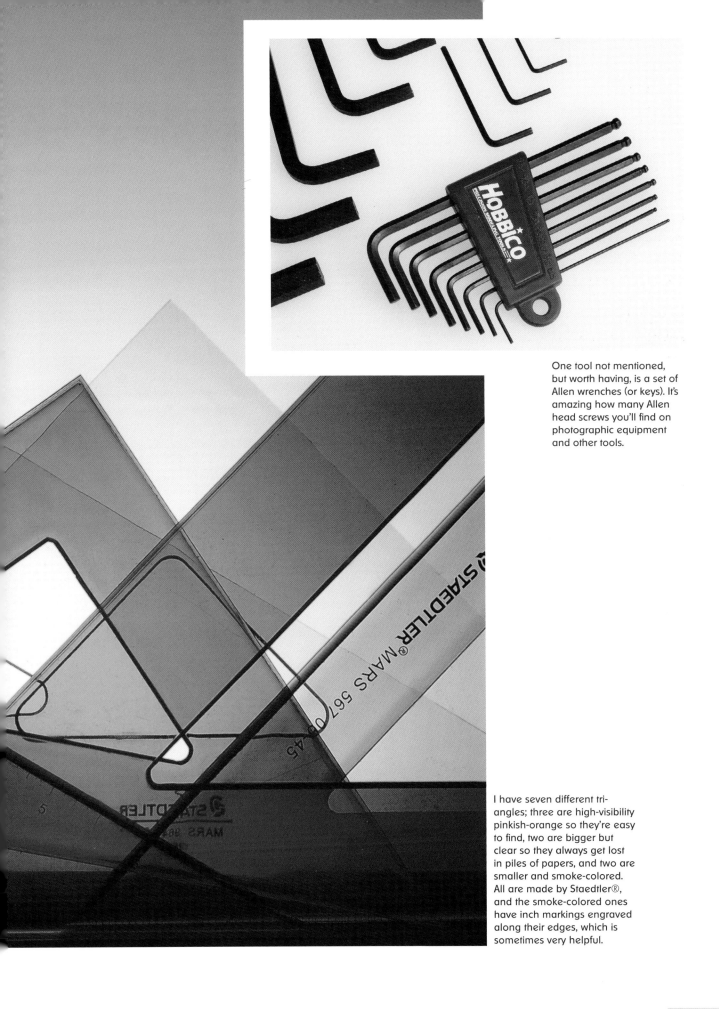

One tool not mentioned, but worth having, is a set of Allen wrenches (or keys). It's amazing how many Allen head screws you'll find on photographic equipment and other tools.

I have seven different tri-angles; three are high-visibility pinkish-orange so they're easy to find, two are bigger but clear so they always get lost in piles of papers, and two are smaller and smoke-colored. All are made by Staedtler®, and the smoke-colored ones have inch markings engraved along their edges, which is sometimes very helpful.

Although X-ACTO® brand blades sell for about $25 per 100 pack, other companies make (or import) brands of blades that fit X-ACTO® handles just fine and cost about half as much. I use these blades like water and have not seen any huge difference in quality.

X-ACTO® Knife

Although I recommended using a utility knife earlier in the "Hand Tools" section, for more delicate work, I use a No. 1 X-ACTO® knife and a No. 11 blade. The X-ACTO® is lighter weight, the blades are sharper, and it's easier to cut curved or irregular lines using it.

When shopping for blades, keep in mind that you will likely need a lot of them. Because X-ACTO® No. 1 knife handles are so light, the blade in the knife must be really sharp to work well. That, in turn, means you must change blades often. Don't try to save a few pennies by using a blade until it is as dull as a butter knife. Ruining a 6 or 8-dollar show card or cutting yourself because a dull blade slipped off a line instead of cutting through it—well, that is just plain wasteful and can be painful too!

And, one final thing about X-ACTO® blades: You can't just throw a used one in the trash can and expect that an accident won't happen. One will happen. To avoid this, I put all my old, dull blades in an empty pharmacy prescription bottle. When the bottle is full (about 200 blades), I put the cap tightly on the bottle and throw the whole thing away. That way, I never cut myself on an old blade when rummaging through the trash looking for something I've thrown out by mistake!

Single-Edge Razor Blades

Although I use my utility knife to cut 1/4- and 1/2-inch (0.6 and 1.3 cm) foam core board, often I just work with a single-edge razor blade when I'm putting together a set. (See the photo on page 85.) They cost about 10 cents each when bought in bulk, and I find it easier to grab a fresh one than it is to change blades on my utility knife.

Fun-Tak!

Loctite Fun-Tak (Elmer's calls their version of it "Poster Tack," and Scotch calls theirs "Adhesive Putty") is a kind of reusable putty that you can use to hold an item in place while you photograph it. You can even use a blob of it to hold a small fill card in place when photographing tiny objects. To use it, you knead a small blob of it until it gets soft and, well, tacky. It is easily removable and reusable—a small blob of it lasts seemingly forever—it doesn't mar surfaces, and the bond it makes between the objects being tacked together is not very strong. Currently, most versions available are either green or blue, but the Scotch brand comes in white (recommended). It is very cheap and, as I said, you only need to buy it once because it's reusable! I (and every other still life photographer I know) use the stuff constantly.

Tape

All kinds of tape! Gaffer taper, masking tape, clear packing tape, electrical tape, reinforced strapping tape, even plain old Scotch® tape are all useful to have around the studio. Gaffer tape is not the same as duct (or duck) tape! Gaffer tape has a fabric base, while duct tape has a plastic base. Put duct tape on or near a hot light, and it will melt. Gaffer tape won't! The adhesive will migrate off the plastic backing

of duct tape and onto whatever the tape is stuck to. You'll need Goo-Gone® to get it off! Gaffer tape is so useful I have it in all three available colors—grey, white, and black. I buy it spooled on large cores to use in the studio and small cores to so I can pack it into my camera case for location shoots. Without stretching the truth, I can say that I could almost build a photography set using only gaffer tape!

No matter what, don't be intimidated by the approximately three-dozen-item list of tools I've just described. As the saying goes, Rome wasn't built in a day, and you don't have to go out tomorrow and buy every tool on the list. When I started out on a shoestring and a prayer, I had my camera, two lenses, a hammer, a pair of pliers, and a screwdriver (three screwdrivers if you counted the two on the Swiss Army knife in my pocket)! But, as I worked as an assistant for other professional photographers and on still, film, and video commercial sets, I saw and learned how real pros did it better, faster, and smarter. So, it's perfectly OK to start with just a camera and a screwdriver, but I'm hoping you'll find it comforting to know you can replace that screwdriver with a power tool when you're ready and able to.

How the
Photographs Were Done

Since this is a photography textbook, and because I created the photographs in Chapter 3 using techniques that are a little off the beaten track, I thought I would spend some time explaining how, what, and why. Although some of the tools I photographed are colorful, at times you might be faced with less interesting items. Personally, I like strong, rock-em, sock-em colors, because I feel they add impact and stop the viewer in their tracks. But, this does not mean that I won't use a more subtle, softer, palette if that is what the subject or client demands. When it comes to photographing tools, however, I generally like to use strong, intense colors in a limited palette, with crisp lighting.

I created the soft-edged, "ball of color" background that you saw in most of Chapter 3's images by placing a flash head with a colored gel on it and fitted with either a grid holder, a grid holder and grid, or nothing, behind the translucent background. The choice of which of the three grid options I chose depended on a few things. Obviously, you can change the size of a beam of light shining through a translucent background by moving the light closer to (or farther away from) the background it is shining through; or you can change it from a set distance by adding a light modifier (in this case, a grid holder or a grid holder and grid). But, this raises the question as to why I would choose one solution over another.

Well, there are multiple reasons for choosing which way to narrow a light's beam in this situation, and other factors affect each way of doing it. Here are just a few of them:

The size of the light's pattern should be determined by the size of the subject: A big subject might require a big, soft-edged circle of light behind it, while a small subject might require a much smaller soft-edged circle of light behind it.

If your set is built close to a studio wall, you might not have enough room to back away and get a soft-edged circle of light as large as you might want, especially if that light is fitted with a grid.

Depending on the density of the colored filter you are using, and considering that a grid cuts both the intensity and the size of the light beam passing through it, you might choose a flash head without a grid on it (positioned close to the background) if you wanted to use a dense blue gel. Or, you might want to use a flash head with a grid holder and grid on it behind and farther away from the background if you used a single, lower-density yellow or orange.

Because this is partially a creative decision and partially a technical decision, you'll have to make the decision for your specific arrangement. But, regardless of which way you get the light's circular beam to the size you want, the gelled light is projected through a sheet of diffusion material that is the photograph's background. For my translucent background, I used a roll of polyester diffusion material called Tough Lux (60-inch x 15-foot rolls are available from setshop. com). The problem is, when I was lighting the subject, the Tough Lux (which is white and behind the subject) was also illuminated, and that made the colored light coming through it (from behind) look washed-out. As an example, imagine taking a one-gallon bucket of white paint and pouring one ounce of colored paint into it; the resulting pale paint color is what my backgrounds ended up looking like. Look at figure 1 to understand what I mean.

figure 1

figure 2

figure 3

The Multiple Exposure Trick

The way to avoid that washed-out look is to make two separate exposures and then combine them digitally into one picture. (I used to do this same technique when I was shooting film, by making an in-camera double exposure.) The first exposure was of the translucent background, and the second exposure was of the lit subject. When I made the exposure of the lit subject in the foreground, I covered the translucent background with a piece of black velvet; and when I made the exposure of the colorful background, I turned off the flash units lighting the subject. The resulting two photographs, when viewed separately, had the product perfectly lit against a black background in one (figure 2), and the subject as a total silhouette against a richly colored background in the other (figure 3).

As an aside, but worth noting, if the subject itself is translucent and colorful, you might forgo using the colored gel over your background light and just use the translucent part of your subject from its silhouette (figure 4). Further, you might forego lighting the front part of the product altogether and instead just use the silhouette of the subject and its translucency to increase the impact of the image (figure 5). Chances are good if you are assigned (or decide on your own) to do this, you'll also be shooting an additional beauty shot of the subject that will be used as an inset in the final finished artwork. If your subject isn't translucent in whole or in part, but has a distinctive shape, a silhouette may be enough to identify what it is, however—and this is my opinion—a simple black silhouette of almost any subject leaves too many unanswered questions for the image to be of commercial use (see figure 7).

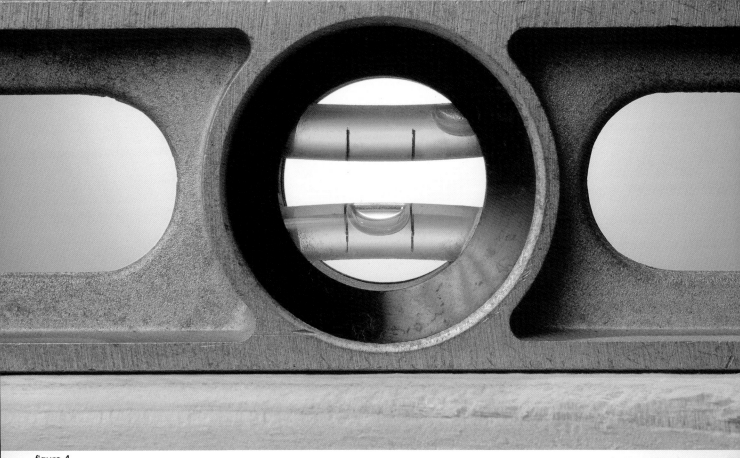

figure 4

By limiting your palette to black, white, and the color of the translucent part of your subject, you can make a very impactful image.
The contrast of the single color against a black or white background makes for a very bold graphic.

figure 5

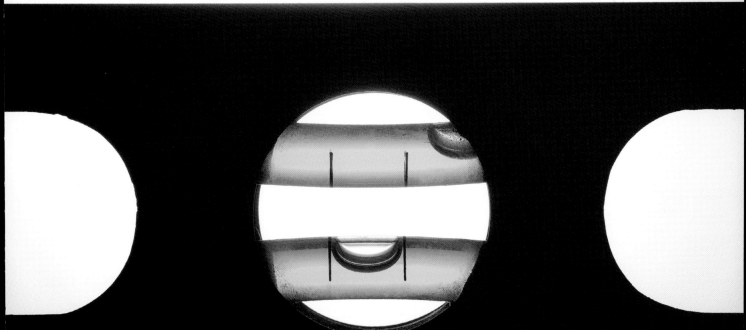

Now, back to the double exposure. When neophytes (and even clients) see the final image without having seen the two separate ones, they scratch their heads and end up thinking it's magic! But I know the magic is just solid photographic technique and a piece of black velvet, and now you do too. Figure 9, at right, is the final image I created by combining the images in figure 2 and figure 3.

Many DSLRs offer the ability to combine images in the camera. Here's how I do it: First, I take a picture of the subject, correctly exposed, and then bracket my exposure of the background so I have a number of exposures to choose from when I'm ready to overlay the two shots. Next, I use my camera's image overlay function to combine my favorite renditions of the colorful background with the lit subject image.

figure 7. While this silhouette is definitely a hammer, the image doesn't tell you who makes the hammer. Not many clients are going to be satisfied clients if their particular product can't be identified.

figure 6. Here is another example of using a limited palette when photographing a translucent subject.

figure 8. All rules are meant to be broken! I often talk about how I prefer a limited palette of colors. But sometimes, if the subject (or my client) demands it, I'll be the first to jump one off a colorful cliff. You can't make creative decisions about the palette you're going to work with until you look at the subject first.

figure 9

If your DSLR doesn't offer such a feature, then you can use Photoshop instead: Combine the two images by making each a separate layer in Photoshop and then adjusting the opacity of each layer independently. (You cannot adjust the opacity of the Background layer in Photoshop, but you can if you rename it to something other than "Background.")

Regardless of the method used to combine the images, if the primary subject is brighter than the background in the final image, its value becomes more visually important than the background color. Boost the brightness of the background color relative to the subject, and it becomes more visually dominant. Look at figures 10, 11, and 12 to see this effect in practice.

Hint: If your camera has a multiple exposure feature that allows you to combine images as you shoot them, I do not recommend using it. Most in-camera multiple exposure shooting modes will either automatically adjust gain or not adjust it at all, and since the multiple frames will be flattened and saved as one image, you can't adjust them separately later. That's why I recommend using either the camera's image overlay feature (which creates a new image file, leaving your original ones intact) or an image editing software like Photoshop to combine the frames after the fact.

figure 10

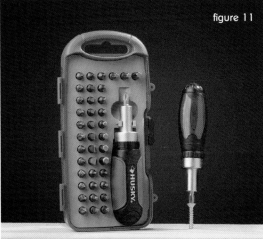

figure 11

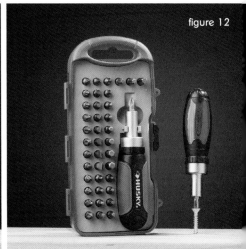

figure 12

The subject in figure 10 is brighter (and therefore stronger) than the background; in figure 11, the background brightness has been increased in relationship to the subject; and the background and the subject are of equal brightness in figure 12. While the differences are subtle, this is a pretty effective technique for making the subject appear more prominent.

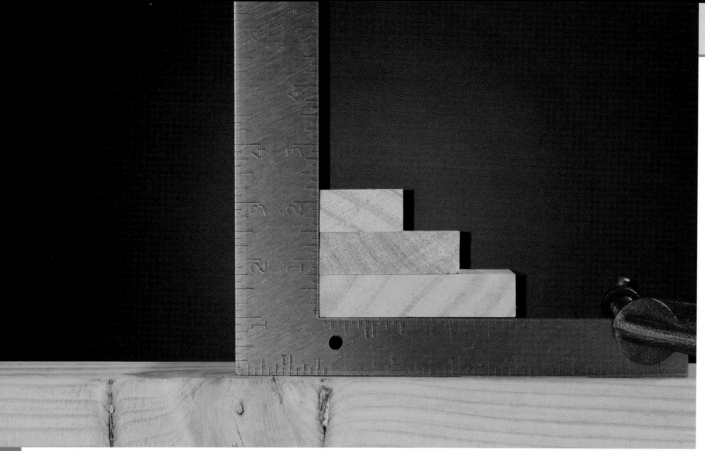

Figure 13. Here's what happens if your subject or tripod moves between the two shots you need for the double exposure technique I'm describing. While in this case it's not a pretty picture, and something you'll probably wish to avoid most of the time, keep it in the mental filing cabinet, because you may be able to use it to creative advantage someday!

Pitfalls to Avoid

For this whole technique to work, there are three things you must do: First, there has to be a horizon line in the set. The surface the subject is on must end, and there must be some open space between the tabletop surface and the background (in this case, the Tough Lux screen). This is necessary because you need a space to slip the black velvet curtain into so it's behind the subject and covering the background during one of the two exposures. The second thing that you must make absolutely sure you do is to leave the item(s) you are photographing in exactly the same position from one shot to the next. If you do not, the images will not match up. The third imperative is that the camera does not move between shots. Not even a millimeter! If the camera or the subject moves at all, the two images won't overlay properly, and you'll go nuts using Photoshop to try and fix the mistake (see figure 13). I find that it's easier, and much faster, to invest the effort in doing it correctly in the first place.

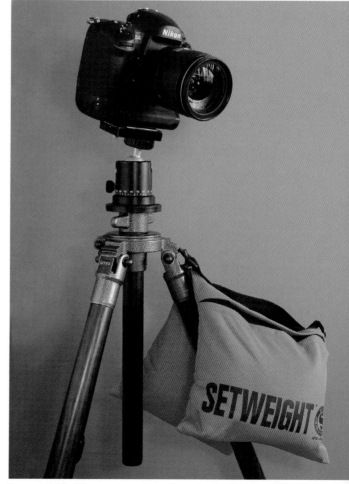

figure 14. My 22-pound sandbags from the Set Shop in NYC

figure 16. An 8-pound sandbag made by Manfrotto, which I filled with four 2-pound plastic bags of art sand I bought in a craft store—two in each side of the Manfrotto bag

figure 15. My smaller, 8-pound bags filled with metal shot, which I can drape over things

One way to insure this is to use a heavy tripod and a strong tripod head; and to go one step further, hang a sandbag or other weight from the tripod to really tie it down. (See figures 14, 15, and 16.)

Keep all these things in mind, and you can really crank up your final photograph's color and impact to make a dull subject more memorable.

You can see sandbags in use in every Broadway theatre, on every feature film or video commercial set, and they are standard accessories in almost every commercial still photography studio I have ever visited. Simply put, when they don't want something to move, when they need a counterweight, pros use sandbags!

figure 17. For the images in Chapter 3, instead of a sandbag, I clamped an old, very heavy vise to my tripod's leg because I have a few of them lying around my studio. Do I think it is better to use a sandbag instead of an old rusty vise? Yes I do! But, in this instance, my sandbags were being used on another set, and the vise was handy. It can't hurt to have a few things like this around, so you can improvise when you need to. From old vises you pick up at garage sales, to canvas shopping bags filled with large cans of soup or vegetables, to a pair of full 2-liter soda bottles tied together at their necks with a length of cord—anything that you can drape over, hang from, or clamp to a tripod, sawhorse, or light stand can become a stabilizing influence worth exploring. The only caveat to using something like the vise shown here is to not over tighten it! I'll repeat myself: Do NOT crush your tripod's leg proving how strong you are! You can even make a rope loop to hang your vise from instead.

Other Tips and Tricks

Point of View

Another trick I used quite a bit in Chapter 3 has to do with point of view, and it is really important. Because I also photograph a lot of people, it occurred to me at some point to get my camera down to an imaginary "eye level" of an inanimate item I'm photographing. This seems to help give the item an almost human side, plus it eliminates the inherent distortions created by shooting down on it. (See the picture of the pilot-hole drill bits on page 59 for a good example of my "eye level" technique.)

Creative Lighting

I used lighting to make my subjects pop. In addition to using a large main light, I often add a second, smaller light source to my lighting scheme to create drama. Over the years, I have used condenser spots, fresnel spots, snoots, barn doors, flags, and grids to narrow the beam of my small-source, "kicker" light. Why, you ask? Smaller-sized light sources (those with narrow beams) create larger, harder-edged shadows. Those shadows, combined with the small highlights that small light sources create, help to accentuate details and textures on a subject. (See Chapter 5 for a more complete discussion of this.)

I don't aim my light sources just anywhere, either—I often try to light as many of the subject's surfaces as I can, using both lights and fill cards. This is especially important if the subject has reflective surfaces. Look at the image of the hammer on page 62. Counting the face, the poll, and the chamfer between the face and the cheek, the hammer's striking element alone has ten surfaces (but only six are visible). The hammer's handle has eight surfaces (though only four are visible). Not counting the nail (which I touched up with an emery board to make its steel color pop), the hammer has 16 visible surfaces, and I lit 13 of them (either with a light source or a fill card). Taking the time to light an inanimate subject so thoroughly can really make it come alive!

Bring Life to Your Subject

Take a look at the image of the pairs of pliers on page 63. In this photo, there is a hard light just skimming the tabletop level to the right side of the subjects. While this light makes the surfaces of the pliers look more three-dimensional (pop!), note that all the pliers are all tilting toward the light source. Plants do this too, and the term for it is phototropism. By simulating it with my arrangement of inanimate objects, I help infuse my subjects with a sense of life. Likewise, I let the left edge of the right-most pair of pliers go black to accentuate it. I did that because I felt that the sexy, black, S-shaped curve and the pivot bolt added a feeling of life to my subjects. Doing things like this to inanimate objects is an important tool to help your viewer feel that the object you're photographing has life.

Reflective Surfaces

If nothing is reflected from a reflective surface in your image, then you end up with a black hole instead of a surface in your photograph. This does not mean you should automatically discard the thought of leaving a surface unlit, but instead, make a conscious decision about when and where you do so.

The difference in the subject's position between getting it to reflect something and leaving it to reflect nothing at all is subtle. Look at the image of the three razor blades (figure 18). The set for this photograph included a white fill card immediately to the left of my camera, a shoot-through umbrella immediately to the left of the fill card, and neither to the right of the camera. (See the illustration, figure 19.) Note that, while the difference in the positions of the three blades is slight and hardly noticeable, the reflections in the three blades are wildly different. While the reflections in the razor blades on the right and left might be of value if the image were illustrating a concept, the manufacturer of the razor blades, looking for a true image of his product for commercial purposes, would choose the one in the middle every time!

figure 18

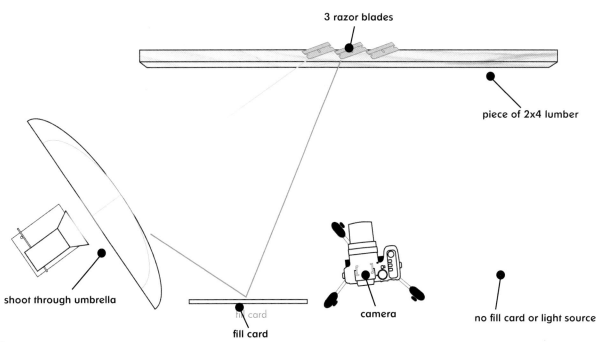

3 razor blades

piece of 2x4 lumber

shoot through umbrella

fill card

fill card

camera

no fill card or light source

figure 19

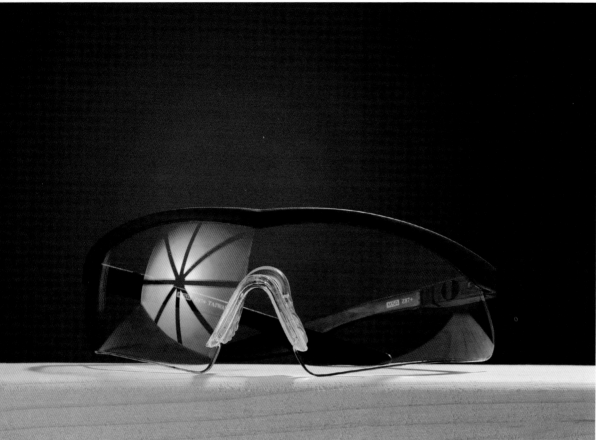

To illustrate just how different three images of a similar item can look when each is shot in a different style, here are three images that appeared in Chapter 3. I'm showing them here side by side for comparison.

Figure 20: A beauty shot of a pair of safety glasses. I added an illustrative touch by making one eye starry to show what the glasses can protect you from. I made the "star" by putting six pieces of opaque tape across my diffuser frame with a light behind it that was reflected in the safety glasses.

Style and Value

Lastly, as a matter of style, here are similar subjects shot in very different ways (figures 20, 21, and 22). One is not better than the other; each is just different. However, what you might charge for doing each starts off at a higher price for figure 20, less for 21, and even less still for 22. This price differential reflects the amount of time required to create each image, how much understanding of photographic technique is required, and its degree of difficulty to produce.

Lastly, because it is germane, note that each image going from figure 20 to figure 22 was shot at a successively larger aperture than the preceding image, so the depth of field became more and more narrow. While you can raise the ISO of your DSLR to insane levels, you will find that the best image quality for reproduction purposes is found at lower ISO levels. In turn, this means that getting to small apertures for extended depth of field and better clarity requires either longer exposures or more powerful light

sources to illuminate your subject. This is especially true as you move in for extreme close-ups. I most often prefer to use a tripod for shooting still life subjects (if the subject is not going to move, then why should the camera?), but using a tripod is sometimes a hamper on creativity when it comes to finding the perfect camera position. This, in turn, means I feel the better alternative is using bigger, more powerful lighting equipment that, in turn, costs more!

The most important lesson here is that everything about the technical aspects of a photograph are interconnected, and one choice often leads to another, and another, and so on. For instance, sometimes a decision that requires bigger and more expensive lighting equipment affects how much you must charge for a particular photograph. Someone has to pay for the equipment you're using, the time it takes to set it up (and break it down), the time it takes to learn how to use it properly, and the time it takes to maintain it—and that someone shouldn't be you!

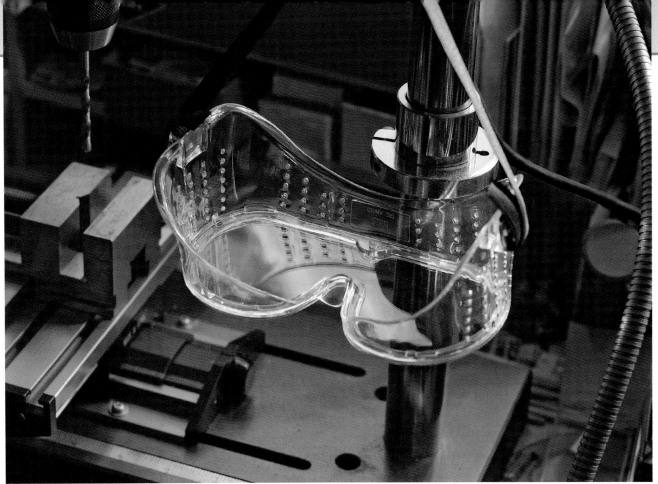

Figure 21 represents an in-use kind of image. Interestingly, although the white balance on my camera was set to daylight (5600K), I turned on an incandescent work lamp (3200K) hidden behind the drill press, which warmed up the props and made the goggles pop.

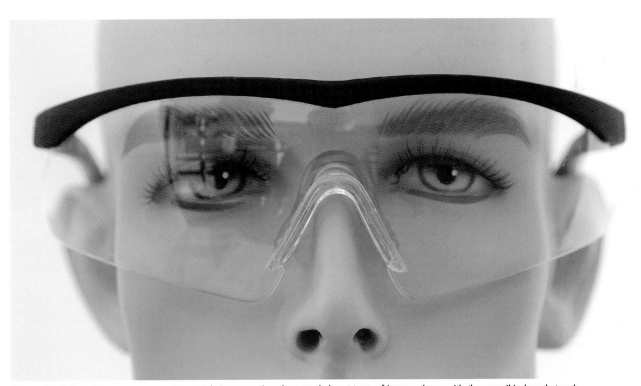

Figure 22: This last image represents a quick, inexpensive drop-and-shoot type of image done with the manikin head standing on a kitchen table and lit by window light. To get the high-key effect, I placed a fill card so the light from the window would illuminate the wall behind the manikin while keeping it from reflecting in the safety glasses. By adjusting my exposure so the manikin head and safety glasses were correctly exposed, the eggshell-colored wall of the kitchen blew out to white.

4

Three Simple Building Projects

O K, you've assembled a selection of tools, and you know enough about lumber to get yourself in trouble, so it's time to try our hands at building something! But, to ensure success, let's start off simple. We don't have to build a two-story house after all!

For the first of the three projects (Project 1) described in this chapter, we are going to build something using only two small rolls of gaffer tape (one black and one white) and two 1/2-inch-thick, 4x8-foot sheets of black / white foam core (one side black, one side white). The finished product is called a "V-flat." For the uninitiated, foam core is a sheet of Styrofoam with heavyweight paper glued to each side of it. I chose this first project because the very worst that can happen is you'll ruin two sheets of foam core and stick a few of your fingers together with some tape. Because we won't be using dangerous tools, there are hardly any safety concerns or chances of drawing blood during this project, so I'm hoping you'll be willing to dive in with no trepidation. Let's get started!

Project 1:
Build a Simple V-Flat

In the next project we tackle (Project 2), I'm going to mention using something called big flats as lighting tools. Later, in Chapter 6 (Lighting Tools), I'll write extensively about using fill cards. While these are both very important tools in your arsenal of lighting equipment, sometimes getting a big flat, or even a medium-sized fill card, to stand by itself is a terrible exercise in frustration. A V-flat, on the other hand, can make things much easier: It is two pieces of like-sized material hinged to each other along one edge to make a "V" shape when opened. By opening the two sides of the V-flat to any angle between, say, 30 and 90 degrees, you can stand a V-flat on its end on a flat surface without using additional supports.

I made three V-flats to illustrate this part of the book: one 4x8-foot flat made with 1/2-inch-thick black / white foam core, and two smaller ones (made from 1/4-inch black / white foam core) to illustrate their use in a tabletop setting. While the larger one can be used when lighting large products (chairs, grandfather clocks, tables, filing cabinets, etc.) it can also be used for lighting full-length and bust-length portraits or fashion images. Of the two smaller ones, which are used for tabletop photography, I've purposely made the hinge on one of them incorrectly so it is easier to see and understand how it works. The real trick to this project is designing a hinge between the two flats that is easy to make, has a large range, and is nearly invisible, while being both flexible and secure. That's where the gaffer tape comes into play.

Bill of Materials

• Two 4x8-foot, 1/2-inch-thick black / white foam core boards, available from the Set Shop (SetShop.com).

• Two 20x30-inch, 1/4-inch-thick black / white foam core boards, available at almost any art supply store.

• Two small-core rolls of gaffer tape: one black, one white. Don't mistake gaffer tape for duct (or duck) tape. As I said in Chapter 3, duct tape can cause you all sorts of problems, like migrating adhesive and melting plastic. It has been said that real gaffer tape can be used to fix almost anything—forever! You'll use eighteen inches of tape for each of this V-flat's hinges and a small core roll is 12 yards (11 m) long, so you can either make a lot of V-flats or use the remaining tape in hundreds of other ways.

For each barn door hinge, you'll need three tape strips. For a 4x8-foot V-flat, you'll need to make nine tape strips for a total of three hinges. For a small V-flat, you'll only need to make six tape strips for two hinges.

Instructions

The kind of hinges that are on barn doors allow the doors to swing open in either direction—into the barn or out. We are going to copy that design for our V-flats. This will allow you to set up your V-flat as either a white reflective surface or a black non-reflective surface.

Each hinge will comprise three 6- to 8-inch strips of gaffer tape. We'll need three hinges for the 4x8-foot V-flat (nine strips of tape) and two hinges for the tabletop V-flat (six strips of tape).

The tricky part is that each strip must be sticky on one side for half of its length and sticky on the other side for the other half. We are going to accomplish this seemingly magical feat by making each tape

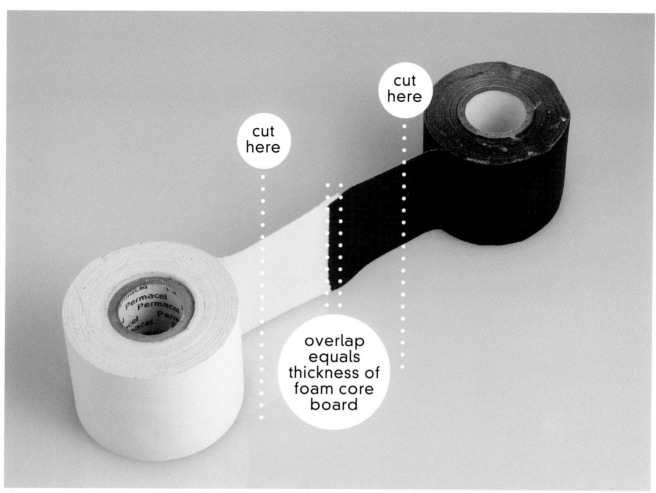

cut
here

cut
here

overlap
equals
thickness of
foam core
board

This image shows you how to make the tape strips described below. As the picture demonstrates, the overlap of the two pieces of tape should be equal to the thickness of the foam core board you are using.

strip from two shorter but equal-length pieces of gaffer tape, one black and one white. We are going to place one piece of tape sticky side up and then attach it to a second piece of tape that is placed sticky side down. The pieces should be attached to each other at the short sides, making a strip of tape that is one piece wide and two pieces long. They should overlap each other by approximately the thickness of the foam core you are using (either 1/2 inch or 1/4 inch) and, once they are together, the resulting strip will be approximately twice the length of each individual half. Whew! I sometimes can't believe how hard it is to explain a simple thing using words alone. Thankfully, this is a photography book, so I can use pictures to help you understand! Look at the pictures on the opposite page to better understand how a barn-door hinge on a V-flat works.

As I've said, each hinge is made up of three tape strips. For the large V-flat, you'll need three hinges (nine strips of tape), and for the smaller one, you'll need two (six strips of tape). You place each tape strip so the white half of the tape strip sticks to the white side of one foam core board, and the black side of the tape sticks to the black side of the other board. To make the position of the tape strips easier to see, I made one V-flat with the tape reversed—the black tape is on the white side, and the white tape is on the board's black side. (See photo at right.) However, if you use the white side of the tape on the white side of the board and the black side of the tape on the black side of the board, you'll save yourself some Photoshop retouching; it is quite possible, if you use black tape on the white side and vice versa, that it will reflect onto your subject. Furthermore, your V-flat will look so much neater and more professional if it is all one color on each side!

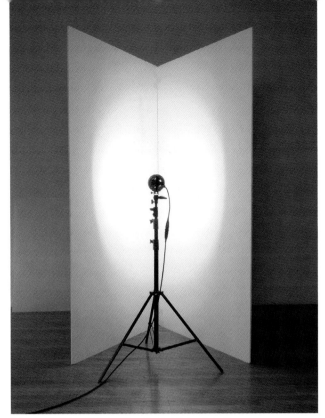

A large, 4x8-foot V-flat with a light shining into it.

If you can imagine that a softbox emulates the light you get from a window with the added advantage of allowing to you position the "window" where you want it, then a large 4x8-foot V-flat emulates the light you get from a doorway or a very large window, with the same added advantage, of course. Since I just compared a V-flat to a softbox, and to take this project to its logical conclusion, you can use a few spring clips to cover the open side of the V with a diffusion material such as Tough Lux to more fully emulate a softbox type of look. (For more on softboxes, see pages 127-129.)

To use your new V-flat, open it and stand it on the V-shaped end so it looks like an open book sitting on its end. Place the open side (the inside of the book) where you would want a large light source to be, and place a light on a stand between the two sides of the V, aimed into it. The beam of the light bounces around from one side of the V to the other and eventually comes out as a very soft light source from the open side.

But, the advantages of having V-flats available in your studio are multifold. In addition to the previously mentioned self-supporting feature and its usefulness as a large, soft light source, it can also be used as a fill-light reflector when the open side of the V is placed on the opposite side of a subject from the light. Or, because of the barn door hinges, you can reverse it so the black side of the foam core is on the inside of the V, in case you don't want any illumination from a light on the opposite side of the subject to bounce back. If you are working in a white-walled studio, placing the black side of the V-flat on the opposite side of the subject from the light will result in darker shadows and an image with more contrast.

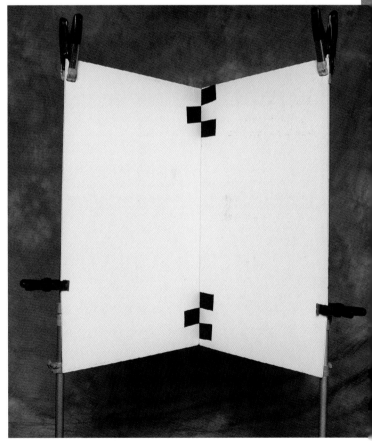

For this smaller V-flat, I purposely reversed the application of the tape strips (black tape on the white side, white tape on the black side) so you could see how the tape strips are applied.

Project 2: Diffusion Screen

For this project, I'm going to illustrate how to build a simple diffusion screen. Although we'll be using real tools for this project, don't get scared. At most, you'll be drilling holes, driving in some screws, and shooting in a few staples. More importantly, what you'll end up with is a highly adaptable studio lighting tool that will allow you to create unique lighting effects that would be nearly impossible to duplicate with commercially available products. And, the whole thing only uses about $40 worth of materials.

Some collapsible metal hoop diffusers can cost anywhere from $50 – 90 and, while these diffusers certainly have a place in location photography (I have 4 of them!), the non-collapsible one described here is easier to mount and position for studio use, stores easily (it's only 3/4-inch / 1.9 cm thick), and is certainly less expensive.

It's worth noting that in the still life photography game, unique lighting effects make for unique images; and potential clients are willing to pay dearly for uniqueness. So, without further adieu, this is how you build a simple, 36x36-inch (91.4 x 91.4 cm) wooden frame onto which you can staple some Tough Lux diffusion material.

Bill of Materials

• 12 feet (3.7 m) of 1x1 clear-finished pine

• Four 1-inch (2.5 cm) or 2-inch (5 cm) corner braces. The 1-inch corner braces are more than strong enough to support your frame with its Tough Lux covering, but some photographers like to overbuild things, so they might prefer the stronger 2-inch corners—I did!

The 1-inch L-shaped inside corner brackets only require two screws each, while the larger 2-inch versions require four screws each. But, because we're only using this wooden frame to hold a few ounces of Tough Lux in place, the smaller 1-inch versions really are more than sufficient.

• A package of 100 No. 6 x 3/4-inch flat-head Phillips wood screws. I always buy screws and nails by the 100 count (or 1-pound box). Doing this is much less expensive than buying these items one or two screws at a time.

• 36 inches off a roll (48 inches x 15 feet) of Tough Lux. The Set Shop sells 60-inch x 15-foot and 48-inch x 15-foot rolls of their Tough Lux. I buy the 60-inch wide rolls so I can also use it for backgrounds and diffusers. But, if your budget is tight, a 48-inch roll will work, and its 15-foot length will leave a lot leftover for other applications. Furthermore, for the really frugal, you might consider hooking up with two other photo buds and buying a roll collectively. Personally though, I buy a whole roll for myself because it is the diffusion material I use most frequently.

Tools Required

Jigsaw or hand saw (though this is not necessary if you can have the lumber cut to size at the lumberyard)
Variable-speed electric drill
Pilot hole bit for No. 6 screws
Phillips head bit for drill
Triangle or carpenter square
Pencil or pen
Staple gun
Staples for gun
Mat-cutting knife

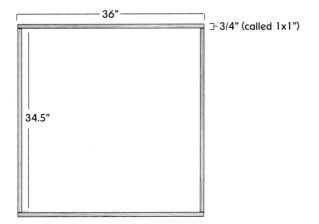

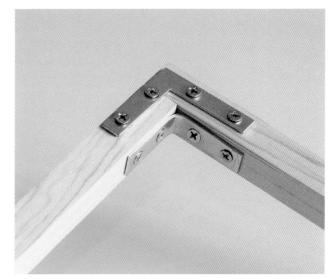

There are two different types of corner brackets you can buy, and both are available in different sizes. Usually, I prefer the kind that fit inside the wooden corner as opposed to those that go on the side, because the latter type makes it impossible for the Tough Lux covering to lay flat against the wood. But, if your hardware store of choice only has the flat kind that fits on the side of the corner, don't fret—it doesn't really make that big a difference which kind you use. On one corner of the diffuser I made for this demonstration, I used both types of corner brackets. That's way overkill, but that way, you get to see them in comparison.

Instructions

Start with your lumber: Either have the lumberyard cut the 12 feet of 1x1 into four pieces, or do it yourself. You'll need two 36-inch (91.4 cm) lengths and two 34.5-inch (87.6 cm) lengths. If you buy two 6-foot (1.8 m) lengths, you'll end up with only 3 inches of scrap material. Now, arrange the pieces on the floor as shown in the diagram at left so you can see what your diffusion frame will look like. Just make sure that one corner is square (use a triangle or a carpenter square).

Next, place either a flat plate or an inside corner bracket at each of the four corners and mark the screw hole locations in the bracket onto the four pieces of wood. Using your pilot-hole drill bit, drill holes through the 1x1 at each screw location. Starting at one corner, work your way around the perimeter and screw a single bracket into each corner so that, when all four corners are finished, you have a square wooden frame.

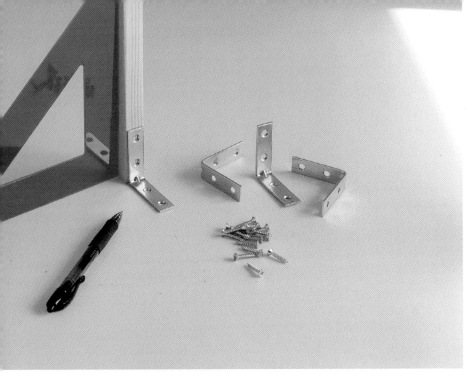

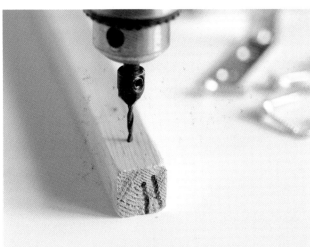

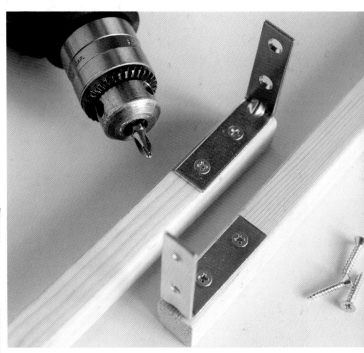

You'll need one corner bracket at each corner of the diffusion frame.

Now, staple a piece of Tough Lux to the frame. Some photographers get staple-happy and shoot a staple through the Tough Lux every inch or so, but but that's about as necessary as a screen door on a submarine! Three or four evenly placed staples along each side are the most you'll need. Using fewer staples means it's easier to break the diffusion screen down if you want to make another sized frame using the recovered wood.

Your diffusion frame is finished! That wasn't so hard, was it? If this whole project takes you more than an hour to complete, you're doing something wrong! I was photographing as I was building the one in the photographs, and it took me less than 30 minutes.

The hardware you'll need to make a diffusion frame.

This is what your 36-inch square diffusion frame will look like when you're done.

As with anything you build yourself, the possibilities for modification are endless. If the single sheet of diffusion material is not enough for your needs, you can always staple a second sheet of the diffusion material on the other side of the frame. And, if putting a sheet on both sides of the frame is still not enough, take out all the wood screws, save that hardware, and rebuild your frame with 1x2 lumber instead of 1x1, to make a thicker frame. The added distance between the two layers of material will increase the amount of diffusion.

Don't limit yourself to 3x3-foot frames, either. You can build a smaller frame or a much larger one too. I know a fashion shooter who builds similar frames (but with 1x3 lumber) that are 60 inches (1.5 m) wide by 8 feet (2.4 m) tall. He uses two spring clamps to attach them to a weighted light stand, and it stands up just fine. In fact, you could build two (or more) of these larger frames, and spring clamp each one to the next, put a bunch of lights behind them and create a gigantic wall of light, if your subject is large enough to need that. Think outside the box, and use the basic idea described here to create what you need!

Let me now tell you—and I've been waiting to write this since I saw Mr. Miyagi say, "Now show me sand-the-floor," in *Karate Kid*—you might think you just built a diffusion screen but, "Everything is not as it seems, Daniel-san." Put a light that has four barn doors clipped to it behind your screen, and you've created a softbox-type of light for about 1/8 the cost of a like-sized, commercially available one! (See pages 127-129 for more information on softboxes).

Want another example of the cost-savings advantage to using a diffusion screen? Manufacturers of commercially available softboxes aren't interested in selling you just one of their softboxes. They want you to buy all the different sizes. They want each photographer to have, for example, a 30x40-inch rectangular softbox, a 24-inch square softbox, and a

pair of 12x36-inch softboxes (aka, "strip light"). But, using just a single 36-inch square diffusion panel, one or two mat boards, and a few spring clips, you can create every different-sized softbox I just listed! "Holy Savings Batman!" Or, maybe I should have said, "Holy Ingenuity Batman!" instead.

Here's a 36-inch square diffusion frame flagged down to emulate a 12x36-inch square strip light.

just skim across the softbox's diffusion panel? What happens if you want one edge of a softbox's diffusion panel to get more light than the other edge so you get a graduated intensity of light from one end to the other? Let me tell you what happens: You can't!

But, if you build the diffusion panel I'm suggesting, you can position the diffusion panel and the light independently of each other, and by doing so, you can create lighting effects that are totally unique and can't be duplicated by any commercially available softbox! Just how much is a unique lighting source worth? To many high-end clients who can understand the difference in what they are seeing, priceless!

However, thinking about building this diffuser only from a money-saving point of view is very shortsighted. Consider this: Every commercially available softbox I have ever seen (and I've seen almost all of them!) has the light source positioned so that it shines through the center of the softbox's front diffusion panel. But, for argument's sake, what happens if you want to have the light source

Here you can see just some of the different lighting effects that can be achieved using a diffusion screen and a light that can be independently positioned. These differences in the lighting pattern on the diffusion screen become particularly important when the diffusion frame is reflected in a subject.

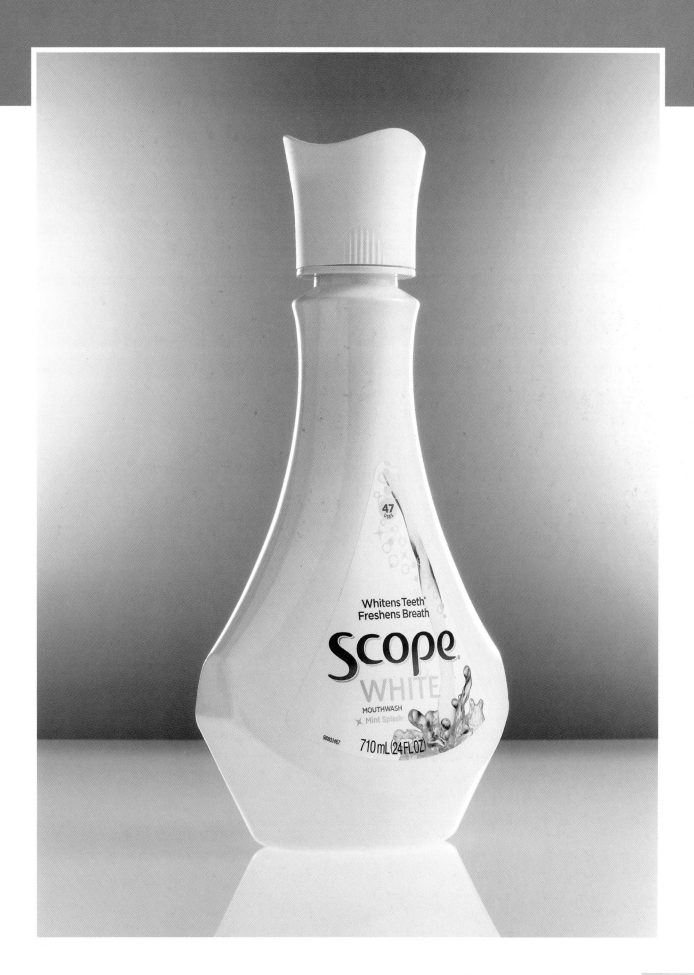

Project 3: Build a Still Life Light Table

A light table is a piece of photography studio furniture whose top is made of translucent acrylic plastic (one such brand is Plexiglas®). Often called a "sweep," the acrylic tabletop extends past one edge of the table's flat top so it can be flexed upwards to create a background without a horizon line. Additionally, because the table's top is translucent, you can place a light (or lights) under the table as well as above it to eliminate shadows altogether. There are commercially available light tables from a few manufacturers, but there are big advantages to using one you construct for yourself. Here just are some of them:

• The cost differential! Commercially available light tables using an approximately 4x8-foot sheet of acrylic can cost upwards of $2000, but you can construct your own for under $500, or even for under $300 if you already have some of the supplies, which is likely. That difference is not small potatoes!

• All the components of a scratch-built light table can be broken down and used for other things when you don't need your light table. The sawhorses, C-clamps, floor-to-ceiling uprights, sand bags, closet poles, and even the acrylic sheet itself can perform other duties when not being used as parts of your light table.

• When it's not in use, the acrylic sheet used for the table's top and background surface can be either stored flat and hung on a nail hammered into the studio wall or used as a giant diffuser screen on other assignments.

• When you buy your 4x8-foot acrylic sheet, you can have one side sandblasted (or chemically etched), giving you a choice of two different surfaces: one glossy and one matte. The standard glossy side will show a reflection of your subject, while the matte side will not.

• You can flex the acrylic sheet at its front and top edges (as shown on page 112) to strengthen the tabletop, so it can support heavier products without sagging.

Here, you can see the difference between the glossy side and the sandblasted or chemically etched side of an acrylic sheet. The glossy side, used in the photo to the left, accentuates reflections, while in this photo, the sandblasted side eliminates the reflection altogether.

• Being able to flex the tabletop's front edge downward offers another advantage: You're able to shoot from a lower point of view, which can make your subject appear both monolithic and larger than life. Conversely, some of the commercially available light tables have a level front table edge, which limits you to shooting your products either straight on or from above.

• By erecting your light table right in front of your client's eyes, you can really impress them with your creative abilities. Impressing a client before you even take a picture gives you a big advantage!

Or, if you erect your light table before the client even arrives at your studio, you will have an impressive piece of studio hardware that will put their mind at ease in regard to your photographic abilities. The client will be even more impressed when he asks about it, and you tell him you designed and built it yourself. One of these things is not true (and I'll never tell which) but your client will still be impressed!

• You can leave your light table always set up to impress your photographer friends when they visit your studio. It's true!

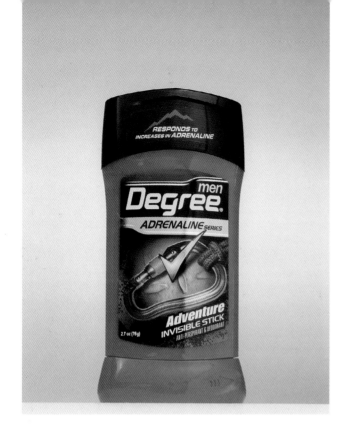

• Did I mention it was less expensive, stronger, and offered more ways to express your photographic creativity than a commercially bought light table? I did? OK then, let's do it!

Bill of Materials

• One 4x8 sheet of 1/8-inch-thick, white, translucent Plexi, sandblasted (or chemically etched) on one side. Source: setshop.com. Local delivery on this could run you $100 or more, so don't forget to budget for it!

• One pair of Timber Toppers. Source: setshop.com. Two lengths of 2x4, floor-to-ceiling height, minus 2-3 inches. Source: local lumberyard.

• Two Setweight 22-pound (10 kg) sandbags. Source: setshop.com.

• Four 6-inch (15.2 cm) C-clamps. Source: harborfreight.com. Two 60-inch (152.4 cm) lengths of closet pole (dowel). The ones I used were only 55 inches long, but you might as well get 60-inch poles, because they could be used to hang a half-wide roll of seamless in a pinch.

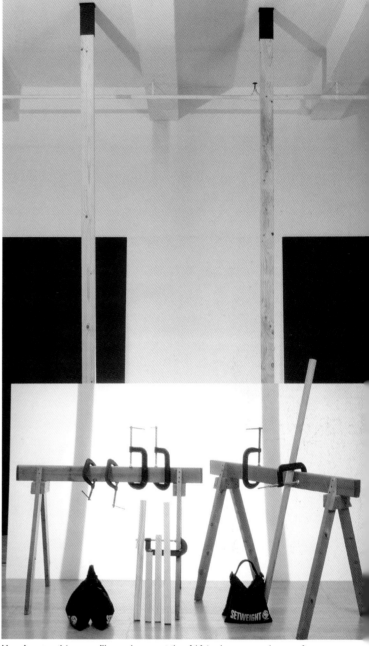

Here's everything you'll need, except the 1/4-inch rope and one of the two closet poles.

• Four short pieces of 1x2, each about 6 – 14 inches (15.2 – 35.6 cm) long. Source: scrap box at the lumberyard.

• One pair of sawhorses, build or buy. Source: local home improvement store.

• 8 feet (2.4 m) of 1/4-inch rope. Source: tool or home improvement store.

Instructions

Get an assistant! I've erecting something big like a light table by myself, but having two people do it is so much easier, more fun, and makes it less likely you'll ruin your expensive sheet of acrylic.

The first thing you're going to do is drill a 1/4-inch (0.6 cm) hole in your acrylic sheet. Use a ruler to find the center of one of the 4-foot edges, pick a spot on the centerline about 2.5 to 3 inches (6.4 to 7.6 cm) in from the edge. This is where you'll drill your hole. But wait! Stop! If you use a regular drill bit to drill your hole, you run the big risk of the bit getting hung up in the hole and cracking your sheet of acrylic! There are special drill bits for drilling acrylic (search for "plas-drill"). These special bits have a sharper point than ordinary drill bits, and they are designed to drill through acrylic without getting hung up. But, even after popping for the five bucks to buy the special drill bit, I take the added precaution of clamping a piece of 1x2 on both sides of the acrylic sheet with two C-clamps and then drilling through the wood / acrylic / wood sandwich. Doing so stabilizes the acrylic and stops the drill bit from getting hung up in the hole as it punches through the acrylic sheet. Now. Now you can drill the hole. Next, peel the protective paper / plastic coating off both sides of the acrylic sheet. I often do

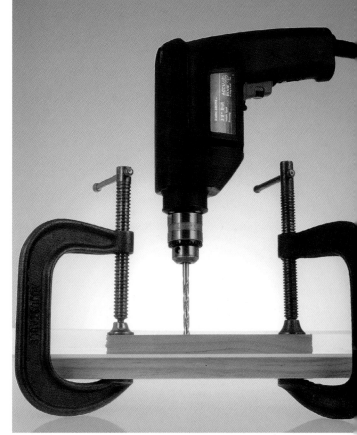

If you don't have a special acrylic drill bit, you can make a wood / acrylic / wood sandwich and use a regular drill bit to drill the hole in your acrylic without cracking it.

this after I've drilled any holes I need to drill. Work slowly and if the protective paper starts to tear, pull on the torn edge until the two halves are even again. Trust me, it's easier on your fingernails if you can peel off the protective paper in one piece!

The special plas-drill bit is on the right.

I suggest placing your floor-to-ceiling timbers on a 48-inch center to make the potential shooting area that much wider. While it may not seem like much of a difference, doing so will make the useable background of your light table approximately 44 inches wide instead of only 40 inches. That extra 4 inches can sometimes come in very handy and save you a few extra minutes cleaning up the final image in Photoshop.

Now, you're going to erect your floor-to-ceiling supports. Grab the 2x4s and put the Timber Toppers on the ends of the 2x4s that will be at the ceiling. Position the lumber with the wide sides facing where the rear of your table will be situated. Place the two 2x4 verticals on a 48-inch center. That is to say, if you measure from the center of the wide side of one 2x4 to the center of the other, it should be 48 inches. If you do this correctly, the total width of the two 2x4s you just positioned should measure 51.5 inches (130.8 cm) wide from the far side of one 2x4 to the far side of the other.

> **Note:** All of the items on the list should be part of a studio's standard equipment, are reusable, last forever (well, for a very long time), and are capable of being used for other purposes besides building a light table.

There is some disagreement about whether you should use Timber Toppers (as I suggest) or a product called Autopoles. A pair of Timber Toppers is about 1/5 the price of a pair of Autopoles, but that's not the only reason I prefer the Timber Toppers: They allow me to use standard 2x4 lumber, and it is much easier to clamp the acrylic sheet to a 2x4's flat sides than to a cylindrical pole, plus the construction is a lot more secure that way. Next, I'm always working in the same studio with a fixed-height ceiling, so I don't need the adjustability that a pair of AutoPoles offers. That being said, if I were constantly setting up a studio in rooms with different ceiling heights, I would probably have a pair (or two) of Autopoles in my arsenal. Lastly, from an aesthetic point of view, I prefer the organic look that comes from using wood instead of the cleaner more sterile look of using metal. This is because I'm into being green these days, but your choice is yours.

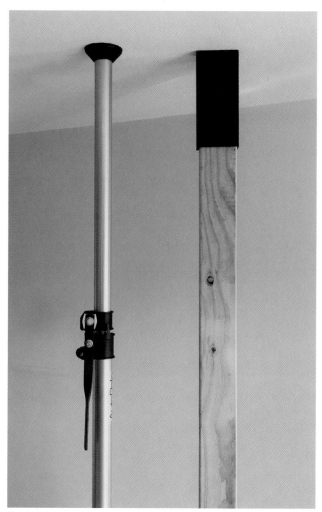

The battle of the floor-to-ceiling poles! The Autopole on the left is more expensive but much (much!) more adaptable to differing ceiling heights. The Timber Topper accommodates 2x4s, which are much easier to clamp things to.

A Timber Topper is a metal box with a folded spring inside of it. In use, you insert a 2x4 (that is 2 inches shorter than your floor-to-ceiling height) into its open end, place the Timber Topper's top against the ceiling where you want it, and then lift the beam upwards and "walk" it into position until the beam is vertical.

After you've decided which side of your acrylic sheet you want to use, position the sheet with that side facing away from the uprights, and stand the short edge of your acrylic sheet up vertically against the 2x4 verticals so the top edge of the sheet is approximately 6 feet (1.8 m) off the ground. The end with the hole in it should be at the bottom. Using two C-clamps and two pieces of scrap 1x2 lumber (to spread the clamping pressure and keep the steel C-clamp from cracking your acrylic sheet), clamp the acrylic sheet to the two 2x4 verticals, leaving the top 12 to 18 inches (30.5 to 45.7 cm) of the acrylic sheet not clamped.

If you were to climb up on a ladder at this point in the construction process and look down at the top edge of your acrylic sheet clamped between the two 2x4

The Autopole ratchets upward to the approximate floor-to-ceiling height and then you lower the locking lever to extend the pole a short amount more, which locks it in position.

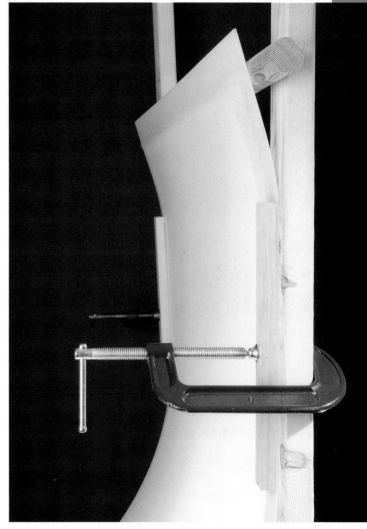

vertical uprights, you'd notice that it doesn't follow a straight line between the two uprights, but instead, it bows out between them. That's because the 1/8-inch acrylic sheet is not strong enough to support its own weight. However, if you and your assistant each take one top corner of the acrylic sheet (above the C-clamps) and flex it forward, you can drop one of the two closet poles into place behind it. You don't need to clamp the closet pole in place; it will sit there all by itself. You've just made the acrylic sheet infinitely stronger, and it will be straight as an arrow now!

Place your two sawhorses parallel to one another with their top rails approximately where the sides of your tabletop will be located. Then grab one side of the unclamped end of your acrylic sheet and have your assistant grab the other, both of you lifting and flexing it so the long sides of the sheet can sit on the sawhorse tops. As you're holding up the acrylic, you can now slide the sawhorses under it and set it down to rest on them. As with the uprights, clamp both sides of the sheet to the sawhorses' tops using a scrap of 1x2 to spread the pressure.

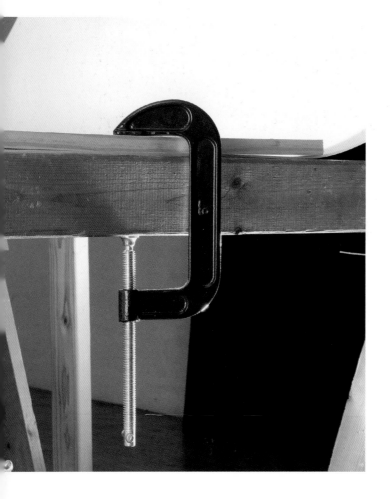

A note about the C-clamp placement: By looking at the pictures carefully, you might notice that I put the large sides of the C-clamps in front of the vertical uprights and below the horizontal tabletop. You should understand why I did it this way. For the vertical back of my light table, I often want a light to just skim the rear of the translucent acrylic from the side. If the large side of the C-Clamp were sticking

out at the rear of the table's back wall, it might cast a shadow onto the table's vertical back. While I can fix this sort of thing in Photoshop, why waste my time doing so when I can eliminate the problem before it becomes a problem?

Likewise, on the horizontal tabletop where my product is sitting, I often use a small kicker light to illuminate an edge of the subject. If the large side of the C-clamp were sticking up above the acrylic's surface, it might cast a shadow onto the table's surface and my subject. Again, why waste my time in Photoshop when I can eliminate the problem before it becomes a problem?

You will notice that the front edge of your tabletop bows downward between the sawhorses because the force of gravity is stronger than the strength of the acrylic sheet. We are going to use another closet pole like we did on the top part to flex the front edge of our acrylic tabletop downward so it is strong and level. Here's how we are going to do it: Clamp the last two C-clamps to each of the inner front legs of the two sawhorses. Pass the closet pole through the two C-clamps. (In truth, the front closet pole doesn't necessarily have to pass through the C-clamps. The closet pole can just be under the C-clamps and held in place by the upward force caused by the acrylic sheet's downward flex.) Tie a loop of rope through the hole you drilled in the front edge of the acrylic sheet. You and your assistant each use one of your hands to lift the bowed center of the acrylic sheet while simultaneously using your other hand to press down on its front corners. By shifting your hands around, one of you can hold the acrylic flexed downward while the other ties off the rope to the closet pole.

One interesting point worth noting: Sometimes, because the front edge is flexed downward, it exerts an upward force on the front legs of your sawhorses as it tries to straighten itself. This force is strong enough to take weight off the front legs of the sawhorses and can make the table's surface less stabile. I have found that adding a sandbag to the front of each sawhorse

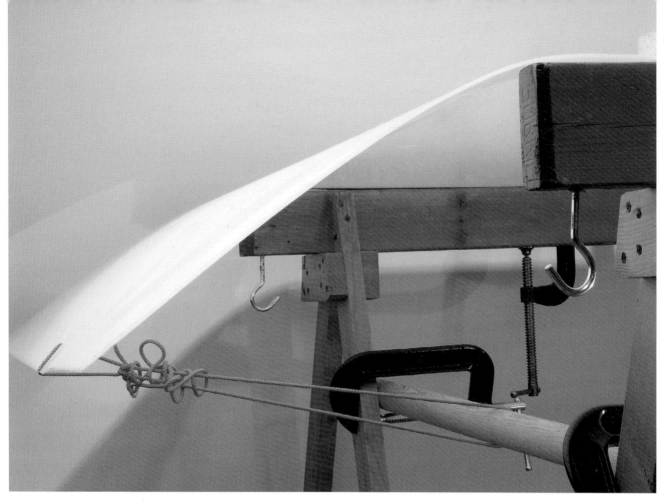

helps counteract this front-end lightness. To accomplish this without the sandbags getting in the way of the lighting I might want to use, I screwed a hardware store hook into the undersides of my sawhorses, toward the front of course, and I hung a sandbag on each hook to make everything rock solid.

Congratulations! You have created a unique, impressive, studio tool that offers loads of lighting possibilities, and you've saved yourself a bunch of bucks in the process!

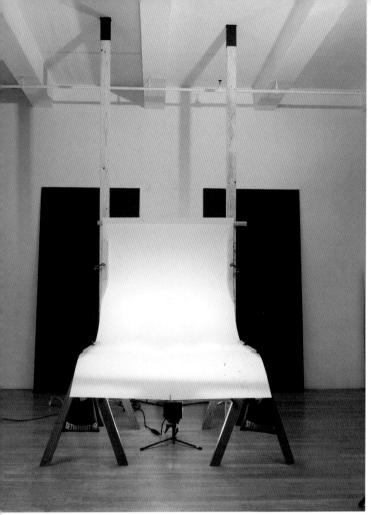

The finished light table, a frontal view.

Speaking of Tables

Aside from the obvious need for a table to shoot on,
I can't even begin to tell you how many worktables
you'll need in a still life photography studio! To
name but a few, you need tables for unpacking
products to be photographed, repacking products
you've already photographed, subject preparation
(dusting and cleaning), sorting products by size, and
selecting props. You will need tables for food prop
preparation, tables to put layouts and paperwork
on, to put different lenses and camera accessories
on, and even a table for your computer's monitor
so your client can see big images of what you are
shooting from a tethered camera. You can't just do
this type of work squatting on your studio floor!
And, even if you are willing to work on the floor,
doing so is murder on you lower back and your knees,
your perspiration will drip on your subject, plus you'll
look just plain dumb doing it in front of a client! Not

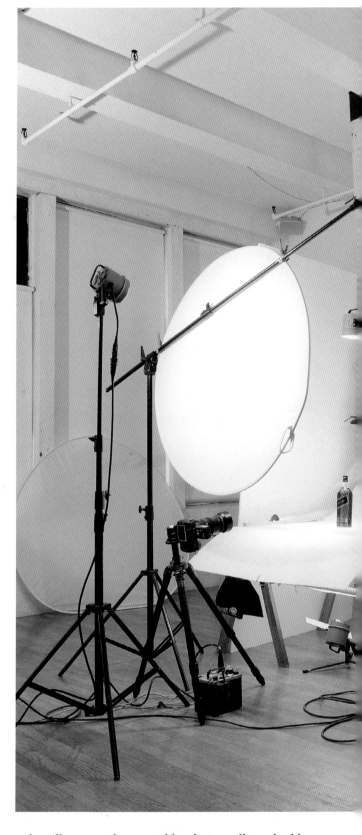

only will you need many tables, but you'll need tables
with tops of differing heights. Get that big, profitable,
first assignment to shoot a 100-image catalog, and
you'll immediately understand what I mean!

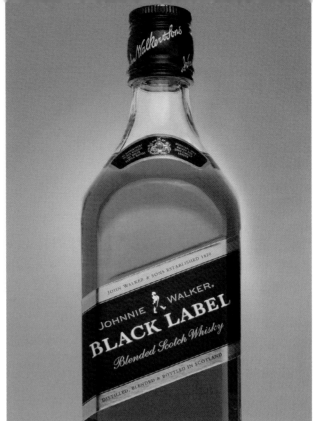

An example of the kind of photograph you can create on your light table.

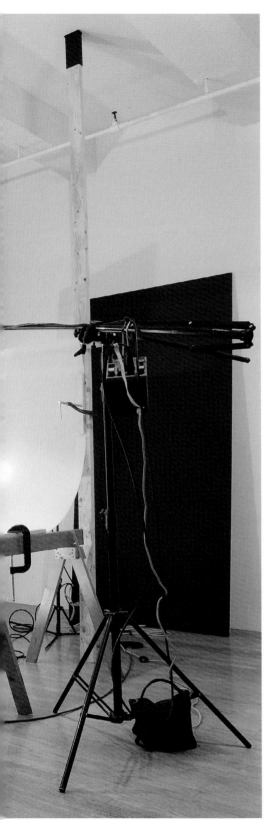

The finished light table, shot while a photograph was being created.

Where are you going to get all these tables? For strong standard-sized tables, you can often find an institutional furniture supplier and order two, four, or six tables from that company's catalog. Many of them have strong particleboard top surfaces covered with Formica® and equally strong metal frames and legs. The standard size is usually about 2.5x6 feet (0.8 x 1.8 m), and if you need a larger work surface than that, you can just push a few of them together. Plus, when you're not using them, they can be folded up and stored against a wall!

Extra Credit Project: Build (or Buy) Sawhorses

This last project is more of an assignment, really. You will need some sawhorses—you can buy metal or plastic readymade sawhorses at many home improvement stores, you can buy sawhorse kits, where you supply your own 2x4 lumber and make your sawhorses using the provided hardware, or you can build them from scratch.

If you ever look around a real lumberyard, you might notice that the people working there often build their own sawhorses. While I won't be giving you detailed instructions on how to go about building your own here, if you study the photos of the light life table in Project 3, you can probably gather enough information from them to figure it out all by yourself. Besides, starting from scratch and making them yourself is good practice for any studio photographer!

5
The Lights

Talking about lights and lighting equipment is like talking about a society's infrastructure: It's just not a sexy topic! But, try running a society without roads, sewage systems, clean water, or electricity, and you'll find the whole system quickly breaks down into anarchy. Likewise, a photography studio needs lights and lighting equipment. Cameras and lenses are sexy, but try making still life studio photographs without lights and lighting equipment, and you'll discover that it is very difficult to do. Sure, you could tack a bed sheet to a wall, push a flash unit into your DSLR's hot shoe, set the flash and camera to auto, and blast away, but do you think anyone would pay you for the resulting images? Not likely! They can do that for themselves, without hiring you! We live on a trade- and commerce-driven planet, where merchants and manufacturers must sell their products against stiff competition. To do so, they need beautiful photographs of those products and professional photographers to create those photographs. So let's stop stroking our sexy cameras for a few moments and talk about lights and lighting!

A flash head with a barn door attached

Glossary

Before we can start this chapter (and the two that follow), we have
to spend a moment on lighting vocabulary so that we are all on the
same page. Don't worry—there won't be a test! But if you can come
to understand the concepts in this chapter and the two that follow so
well that they become second nature, you'll be a much better artist and
businessperson. So, for now, just do your best to familiarize yourself with
the following terms and stick the information in the back of your head.

AC / AC-powered: Alternating current, referring to a piece of equipment that
gets its power from a wall outlet.

Bank Light: See Softbox.

Barn Door: A flat plate of any material attached to the side of a light that limits the width or height of the light's beam. (See photo at left.)

Continuous Light Source: The sun, a hot light (tungsten or quartz halogen), or any other continuously shining light source (as opposed to a strobe or flash, which only emits light for a very short amount of time). (See photo below.)

Diffuser: Any translucent piece of material that interrupts a light's beam and spreads it out, making it softer before it illuminates the subject (see Translucent, page 120).

This is a Lowel Omni light. It is a continuous light source that you can fit with 100- to 500-watt quartz halogen bulbs. Their color temperature is 3200K, which doesn't match with daylight or flash (5600K). They also put out a lot of heat, so I don't find them suitable for still life product photography; but, if you want to shoot video with your DSLR, you'll need a source of continuous light.

Dynamic Range: The range of illumination levels that can be recorded by a camera's sensor in a single exposure while preserving detail in both the shadow and highlight parts of the subject.

Electronic Flash: See Strobe.

Fill (light): A light, usually positioned on the opposite side of the subject from the main light, or near the lens axis, whose job is to lighten the shadows cast by the main light.

Fill (card): Also called a show card or a mat board, a fill card is a white, silver, gold, or colored cardboard sheet usually positioned on the opposite side of the subject from the main light, whose job it is to lighten the shadows cast by the main light.

Flag: Something placed in front of a light to limit part of its beam.

Flare: Usually seen as balls (or orbs) of color within the image's frame, flare is caused by a light source either within the frame or just outside the edge of the frame. The light coming into the lens reflects off one or more of the lens' elements, and that reflection causes a degradation of image contrast. Flare can sometimes be used creatively, such as the orange balls of color you get when shooting into the sun. Decreasing your exposure, either by using a smaller f/stop (preferable) or a shorter shutter speed, can sometimes help to control flare.

Generator Pack (flash pack / flash generator / pack): An electronic device (a box) on professional-level

flash units that converts battery or AC wall power into enough electricity to excite the gas in a flash tube (and make it emit light). Generally speaking, flash "heads" plug into a pack, and the pack powers the lights from either an integrated battery supply or an AC cord plugged into a wall outlet.

Glare: A reflection of a light source in a subject that is so strong it obliterates the subject behind the reflection. Changing the position of the subject, changing the position of the light reflecting off the subject, or diffusing the light source causing the reflection can sometimes control or eliminate glare. In relation to flare: lenses flare, and subjects glare.

Grid: A piece of metal honeycomb that is positioned in front of a hard light to narrow its beam. (See photo below.)

Grip / Grip Equipment: Some accessory that is used to position and hold a light, scrim, flag, filter, diffuser, or some other piece of photographic paraphernalia in place. (See photo, bottom right.)

Hair Light: A light placed over and behind the subject to separate it from the background and help to make the set look more three-dimensional so the subject and the background don't appear to be on the same plane. If the subject is human or animal, it lights the hair on top of the subject's head without lighting the front of the subject. If the subject is inanimate, it would light the area where hair would be on its top!

Instantaneous Light Source: A flash unit. (See photos below and at right.)

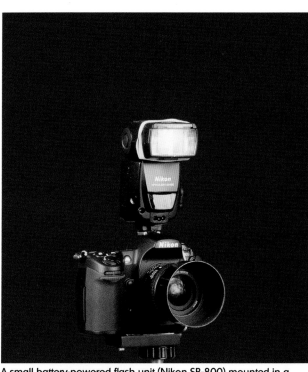

A small battery-powered flash unit (Nikon SB-800) mounted in a camera's hot shoe

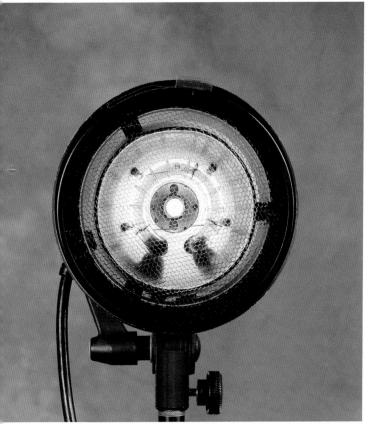

A flash head with a grid attached

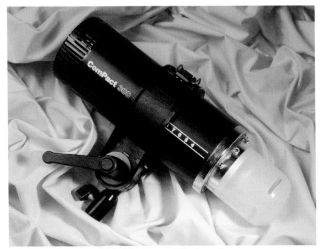
A Profoto Compact 300 AC-powered flash unit

A Profoto Compact 300 AC-powered flash unit

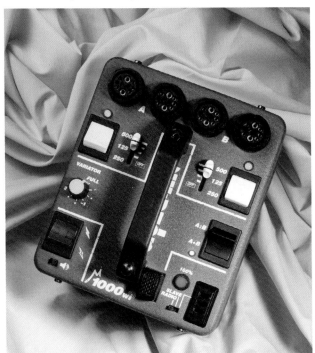
A Dynalite generator pack, which is used to power the flash heads.

Lumen: A measure of a light's output that takes into account the wattage and the reflector's efficiency.

Main (light): The primary light that illuminates a subject.

Modeling Light or Lamp: A modeling light is a continuous light source, often an incandescent or halogen bulb. In the context of this book, a modeling light is built into (or combined with) a flash unit to approximate the light the flash tube will produce.

Opaque: Any object or material that doesn't let light pass through it is opaque.

Pattern: The shape and size of a light's beam when it hits the subject.

Reflector: Any surface that bounces light off itself and then sends the light beam in another direction. Reflectors might be round and surround a light, or they might be a flat surface.

Scrim: Something put in front of a light that alters its intensity without altering its other qualities.

Snoot: A tubular-shaped piece of photographic equipment that limits the angle of a light's beam. They produce light similar to a grid but are more bulky.

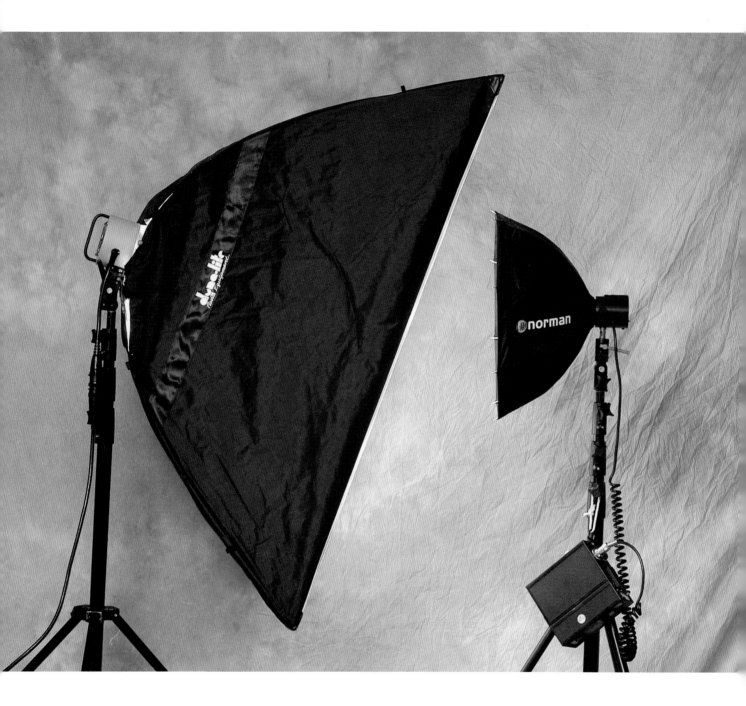

Softbox: A hollow, soft- or hard-sided box or trapezoid with a light shining into it from one side, passing through a diffuser, and exiting from the other side. (See photo above.)

Spill: The part of a light's beam that is wider than, and thus not contained by, a reflecting surface.

Specular: Mirror-like or having the properties of a mirror.

Strobe: An instantaneous (as opposed to a continuous) light source powered by either a battery or an AC supply that emits light for a very short duration of time.

Translucent: Any material that lets some amount of light shine through it. A translucent material changes the quality of the light passing through it by making it appear to be a broader light source. (See photo above, right.)

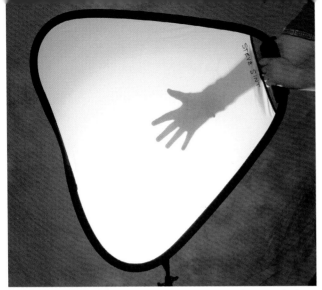

You can't quite see through something that is translucent, which means that a translucent object changes the quality of the light that passes through it.

Umbrella: An opaque or translucent umbrella with a white or specular inner surface that you aim a point source light into. The light from the point source bounces off the umbrella's inner surface and is then redirected to illuminate the subject with broad light. Or in the case of a translucent umbrella, the light passes through the inner surface of the umbrella and exits through the outer surface on its way towards the subject. In this second case, the umbrella is acting as a diffuser. (See photo below.)

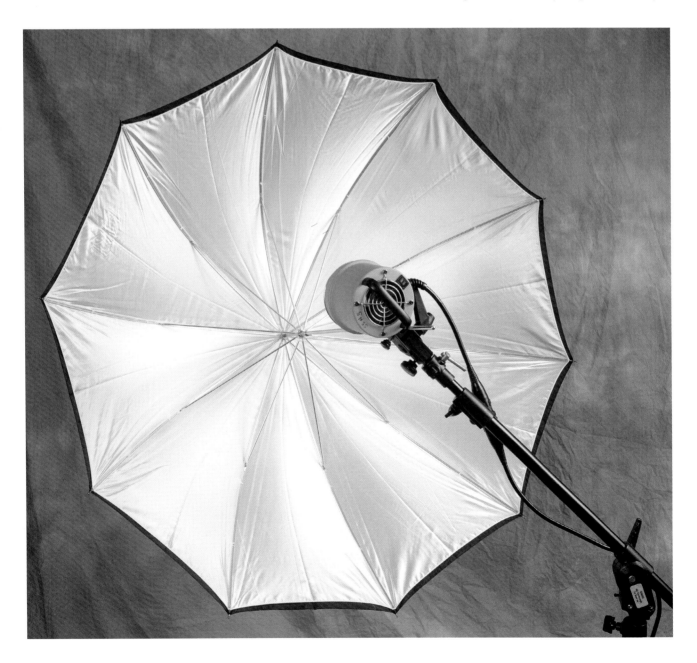

Light Sources

OK. The glossary is finished. Let's begin. Let's start with a tiny bit of history. There have been five major light sources used by photographers over the years. When photography was first invented, all images were taken by naturally occurring light. Other than fire (candlelight, lanterns), manmade light didn't exist! And, the emulsions back then reacted to light so slowly, requiring such long exposures, that photographers needed bright sunlight for consistently good results.

In the early 1900s, Edison came along and invented incandescent lighting (not to mention motion pictures). This type of light improved and evolved until it was a useful light source for photographers and cinematographers, eventually becoming the second light source for photography!

In the late 1940s, Harold Edgerton invented the strobe (electronic flash), which eventually became a third source of light a still photographer could use to make images. Electronic flash offered a number of advantages, especially a short duration that could freeze action (making for sharper images) and a color temperature equal to daylight (so it could be mixed with daylight without throwing off colors and tones).

Although florescent light was discovered about 100 years earlier, it wasn't until shortly before the invention of the electronic flash that commercial sales of fluorescent lamps by GE commenced (in 1938). However, when florescent light was first made commercially available, it was a discontinuous spectrum light that had almost zero red component and too much of the green component of the visible spectrum. Unlike incandescent lighting, florescent light produced little heat and used little power, so it had potential. Developments in florescent lighting technology and the invention of digital photography (which can cope with florescent lighting's limitations) finally made florescent a viable form of light for photography. Hence, it became the fourth light source.

How a Flash Unit Works

Since I recommend using an AC-powered flash unit, I thought I should spend a few moments on how a flash unit works. All flash units that I know of contain a flash tube and an electronic device called a capacitor. The flash tube (often made of quartz) is a long, skinny tube filled with a gas (almost universally Xenon) that can be excited into emitting light when electricity passes through it. The gas-filled tube is sealed at each end with an electrode passing through both ends. The problem is, the gas in the tube requires a lot of electricity to excite the gas enough to make it emit light. Enter the capacitor!

Now, to understand how capacitors work, I will ask you to make a mental leap as I draw an analogy between electricity and water. Imagine that you have a bucket that you are filling with water from a garden hose. It takes a while to fill the bucket, and once it is full, you lift it and turn it over so that all the water dumps out in one big torrent. In this analogy, the capacitor inside a flash unit is the bucket, and the water from the hose is electricity from either a battery or a wall outlet (depending upon the power source your flash uses). Like the bucket, the capacitor slowly fills with electricity and, once it is full, your flash unit is ready to fire. When you fire the flash—through either a hot shoe on your camera, a PC cord, a radio slave trigger, or a light actuated slave trigger—the capacitor(s) inside the flash unit dumps all the electricity into the electrode at one end of the flash tube. The torrent of electricity jumps through the gas in the flash tube, making it emit light, and leaves the flash tube through the electrode at the other end. At this point, the flash unit's power source (either a battery or an AC line) starts to slowly refill the capacitor(s), and the process repeats itself.

I am telling you all of this because, other than a busted flash tube, the one thing that can stop a flash unit dead in its tracks is a leaky capacitor! Like a bucket with holes in it, capacitors often start to leak electricity when they aren't used for a long time. To combat this, you have to perform a process called "forming" your capacitors from time to time—this is especially true if you have some flash units you don't use regularly. It's very easy to do this. Once a month or so, turn on all your flash units and let them sit turned on for a day or so. You don't even have to fire the flash unit while they are on! Every time the capacitor(s) leaks a little bit of electricity, the power source refills it, and each time that happens, the capacitor is being "formed." This process makes it stronger and less prone to leaking. It's really quite amazing; turn your flash units on every so often and just walk away from them for a day. Doing this will make your flash units last almost forever and they'll never be too pooped to pop when you need them to!

Finally, the LED (light emitting diode) lighting came along, which produced even less heat and used even less power than florescent light. In some fields of photography and video capture, LED lighting has become all the rage, and it is our fifth source of photography lighting. So, there are now four manmade light sources to choose from for making studio photographic images.

For a variety of reasons, I believe that electronic flash is currently the best choice for making still life photographs. Specifically, the similarity to daylight and short duration that I mentioned before make it my choice. Furthermore, today's AC-powered professional flash units often include quartz halogen modeling lamps (a form of incandescent light) that not only let you see the effect the electronic flash will produce when it fires, but can also be used as primary light sources all by themselves. This feature actually allows an AC-powered flash system to be used as two separate and independent lighting systems: There is no reason that you cannot use only the modeling lamps to provide the illumination to make a photograph! The truth is, with more advanced AC-powered flash units, the modeling lamps are often 250-watt quartz halogen bulbs, and by increasing your ISO from 100 to 400 (two stops), for example, that bulb is effectively four times as powerful as it was before (twice as powerful with each stop increase). If there is no AC power source available, the choice of which light source to use might change, but for studio photography in general and still life studio photography in particular, I believe that electronic flash with quartz halogen modeling lamps is the best way to go.

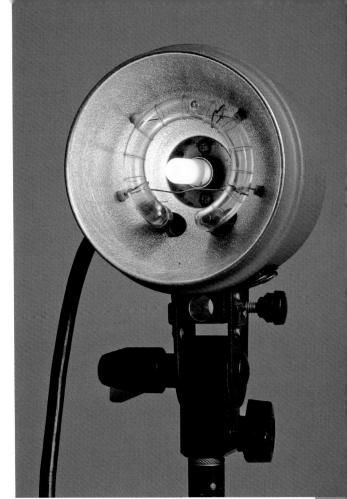

The business end of a typical AC-powered flash head. The peanut-sized bulb in the center of the reflector is a 250-watt quartz-halogen modeling lamp. The circular glass (actually quartz) tube surrounding the modeling lamp is the flash tube. Because the flash tube is a different size and shape and in a slightly different position than the modeling lamp, the light the modeling lamp produces is only an approximation of the light the flash tube will produce. This is not usually a problem when doing something like a portrait, for example, but it can become very significant in the more exacting world of still life photography. This difference has even greater import if the subject of the photograph is reflective!

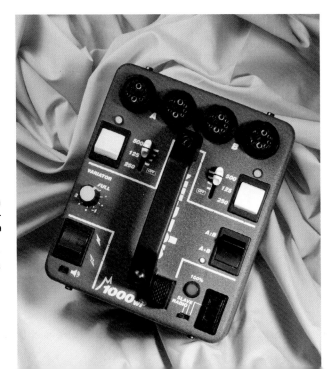

This is what a Dynalite flash generator pack looks like. It converts the power coming out of a wall outlet into power that the flash can use to excite the gas inside a circular flash tube like the one shown in the previous image. It is the brand I use, but other brands are equally useful. As high ISO quality in DSLRs continues to improve, you can get by with less powerful generator packs than the ones I use.

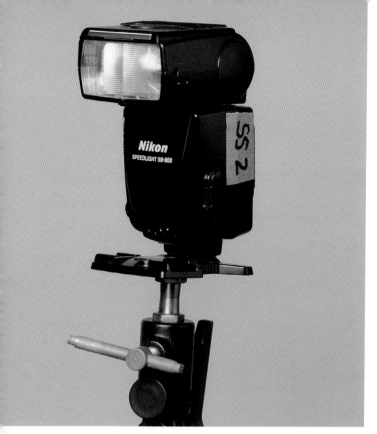

A typical battery-powered flash unit. Although I have a few of these, I don't really find them suitable for anything other than weddings, some portraiture, and high-volume, drop-and-shoot product photography. This is because their reflectors are harsh, their recycle times (at typical still life apertures) are relatively long; and most importantly, they do not have modeling lamps so, in effect, you are always lighting and shooting blind.

Light Quality

Regardless of the source of the light, neophytes often talk about the quantity of light available. However, past a certain point of quantity, I am much more interested in the quality of the light that is produced. All light sources fit into two broad categories of quality: soft light and hard light. The terminology used has nothing to do with the lights themselves, but with the type of shadows each produces. Soft (also called large or broad) light sources produce small, soft-edged shadows that minimize subject flaws and textures. Hard (also called point or small) light sources produce large, hard-edged shadows that accentuate subject flaws or textures. Look at the illustrations below; they show the nature and size of shadows produced by each type of light.

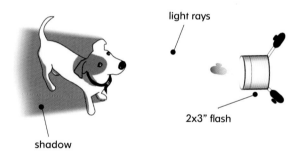

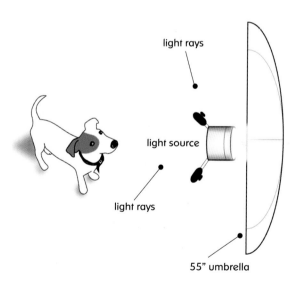

I know what some of you are thinking right now! Exactly how small is a small, hard light source, and exactly how large is a large, soft light source? Nothing in photography is absolute, and every attribute of anything is dependent upon other things. That being the case, whether a light is hard or soft is dependent upon whether it is direct or diffused, how far it is from the subject, and its size relative to the subject.

The most obvious example I can give you is our sun: It is one million miles in diameter, but because it is 93 million miles from Earth, direct sunlight (hitting a subject on Earth) is a small, hard light source (it

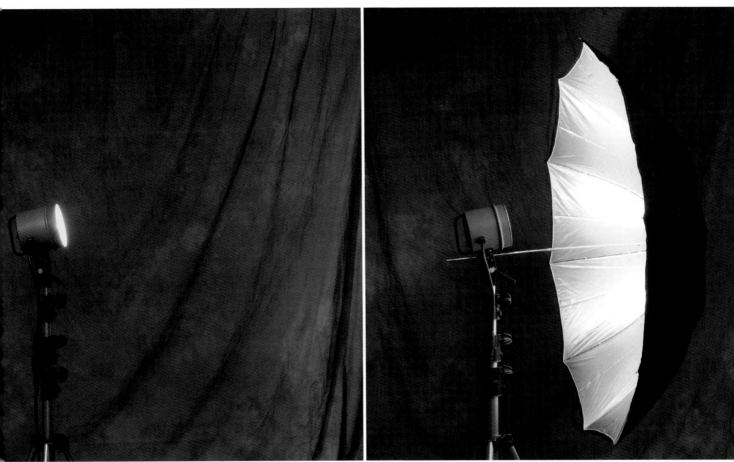

On the left, you see an example of a hard light source...and on the right, you see the same light with an umbrella mounted on it as an example of a soft light source.

creates large, hard shadows); however the same sun, diffused by cloud cover is a soft light source (with small, soft shadows).

If you are photographing a 1-inch diameter wedding ring, and your light source is 12 inches in diameter and 6 inches from the subject, then it is a soft source; but if you are photographing a 50-inch-tall file cabinet and using the same 12-inch diameter light, but it is 15 feet from the subject, then it is a hard source. Confusing, huh? To simplicate (a word I made up) things a bit, let me end by saying that almost any light source you buy, take out of the box, and use is a hard light, but the moment you put some large form of light modifier (such as an umbrella,

softbox, or other diffuser) on it, then it becomes a soft light source, taking into account its size and distance from the subject and the subject's size.

Now, about those shadows: Let me introduce you to umbra and penumbra. Not only does a broad light source make smaller shadows than a point light source, but the edge of the shadow's pattern is also more graduated. This edge of the broad source's shadow pattern is often termed "softer," and that is why broad light sources are often called soft lights. A shadow is made up of two parts, called the umbra and the penumbra. While the umbra part of a shadow is the total absence of light, the penumbra is the lighter part of a shadow that is

partially illuminated. Point source lights have a very small penumbra (basically irrelevant in real-world situations), while broad light sources have a much larger penumbra. It is this larger penumbra that makes the shadow's edge more gradual (softer), and this is what helps minimize the subject's flaws. Look at the illustration below to see where the penumbra is. It is the same as the soft light illustration on page 134, but this time, I have defined the penumbra by shading it in cyan. The umbra is still shaded in gray.

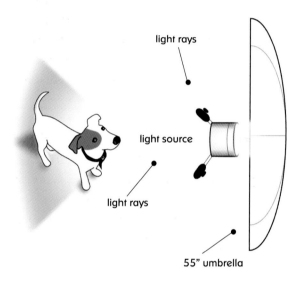

To get the effect you want, there are two parts of a shadow you can control independently of one another:

1. Its size

2. How hard or soft the transition between the umbra and the penumbra is. Large shadows create drama and let you hide parts of the subject you don't want the viewer to see, while small shadows feel less oppressive and expose more of the subject to the viewer. Hard-edged shadows can become a design element in a photograph, while soft-edged shadows call less attention to themselves, even to the point that the transition between the umbra and penumbra is so soft the edge of the shadow almost disappears.

Generally speaking, for my studio still life photography, I use soft lights as a primary source of illumination and mix in hard lights for accent lighting to bring out specific details. However, if the primary attribute of my subject is its texture (leather, fur, lace, sandpaper, etc.), I reverse my lights' roles, using hard lights as my primary source of illumination and soft sources for fill to control the depth of my shadows.

Lastly, depending upon the type of reflectivity my subject possesses, I choose my soft light sources based upon the type of reflection I want to see in my subject. As an example of this point, I direct you to the cover of this book and the reflections on the blue goblet. See pages 164-165 for a discussion of the reflectivity in the cover image.

How to Make Soft Light

There are many types of soft light sources. Some are available commercially, some you can make yourself (Chapter 4, Project 2), and some you just cobble together as the need arises.

Traditional Umbrellas: Traditional photographic umbrellas are very good for location work and portraiture, but I don't find them very useful for studio still life photography. In the first place, light spills off the umbrella's edge, and then this spill light hits nearby walls, ceilings, fill cards, and other studio paraphernalia. Now, this secondary light bounces back at the subject and lowers the contrast of the individual umbrella's light. Next, because a traditional photographic umbrella used in a traditional way offers no way of controlling the edge of the shadow's pattern, you can only achieve small shadows with soft edges when using it. Lastly, and possibly most importantly, the reflection traditional umbrellas create in almost any reflective subject is not pretty—it almost looks like a spider.

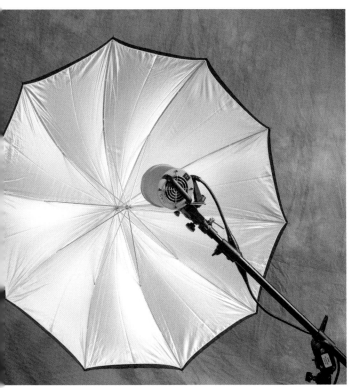
Traditional photographic umbrellas set up and break down quickly. They also pack away very compactly.

Softboxes: Commercially available softboxes are usually trapezoid-shaped boxes with opaque sides. The rear of the box holds a light shining into the box, and the front of the box is covered with a diffusion panel. They don't create the spill that traditional umbrellas do, and they offer more contrast than traditional umbrellas (used traditionally). However, the design of a commercially sold softbox limits you to a fixed distance between the light and the diffusion panel (plus the light is always shining through the center of the diffusion panel), so you can't control the edge of the shadow's pattern independently of its size, nor do they allow you to make the front surface of the softbox fade from light to dark which can affect how its reflection appears in a glass or specular surface. That being said, many photographers use them religiously.

Some softboxes contain a secondary diffuser halfway between the light at the rear of the box and the diffusion panel at the front of the box. This secondary panel is added to smooth out the light's pattern, but I find this can be either an advantage or a disadvantage, depending what effect I'm trying to create.

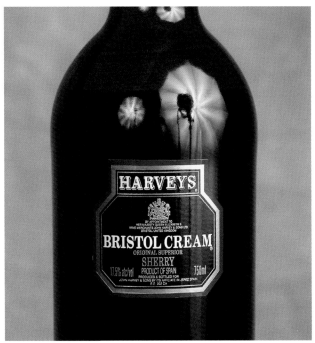
This is the reflection two traditional umbrellas create in a bottle.

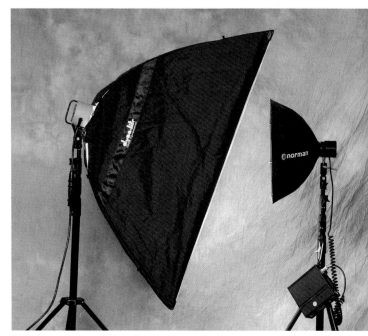
Commercially available softboxes are available in a variety of sizes and shapes. Here are two such examples.

A softbox light without and with a secondary diffuser (left and right, respectively). The secondary diffuser, located halfway between the light and the front diffuser panel, further smoothes out the light's pattern on the front panel. A smooth pattern on the front diffusion panel can be important, because that panel's image will be reflected in any subject with a reflective surface.

Two pieces of opaque gaffer tape across the front of a softbox can make its reflection in a specular subject imitate the effect of mullions on a window.

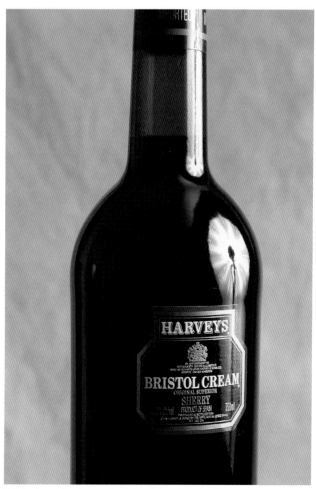

This is the reflection a single traditional umbrella creates in a bottle. Note the tone of the grey background--compare it to the background tone in the next image of the bottle, lit with a softbox.

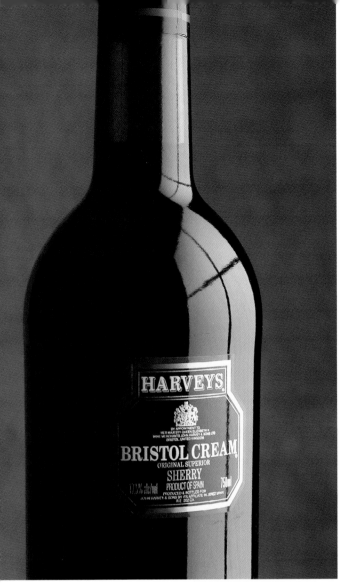

The difference in background tones between this image and the one on page 128 occurs because the softbox contains the spill, and the umbrella doesn't. Which image looks more finished, more dramatic, and more professional to you? No need to answer, it was a rhetorical question.

Shoot-Through Umbrellas and Disc Diffusers:
As I've grown to have a better understanding of how to control the size and edge of my shadows independently of one another, I have moved away from using commercially available softboxes. However, there are at least two ways to use commercially available photographic accessories that allow you to change the light-to-diffuser distance and the light source size independently of one another, and for that reason, I prefer them. I call these items bank light (softbox) impersonators, and they are worth knowing about. One is a shoot-through umbrella, and the other is a hoop-type diffuser.

Both of the bank light impersonators shown below offer the control I'm looking for (especially for shooting specular subjects), but I am still not perfectly satisfied with the size and shape of the reflections they create. Because of this, for my most often-used soft-source light, I use a light on one light stand behind some form of diffusion panel held on a second stand. For my diffusion panel, I use either a sheet of translucent acrylic or one of my hand-made diffusion frames (see chapter 4, Project 2). Or, sometimes I use a roll of Tough Lux hung like a seamless paper backdrop from a cross bar with a length of 1x2-inch lumber spring clipped to its bottom end to keep it taut. When working with a diffusion sheet this wide, I often use more than one light behind the diffusion screen to make the light coming through the diffusion sheet more even, and sometimes I even add colored gels to the light or lights for a special effect. (See the feathered Super Clamps on page 187 for an example.)

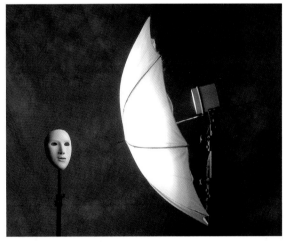

Below are just some of the ways you can use a diffusion screen and a light mounted on a separate stand to get a variety of different effects. All four will change the reflection the diffusion screen creates on a reflective subject's surface. These effects cannot be duplicated with any (any!) commercially available softbox!

This setup is roughly the light and diffusion panel positions found on commercially available softboxes, but if you are unhappy with the result using the ready-made softbox, there's not much you can do to change the result to something different

Here, I've simply moved the light so it is off center on the diffusion screen. Both this setup and the next one will result in a reflection that fades from light to dark.

The light is just skimming the diffusion screen's surface.

The front side of diffusion screen is flagged down to emulate the lighting you would get from a strip light type of softbox. This setup is perfect for tall, skinny products like wine bottles, or when you want to limit the width of a softbox's beam.

Note: Although I've often used two or three diffusion panels to light a photograph (see the portfolio images in chapter 9), I generally use one diffusion screen of some sort plus some fill cards. So, the question you might ask is: When do I use which type of diffusion? Well, an acrylic sheet offers more diffusion than a sheet of Tough Lux does, so if I want a simple "blob" (for lack of a better term) of light, I use a translucent acrylic sheet. But, if I want more distinct shadows, or if I need to "float" a diffusion screen at the end of a boom, I use a lighter-weight Tough Lux diffusion screen (see Chapter 4, Project 2). And, if my subject's surface is not specular (mirror-like), I often use either of the bank-light impersonators I mentioned on page 129.

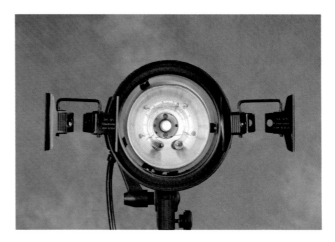

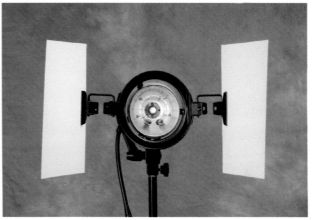

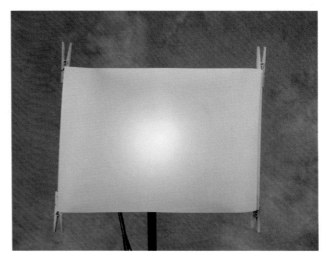

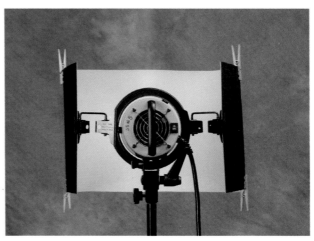

Improvised Softbox: Note that the size of a softbox's front surface is relative. For example, a small diffusion screen / light combination can be considered large if the subject of the photograph is a wristwatch or a ring. If the subject is small, you can cobble together a soft light using a grid holder, a grid, two Bogen/Manfrotto Multi-Clips, two pieces of mat board, and an appropriately sized piece of Tough Lux clothespinned to the mat boards. Look at the images at right to see just how such a light might be constructed.

How to Make Hard Light

Just like soft lights, there are many ways to make stock (store bought) hard lights into even smaller sources. You might want to do this to limit spill onto a second subject adjacent to your primary one, or just to create an even blacker shadow with a harder edge. Here are the two I use most often:

Grids: Since I mentioned using a grid holder in the last soft light example, let me begin with hard lights with grids. One way to narrow the beam of a hard light is to place a grid in front of it. Grids are approximately 1/2-inch-thick slices of metal honeycomb material that narrow the angle of a beam of light passing through them. Normally available in 10-, 20-, 30-, and 40-degree angles, an approximately 6-inch-diameter circle of the honeycomb material clips into a grid holder, which in turn, clips onto the front of a flash reflector. While I mostly use a 20-degree grid for portraiture, I use the whole gamut of them for still life work.

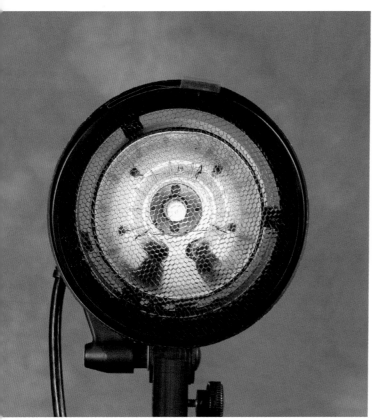

This is what a grid looks like when it's clipped into a grid holder.

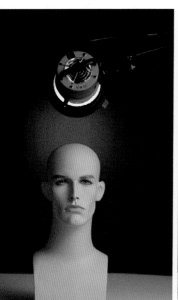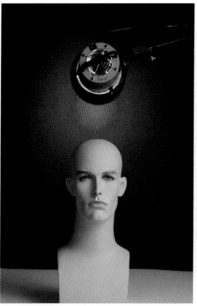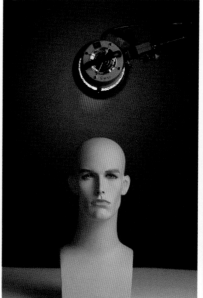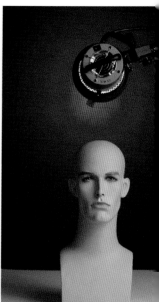

These four photos illustrate the relative size of the light pattern created by 10-, 20-, 30-, and 40-degree grids. I used a manikin head so you could have a sense of scale.

This is a roll of Lee Black Foil and the box it comes in. Note that Lee foil is about twice as thick as regular heavy-duty aluminum foil you buy in your local supermarket, and its black color means the outside of the snoot doesn't reflect another light source onto your subject and make you crazy trying to figure out where that hot spot is coming from.

Snoots: Snoots are another way of limiting a light's angular beam, but they are bulky and more cumbersome to use than grids. That is especially true of hard snoots that are usually about 6 inches (15.2 cm) in diameter and 9 – 12 inches (22.9 – 30.5 cm) long. However, a long time ago, I watched a gaffer on a feature film set rig a snoot out of heavy-duty, black anodized aluminum foil. Seeing that changed the way I made and used snoots. That gaffer wrapped a length of the black foil around a light head into the shape of a tube, held it in place with a piece of gaffer tape, and then he pinched in part of the tube's end so the light's beam pattern conformed to the subject he was lighting! That last little wrinkle was it! From that day forward, I only used custom-made snoots designed specifically for whatever subject I was lighting. I buy 50-foot rolls of the black foil (made by Lee Filters), and because I primarily use grids, a roll of the foil seems to last forever.

This is what a Black Foil snoot looks like.

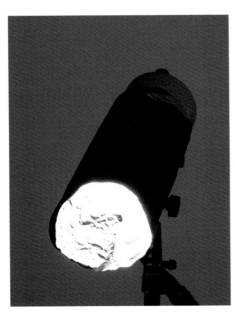

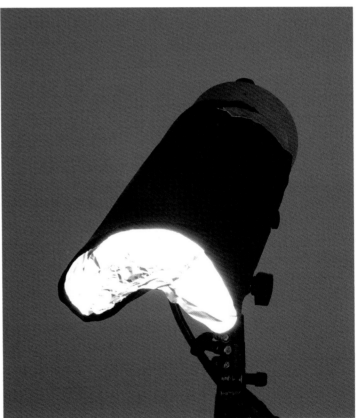

On the left is the business end of a Black Foil snoot in action. On the right is a customized snoot with its end bent to mimic the subject's shape, which limits the light to the area of the image where the subject is, leaving the background relatively dark. This allows you to spotlight a central subject but keep the edges of the image's frame dark to contain the viewer's eye.

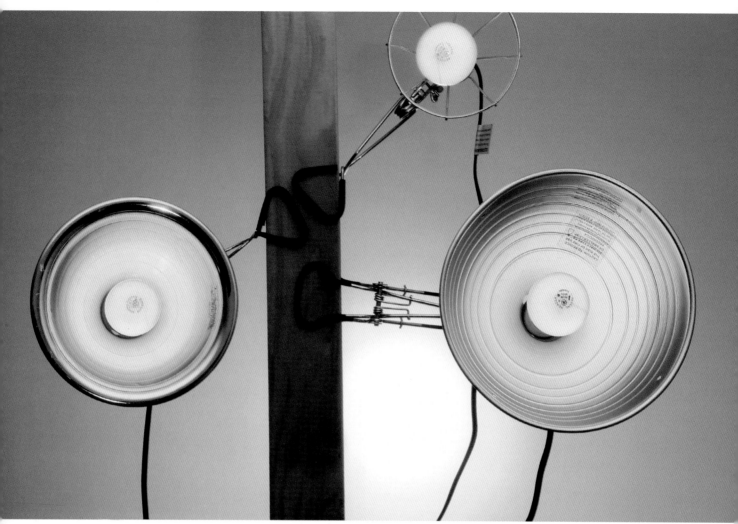

This is what my very first set of photographic lights looked like. Not counting the bulbs, each spring clamp fixture cost me no more that $10 – 12 dollars! If you are going to use this approach, though, remember that these lights do not match daylight, so plan on doing your portfolio shooting after dark to avoid weird mixed-light effects. Also, make sure all the bulbs you buy are the same wattage, because like-wattage bulbs will have a similar color temperature to one another.

Cheap Lights

It's quite scary to think about all the money photographers need to spend on their lights, light modifiers, and grip equipment. Even if you are very frugal and shop wisely, the total expense adds up very quickly. A typical studio rig like I use, which includes four or five flash generators, six or eight flash heads, a lot of light modifiers, and a cartload of grip equipment, is enough to make you shudder! Even if you bought just six of the high-end shoe mount flashes, you're looking at almost $3000, not counting stands and all the other paraphernalia. But, that doesn't mean you have to buy it all on one crazy shopping spree, on one day. Furthermore, a good set of lights lasts almost forever, so in a way, if you make choices with the long haul in mind, you can build a system that continues to grow, but is also compatible with what you've bought previously.

Also keep in mind that if a light says it is designed specifically for photography, it might well cost you four times what a similar product (that isn't designed specifically for photography) would. In truth, the designed-specifically-for-photography equipment is almost always better, but at your humble beginnings, what you really need are just lumens. For example, a single 500-watt quartz halogen Lowel Omni-light sells for around $200, but two 500-watt quartz halogen work lights with a stand sell for $35 at Harbor Freight! Are the Lowel lights better? Absolutely! But, when you're starting out, a $35 investment won't break the bank, and those lights are useable until you can afford something better. Look at the following photos for some ideas on this approach to your lighting needs.

The simple truth is, a professional photographer needs lights! Amateurs can afford to wait for the golden hour, but a client is likely to need a picture shot during the other 23 hours in the day. The more pictures I've created, the more I've realized that lighting is more important than just about any other aspect of photography. My advice is to develop an interest in lights and lighting, and embrace every technique you learn along the way. In light of this (ha-ha...get it?), the next chapter is about lighting accessories. Let's move on!

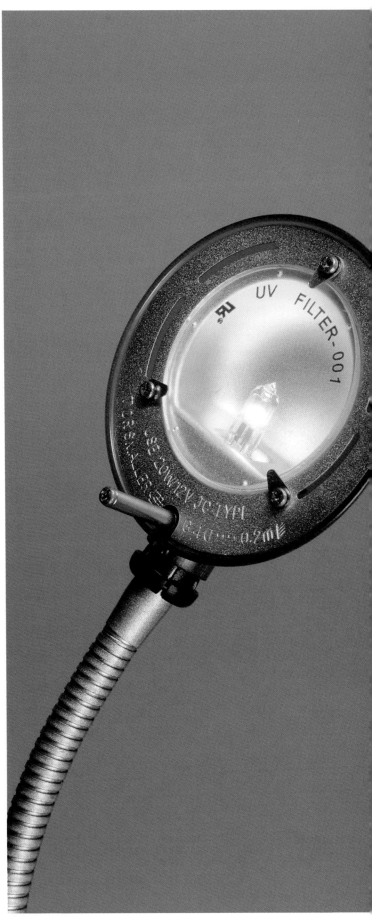

There are home-decorating lights available today that use 12-volt quartz halogen bulbs, and some of these systems even come with clip-on desktop lamps that include a transformer to convert household current to 12 volts DC (direct current).

6

Lighting Accessories

You just read five chapters about getting ready to create photographs, but nothing about actually creating them! If this book were a house, those chapters would be the foundation. I tried to give you both direction and information about kinds of still life photographs, finding and creating a space in which to take photographs, and then putting together a place to put the subject in (the studio) and on (a tabletop). Now it's time to start thinking about creating the photograph.

If all photography is about light, then it's the studio photographer's job to control that light. But "control" is such a nebulous word. What does "control" really mean? Well, light is a form of energy, just ask any scientist. So controlling light means harnessing that energy to get the viewer of your images to feel the way you want them to about the subject of your photograph! Plants react to light; they grow towards it. Humans react to light too; it can create an emotional reaction within them. Don't believe me? Have you ever stood outside on a bright sunny day and just felt great? What about doing the same thing on a cloudy, dark-sky kind of day? Well, as sure as light is an energy form, it has some properties that you can actually list and define. Furthermore, those properties can be used to create emotional reactions in the people viewing your images!

When a person gets their first camera, they don't think about light at all; they only think about the camera. Later, when they realize they can't take a picture in the dark of night, they think about getting a flash or buying a tripod. But, at this second stage in their love affair with photography, they are only thinking about the quantity of light they need to take a picture. They check their camera's LCD screen or open an image file on their computer and they are excited that they got the correct exposure. But, what comes after having a sufficient amount of light to take a picture? Those people finally arrive at thinking about light's properties, and not just "how much." Figuring this out is no easy task. It takes a lot of thought and an understanding of a bigger picture than just pushing the shutter button on a DSLR. This doesn't just happen overnight, and in truth, there are those of you who will never get it! But nothing that comes easily is as worthwhile as things that take more effort.

In those thrilling days of yesteryear, in my early days as a photographer, I just loved the feel of my SLR (note, no "D") in my hand. It wasn't even about taking a picture; just the feel of that SLR in my hands was enough to light my fire. Later, when I realized how much fun it was to take pictures, I wanted to take pictures all the time, anywhere and everywhere. So, I spent a huge amount of time thinking about getting the quantity of light I needed to take my photographs. Finally, after years and years, when I got to the point that I always knew how to ensure I had enough light, it dawned on me that I could control the light to reinforce the story I was trying to tell through my images. I could use my photographs to communicate! Getting to that point was a journey filled with epiphanies and as many moments of joy unbounded as moments of frustration and gnashing of teeth. I am writing this

book so you can get to the joy part faster with a lot less teeth gnashing. The properties of light, as I see them, are as follows:

- The direction of the light source(s)
- The contrast of the light source(s)
- The size of the light source(s)
- The color of the light source(s)
- The emotional feel the light source(s) creates

I believe the first four of the properties listed are objective, concrete, and quantifiable, while the fifth is subjective, fuzzy, and can't be quantified. Sadly, Number Five is the hardest to understand and explain. So here's my plan: This chapter will deal with controlling the first four objective properties of light, and then we'll deal with the nebulous, subjective Number Five in the next one. And maybe, with a little luck, you'll discover and understand some of Number Five as I go through numbers 1 – 4.

To start this understanding of Number Five right now, please note that all five properties mention "light source(s)." Sometimes, differences between two light sources used to illuminate a single image can help to create the emotional reaction cited in Number Five.

Going back to the analogy of building a house, if the first five chapters were the foundation, then this chapter and the one that follows will be the first floor and the wraparound porch of the house. Yes, since I'm the one building this house, it has a wraparound porch!

Controlling the Direction of the Light Source(s)

Controlling the direction of the light source hitting your subject is really the act of physically putting the light source where you want it to be. If you want the direction of the light source to come from where the lens of your camera is, then it's simply a matter of putting a flash unit in the hot shoe of your camera. But, in honesty, and as I've said unequivocally, having the light come from close to the lens axis is boring. This is primarily because it makes the subject look flat (like a cardboard cutout) instead of round, voluptuous, and three-dimensional. A light in a hot shoe is like a punch in the subject's nose—almost an affront to your subject's three-dimensional reality. It is a compact, relatively inexpensive solution to getting a sufficient quantity of light and freezing action, so it has its place. But, the quality of the light in the camera's hot shoe (primarily because of its position) leaves a lot to be desired and robs you of an important creative tool.

Light Stands

The first step in taking back that creative tool is getting the light away from the lens' axis. The easiest way to do that is to use some kind of light stand. I know, I know, some of you might think a light stand is a light stand is a light stand; just as you might think a clamp is a clamp is a clamp; and that a floor-to-ceiling pole is a...well, you get it. Except, when it comes to studio still life photography, many times, one light stand will work and another one just won't! (More on that later.) If the whole idea of controlling the light's direction is the ability to place lights where you want them, then whatever holds a light where you want it in is worthy of your consideration. And, while controlling the light's direction only requires one stand (or other means of positioning a light), often two or more secondary light stands are required to control the other three properties (intensity, size, and color). That said, you're going to need a good number and variety of stands.

There are literally dozens of attributes of light stand design worth considering. Here are examples of three common light-stand designs:

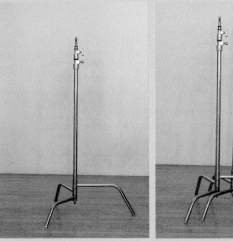

The image on the left is a C-stand. C-stands are difficult to use for location assignments because their legs don't collapse compactly against the stand's central tube, which makes them more bulky when the legs are folded up. However, they are the standard for the cinema industry and many still photography studios. C-stands are also heavy, they're made of steel, but their asymmetric leg design allows them to be positioned very close together (photo at right, above), and that specific feature is often very helpful.

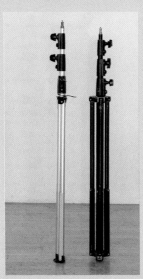

This photo shows two other, more traditional light stand designs. The black stand on the right is the most traditional design, while the one on the left is a newer design called a Stacker stand. I have found that approximately three collapsed Stacker stands fit into a space that will only hold two of the more traditional stands.

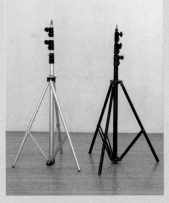

In this shot, you can really see the difference between how the traditional and Stacker stands' legs look when extended. I have both types of these Manfrotto stands, but I actually prefer the more traditional (non-Stacker) type because they seem to work more smoothly for me.

DIY Light Stands

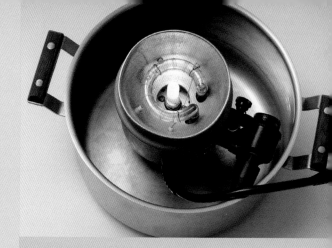

To improvise, you can use a Pyrex® baking dish or an aluminum pot as a very short "light stand." What? Why not just set the light on the floor? Well, depending upon how much heat the light generates and what the shooting floor is made of (or covered with), you may need something to absorb heat and protect your flooring. For example, if you are using quartz halogen hot lights, and you have carpeting or linoleum flooring, you'll definitely need that buffer.

You can also improvise with photographic accessories by using them in ways other than what they are designed for. One time when I had to I build my studio in a client's warehouse, I didn't want to drag my Pyrex® baking dish along with me on a location shoot because baking dishes are bulky, and they look "unprofessional" (even though they work great). Furthermore, without them, my better half couldn't cook dinner while I was out shooting! So, I was at a loss for a more portable, professional-looking, tiny light stand. Well, it just so happens that one of my favorite camera bag accessories is a Manfrotto 709B Digi Table Top Tripod. For the record, I find this tiny, heavy-duty aluminum beauty so useful I have two of them, and have even given them as Christmas gifts to my assistants over the years! Further, while one big New York camera store lists the item as "discontinued," I found them again on Manfrotto's US website (manfrotto.us). I added a 5/8 stud to one of mine (more about studs later) and voilá; I had the perfect tiny light stand! There are other, both less- and more-expensive tabletop tripods available, but the Manfrotto 709B Digi works for me!

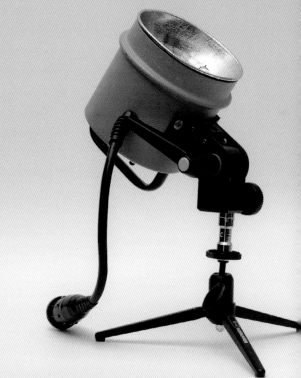

You can even build an inexpensive light stand yourself by filling a 1- or 2-gallon plastic paint bucket with cement and pushing into it a 6- or 7-foot length of wooden closet pole, a piece of 1x2, 2x2, or 1x3 lumber, or even a length of metal conduit pipe before it sets. You can spring-clamp the pole to the side of the bucket to keep it in a vertical position or jury rig a way to keep the pole centered and vertical until the cement sets. (Be sure the pole in the cement bucket is absolutely vertical before the cement sets up, or you'll end up with a tilting light stand that falls over all to easily!)

Although this $15 – 20 dollar light stand is certainly inexpensive, you must realize it's a temporary measure that creates a set of problems all its own. In the first place, moving your cement stand around is difficult because it's so heavy. You can leave the handle on the bucket to make it easier to lift or grab the pole, tilt the bucket, and roll it on its edge to get it into the position you want, but just try taking this type of light stand on a location shoot!

I have a second problem with this type of inexpensive light stand: Regular, three-legged light stands are stable because of the very large base created when the three legs are extended outward, while the cement bucket stand gets its stability from the heavy mass of cement at its base. However, the cement bucket stand's base is relatively small, so it is still easy to tip it over, which can be a big bummer to a young photographer starting out on a small budget. Let's see, you save between $30 and $80 over the cost of a traditional light stand, but your inexpensive stand falls over, and the resulting crash smashes the $400 flash unit you have attached to it! Hm—maybe this wasn't such a good idea after all. But, if you're just starting out, and you're going to use inexpensive, lightweight, incandescent, spring-clip lights with spun aluminum reflectors, the cement bucket light stand is a viable solution.

To any jaded pros reading this book who think this can't possibly work for high-quality images, I can only say that light is light, and my first portfolio was shot with just such a set of cheapo lights. For the record, I might have said "inexpensive" instead of "cheapo," but that wouldn't have done their low cost justice! They're about $8 – 12 each (not counting the bulbs).

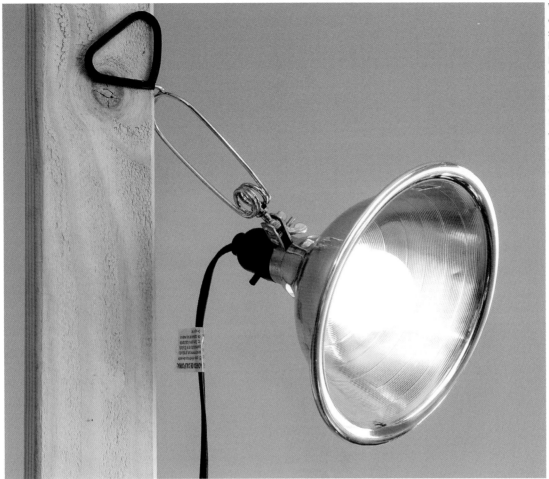

While I no longer use buckets of cement with a piece of 1x2 stuck in them as light stands, I did find three different inexpensive spring clamp lights that are similar to ones I used at my beginnings. Here is an $8.47 spring clamp light I picked up at a Home Depot. The fixture can handle up to a 150-watt bulb. If you're interested in these types of lights do not exceed the fixture's recommended maximum wattage—always remember, safety comes first!

Maybe you aren't into mixing gallons of cement, let alone pouring it into buckets and holding poles upright in it until it solidifies! Maybe you don't have to be; provided you have a reasonable but realistic amount of bucks to spend! Luckily, there is a veritable forest of commercially made light stands available. One big store in my town offers 848 different light stands, and a Google search for "light stands" results in over eight million hits, so it's obvious there is a light stand made that can fulfill your needs.

A while back, a photographer friend of mine—an available light specialist—called to say he finally needed to buy some AC-powered lights and asked if he could visit my studio. When he stopped by, he showed me his flash shopping list: two packs, 4 heads, a few light modifiers, and four light stands. Well, on that day, I happened to be doing a complicated double exposure on two different sets. By the time I had finished lighting my two sets and putting up two backgrounds, I had used a baker's dozen of stands and six floor-to-ceiling poles. My friend, after he counted them and saw how all of them were used...well, let's just say he rethought his shopping list. You don't just need stands (and booms) to hold lights; you also need them to hold diffusers in front of the light, to hold fill cards opposite the light, and to hold flags and scrims, which either block part of the light's beam or cut the intensity of the light's beam, respectively. More on that shortly.

So, you need a lot of stands. Additionally, and to complicate things, you'll need different kinds of stands if you don't want your creativity to be fettered by your equipment's limitations. You'll need very, very, short stands so you can position a light under a subject or a translucent acrylic tabletop; short stands so you can hide a light behind or below a subject; tall stands to position a light high-up or to support a background; heavy stands to support booms or bank lights; stands with special legs so they can be placed close to other light stands; and even lightweight stands for when a clients asks you to build a studio in their factory or warehouse. Before you freak out at just the thought of the cash required to buy a dozen (or two dozen!) light stands, remember: You don't need to buy all of them at once; and, by being creative, you can make wise selections to save money. You may even decide to make some quasi light stands yourself to be frugal.

But, which ones do you need? There are differences you can see and ones you can't see between commercially available light stands that affect the stand's capacity and portability. Let's break down the choices offered using some specific criteria worth considering, whether for digital still photography or DSLR video use, and whether you are a newbie or a pro.

Stands in a can! As your collection of light stands grows, one great place to store them (plus your tripods and wooden cross bars) is a strong, rubbery plastic garbage can; I use the Rubbermaid brand and they seem to last forever. I use the 32-gallon size because the larger-sized one is taller, and I find I can actually loose my shortest stands in the bottom of them!

Height: What's the stand's maximum height? If you're only working in one studio space all the time, you never need stands that are taller than your studio's ceiling height. Actually, even ceiling-height would be overkill, because the light on top of the stand, plus any modifiers (banks, grids, diffusers, and umbrellas, for instance), takes up a bunch of your floor-to-ceiling height. But, if you want to use those same stands on location shoots in factories, loading docks, hotel ballrooms, and other spaces with basically unlimited height, 12-foot stands are really nice to have! Even if you're only shooting in a low-height studio, two 12-footers are nice to have to use as boom stands (see pages 145-149 for more on booms), because the overlapping tubes inside the main tube of a 12-foot stand makes it much stronger at lower heights.

One of my studio spaces, which I use for much of my tabletop shooting, has 8-foot ceilings, but because I also do a lot of location shooting where I construct studios in warehouses and loading docks with basically unlimited ceiling height, it has come to pass that I basically have two sets of light stands. Although I mix and match stands from both sets, the taller set is used primarily for location shoots, and the shorter set is used primarily in my low-ceiling, tabletop studio. I have about ten 12-foot stands and six 7 to 8 foot stands, plus the equipment to put up three pairs of floor-to-ceiling poles (see pages 107-109), and I can clamp a light or a light modifier onto any one of them.

Risers: How many sections a light stand has is also worth considering. Risers are sections of a light stand that, well, rise; and all stands have one more section than they do risers. A two-riser stand has three sections, a three-riser stand has four sections, and so on. Personally, I like the three-riser design for my taller stands so they collapse more compactly, and two-riser models for my shorter stands so I can change the height of the light atop the stand more quickly. However, I have a few (four exactly) three-riser shorter stands that I use for back or background lights because their short stature when fully lowered makes them easier to hide behind a subject (even though they are a hassle to use at their full heights). See the photo at right that illustrates the difference between two- and three-riser stands.

Weight Capacity: How much weight can the stand support? Here's the scoop: Even if you're using a bank light (or anything else heavy), a light stand with a 20 – 25-pound capacity is much more than sufficient. In fact, you can get by with lower capacity stands if you are using a battery-powered, hot-shoe-sized flash head. Of course, if you are advanced enough to be using lights that weigh more than 20 – 25 pounds, you already should know all this!

Physical Weight: How much does the stand weigh? Unless it's for a particularly heavy-duty use, those that weigh between 6 and 10 pounds are all fine, but if you do a lot of location work, stands on the lighter side of the range are better!

Legs: How do the legs work? A stand's legs can pivot outward from either the top or the bottom. Traditionally, they pivot at the top, and the bottom of each leg moves outward as you open the stand. While I find these very stable, two of my stands work oppositely—legs that pivot at the bottom. This means you can arrange the legs so they lie flat on the floor, and that means the stand can be placed very close to another stand. See the photo at right to understand the difference.

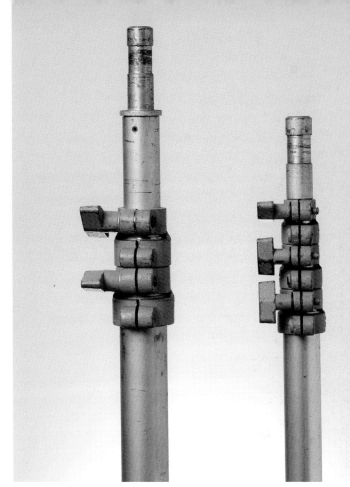

Three-riser stands usually collapse more compactly and have a shorter minimum height. Two-riser stands are easier to use when you want to make large changes in the stand's height because there's one less section to open and close. The choice is yours, but I have and use both for different purposes.

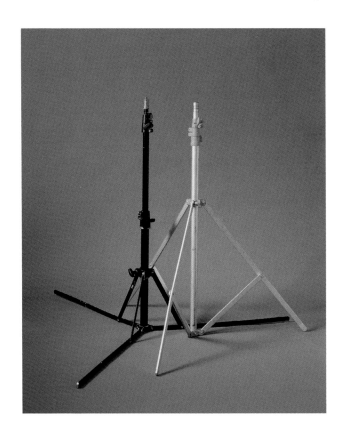

Color: What is the color of the light stand? Light stands don't really come in colors, so it's not like you can go out tomorrow saying, "Today I'm going to buy a day-glow orange light stand." But, they do come in black, polished aluminum, or chromed steel. If you're shooting reflective subjects, let me save you hours of retouching in Photoshop or draping every stand on the set in black velvet: Buy black light stands! And, while we're on the topic, black tripod legs are better than silvery or polished aluminum ones for the same reason! While it is true that having fluorescent, safety yellow or orange tripods and light stands might be helpful on a dimly lit location shoot, those colors are just bummers on a still life set!

Studs: Here's an important suggestion: Regardless of how many sections or risers your stands have, or the types of legs, height, capacity, weight, or color you choose, all of them should have the same diameter stud on top. Settling on one stud size just makes life easier! The still photography, pro-grade standard is a 5/8-inch diameter stud, and it's amazing how many pieces of pro-grade lighting gear can be linked together using this size of stud. Some hobby-grade equipment uses a 1/2-inch stud, but if you try to mount something with a 5/8-inch hole on a 1/2-inch stud, it never locks on well and always seems to rattle around on the smaller stud or tilt at a weird angle once you tighten down its locking screw. You can get an adapter to fit a 1/2-inch stud into a 5/8-inch hole, called a bushing, but bushings are small round tubes that are very easy to loose or misplace. (I should know, because I've lost a bunch of them over the years!) Conversely, you can buy really high-quality adapters that convert a 5/8-stud to a 1/2-inch stud.

Way back in Chapter 3, I showed you a set of drill bits. The largest bit in that set was 1/2-inch in diameter, but a 5/8 bit may be handy to have too. I often use a piece of 1x2 lumber between two light stands to make a crossbar over a set I'm working on, or to hang a half width roll of seamless paper on. Should you need to do that, there are three ways to hold the 1x2 crossbar in place: 1. You can use gaffer or duct tape, but that solution is difficult to adjust,

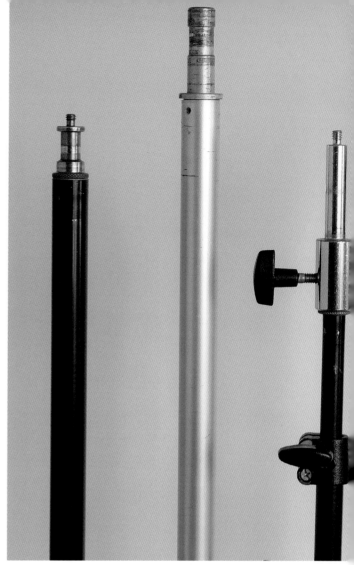

Here are some of my light stands' tops. Note that regardless of how thick or thin the top section of the stand is, all of them are fitted with a 5/8-inch stud. Also note that the light stand third from the left is fitted with 5/8-inch to 1/2-inch adapter, so now you know what one of those widgets looks like too.

messy, and time consuming to set up and break down or, 2. You can use two super clamps (covered later in this chapter) to hold the 1x2 crossbar, but that ties up two of your expensive super clamps or, 3. You can drill two 5/8-inch holes through your 1x2 crossbar, one near each end of it. That allows you to just drop the crossbar onto two light stand studs. I find that last option to be best, because it's clean, fast, easy, doesn't tie up any clamps, and only has to be done to a crossbar once! But to do so, you're going to need a special 5/8-inch drill bit for wood. I've done this enough over the years that two of these 5/8-inch drill bits have found their way into my toolbox.

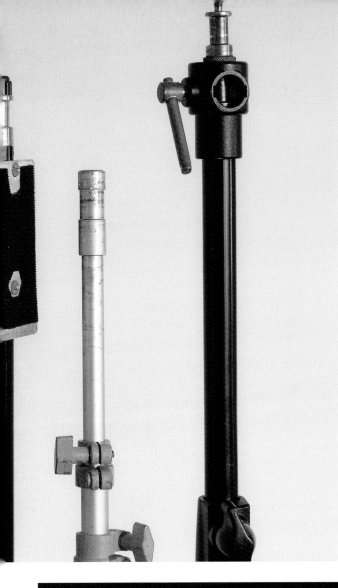

Booms

The next most often-used way of controlling the direction of the light when you want to place it in an unusual place is a boom. A boom is a horizontal pole that is attached to the top of a traditional light stand using a piece of equipment called a grip.

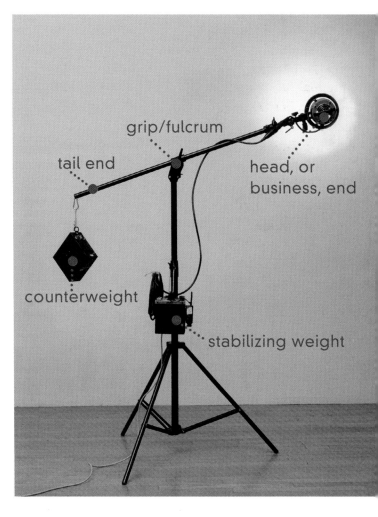

Using a boom, a photographer can, for example, place a traditional light stand next to a tabletop and have a light, attached to the end of the boom arm, extend outward over the center of the tabletop. While most still photography booms are usually only 6 to 8 (1.8 x 2.4 m) feet long and are designed to hold a light in position, cinematographers often use much longer booms (up to 25 feet / 7.6 m) to suspend a microphone out over a set to record the actors' voices. Many booms are adjustable in length, and you can also adjust where the fulcrum is (where

Here are my two 5/8-inch drill bits. I bought my second one just before I found my first one, which I had misplaced!

the light stand top and grip are located) to help with balance. The end of the boom, where the light is located, is often called the head (or working) end, and the opposite end is often called the tail end. Many times, you hang a weight on the tail end of a boom (to counter the weight of the equipment at the working end), called a counterweight. Booms are very useful, because they let you place a piece of photographic equipment in a position so as to seemingly defy gravity. That piece of equipment, having no visible means of support, may be arrested on vagrancy charges (apologies, I had to say it!).

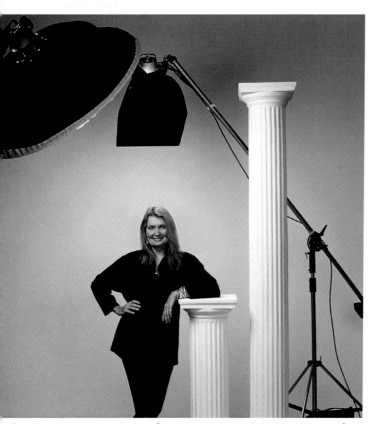

If you're going to shoot fashion (and even portraits of singles and groups) you'll probably need heavier, stronger, remotely controlled booms with a longer reach. This means getting steel light stands instead of aluminum ones to support your boom and heavier counterweights to offset the longer boom arm's extra length.

Be aware, when you shop for booms or grip equipment, that there are a limited number of manufacturers making pro-quality grip gear. When choosing products from the Avenger, Manfrotto, Matthews, and Lowel lines, you can't really go wrong with anything they make. (Manfrotto manufactures the Avenger line of studio photography products.) This does not mean that there aren't other manufacturers whose equipment isn't worthy of your consideration, but if you see a particular piece of equipment that appears to be the same as a piece of equipment from the four manufacturers I listed above, but it is selling for one third or half the price, chances are good it is not of the same quality! There are even commercially available booms that allow you to adjust the angle of the light's direction at the head end of the boom remotely, but they are expensive, heavy, and I don't think they are necessary for tabletop photography. However, I would use one or more of those if I did a lot of fashion photography (see photo at left).

I own one commercially available boom that I use constantly when I'm on location assignments (the Manfrotto 420NSB Convertible Boom Stand, in black, of course). But, the simple reality is that I can cobble together five different booms using grip equipment (see the lighting glossary on pages 116-121 for a definition) in my studio. I just attach a grip head to a light stand, and then I can clamp nearly anything into it, as long as it's the right shape and size. My improvised booms have boom arms with a wide range of diameters and lengths, and they are made from wood, metal, or even a commercially available legless light pole.

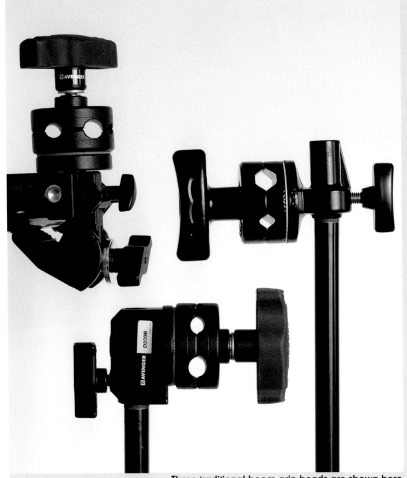

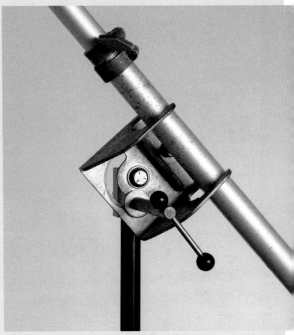

This is my Lowel Grip that has been with me since the late 70s. Unlike all four of my other grip heads, the Lowel Grip can handle boom arms up to a 2x4 piece of lumber!

Three traditional boom grip heads are shown here.

My Boom Grip Heads

On the left in the above photo is an Avenger grip head attached to a super clamp that allows me to clamp my boom grip to anything from a traditional light stand to a wooden floor-to-ceiling support. It also features a rubber-covered locking screw that is easy on your hands when you tighten it and can hold four different diameters of arms or rods.

In the middle is an Avenger boom grip head that fits any 5/8-inch light stand. It features two different threaded holes that you can thread the head's own locking screw into, depending on what type of stud is on the light stand you are mounting the grip to. This one has the same rubber-covered screw handles and variable holding capacity as the other Avenger head.

And finally, the third head is a Matthew's that doesn't feature the two threaded holes or the rubberized clamping handle like the two Avenger versions. But, it does have hexagon-shaped holes that can grab a round boom pole really well. Furthermore, it does a fine job of clamping a 3/4-inch square boom pole if you face one of the square pole's corners upward. While I like and constantly use all three of these grip heads, the Matthews grip seems to have a slightly nicer finish.

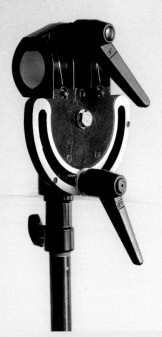

This is the tilting device that came with my Photek 84-inch diameter Sunbuster umbrella that has a 1.25-inch shaft. But, just because it came with my umbrella doesn't mean I can't substitute a like-sized boom arm for the umbrella shaft. I find it so useful I have two of them!

Safety: Booms help you defy gravity, but defying gravity is no easy feat, and there are a few safety precautions you should always take when setting up a boom to be hung over a set (and a subject!), just in case gravity decides it doesn't want to be defied. They are as follows:

• Always place one of the boom stand's three legs directly under the business end of boom arm (where the light is).

• Always hang a counterweight from the tail end of the boom arm. The longer the boom extension is, or the heavier the item is that's hung on it, the more important this is. On a related note, almost all my camera bag straps have lightweight aluminum carabineer clips attached to them that I use to hang my counterweights. The clip goes through a hole that's drilled in the tail end of the boom arm, and the counterweight is hung from the clip. These or similar clips are available in most hardware stores, and they are inexpensive.

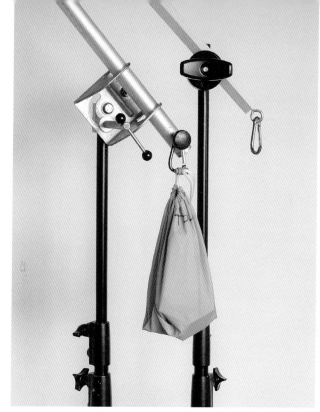

Almost anything heavy can be a counterweight. In fact, I often use ditty bags bought in camping goods stores and fill them with sweet potatoes, big cans of soup, or a pair of angle plates—anything heavy. I recommend using a rope tied in a square knot to attach counterweights and dousing your knot with a few drop of Krazy Glue®.

You might not have to look further than a flash generator pack with a loop of rope tied to its handle for a counter weight.

The rest of the rules, while important, can be treated slightly less seriously if you do so judiciously:

• Do not exceed the weight limits of the boom you are using. However, if the light stand and the boom arm it supports are not fully extended, the overlapping riser tubes inside the stand (and the boom arm) can add to its strength and weight capacity.

• Hang a second weight just above the boom stand's base to stabilize the boom and stand and keep it from toppling over. But even if you do that, you still need a counterweight hung from the boom's tail end. Even if you do follow this rule as an added insurance policy, position the boom's fulcrum (its balance point) so that the boom itself balances right over the light stand that is supporting it.

• If you are adapting lightweight flash units such as battery-powered, shoe-mounted Speedlights (e.g., Nikon SB-900, Canon 580EX) to use on your boom, those last two rules are slightly less important to

observe, because these flash units' light weight puts very little stress on the boom, grip, and boom stand. You can see a picture of just such a flash unit on a boom, bottom right.

Think Outside the Boom Box! Rightly so, almost every studio photographer thinks of using a boom when they want to float a light over a subject. But that's not the only time a boom can save the day! Many times, you'll find yourself shooting straight downward at relatively flat subjects arranged on a board lying on the floor. Some of you might ask, "Why wouldn't you just put the subjects directly on the floor instead of on a board lying on the floor?" See page 253 for an explanation.

Often, to add drama or impact to a relatively flat subject, you can position a secondary light very close to the floor but just above it so the light's beam just skims the subject's surface. Doing so can make your subject crackle with energy as if it's taking some of the skimming light's energy for its own. At right are two pairs of images where the image on the left is done with a single soft light source (a shoot-through umbrella in the first pair and a ceiling bounce in the second pair). But, in each pair of images, the image on the right has a second light just skimming the subject's surface. Which version do you find to be more interesting and have more "crackle"? Below the two pairs of images, you'll see an image of just how to arrange a light on a boom to accomplish this off-the-beaten-track solution.

A Note about Caring for Your Grip Heads: As a grip gets older, sometimes the threads in the locking screws start to gum up and become hard to use. The gunk on the threads is a mixture of rust, oxidation, and just plain old crud. Occasionally, I shoot a squirt of silicone spray lubricant on all my grips' threaded parts and run the screws in and out a time or two to spread the lubricant along the whole screw. Wherever you do this, understand that you don't need a lot of lubricant—a one-second spray is way too long, think of using a split-second "spritz" instead—and you don't have to do it very often (maybe once a year).

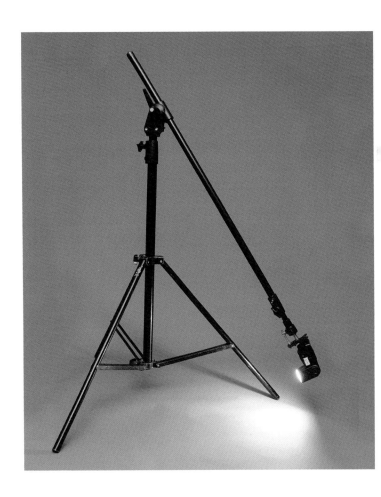

Super Clamps!

Another item helpful for controlling the position of a light (and hence its direction) is the ubiquitous super clamp! Originally introduced by Bogen Photo in the early seventies, and now available under other brand names from a host of other distributors, a Super Clamp is a heavy-duty, cast metal clamp that has a V-shaped opening that opens to about 2.25 inches (5.7 cm), can support up to a 33-pound (15 kg) load, and has a hole in it that is sized to receive a 5/8-inch stud. It also has a locking screw to secure the stud in its hole and a safety interlock release button, so the stud doesn't come out of it until you press the safety release button after you've loosened the locking screw.

Super clamps can do so many more things on a still life set than just position a light, and they have so many accessories available that can be fit into them, that they seem to multiply like rabbits in many studios. In fact, at last count, I have eight that were bought over a 30-year span. And, although they can be used to hold a light where you want it, which affects the light's direction; or a flag, which affects the light's size; or a diffuser, which can affect both the light's intensity and size; or a gel screen, which affects a light's color, they are also useful for holding backgrounds and building booms, plus a slew of other uses.

Mine were sold under five different brand names: Bogen, Matthews, Photek, Manfrotto, and Avenger, but I have a suspicion that Manfrotto manufactured all of them. And, as mentioned previously, because all super clamps take a 5/8-inch stud, there are a bunch of useful accessories you can buy for them. All in all, each super clamp is an important tool that every still life photographer can use for a variety of purposes!

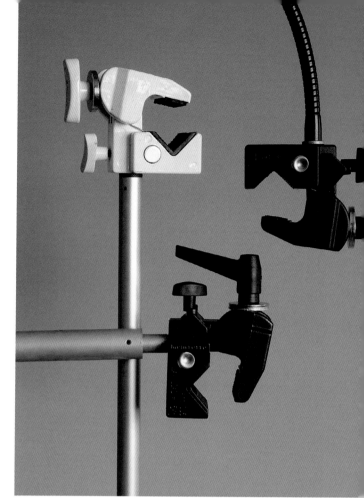

Here are three of my super clamps. With enough super clamps and their accessories, it is possible to position a light or a light modifier just about anywhere you want one, literally! The white one is a Matthews Super Clamp, and I bought a pair at the SetShop as soon as I saw them just because I liked the look of them! But, I have also seen chrome-plated ones that I've never bought because a chrome-plated piece of grip equipment is just the kind of thing that can inadvertently bounce a highlight onto your subject and drive you nuts trying to find the source of that particular reflection!

Hint: Steel studs are much stronger than brass ones, but sometimes a manufacturer chrome-plates a stud, and there's no way to tell if the underlining metal is brass or steel; you can find that out easily if you have a magnet handy because brass is not magnetic.

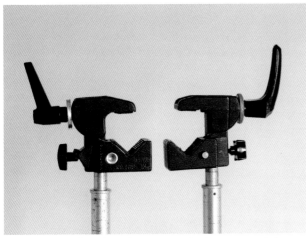

Over the years, there have been two major improvements to the super clamp design. One is a locking handle that can be tightened and then repositioned so it's out of the way; I find this improvement helpful. The second is a triangular, plastic, v-shaped piece that can be placed in the clamp's groove so it's easier to tighten the clamp against a flat tabletop. However, I've lived without this improvement for a long time and never found a problem tightening the clamp against a tabletop or door so, although it seems like a nice addition to the design, I doubt I'll use it often!

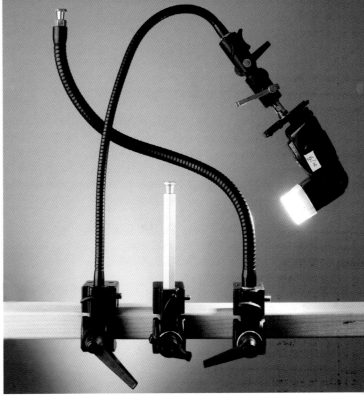

Here are three helpful accessories for super clamps. From left to right: a lightweight flexible arm, a 6-inch extension bar, and a heavy duty flexible arm. The flexible arms are very useful for attaching a light, fill card, or flag to the free end and then bending the arm to the position you want. The 6-inch extension, when used in conjunction with two super clamps and another light pole, lets you position that vertical pole very close to a light stand to hold a diffusion sheet, a gel, or a flag right where you want it.

Here is a selection of four studs that all fit into a super clamp. The ones on the far left and far right are made of steel and are much stronger than the two brass ones in the center. For the rare times I've mounted a tripod head and a camera on a super clamp, I've always used the steel stud on the left. Note that is has both 1/4-20 (US) and 3/8-16 (European) threads available on its opposite ends, which makes it even more adaptable, because some pro-grade tripod heads and medium format cameras use the European thread size.

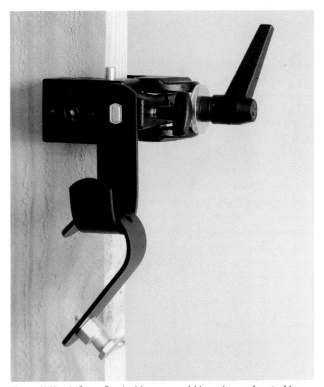

These U-Hook Cross Bar holders are sold in pairs, and a stud in each hook fits into a super clamp, which is then attached to a floor-to-ceiling pole. A round cross bar is passed through the core of a roll of seamless paper and rests on the two hooks. To give you a better view of the hooks and their function, I turned one upside down and hung it from the other hook.

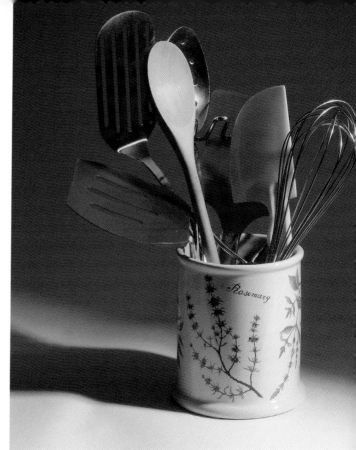

The Contrast of the Light Source

Remembering the diagrams in Chapter 5, I explained how hard light sources produce large shadows with crisp edges, and soft light sources produce small shadows with soft edges. While that information is certainly important, what we will be exploring now is the difference between the amount of light on the lit side of the subject and the amount of light in the shadows the main light produces. That difference is called contrast. Above are two very similar photographs of a container of cooking utensils. The only difference between the two is how deep the shadows are. The one on right, with the deep, dark shadows has very high contrast; and the one on the left, with very open shadows, has lower contrast.

What I'm really talking about here is the difference between the light intensity on the lit side of the subject compared to the light intensity on the shadow side of the subject. This difference is a useful tool that is worth considering when you light a subject. Deep, dark shadows can create drama, be used to obscure parts of a subject you don't want to show and, in certain instances, they can even become a design element in your image's composition. Conversely, shallow, open shadows are less dramatic, expose more of your subject, and impart a feeling of lightness.

Some may think this means that to get an image with less contrast, it is only a matter of the photographer using a second light source to fill in the shadows caused by the main light. But in reality, using a second light can open up another huge can of worms. Using two lights to illuminate any three-dimensional subject (other than something relatively flat, like a painting) can create two

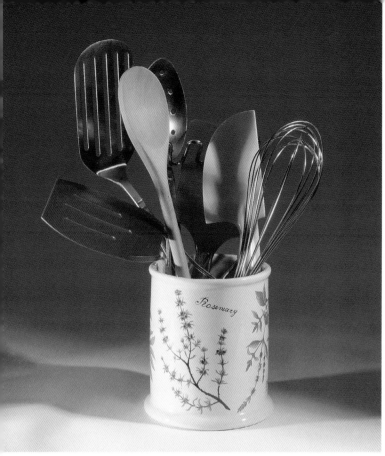

As you can see in the right-most photo, multiple shadows in an image can be very distracting. On the other hand, each of the two photographs on the opposite page has a shadow that is clean and "makes sense."

sets of shadows, and that can be both distracting and confusing to the viewer, as you can see in the photo above. That distraction and confusion can be so great as to overpower your subject and almost cause the viewer to not see the subject. Forgive the pun, but not seeing the subject means the viewer misses the point of your photograph.

There are those of you who read my book *Digital Portrait Photography: Art, Business, and Style* and might point to all the places in that book where I wrote about using both a main light and a fill light to illuminate a portrait subject and feel that what I just said is in direct contradiction to that. I can only say that there is a huge difference between lighting a person (or other animate being) and lighting

any kind of inanimate widget. While a person, pet, or animal has a face, eyes, and an expressive personality, an inanimate object has none of those attributes to help "carry" the image, so it is up to the photographer using their lighting to create a personality for the inanimate subject—a simple one with few if any distractions. Creating a personality in an inanimate subject through the use of lighting is not easy to accomplish, especially with the added confusion caused by a double set of shadows!

Because of all this, and generally speaking, although I prefer to light my still life subjects with only one primary light source, I must find a way to add light to the shadow side of my subjects that doesn't have a signature; one that doesn't leave a footprint in the sand.

Fill Cards

If we want to control the depth of the shadows in our photographs, how can we accomplish that with only a single light source? Although there might be others, one easy way to do this is to reflect a portion of the single light source back onto the subject by bouncing it off a carefully placed surface. Because the light rays from the single source usually have to pass the subject, proceed to the carefully placed bouncing surface, and then travel back to reach the subject, the distance they have to travel is always longer that the original source's distance from the subject. This increased distance, combined with the less than 100% reflectivity of the bouncing surface, makes this secondary fill lighting less powerful than the main light source, which goes a long way towards insuring it won't be strong enough to create a second set of shadows! See the illustration below of a typical set (including a few light rays drawn in red) viewed from above to see a visual representation of what I just described. The reflective surface that the single source bounces off of is called a fill card, and it is one of the most important tools in the still life photographer's arsenal.

Safety First

If you think you can lay a 500-watt (or even less!) quartz halogen lamp within 3 inches (7.6 cm) of anything cardboard and not have a potential fire hazard—well, you are crazy mon! Be Careful! All right, I've said this five times already!

Hot lights don't mix well with gelatin or polycarbonate colored filters, diffusion materials, paper, or paper mat boards. A word to the wise: Keep a fire extinguisher handy, and have a plan ready to go about what you are going to do if something catches fire on your set. In fact, you should have this plan figured out before you turn on your first studio light! Expect the unexpected so that you and those around you—possibly even loved ones (or not) —will never end up crispy critters!

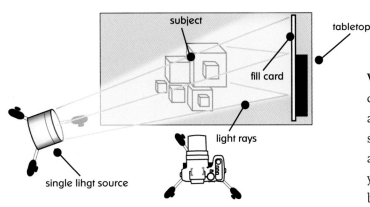

Note that, while fill cards are usually white, no reflective surface (not even a mirror) reflects 100% of the light that hits it. By changing the fill card's size, its distance from the subject, and even its reflectivity (by using a grey fill card instead of a white one, for example) you can control just how much light the fill card reflects back toward the subject. That, in turn, affects the relative intensity of the original single light source when it is compared to the fill card light source.

Why Fill Cards? It has been said (and I have written) countless times that a photographer's best friend is a guy named Phil...well actually "fill." Especially in still life photography, the more you experiment with and work at lighting inanimate subjects, the more you begin to realize that there is a major difference between how the camera sees light and shadow compared to how our human eyes see it. In a nutshell, this is because the camera lens has a single fixed aperture when taking a picture, while the human eye scans a scene and has a constantly variable aperture. This being the case, studio photographers usually must find a way to add light to the shadow side of their

subjects so that the camera can record things either as the human eye's variable aperture sees them or how the photographer wants them to be seen. Doing this means filling in the shadows caused by your main light, hence this is most often done with an item aptly named a fill card, so let's talk about those.

Because of the disparity between how the camera lens' aperture works and how the iris in the human eye works, this might be one of the most important things I'll be explaining in this book. Furthermore, if you consider the fact that when you photograph reflective items (e.g., silverware, chrome, water, and glass) you aren't really photographing the item, but what's being reflected in the item instead (and it's usually a fill card!) so using fill cards creatively surely goes up a few notches on the importance scale. The truth is, many transparent and/or reflective subjects would be dead and lifeless, or not even visible at all, if something weren't reflecting off their surface!

In almost every instance where the main light is located away from the camera's lens axis, it creates shadows on the subject. These shadows help create a three-dimensional look to your subject—making it look round, have depth, and look real instead of looking like a cardboard cutout. It's not only about the presence of shadows, though: You want all those good things I just mentioned that shadows create, plus you want to control how deep those shadows are.

There is no rule that states shadows must be inky black, especially when an open shadow will accomplish the same thing. That is where fill cards can really help you.

Using Fill Cards: Pulling back the curtain for a moment, look at the left-hand picture below, and compare it to the final picture on the right. While two lights lit my subjects for this photograph, the one that you can see on the left is a shoot-through umbrella, but the second (out of the frame, above the subjects) is a direct flash with a 20-degree grid on it, suspended from a boom directly above the C-clamp "tree." This top light is the main light on the subject, and it creates a shadow beneath each clamp. But, that secondary light you can see is creating its own different set of shadows on the subject, and two sets of shadows is a recipe for a confused viewer, because double shadows look unnatural. So, to almost completely eliminate the second set of shadows created by the umbrella light, I added three fill cards that, when placed and clipped together, formed a white wall beneath and to the right of the C-clamps.

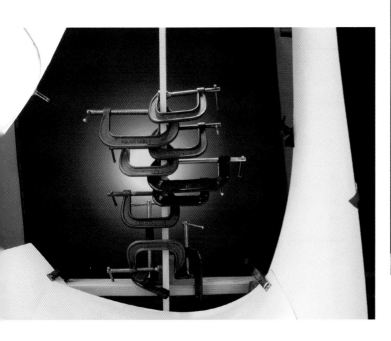

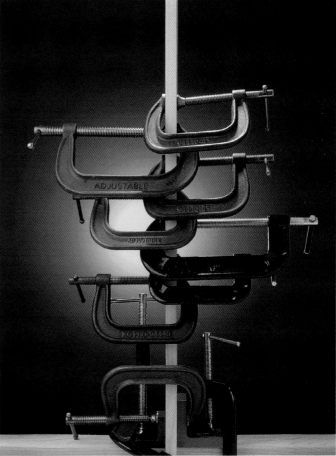

On a related note, and at least when it comes to photography, all rules are meant to be broken! Therefore, although I do many of my product still life images with a single light source and fill cards, and even though I am recommending you start off this way, I use two or more light sources for many of my images. However, whenever I do, I am extremely aware of the shadows I'm creating as I work out my lighting scheme.

Smaller Fill Cards for Smaller Subjects: While fill cards (sometimes called show cards or mat boards) are usually about 30x40 inches (76 x 102 cm) when purchased, that big a size is often cumbersome to use. While they are necessary for large subjects, small tabletop subjects might be lit with much smaller fill cards.

While it's easy to use a spring clip to hold a full-sized fill card using a light stand or two, how do you hold a smaller fill card in position when you want to place it on the tabletop (but outside the photograph's frame) very close to a small subject? For that, you need some small weights to lean the little fill cards against and blobs of Fun-Tak® to hold them in position.

About now, you probably want to know what kind of weights I'm suggesting. Well, the kinds of weights you can use are only limited by your imagination, but here are a few ideas: One friend of mine uses blocks of scrap marble he found in a monument shop. Each is about 5x5x2 inches (13x13x5 cm) and weighs a couple of pounds. He presses a blob of Fun-Tak® against the edge of the block his fill card is resting against and presses the fill card against the block. I've seen other photographers use bricks but they're always dropping that red grit on the set. A long time ago, I was perusing the items at a garage sale, and the seller (a retired machinist) had some small cast iron angle plates for sale at very reasonable (no, dirt cheap) prices. I bought four 2x2-inch (5x5 cm) and two 3x3-inch (7.5x7.5 cm) ones for ten bucks, and that started my angle plate collection! (See photo, top right.) But, angle irons are normally expensive, so I only buy them if I can find them

An angle plate has an exact right angle built into it, plus you can spring clip a fill card to its vertical face.

Steel blocks are less expensive and not exactly square like angle plates, but they are a good substitute when you need a small, dense weight to hold something in position.

at a garage sale or junk shop. Still, over the years, my collection has become pretty large, and for a long time, I thought I had more than enough of them. Then, a huge assignment shooting hundreds of little widgets walked through my studio door! I hired on two other photographers, we had three sets running for a week, and I found I didn't have enough angle plates to go around.

One of the other shooters brought over a box of steel blocks from his studio, and after one look, I knew I had to have a set of those blocks for my own! So, I turned to the Internet, searching "steel, small amounts." I ended up buying a whole mess of 2x2 and 1x1-inch (5x5 and 2.5x2.5 cm) stainless steel bar stock.

If you find the need to use weights on the subject side of the fill card, there is one problem you may run into. Sometimes, especially with highly reflective surfaces, using a small steel block on the subject side will ruin the reflection of that fill card in the subject. When faced with that problem, I often use a strip of gaffer tape (the same color as my fill card) like a hinge running along the fill card / tabletop joint in place of the subject-side weight. I can then change the angle of this fill card by moving the weight behind in and out.

Fill Cards Work with Any Light Source: While some of you might think that fill cards are only used in a windowless, darkened studio, nothing could be further from the truth. They can even be helpful when you are using a natural light source such as window light! I shot the image of the three antique teacups below to illustrate using armature wire to create a fixture to float one teacup above the others (see page 209) but, while I was at it, I did a pullback shot of the set to prove that fill cards can work with naturally occurring window light just as easily as they can with studio lights!

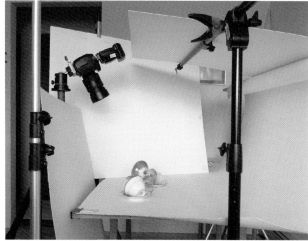

Note that, in this instance, I used fill cards to one side of the subjects, above the subjects, and beneath my camera lens, along with a white seamless under and behind my subjects to create an almost fully enclosed five-sided box leaving only the side with the naturally occurring window light open. More importantly, because I wanted a light, airy, high-key effect to compliment the delicacy of the teacups, I added a shoe-mounted flash to my camera but aimed it at the wall of fill cards to the left of my subjects.

While I always use white tape to make my hinges for fill cards, in this instance, I used black tape so you could see it better.

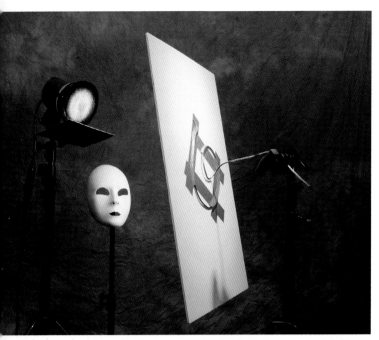

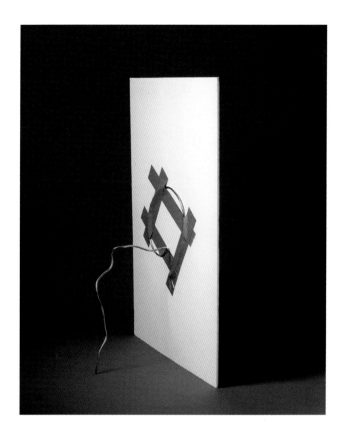

The mime mask in this photo is lit by the light on the far left. However, the light's beam does not hit the mime mask directly (note the barn door at the bottom of the light), but instead bounces off the surface of the fill card to the right of the mask. That fill card is held in position by clamping the armature wire handle taped to the back of it in a grip on a light stand. For the record, in this instance, I used 3/16-inch armature wire, but you could use thicker (1/4 inch) or thinner (1/8 inch) wire, depending upon just how big and heavy the fill card is.

I found another use for armature wire that is also worth knowing about. Armature wire's unique ability to hold any shape it's bent into while still being malleable enough to be bent by hand makes it a perfect tool to hold a fill card in the exact place you want it. I learned this technique while visiting the studio of still life photographer and friend, Ned Matura. Ned takes a long piece of armature wire (about 3 – 4 feet / 0.9 – 1.2 m) and bends one end of it into a large loop while leaving the free end straight. He tapes the loop to the back of a foam core fill card with a few strips of gaffer tape and positions the other end of the wire so it extends off the card's surface perpendicular to it. The free end of the wire becomes what I can only describe as a handle sticking out of the fill card's rear surface. In use, the free end of the wire is held in a grip, and you bend the wire to position the fill card exactly where you want it. Or, in another application using this technique, the "handle" can be bent like a foot to let the fill card stand on a tabletop surface. See the photos above.

The BIG Frontal Fill Card! One of today's most popular lighting styles is soft back lighting using a softbox or a light behind a diffusion frame. Making the front edge (the one nearer to the camera) of the softbox or diffusion frame higher than the rear edge creates a natural-looking fade to the background that is very appealing. On the negative side of the ledger, the only problem with doing this is that it leaves the front of your subject (and its label!) in shadow and that is not the kind of thing that will endear you to your client who is trying to sell his product.

The solution to this problem is relatively easy. You hang a full size fill card (approximately 30x40 inches / 76.2 x 101.6 cm) in front of camera either on a boom arm or a crossbar to bounce some of the light coming from the softbox back into the subject's front. But wait, if you do that, the large frontal fill card blocks the lens from seeing the subject at all! Oops, I forgot to mention that you frame the picture and set your camera's height before you hang the card, and after you hang the card, you mark and cut a circular or rectangular hole in it that is a bit larger than the front of the lens you are using.

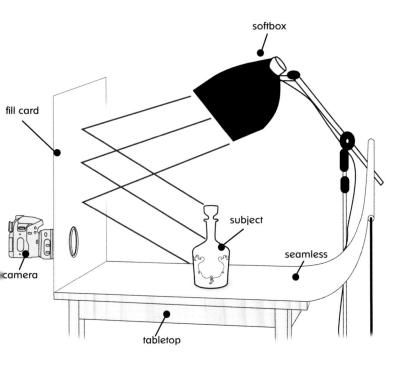

softbox

fill card

camera

subject

seamless

tabletop

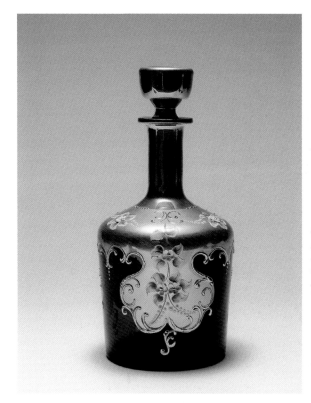

It pays to use a zoom lens for this type of shot so you can reframe the subject without taking apart the whole set! I mention this because when I do it, and if I'm faced with a round subject, I have been know to clip (or tape) two additional large fill cards to both vertical edges of the central card with the hole in it. That is a lot to disassemble just to move the camera! Because there's really nothing to see with up to three large fill cards blocking the view of the set, I've included an illustration of what a side view looks like, along with two photos of a subject—one shot with and one without the big frontal fill cards.

Finally, if the seamless I'm using is close to the same color as my big frontal fill card, I often run the front edge of the seamless a little up the frontal fill card and attach it there with two spring clips. Either that, or I flex the bottom edge of the fill card up to the bottom of the tabletop and clip it there. Or, I can sometimes accomplish the same thing just by making sure the frontal fill card's bottom extends below the surface of the tabletop. Doing any of these three things eliminates any gap between the tabletop and the frontal fill card that might translate to a dark gap reflected on the front of my subject. See the illustration above and the photos at right to better understand what I'm talking about.

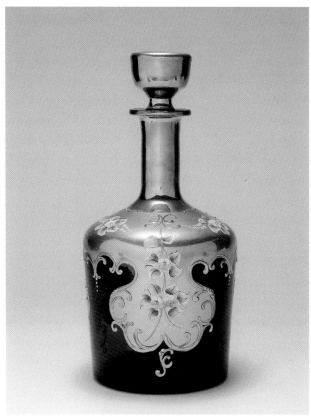

But Wait, There's More! As Marissa Tomei (as Mona Lisa Vito in *My Cousin Vinny*) assures the court as she sat on the witness stand examining photographs, there really is more! While this little section doesn't really pertain to the direction of the light, it pertains to the direction of the subject and fill cards in relationship to each other instead. I've decided to fit it in here because it is so important. When you shoot reflective items, slight turns or tilts of the subject can make huge differences in how a reflective subject appears to the camera! At right are two pictures of the same pair of pliers. On the left is an image of the pliers with correctly placed fill cards and the one on the bottom has those fill cards removed. Pretty dramatic difference, huh? More importantly, the metal parts of the actual pliers have a bright, shiny chrome finish, so even if you prefer the one on the right (for some other reason), I guarantee you the pliers manufacturer would not.

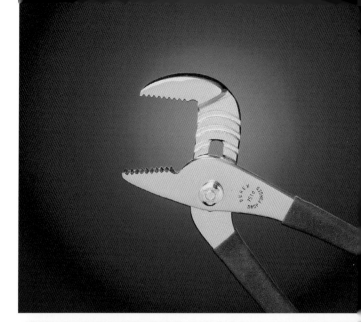

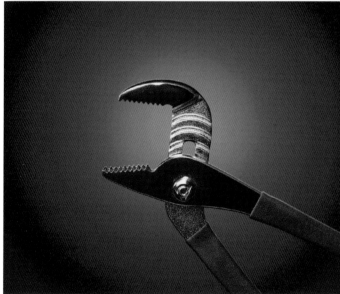

But wait, there's more! Before leaving the very important topic of using fill cards for still life photography, here are a few hints that will help you get them to work for you:

If your camera's lens is at tabletop level (as it is here) you won't be able to see what the reflections look like to the camera's lens if you try to view them while standing upright. To see if the effect you're trying to accomplish is actually happening, you have to get your eye down so it's right next to the camera lens! Sometimes, if there's room, I actually stick the back of my head right up against my lens hood.

For those of you who shoot pool (or billiards), imagine you are trying to do a bank shot off one of the table's rails, except instead of a ball hitting the rail, it's a light ray hitting the fill card. In technical terms, this is called, "the angle of incidence is equal to the angle of reflection." It means that at whatever angle a light ray hits a reflecting surface, it will bounce off it at the same, but opposite, degree of angle. See the illustration at right to understand what I'm explaining; in it, I trace three different light rays hitting a reflective surface at three different angles.

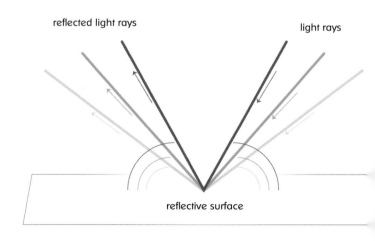

reflected light rays

light rays

reflective surface

Not only can you slightly change the position of the light source, fill card, or camera, but you can also rotate or tilt the subject ever so slightly to get the effect you want. Sometimes tweaking the position of the subject just a little bit will be the fastest (and easiest) way to get the result you're after.

The closer a fill card (or light source) is to the subject, the bigger its reflection will be. If you place a white fill card close to the subject so that it gives you the perfect size reflection you want (and need), but the reflection is too strong and bright, you can't just back the fill card off and expect its reflection to remain the same size! But, you can use a light or dark grey card instead of a white one (at the same distance from the subject) to get a less intense reflection that is still the large-sized reflection you are looking for!

Sometimes, such as when a product is wrapped in plastic, you don't want any reflections to hinder the viewer's ability to see the product. In that case, do the opposite of what you would do to make a reflective surface pop: Make sure nothing is reflected in the subject's plastic wrapper that will obscure the view of the subject. But, when faced with that type of product, I often leave a touch of a reflection in an inconspicuous place on the plastic so the viewer understands that the product comes wrapped in plastic.

When making images of an inanimate object, the subject isn't going anywhere and neither is your camera if it is mounted on a tripod. That being the reality, I suggest slowing down and studying the reflections in your subject. Try to get into the habit of looking critically at each surface of the subject one at a time; doing so will improve your results dramatically.

When I first started using fill cards, I had no idea where to place them. It was funny (and pathetic) to watch me trying to figure it out as I would place a fill card somewhere, then look through my camera's ground glass (in those days I was using a view camera), then I'd curse, and then I'd put the fill card somewhere else, only to repeat the previous steps again! The same thing will probably happen to you, but don't get discouraged. After doing it for a while, you actually get a feel for the process, and you'll be able to come up with an approximate position for the fill card as if by magic. That's cool because, after seeing what a correctly placed fill card can do, it is (magic)!

And, Ms. Vito makes a lovely, lovely witness! Don't wait, there's no more, let's move on!

Making a Scoop

In practice, when using a fill card, a photographer usually positions it on the opposite side of the set from the main light. This is even true in the case of the big frontal fill card described before, because in addition to making a reflective subject come alive, it is almost always used in conjunction with a soft backlight, even if the subject isn't reflective, in order to light the front of the subject. But when I thought about it, I realized that I could also position a light so that it bounced off a big fill card but never hit the subject directly. I came up with the idea of using a broad source hair light instead of a point source hair light and didn't know what to call it. I decided to call it a scoop.

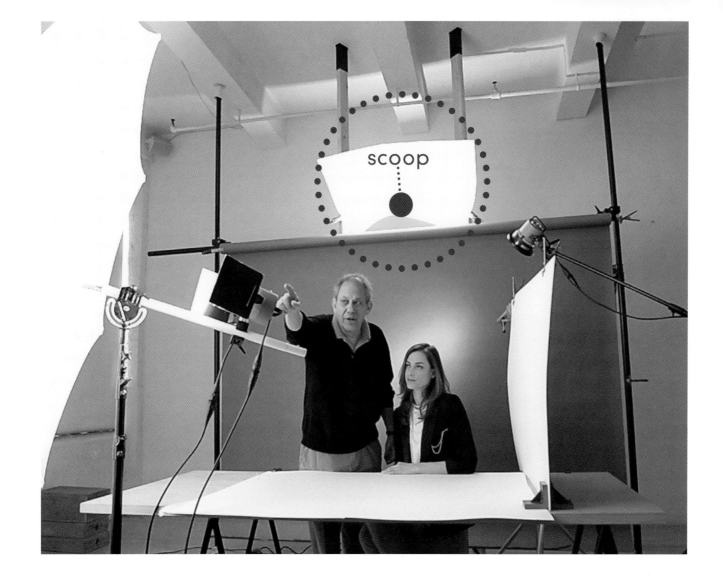

Let's back up a second to help you understand what I used my scoop to replace. Many photographers use a light with a grid on it for a hair light in portraits and still life photographs (even though most still life subjects don't have any hair). No matter its name, using a light with a grid or a snoot on it for a hair light is not always a perfect solution for this particular light, because if you're photographing a group of products or a group of people, a grid or a snoot might not provide a wide enough beam to illuminate all your subjects evenly. (See the glossary in Ch5 for more information on hair lights.)

My scoop has become a standard part of my bag of tricks, and here's how I made it. I put up two 2x4 floor-to-ceiling beams (see pages 107-109) but instead of making the beams square to the background, I rotated each one outward to an approximate 45° angle. I then flexed a full-sized fill card between the

beams, positioned up near the ceiling, and held the card in that position with four spring clips (see top photo at right). Next, I put a flash head under the rear, curved edge of the scoop and aimed the light up into the flexed fill card. Finally, I put a seamless paper background in front of the light shining up into the scoop (see bottom photo at right). The whole rig was simple to erect and the resulting lighting was terrific—maybe you might want to try this idea yourself!

The Same, Only Different: A while after building my first scoop, which was, in effect, a fill card used as a primary light source, I was faced with photographing a ton of glassware. Usually, because photographing reflective items such as glassware is more an exercise in photographing reflections than in photographing the items themselves, I would position my big square bank light to one side of the subject, put a big fill card opposite the bank

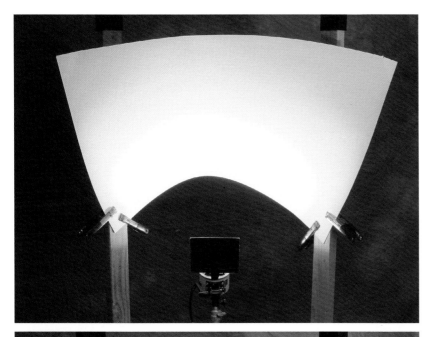

Some hints to get the scoop to work the way you want it to: 1. You'll need a small flag on the front of the light behind the seamless so its light doesn't shine through the seamless paper. 2. The flexed fill card should be almost vertical because if it is tilted forward, it will project light onto the top of your seamless.

and start to shoot. But on this particular day, my big bank light was tied up on another set, so I experimented with using other light sources. I tried using one of the diffuser screens I described making in Chapter 4, I tried using a collapsible disc diffusion screen, a regular umbrella, and even a shoot-through umbrella but, for various reasons, none of these alternatives gave me a reflection in the glassware that I was happy with. Then I remembered my scoop! So I set up two 30x40-inch (76.2 x 101.6 cm) fill cards, one on either side of my subject, added a light with a barn door on the bottom of it (so no direct light hit my subject) behind and peaking over the top of one fill card, with its beam hitting the other one. That was it! Perfect!

I added a grid spot with a blue colored gel on it coming through a Tough Lux background to create some action in the background (make it come alive), and I was home free. Although those images were shot on film that I never bothered to scan and digitize, I recreated a similar image (plus one using a shoot-through umbrella so you can see the differences in the reflections they create), along with pullback shots of both so you can see how I did it. This proves there's more than one way to get that big rectangular reflection that a bank light provides.

Fill Card vs. Bounce Card: What's the Difference?

To help you better understand the concept I am explaining here, let me point out that although I am using what would typically be called a fill card to create both of these effects, I needed a new name to describe the lowly fill card in this instance: I decided to call it a bounce card instead of a fill card.

Whenever you position a light so it doesn't hit the subject but hits a fill card instead, that fill card is no longer a fill card (which typically fills in the shadows), but has become a primary light source. One easy way to quantify the difference between a fill card and a bounce card is this: A fill card is used to lighten the shadows caused by a primary light source (a primary light source can be defined as a light source that creates shadows) but, once you aim a light that does not hit your subject at a fill card, that fill card becomes bright enough to create shadows on the subject. When a fill card becomes bright enough to create shadows on your subject, it is no longer a fill card but a bounce card!

It doesn't matter if you are photographing a chrome-plated pair of pliers or a blown glass goblet—when you are shooting highly reflective items, you aren't shooting the item. You are shooting the reflections in it!

The four images presented here show the reflections created by a shoot-through umbrella versus the reflections created by pristine white fill cards. The truth is, you might like some of the reflections created by the shoot-through umbrella, but I feel those same reflections become more important than the item itself and actually become the star of the show. On the other hand, I think the reflections created using a fill card result in a more elegant-looking subject, where the subject is the most important part of the image. Your choice, you decide—or better still, ask your client which one they like better! The truth is, in this case, my book publisher liked the elegant reflection in the blue brandy snifter enough to make it the cover of this book!

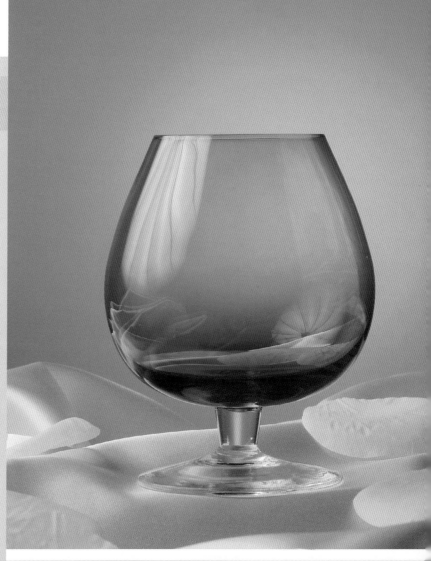

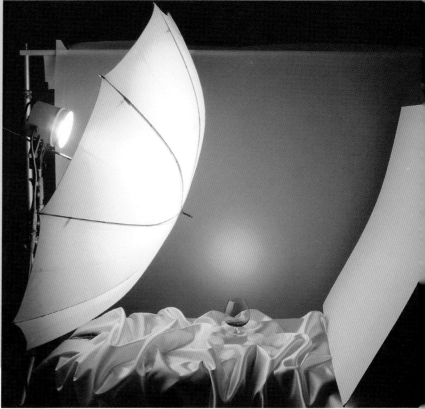

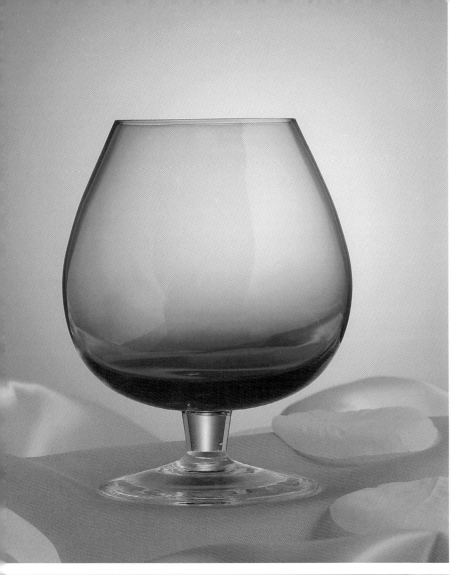

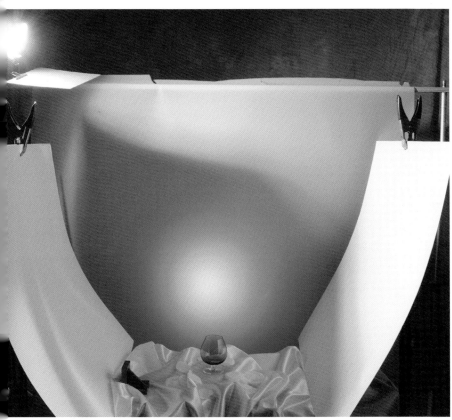

A Logical Conclusion: The Tent

Considering that I have demonstrated almost completely surrounding a reflective subject with white fill cards, if we followed that technique to its logical conclusion, let me pose a few "what if" questions to you. What if we could totally surround a subject with white surfaces? White surfaces on the top, bottom, and all four sides of the subject, with no gaps whatsoever between the surfaces on all six sides of the subject. Hmm...opaque sides and no gaps? Obviously, if we used opaque materials to surround the subject, there would be no way to get any light onto the subject since it is totally surrounded. Our subject would be sitting inside a totally dark box! OK, what if we exchanged the six opaque sides for six (or at least five) translucent ones? If we did that, we could place a light outside the box, and the translucent sides opposite the lit side would reflect light back into the shadows. That might really work out well!

It works so well, in fact, that there are already many products on the market that do just that! These items are called light tents (or Cubes, or Cocoons, to list but two of their trademarked names), and they are a boon to photographers who shoot products for websites and other drop-and-shoot applications. Collapsible tents that store easily are available in dozens of different sizes from 2-foot square cubes up to 6-foot almost square cubes for products ranging in size from a pendant to a pachyderm (a slight exaggeration). There are even complete sets that include lights to illuminate the subject inside the tent. Beautiful lighting that can be produced with minimum effort—why wouldn't every photographer have one, two, or even three different-sized ones? That's a good question. For an answer, read on!

Although commercially available tents are an easy solution for drop-and-shoot assignments, I am not into using them frequently for a few reasons:

They tend to make me complacent. It's all too easy to put something into the tent and use the same lighting over and over again. While this may be fine if I'm photographing a personal item to post on a buy/sell website, or even to shoot the product images for a client's website catalog, but it also results in very similar images that don't elevate or show the uniqueness of any of the items photographed. The reason I do product photography is because I get fulfillment from shooting unique and exciting images. There is no way I would want to lock myself into shooting every product I photograph in the same way. Aside from getting bored, lighting every photograph in a similar way is just no longer a profitable business model in the digital era.

While tents are really good at exploiting soft lighting for illuminating products, they aren't so good at exploiting hard lighting. When I started doing product photography years ago, a big bank light (softbox) and fill cards was all the rage as a lighting style. Today, to increase drama and impact, I regularly mix soft and hard light sources and often throw colored lights into the mix to further my goal of using lighting to trigger emotions in my

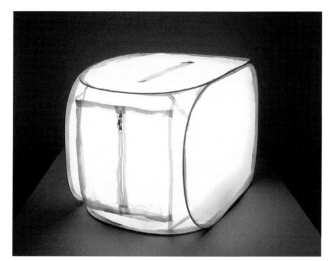

A photograph of a light tent is actually pretty boring; basically, it's a white, featureless box with an opening through which to place the object you're shooting inside, plus some form of adjustable opening through which to stick your lens (in this case, zippers on the top and front sides). In this image, I put my small Photek tent on a floating, light gray plane in front of a darker grey plane, and then I put a bare-bulb electronic flash unit into the tent. This is not the way tents are traditionally used (the lights are most often outside the tent and the subject is inside) but, because the tent was the subject of the photograph, I reversed things a bit!

Here is what a subject can look like if you break some of the tenting rules. My hobby is model-building, and the subject of this photograph is one of my locomotives. But, to shake things up visually, I put a small patch of blue painted sky on the rear wall of the tent and a board with a piece of track and some sifted dirt glued to it on the bottom of the tent to create a more realistic background for my model locomotive. Then, to simulate morning sunshine, I clipped a piece of colored gel (a Lee 204, 5600K to 3200K) to one side of the tent (the one the front of the locomotive was facing) and shot an electronic flash through that gelled side of the tent. The resulting early-morning sunlight effect skimmed the surface of my subject, which helped to accentuate the locomotive's surface details, instead of rendering it as a black hole.

viewer's mind. Speaking frankly (Hello Frank!), I feel that it is difficult to create the lighting I'm currently using with commercially available tents and the lighting they can best produce is both a one-note song and a little out-of-date compared to what I'm doing now.

If a client were to pay you $20 per image to shoot 50 products for a website and you shoot all the client's images using a tent, that client could afford to buy a tent with a lighting system and a small but serviceable digital camera that would allow them to shoot an unlimited amount of products for their website for less than you would charge for the first 50!

Two Special Spring Clips

Although I have dozens of spring clips in many different sizes and designs, there are two spring clips specifically designed for photography that, even though expensive when compared to garden variety spring clips, are well worth knowing about. I'm going to spotlight both now.

Foba is a Swiss manufacturer with a 70-year history, whose line of professional photographic equipment shares the pinnacle of design and quality with only a few other companies. All this quality and great design does not come cheaply—imagine a machinist building a hundred-pound camera stand with the precision of a Swiss wristwatch and you'll get the idea! They use a unique and very weird five-letter naming system for their products, in which each five-letter name seems to have no relationship to what the product is!

Their COKLO spring clips are unique—as well they should be at almost $30 for a single one. At the business end of a COKLO, there are two pincers: One is half round and the other is an extended flat plate. With this design, when you need to clip a fill card to a round pole, the round part of the clip grips the pole and the flat part of the clip grips the card. It really works very well! Ordinarily, even though I mix and match brands of grip equipment, I wouldn't recommend this item because of its price and the fact that you'd need a few of them just to hold all the fill cards you might set up on a complicated set. But, if you have deep pockets, or hit the lottery, well....

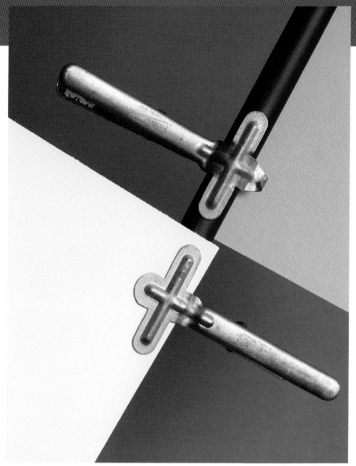

The best spring clips ever? In my opinion—probably! My Foba COKLO clips are so old their color is discontinued. In this image of two Foba clips doing their thing, note that the flat pincer end goes on the white fill card side and the rounded pincer end goes around the boom pole's side holding the grey fill card in position. Pricey, but great, and if you have the budget, worth having a few of!

There are over five dozen spring clips in this photograph, but only one is doing its real job! Check out the Foba clip in the slot between the fill cards in the lower left corner of the image.

The second specialty spring clip I find worth having multiples of is the Manfrotto Multiclip. The prefix "multi" comes from the fact that it is actually two spring clips held together by a squared-off U-shaped wire. I have a bunch of them, and I most often use them to hold small mat board flags clipped to the edge of a light's reflector. You can see pictures of them used in this capacity sprinkled throughout this book. However, using two of them on opposite edges of a reflector lets me add a colored gel to a light while leaving enough air space between the gel and the light so it isn't a fire hazard. Finally, I can cobble together a mini softbox in a jiffy using two of them placed on opposite sides of a reflector to hold two mat board barn doors with a piece of Tough Lux clothespinned between them. (See page 131.) They last forever, they are relatively inexpensive, and I find them very useful—you probably will too.

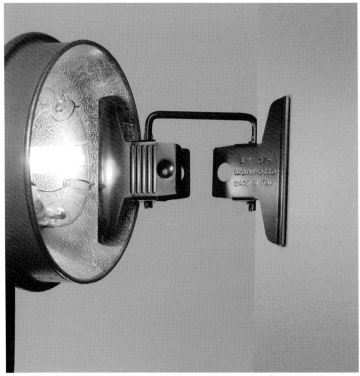

I love Manfrotto Multiclips! I personally own about eight of them.

The Size of the Light Source

This topic was covered in detail in the first book in this series, *Digital Portrait Photography: Art, Business, and Style,* so if you want more information about it than I offer here, let me direct you to that title. You should also know that I strongly believe everything in photography is interconnected, and some of the same techniques that are used to make great portraits are used to make great still life photographs too. In fact, the reality is that the success of a still life photograph, without the personality of a live subject to help carry the image, is even more dependent on lighting. That said, let me touch on the pertinent points about the size of a light source.

As I discussed in Chapter 5, large light sources are often called soft or broad light sources, and small sources are often referred to as hard or point sources. But, does soft and hard mean that one light is made of marshmallow and the other is made of steel? No, not really. But if photographers aren't talking about the lights themselves when they refer to "soft" and

"hard" lights, just what are they talking about? The answer lies in the shadows the two types of light create, specifically in the size and edge quality of the umbra and penumbra (see pages 125-126). Soft lights create smallish, open, soft-edged shadows, while hard lights create large, inky black, crisp-edged shadows.

If you've done even a small amount of studio photography in the past, you're probably familiar with the difference between soft and hard lights. But even if you're new to the concept, you probably already have a good idea of what makes for nice lighting in an image just from your everyday experiences of looking at light. What? You don't look at light? Well, you should start doing that ASAP! For those that do look, you may have noticed, that many subject looks best when lit by a soft, directional light source (a broad light) that minimizes the harsh shadows often associated with a hard or point light source. Let's look at both types of light sources for a moment and examine the qualities of each one.

Soft Light

Before photography was invented, painters had their studios fitted with big, north-facing windows because they wanted their subjects lit by a large, but not harsh, light source.

Flash forward to today, and you'll see every photographic catalog has a lighting section filled with reflectors, diffusers, big umbrellas, and bank lights (aka softboxes), all of which can be classified as light modifiers and, for the most part, represent large light sources. In fact, these light sources are so common today that almost everyone's mental image of a fashion photographer includes lights flashing into big umbrellas; just look at any TV show or movie that features a fashion photographer to prove my point. Big lights are so ingrained in our society's concept of photography that most people can't imagine a studio photographer without them.

But, why are they so ubiquitous now, and why did artists of old paint by the light of a large, north-facing window? The answer to both questions is that a big light source creates beautiful, diffused light that flatters and sculpts the subject, bathing it in a soft light. And, once you understand why this soft light works so well for taking pictures, it can free you to use other commonly available soft light sources to capture that beautiful light for your images.

The Anatomy of Soft Light: Experienced photographers will tell you that broad light sources wrap around the subject, or that they put out a soft light. But because light rays only travel in straight lines, they can't really wrap around anything. And though soft lights produce neither cotton balls nor marshmallows, there is some truth to both of the above claims.

What these photographers are trying to put into words is how a big light source differs from a small (or point) light source, and that difference is best exemplified in the shadows they create. Look at figures 1 and 2 that trace light rays coming from the far edges of both a broad source (a 55-inch / 140 cm umbrella, figure 1) and a point source (a typical 2x3-inch / 5.1x7.6 cm flash, figure 2) with both illuminating a 10-inch (25.4 cm) human head

from the side. Both light sources are 5 feet (1.5 m) from the subject (but in the umbrella figure, the distance is measured from the center of the umbrella's surface and not from the actual light source, because the umbrella is now considered the light source), and the two figures are drawn to the same scale. In both instances, I filled in the shadows created with different colored ink. Notice that the size of the broad source lets its edge rays (which are always straight) reach farther around the subject, so in a way, the broad source does wrap around the subject, but it's not because the light rays bend or curve. Rather, it is because the light source is large enough to cover the subject and then some. And because soft lights are larger, they cast smaller, less harsh shadows on your subject.

What it All Really Means: To illustrate what this means in a real-world situation, I cut the eraser off a pencil and glued it to a piece of mat board. I then took a picture of the eraser with the 55-inch (140 cm) umbrella light and the 5-inch (12.5 cm) diameter point-source light using the same dimensions shown in the illustrations. Bearing with me for a moment, let's make believe the eraser is an imperfection on your subject's surface. Accepting the fact that this would be a very big imperfection in real life, notice how the broad-source light minimizes it (top photo), and the point-source light accentuates it (bottom photo). Note that it's actually the shadow each light source creates that calls more or less attention to the imperfection.

Natural Broad Sources: If you don't yet work with photographic lights or flash units and prefer naturally occurring light, learning the concepts covered in this section will still improve your photos, because it will help you to understand the general principles of light. However, keep in mind that, while you can use naturally occurring, available light to make nice images, understanding and using photo-specific lighting equipment allows you to make beautiful images when quality natural light isn't available. That said, let's talk about the most obvious natural light sources, the sun and sky. Because we know that a small flash is a point source and a large umbrella is a broad source, we can apply

A broad source shadow on the left. Note the penumbra.

A point source shadow on the left.

these traits to their larger, natural counterparts. Therefore, the sun can be considered a point source, while a big patch of open sky without the sun in it is a broad source. Since broad sources create the most pleasing type of light, they're generally what we're looking for, and they're often referred to as open shade. Open shade can be found in just about any outdoor area that is shaded from the direct rays of the sun and is still lit by a large section of the sky.

Imagine shooting a subject on the west side of a building at about 10 A.M., and you're getting an idea of how open shade looks. And, while the sun offers better, more natural color than the bluish light cast from open shade, simply changing your camera's white balance—to its open shade preset, a manual setting of 5900K or 6300K, or a custom setting—

you can correct for those open shade blues in a jiffy. By placing your subject in open shade, you'll end up with a quality of light that will minimize your subject's imperfections, and the resulting photograph will be one your client will probably prefer over one lit by direct sunlight.

Another example of a naturally occurring broad source is the sky on a cloudy day when the sun casts no distinct shadows. Like open shade, cloudy days are also bluish in color, and the white balance adjustment I just mentioned can also correct this problem. In fact, if you adjust your camera's white balance and are careful not to include the sky in your background (because it's often bland), this type of light is amongst the most flattering.

A point worth considering is that, while open shade or an overcast sky offers a beautiful quality of light, it is missing another important feature—directionality. While the non-directional light found on cloudy days is pretty, light from a single direction is an important tool in a photographer's bag of tricks. Single-direction soft light creates shadows, and these shadows can make your subject (be it a still life or portrait subject) look more three dimensional instead of like a cardboard cutout. So, while I'm interested in soft light for the majority of my subjects, I must add a caveat: Given the choice, what I really prefer is soft, directional light, which is tough to find outdoors.

In the studio, there is window light, and that is a pleasing broad source when the sun isn't shining directly into the window. Remember that windows with northerly exposure never have sun shining directly into them, but keep in mind that subjects lit by a northern window can also sometimes benefit from a white balance adjustment—the light tends to be a bit cool (blue). Now that you know there is no harsh, direct sunlight shining into north facing windows, you've discovered the reason why painters almost always used them in their studios. And now that you understand why they chose this kind of soft light, it's time for you to buy, create, or find a broad source of your own and start using it to create beautiful images!

Hard Light

As I said before, the opposite of a broad, soft light source is a small, point source that creates hard-edged, inky black shadows. Point sources also create light that looks crisper than a soft light, making the details of your subject look as if they are etched into a block of granite. Hard lights will create this effect to any irregular surface they skim across. So let's see…if hard light can amplify surface texture (which they do), then certain still life subjects almost cry out for its use! Lace, fur, leather, bread, fruit, and almost anything else with an irregular surface can be enhanced with carefully placed point-source lights. It's as if the energy of a point source light can be harnessed by a knowledgeable photographer and transferred to the subject. (See two examples of this below.)

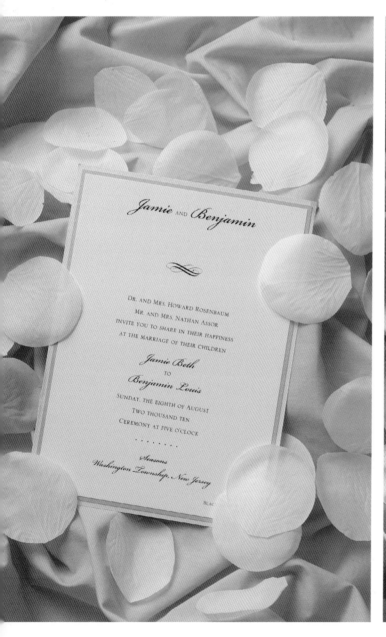
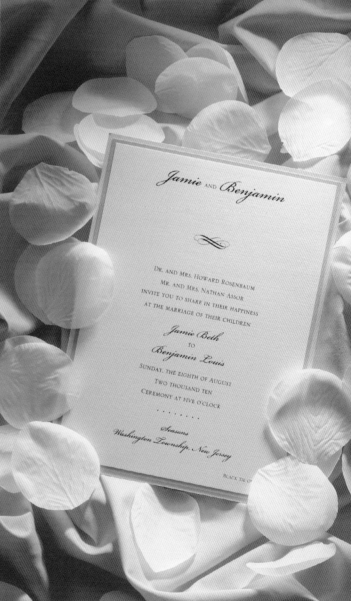

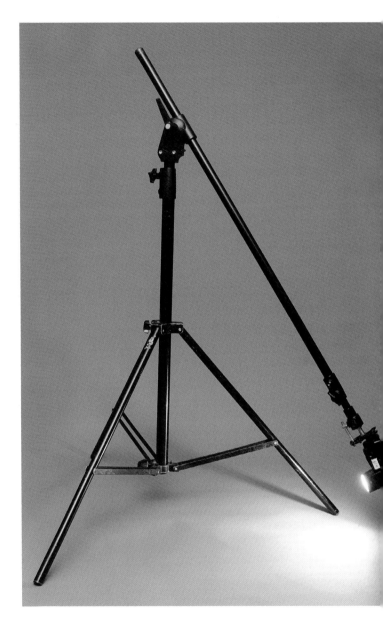

However, I find there is one big problem that arises from using hard light sources by themselves. That problem is the contrast of the light source and the blackness of the shadows it creates. While inky black shadows are certainly helpful to create drama or to shroud parts of the subject you don't want the viewer to see, I prefer to have control over just how deep and dark the shadows are. To accomplish this, I most often mix my hard lights with a very soft light source and use both together. I use the soft source to determine just how deep the shadows will be, and then add a hard light to create the energy-filled highlights I desire. Getting this right is just a process of trial and error. But, compared to working outdoors under direct sunlight, it is pretty easy to control the depth of the shadows working in a studio, especially with still life subjects that don't move or change expression from frame to frame.

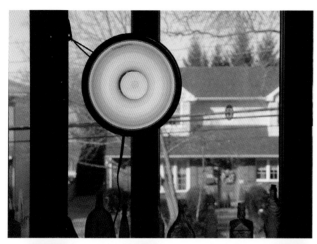

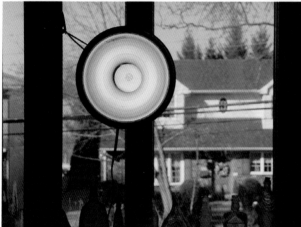

What we have here is a camera aimed at a tungsten light source (a 25-watt bulb in an aluminum reflector) that is placed in front of a window and the scene outside the window is lit, of course, by natural sunlight. If we set our camera to a white balance for sunlight (approximately 5000K) the tungsten bulb in the aluminum reflector (approximately 2500K) appears very yellow. Conversely, if we set our camera's white balance for tungsten, the bulb is recorded "correctly," while the outdoor scene appears very blue.

The Color of the Light Source

Some photographers think light is light, and it's all the same. Well, that's simply not true! Let's start with two common light sources: average daylight such as outdoor sunshine, and a common tungsten light bulb you might find in a table lamp.

The human eye can see the difference between these two types of light when they are right next to one another, but the brain quickly recalibrates our eyes when we are looking at one light color at a time. The whole process is pretty amazing, because it happens automatically!

White Balance and Kelvin Temperature

We will look at each type of light color one at a time next, but before we do, let's talk about your digital camera's white balance setting. White balance (WB) on a DSLR is a funny thing because, depending upon how you use it, it is either subjective or objective. Set it to Auto, and in my opinion you're lost—you have taken an important tool and given decisions about it over to your camera.

Many photographers think that they can ensure correct white balance using their camera's light type settings (Daylight, Incandescent, Open Shade, etc.), but, I have found the colors these settings produce vary too much from camera brand to camera brand. To see for yourself, do this test: Find a friend who shoots a different camera brand than you, set both cameras to the same light type setting (Incandescent, for example), and take a picture of the same subject at the same time under the same lighting conditions, then compare the results. I am willing to bet the results will be visibly different.

Some photographers swear by using a custom white balance for each image, but I find that is not exact enough for still life photography either. What happens if the product you are photographing is in a studio with strong florescent ceiling lighting, and you inadvertently choose a shutter speed that's slow enough to pick up a hint of green from the work lights all over the ceiling? I'll tell you what happens—your custom white balance ends up having a magenta cast if the product you're photographing is in the shadow of a bank light you have hanging over it! Phooey!

Of all the possible white balance methods offered on higher end DSLRs, the only one that is objective, and based on a specific, measurable standard is the Kelvin Temperature settings! I've shot for some studios that have told me I should set my Kelvin Temperature to 4200K when using electronic flash, even though electronic flash is 5600K! Other photographers have claimed electronic flash is 4600K, even though it's 5600K! Maybe those same photographers are viewing their images on a monitor that is sitting under a bank of florescent lights? Or worse still, maybe a quartz halogen desk lamp and window light mixed together lights the monitor. Or, maybe their subject, lit by electronic flash, is sitting on a piece of tan satin that is kicking warm light back up at their subject.

All of this matters because in the exacting world of still life photography, one in which clients pay thousands of dollars (or even tens of thousands of dollars!) for a designer to choose a specific Pantone color for their product's box, not matching that color exactly is the equivalent of an eighth mortal sin! On the next page is a chart showing specific light sources and their Kelvin Temperatures. It is my strong opinion that you should check it out and, more importantly, use the Kelvin Temperature settings as your white balance method. Or, you can just say to heck with it and set your white balance to Auto and try to figure it out in post-production; but don't come crying to me if your newest client starts looking for another photographer after you've shot one assignment!

Kelvin Temperatures to Know

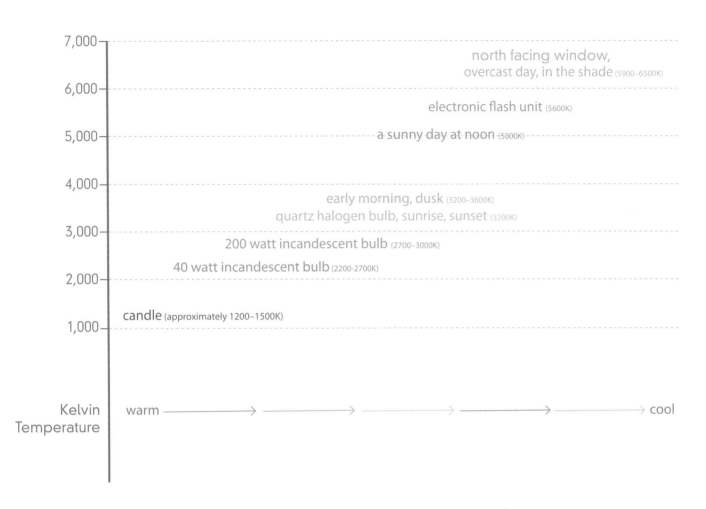

Using Light Color

There are four ways you can use the color of various light sources to help get an emotional reaction from the person viewing your photograph:

Accurate Rendition: In simple terms, this means all the lights you are using to illuminate your subject, along with your camera's white balance setting, should be the same color (Kelvin temperature). The easiest way to achieve this, of course, would be to have all the same kind of light source. All flash (5600K) or all quartz halogen (3200K).

You can, however, mix lights that have similar temperatures, such as daylight (5000 – 5600K between about 10 AM and 2 PM in the northern hemisphere) and electronic flash (5600K) without

any filter compensation over one or the other. Or, it might be slightly more complicated, such as when you have to put a filter over one light to make it match other light(s) illuminating the set. An example of this would be using quartz-halogen video lights (3200K) mixed with an electronic flash that has an orange Lee 204 filter placed over it that changes its temperature from 5600K to 3200K, or conversely, you could put a Lee 201 filter over the quartz halogen light to change its color temperature from 3200K to 5600K. If you used the former solution, you would set your camera's white balance to 3200K; but if you used the latter, you would set your cameras white balance to 5600K.

Shooting an office product in an office setting under florescent lights and mixing it with flash might drive you really nuts. Because average office florescent lights are usually between 20% and 30% green, you might find yourself putting a green filter over the flash (to balance it to the florescent lights), and then putting an equal-density magenta filter over your lens to bring everything back to a daylight balance. If the office location has a lot of window light, you might even get better results by turning off the ceiling florescent lights and just using window light by itself or augmented by unfiltered electronic flash.

A Slight Hint of a Second Color: You can use two or more light sources that are slightly different in color, so that the subject of the photograph has an accurate rendition, but accent lights render other parts of the scene slightly differently.

Have you ever sat in a room of your home and seen early morning or late afternoon, orangey sun streaming in through a window? Did it make you feel nice, peaceful and warm? That feeling is an emotion the warm-colored light is making you feel! Sometimes adding a warm-colored light in the background of a photograph can create the same feeling for your viewer. One cinema set I was on (working as a gaffer) included a kitchen counter with a window behind it. The front of the subject (a stick of butter) was lit with 3200K quartz halogen lighting, but a second 3200K light positioned behind the set and shining through the window was fitted with a Lee 204 filter to make it even more orange, so it would simulate morning sunlight. If you are working with flash units, you could put an orange gel (Lee 204 mentioned before) over a light that skims across the background but doesn't hit the subject, to impart just such an emotion.

Or, say you're doing an illustrative image of some winter wear, and want your viewer to feel the cold. Put a light blue filter over a light, or lower your Kelvin setting by 200 degrees, and you can make the viewer shiver—not really, but close to it! Changing your camera's Kelvin temperature setting as just

described will render the entire image cooler (as opposed to just part of it), but that's OK for an illustrative shot where you can exercise some creative color tinkering.

A Not-so-Slight Hint of a Second Color: How about adding color just for color's sake? You can use two or more light sources that are different in color and arrange them so that the subject of the photograph has an accurate rendition, but secondary lights render other parts of the scene with very vivid, wild colors.

The colored polyester and polycarbonate filters I have mentioned up until now are classified as light-balancing filters, whose prime purpose is to change one type of light to make it match another type of light when measured by Kelvin Temperature. However, both Lee and Rosco (the two primary color filter manufacturers) offer gel filters in a veritable rainbow of colors whose primary purpose is not to bring one light's Kelvin temperature into alignment with another light source, but to add color to a light source just for the sake of adding intense or subtle color.

Both Rosco and Lee offer swatch books that include small samples of each of their product lines: the light balancing and rainbow of colors type. So, if you want to use a variety of colors (over a specific light or two on your set) to create drama and interest in your photos without regard to balancing one light to another, then the Lee Designer's Edition or the Rosco Cinegel Added Colors Classic Edition swatch books are for you! As an important aside, the Rosco swatches are bigger and can totally cover the reflectors on battery-powered, shoe-mount flash units, so if those types of lights are your choice, then this bit of information might be very relevant to you.

Intensifying a Subject's Color: You can use a colored fill card to enhance the color of your subject. Although not an accurate color rendition, you can intensify a metallic color quite easily with a strategically placed metallic foil fill card. Although it is acceptable for an editorial image, I'm not sure if it is playing by the rules for a product photograph.

These are my two Lee filter swatch books fanned out so you can see the range of colors that are available.

The Rosco swatches are much larger than the Lee swatches, and if you are using lights with small reflectors, that may become an important feature in your selection of which swatch book to buy.

Above, you'll see a photograph of a bunch of George Washington commemorative US dollar coins. Pay particular attention to the three full-face coins in the lower center of the image. The coin on the left is reflecting a white fill card, the coin in the center is reflecting a diffused light source, and the coin on the right is reflecting a gold fill card.

When I first tried to shoot a pullback shot of my set, I realized there was nothing to see, because the gold card on the left side of the set was clipped to the grey card on the right (which is white on its reverse side). Neither the camera nor the subject was visible, because they were on the inside of the two clipped-together fill cards. (To make my exposure, I snaked my hand up into the area between the fill cards and released the shutter button by feel.) However, so you could actually see what was happening, I folded back the gold card and clipped it to the boom stand that was holding the diffusion screen. The last image is a reverse-angle photograph taken from the back of the set so you could see how the whole thing looked when the gold and white fill cards were buttoned up (clipped together). While I've never actually mixed white and gold fill cards in the same picture on purpose, I did it this time so you could see the difference it makes in the subject's color rendition.

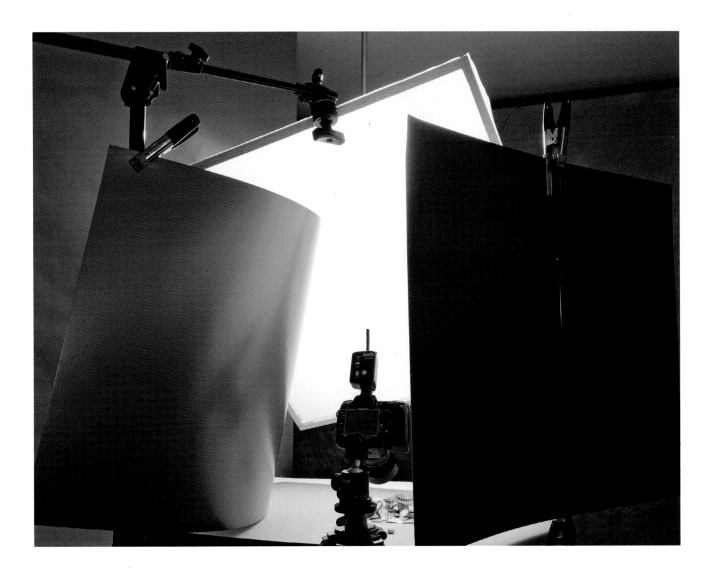

Safety, Safety, Safety Again!

There is a famous book and movie entitled Fahrenheit 451 by Ray Bradbury. It's a classic, frightening vision of the future, where firemen don't put out fires—they start them in order to burn books. The book gets its name from the fact that paper bursts into flames at 451° Fahrenheit. Both Lee and Rosco offer two lines of filters: one made out of polyester and the other made of polycarbonate. Specifically, for the Lee line (although the Rosco line is similar), the polyester filters melt at 356° F and the polycarbonate filters melt at 536° F. The Lee line denotes its polycarbonate filters by calling them the "HT" (High Temperature) series, and Rosco denotes them as their "CineGel" series. If possible (if the color filter you want to use is available in the line), I highly recommend using the polycarbonate filters instead of the polyester ones, especially if you decide to use quartz halogen cinema lighting or electronic flash with modeling lights. While neither type of filter actually bursts into flames, both do melt into a flaming goop, and that melted, flaming, dripping goop can cause other things to catch fire and burn skin badly. Both companies also make vinyl and material scrims and diffusers, and those are flammable too! Have a plan, man!

7

Stopping Your Viewer

We (meaning all people) are literally overwhelmed by images every day—more images than we can even count! That being the case, most of the images people view become nothing more than a fleeting memory and many more of them are hardly even noticed at all! Because of the abundance of images each of us sees every day, the goal of a successful photograph is to engage and stop the viewer for just a small amount of time.

As I have said before, I want to stop the viewer before they turn the page or click their mouse and move on with their busy lives. I often—and only kind of in jest—call it the Three-Second Rule. But, lest you take my idea of three seconds literally, it is important to note that whether you stop the viewer for two, three, or even five seconds is irrelevant; the goal is to stop the viewer for as long as you can!

Near the beginning of the last chapter, I listed five properties of light a still life photographer should try to control. The fifth one is the emotional feel the light source creates. Of the five properties I listed, I knew that Number 5 would be the most difficult to quantify and explain, and it is probably the most important one too. Interestingly, getting an emotional reaction out of your viewer and stopping them for a few seconds can encompass a lot of other things besides the lighting you use. However, let's start with lighting.

Oh, and one more thing, the reality is, I don't have all the answers about Number 5 or the Three-Second Rule (yet!), because my photographic abilities (like yours, if you're honest) are still a work in progress. But, here are some ideas that I have found to work after decades of trying to pin this concept down for myself.

Idea 1: Creating a Comfortable, Familiar Scene

Though it seems an odd way to start a conversation about comfort and familiarity, let me elaborate on the added confusion caused by a double set of shadows I referred to before. I believe one of the easiest emotional reactions you can give your viewer is one of comfort or familiarity. You can use lighting to great effect in creating a framework that reminds them of something they already know.

Generally speaking, people are accustomed to looking at things lit by natural light (i.e., the sun). Single light sources create a single of shadows that fall in one direction, and that is both familiar and natural-looking to most people. However, two light sources create two distinct shadows coming from different directions, which causes confusion for viewers, because it appears unnatural. Although this sounds simple enough, it can become tricky, because it depends upon who the viewer is and what they are willing to accept as real and natural.

Let's divide the entire group of possible viewers (all people) into three smaller groups, with each group being classified by their life experiences:

The first group, usually (but not necessarily) the oldest, is most secure and comfortable with natural things they know to be true. Natural light generally is a single light source that comes from above. It follows that up is up, down is down, gravity always applies, racecars that flip over, crash and burn can no longer run, and every living thing is mortal and needs light, water, and nourishment to survive.

The second group, middle-aged for the most part, has seen *Star Trek*, *Star Wars*, *The Matrix*, and *Avatar*. While they understand and accept the laws of nature and physics that the older group clings to more closely, they are more receptive to the idea that some of the rules of nature may not exist in all cases, but this group does make a strong distinction between reality and fantasy.

The third group, the youngest (raised with constant visual stimulation from manipulated digital images, computer generated videos, and hyper-realistic video games), feels that the laws of nature don't necessarily need to apply. They are most likely to accept that a planet with two suns exists, gravity doesn't always apply, although all things are mortal, they might rise from the dead, and that up and down don't have to be hard-and-fast rules. I think this group is most likely to be willing to suspend their disbelief.

Obviously, all three groups have differing perceptions of familiar and unfamiliar, so creating an emotional reaction of security and comfort depends upon which group you are aiming the photograph at (be it a photograph of a product, widget, or whatever). This process of aiming your message at the specific group you are trying to reach is called demographics. Ad agencies know all about it, and since I often get hired to photograph products aimed at that first group I mentioned, their reality informs the framework in which I often create my images.

Because of this, and knowing which group I'm aiming at, no matter how deep the shadows are that I create, I almost always try to develop a lighting scheme for my studio photographs that creates a single set of shadows going in the same direction. Further, I generally prefer to have my primary light come from above or from the side of my subject, as opposed to coming from below it. Lastly, though not always, I try to create a base upon which my subject can rest, because gravity does apply. All of these things give my viewer a frame of reference they are familiar with, and that familiarity makes them feel comfortable and secure, because they've seen it before. This is not to say that I don't want the images I create to be unique, it's just that I want them to be unique within an existing secure and comfortable framework.

Look at the photo on the left, and all you see is one shadow. Look at the photo on the right, and you'll see two obvious shadows, one on each side of the subject. Was the photo on the right made on a planet with two suns? Don't the two shadows, created by light coming from opposite directions, confuse you? Aren't those same double shadows on the cooking tools confusing too? The last thing you want is a confused viewer, one who is so confused by your lighting they can't even understand what the product is you're photographing!

The opposite of safe, comfortable, and familiar can work too! If you present your viewer with a photograph that is repulsive or violates the collective understanding of reality, it might be jarring enough that your viewer stops for those few extra seconds. Always remember that if anything works to achieve your goal, then the chances are very good that the exact opposite will work too. Think of the images you've probably seen of snarling watchdogs or striking snakes to represent security systems as examples here. Likewise, while pristine beaches, blue skies and beautiful sunsets might evoke good-time feelings for vacation spots, storm and blizzard images might be just the ticket for all-wheel-drive cars or the safety of snow tires. The trick is to get the viewer to have an emotional reaction regardless of whether that emotional reaction is joy or fear. It would seem many neophytes might feel that by doing a bit of Photoshop work they can easily

accomplish the 3-second goal. That being the case, I offer these words of caution: If you decide to Photoshop your image to the point where you seem to be defying gravity (for example), it is imperative that you do not leave footprints giving away how you are doing it. If your Photoshop work is heavy-handed and broadcasts its presence, many viewers will easily realize that the image is a fake, dismiss it, and move on almost immediately. This is the antithesis of what you are trying to accomplish.

Idea 2: Color

This idea is really simple. People like bright, intense colors. Some photographers believe a cacophony of colors is the way to go. Others believe using a limited palette makes the use of color more important. Both will work, and I can even make a valid argument why each one does. Here's another thought: If most everything your viewer is seeing is in color, then maybe the impact of a black-and-white image might be the way to stop them. Remember, if something works, then the opposite probably will too!

Look at the red tomatoes. They're so red they're even glowing! One strong color can stop your viewer in their tracks.

Here is an example of a single color used in a more subtle way. The red boat captures your eye because a bland palette of other colors surrounds its single color. In the foreground of a scene filled with grey and blue tones, the viewer's eye is drawn to it.

Look at the forest of spring clips. They (and the background) are more colorful than a rainbow, a veritable riot of different colors in one photograph. A terrific jumble of strong colors can stop your viewer in their tracks.

Speaking of opposites, choosing specific colors themselves might be used to get an emotional reaction out of your viewer. I think of soft blue as a happy color—heck, they even wrote a song about it: "blue skies, nothing but blue skies..." And while red can evoke danger, it can also evoke excitement and intrigue.

While I often choose colors to accentuate the color of my subject by contrasting against it, taking the opposite theory again, you can even use a similar color to the subject to deemphasize a part of a subject you want to minimize. Note the image of my two staplers (page 64) where I used a green color similar to my old stapler to partially hide it and therefore emphasize the newer, silver-colored one. Do you think I chose a green background behind a green stapler just out of thin air?

In Chapter 6, I mentioned how an orangey backlight could evoke the feeling of early warmth, or on page 178, I suggested using a gold fill card for gold-colored items. The point is, whether you choose a pastel palette or stronger colors, whether you use a single color or multiple colors, every decision you make should be used to emphasize the message, the emotion you're trying to get across. And, although I'm talking about color right now, this thought—that everything can add to or subtract from the emotion you're trying to create—should extend to everything that runs through your brain when you first look at the subject you're photographing. From lens choice to aperture choice to camera position to which type of lighting you use—everything!

If the world is filled with color, maybe you can stop the viewer with black and white! In fact, a green apple is just a green apple, but convert it to black and white, lighten it, turn up the contrast a bit, and it can be turned into a cosmic apple instead.

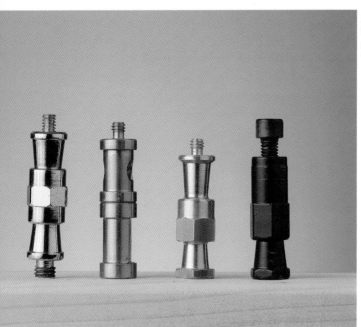

Here's an examle of going for a low point of view on a subject to make it look more "personal".

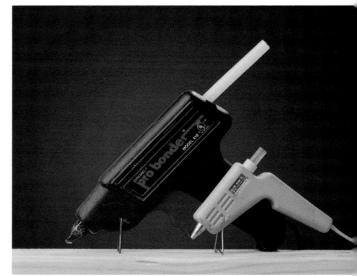

About this image of two glue guns, one art director said it reminded him of a "mom and her kid." A friend of mine, who is a young mother, said it looked like "two animals, a mother and her child getting a drink at a waterhole."

Idea 3: Point of View and Personification

If there were some way to get the viewer to think of the inanimate subject as being alive, that would surely generate an emotional reaction, wouldn't it? Disney did it with mushrooms in Fantasia years ago, and I'm sure nary a soul who saw them didn't think they were full of cuteness. Whether the emotional reaction is funny, sad, sweet, sour, or even repulsive, if I can generate it, I'm there! I dropped another hint about Number 5 in Chapter 3.1 when I discussed the idea of getting down to a still life subject's "eye level."

Well, if going to an imaginary eye level helps to personify our subjects and generate an emotion, what if there's a more concrete shape within the widget that is a sign of life? It happens! In fact I've done that in previous chapters a few times already and I'll even do it another time for you right now. I try not to live in a bubble, and I constantly ask other people I know if they see something in an image I'm working on. What follows are three images I showed to various clients, friends, and co-workers; and in each case, I asked them if it reminded them of something else. The caption under each image includes their comments.

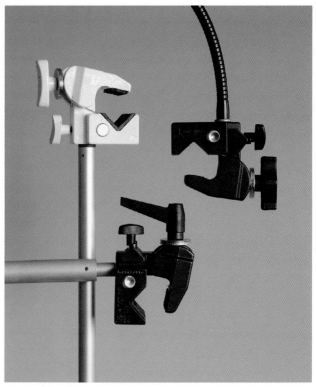

An editor I work with saw this image and zeroed in on the super clamp on the right side. Without any prompting on my part, he said "the one on the right looks like some weird bird's head, maybe a parrot or a toucan." I had thought about the one on the right too, but it reminded me of a Pac-Man-type video game character. However, after he made the bird comment I decided to...

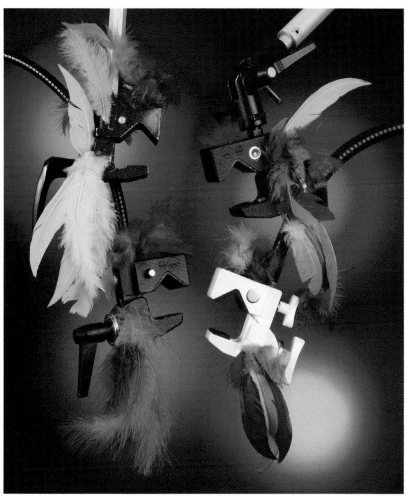

...go to a local handicraft shop and blow eight bucks on two bags of colored feathers and a multicolored feather boa. A few snips with scissors, a few dozen tiny blobs of FunTak® to hold the feathers in place, and four gelled lights behind a diffusion screen allowed me to come up with this image. I emailed a low-res version of it to my friend to show him what he had inadvertently caused to happen. His response was: "Love it! Even more important, my kids love it!" That means I didn't just get an emotional reaction out of one person, but out of three instead.

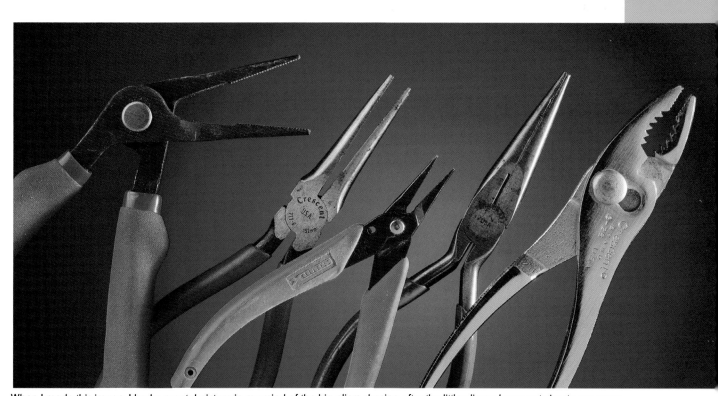

When I made this image, I had a mental picture in my mind of the big pliers chasing after the little pliers who were trying to run away from it. However, one of my students said he saw "a mother bird feeding her chicks." Since the smaller pliers are all facing away from the "mother bird," I didn't intend to create what he saw, but that doesn't matter! What is germane is that he saw something more in the image than what is actually represented, which means I had gotten him to think about the image!

Idea 4: Special Effects

Although I believe I am working in a time when a backlash to using Photoshop for photo composition is starting to appear, at the same time, I feel there is a growing appreciation for doing it in the camera. While this might not be true with low-end clients (without casting aspersions), whose primary concerns are budgetary, many high-end clients are interested in—how can I phrase this?—doing a fake for real. There is a visible honesty about doing something in-camera that is often missing in a Photoshop-generated version of the same basic concept.

One way this type of image is often created is that some part of the subject or set is a model built to a smaller or larger scale (usually smaller), or possibly even some prop is constructed in a forced-perspective, mixed with objects that have a natural perspective in the same image. For example, this practice is common on movie sets: A crashing helicopter, a runaway locomotive, or a space ship are not full-sized; but rather, they are very expensive models, meticulously crafted to perfect scale to give the illusion of reality when the helicopter explodes in a ball of flame, the locomotive flips onto its side and plows up a wall of dirt, or the space ship disappears as it goes into warp drive. These models are extremely expensive, so over the years, I have honed my modeling skills to do some basic model building myself, and my Rolodex includes model makers who are much better at their craft than me.

To help me better describe how to build a light table for a video tutorial I was creating, I thought it might be helpful to build a model of it. Built to a scale of 1/8 actual size (1.5 inches = 1 foot), the wood used was balsa, the C-clamps were painted styrene and machine screws with a short piece of wire soldered into the screw's slot, and the acrylic sheet was a 6x12-inch piece of Tough Lux diffusion material. I chose this scale so the finished model would be big enough to hold a full-scale (life-sized) orange bell pepper that was in season at my local market. I chose a perfect pepper and, if my modeling skills are good enough, the copy headline might have been: "Giant Pepper Displayed in Steve Sint's Studio!"

The goal, of course, is to mess with the viewer's mind and make them believe that something is real even though it isn't. If done well (actually, perfectly) the illusion is complete and the "wow" factor can stop the viewer for longer than three seconds. In fact, if done perfectly, it might become the gold standard of a photograph because one viewer will tell other viewers about the photograph or even go so far as to show it to them! If you ever create such an image yourself, it is extremely valuable to a client, because each original viewer that sees it will show it to two (or more) other viewers. That, in turn, will hugely increase the image's audience.

While I'm not necessarily suggesting you get into model building yourself, although many photographers do, I am suggesting that you don't limit yourself in any way when it comes to figuring out how to solve seemingly difficult concepts. Here are a few such images that I have been lucky enough to create by myself and with the help of model builders.

As a last point in this chapter, I ask you to remember when I spoke about trying to create a feeling of comfort and security in your viewer. I would like to take that concept to another level now. Not only do I want to create a feeling of comfort

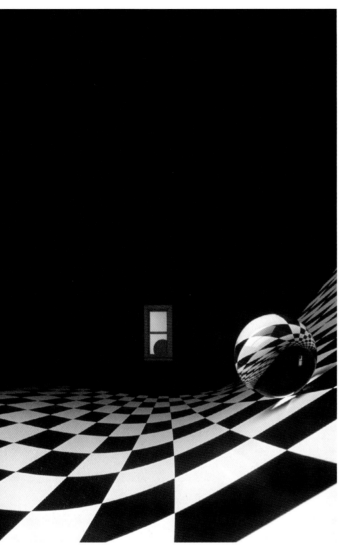

and security in the final viewer of my images, but I also want to create a feeling of comfort and security in my potential clients too. To this end, I often try to show them images containing subjects that are similar to the subjects they are interested in hiring me to photograph. Taken a step further, if I show them images that illustrate a particular concept or use a specific prop (be it a checkerboard or a mime mask), I try to show them the same concept or prop used differently in more than one photograph. I find this advantageous for two reasons: 1. If they don't like one photograph in a series, they might like another, and 2. Most often, my still life clients are interested in having me photograph more than one item, and if I show them the same thing handled in different ways, they can see how versatile I am, which fills them with confidence that I can get their assignment done!

The guy who hired me to do the checkerboard image in Chapter 1 hired me to do a second image for him later. For my repeat performance, I decided to make a checkerboard that could twist and curve, so I called on a friend who is a construction artist. He meticulously built this forced-perspective checkerboard that I could twist and curve any way I wanted to! The bill for him doing this was a cool $2000, for which I charged my client $2500, but after I photographed his picture frame on it, the same checkerboard (with different suitable props on it) became the background for covers of two different national magazines and for the image you see here.

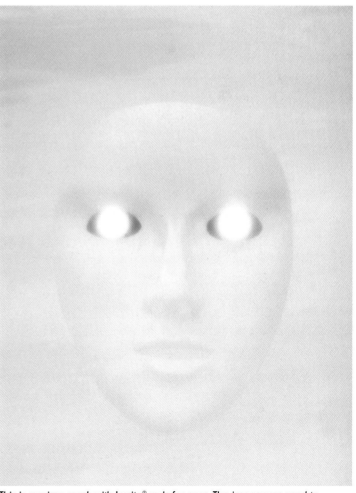

This is a mime mask with Lucite® rods for eyes. The image was used to illustrate the concept of artificial intelligence.

8

Backgrounds and Fixtures

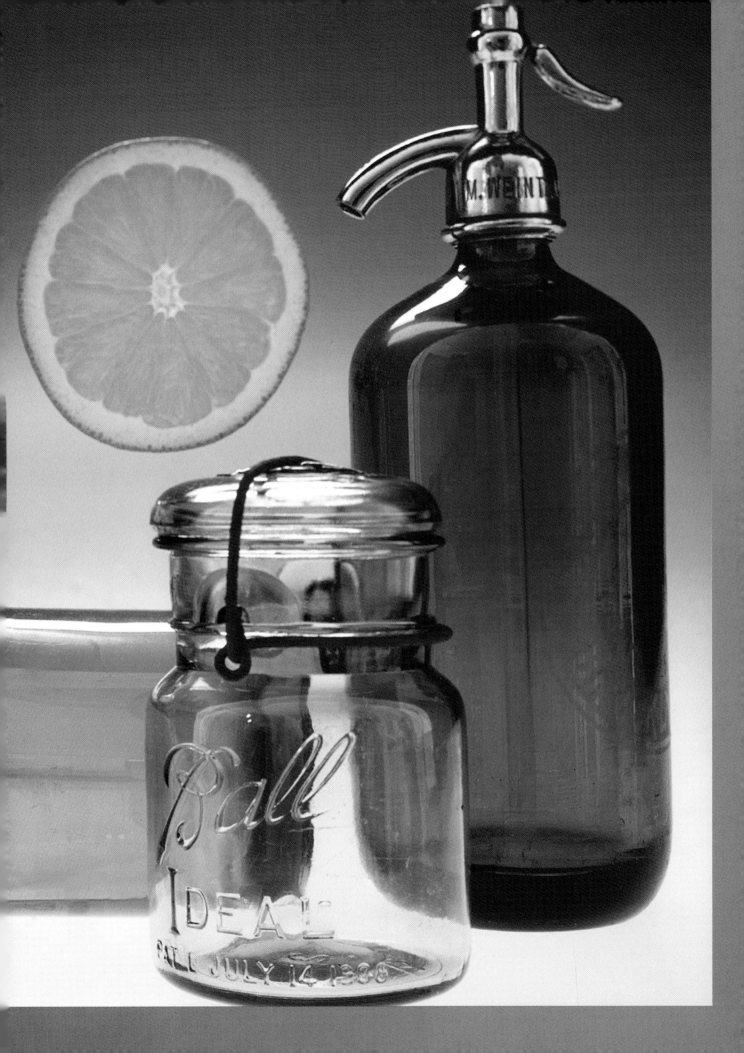

Backgrounds

Shakespeare wrote: "All the world's a stage, And all the men and women merely players." If we stretch that metaphor a bit and say that the products we shoot are the players, then this chapter is about setting the stage. I should mention that your choice of backgrounds is almost as infinite as the products you can shoot! For assignment photography (specifically assignments for a fee), clients' needs or demands often dictate which backgrounds we use, but at the same time, it is often part of the creative service we're providing to offer suggestions and input. Having to offer input and suggestions can be scary, though, because your prospective client might not like your ideas, or even worse, they'll take your idea and then hire another photographer to apply it. However, it will be less scary if you think in large, global themes that aren't extremely specific. In this chapter, you will find some ideas that you can share with a client, or think about yourself if you're working on a portfolio piece or personal still life project.

Horizon Lines

Is the background of your photograph going to have a horizon line? Please don't think of this as unimportant. Even before photographers wrestled with this question, other artists thought about it long and hard too. Even before the invention of the ubiquitous roll of seamless paper, artists used heavy draperies and painted canvas backdrops with one end hung on a wall and the other end rolled out onto the floor to hide the seam between the floor and the wall.

Interestingly, there is no right or wrong about including a horizon line in your photograph. Furthermore, including (or not including) a horizon line in a photograph often seems to be nothing more than a matter of taste and possibly something that goes in and out of style! In truth, there are some assignments where I include a horizon line and other times when I don't, but if the photographs I'm producing will be viewed as a group (such as a catalog), I usually try to be consistent. That being said, as a personal preference, I prefer a horizon line in my still life photographs. I find including one can give the viewer a frame of reference and therefore make the image more believable and more comfortable to look at.

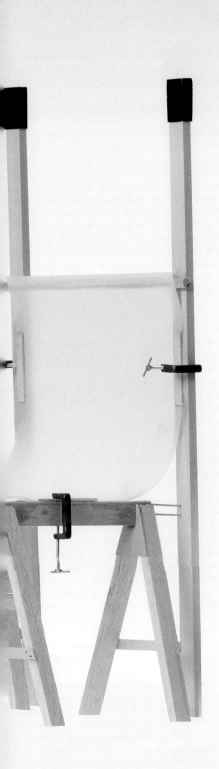

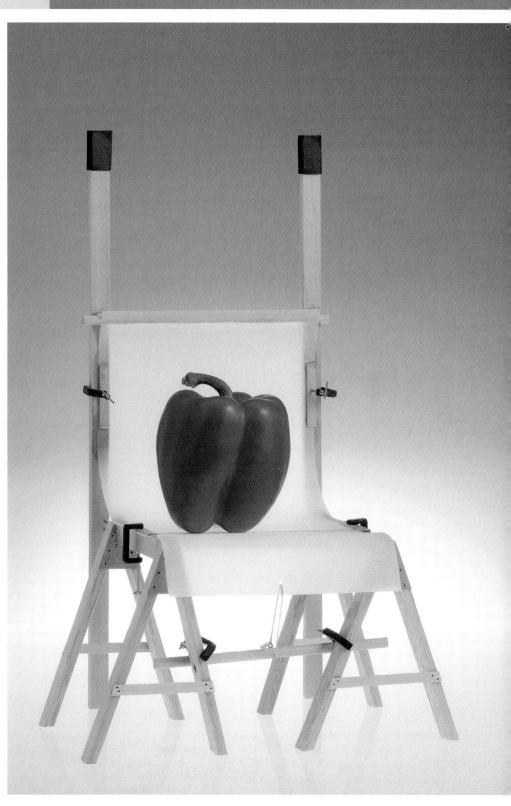

Horizon line vs. no
horizon line? It's your
choice, you decide!

Cycloramas

Before the invention of seamless paper, photographers, cinematographers, and museum diorama makers built cycloramas either in their studio or for display. A cyclorama is a permanent construction of a curved area built between the floor and the wall to hide the seam where the two meet. A curved permanent construction between two adjoining walls can also be called a cyclorama, but it is more often called a coved corner instead, and it is most often used in installations like museum dioramas or model railroad backdrops. There's even a permanent studio construction called a curved cyclorama, which is two wall / floor cycloramas joined by a coved corner.

Almost all such constructions are made with plywood formers covered with flexed plasterboard or wire mesh that has wet plaster spread on it with a trowel. These constructions are made for a few good reasons. First off, a cyclorama using a single wall and floor can be made much wider than any seamless paper roll available. Secondly, a cyclorama floor is much sturdier than any paper covering can be—it doesn't tear or wrinkle the way paper does. This becomes especially important if your subject is large and heavy such as an array of different-colored filing cabinets, pianos, or furniture (all likely examples). Lastly, a cyclorama can be almost any color, because changing the color of a cyclorama is as easy as rolling on a new coat of paint.

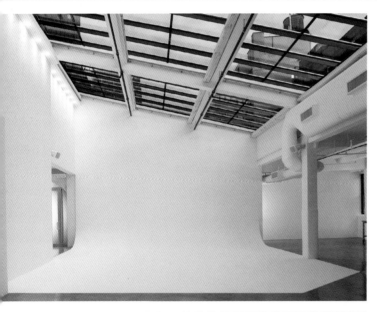

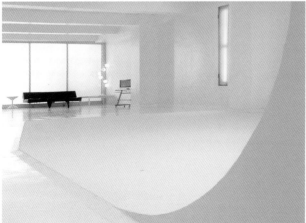

Another point worth considering is if you include a horizon line, should it be high, low, or in the middle of your composition? Generally speaking, I prefer a low horizon line because I feel it makes my subject appear larger than it really is. I dislike mid-placed horizon lines because I feel it cuts the composition in half too neatly; and I hate high-placed horizon lines because it always looks like a mistake, like there should be something more above it. However, as is always the case with images you create, every rule is meant to be broken, so smash away if you feel it improves your photograph!

Here are two images of a cyclorama: a frontal view that shows you the shooting area; and a reverse-angle shot from the side that shows you the curved area hiding the floor/wall seam at the rear of the cyclorama. Both photos are courtesy Go Studios, a rental studio business in New York City.

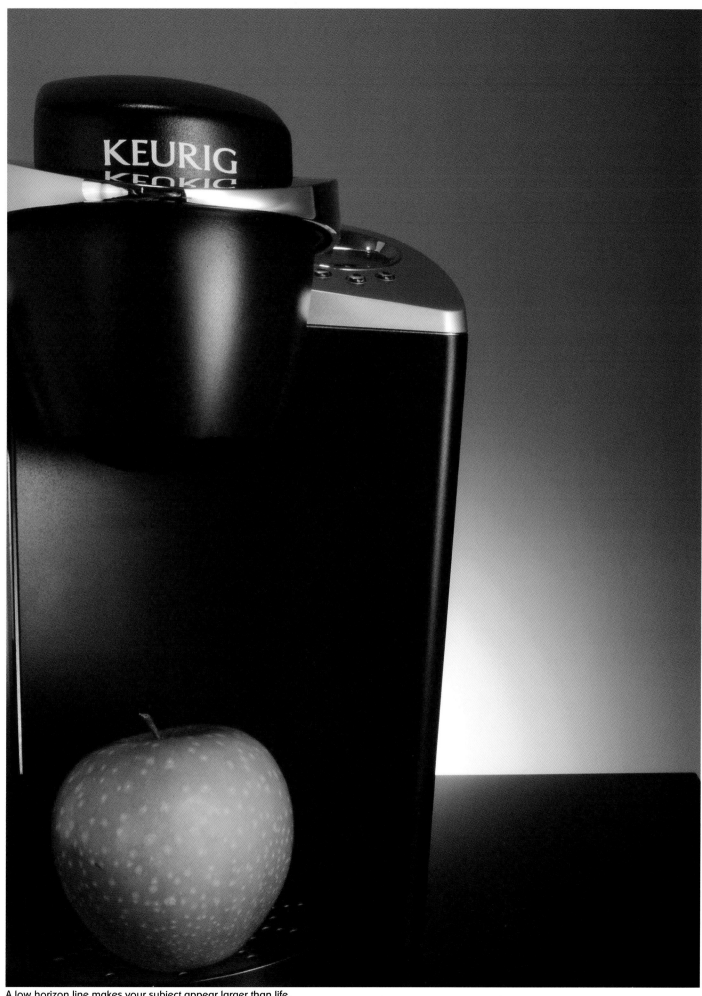

A low horizon line makes your subject appear larger than life.

Acrylic Backgrounds

Opaque or Translucent Acrylic? Before you read any farther, let's get something out of the way. I often use the words acrylic, acrylic plastic, plastic, and even Plexiglas® interchangeably! That's because, generally speaking, for studio photography purposes, they are all the same thing, and they can be used interchangeably. Some manufacturers of acrylic plastics trademark the name of their products, such as Plexiglas® or Lucite® (which is a clear acrylic), but don't get hung up on a brand name. Instead, I find it more useful to focus on the word that describes a particular acrylic's properties, such as opaque or translucent. Regardless of what you call it, or which type you choose to use, it's a good material to use for backgrounds and diffusers for still life photography (if it's translucent).

Because both of the images of the light table model on page 193 use white translucent acrylic for their backgrounds, I though this might be the time to mention the difference between opaque and translucent acrylic as a background. While opaque white plastic will transmit light through it, the edge of your light's pattern (behind the acrylic) will be contained, but if you choose to use white translucent acrylic instead, the edge of your light's pattern will spread more. Neither of these different properties is better than the other, but realizing the difference between them offers you more control. Look at the two images of a light behind a piece of white acrylic at top left.

Top: There are two, same-sized, same-power lights, behind each piece of acrylic, and each light is the same distance from each square of 1/8-inch plastic. The difference between the two sheets is that the one on the left is opaque white and the one on the right is translucent white. Note how the transmitted light's pattern is contained when using the opaque acrylic on the left.

Bottom: I added a large-source light for this shot to illuminate the front of both acrylic squares. Notice how the opaque acrylic square (left) looks whiter than the translucent acrylic square on the right? That's because the translucent one lets more of the frontal light transmit through it instead of reflecting it back at the camera. If you think creatively, you can use these different properties (translucent or opaque) to your advantage.

Making an Acrylic Surface Non-Reflective: All acrylic plastics have a very glossy surface, and glossy surfaces create reflections. But what if you want a translucent surface that is not glossy, a surface that doesn't create reflections? While I have found this technique to only work successfully on white (translucent or opaque) acrylic surfaces, it is worth mentioning. You can have one side of your acrylic sheet sandblasted or chemically etched. This process will turn its reflective surface into a matte surface. I mention having it done to only one side, because acrylic plastic is expensive and having one side glossy and one side matte can double its usefulness. Look at the two images above and below to see the difference in the reflections on a glossy acrylic surface and a sandblasted (or chemically etched) surface, respectively.

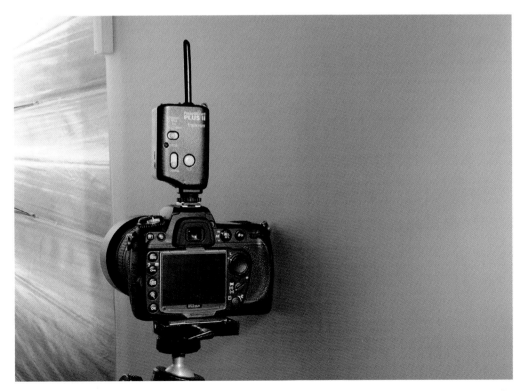

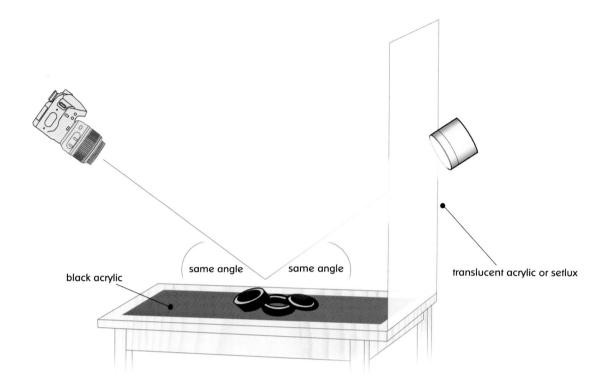

black acrylic same angle same angle translucent acrylic or setlux

Black Mirror Surfaces: Inexperienced photographers often think any black background is a perfect choice for almost any still life subject, but I strongly disagree. While black might work for an occasional portrait, in my opinion, the color black is too dead for a still life photograph. This is especially true for almost all reflective subjects, because black backgrounds often reflect into parts of the subject, creating dead spots on them.

However, if you mix the glossy, reflective surface of acrylic with the color black, I think you can create images that are extremely dramatic. I call these very special images "black mirror photographs," and the high-tech feel of the resulting images makes this concept well worth exploring.

When I employ this technique, I use a picce of black opaque acrylic, but there is also a semi-transparent (not translucent) black acrylic called "smoke." That could possibly be used over a silver or gold show card to add an interesting creative effect. (A show card is a non-archival, less expensive version of a mat board.)

All surfaces, be they part of the background or part of a subject, can be loosely divided into two categories. I have often called them active and passive surfaces. Examples of active surfaces are acrylic, glass, shiny metal, and water. Examples of passive surfaces are velvet, wool, felt, and even flocking paper. Obviously, the two types of surfaces respond differently to light.

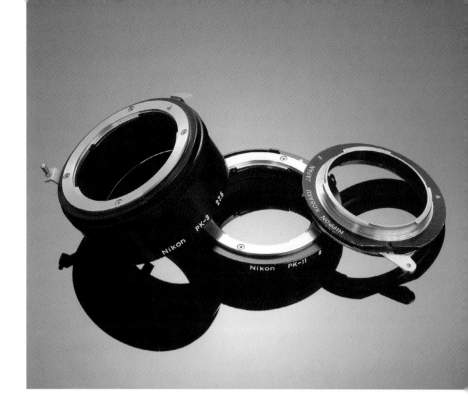

For an active surface to reflect light into the camera's lens, a light that is at an equal-but-opposite angle to the lens' axis must hit it. This rule is called "the angle of incidence is equal to the angle of reflection." The concept is the same as why a pool ball bounces off the side rail cushion, and its direction is dependent upon the angle at which it hit the cushion to begin with. To get a piece of opaque black acrylic to become a black mirror, we'll need a light above and behind the subject we are shooting, and it will also be helpful if we diffuse this light source so that the reflected light spreads and becomes more pleasing to the eye. See the diagram, top left.

At right are two black mirror still life images. By slightly changing the position of the light behind a diffusion screen at the rear of the set, you can change the position and intensity of the light's reflection on the black acrylic background beneath the image's subject(s).

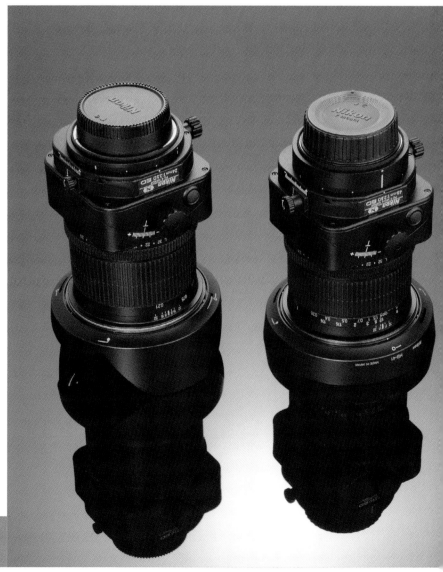

Using black (or any other color) acrylic for a mirror effect requires that the acrylic be scrupulously clean. This can be frustrating, because acrylic is so smooth that it can easily become a static electricity magnet. There are two lines of attack to combat this. One is to use a product called Brillianize® that not only cleans and polishes acrylic, but also cuts its static electric charge. More importantly, you cannot use paper towels to clean acrylic. The paper towels are a major source of lint dust that will have you retouching out dust spots in Photoshop from now till the cows come home! My advice: Take an old, very well laundered (so it's lint-free) tee shirt, and cut it into rags that will only be used specifically for cleaning acrylic. Store the rags in a zip-lock baggie when you're not using them so they don't pick up dust while they are waiting to be used. If you want to work with acrylic, then you've got to learn how to work clean—or be willing to spend a lot of time in post-production retouching!

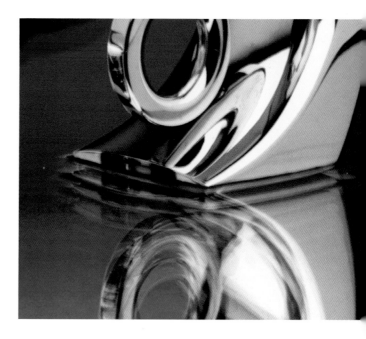

Some photographers try to use glass mirrors to get the same effect, but I have found this difficult to do. In the first place, many mirrors create reflections with a green color cast because the glass used in making the mirror has a slight blue/green tint in it. Secondly, because the reflective surface of a mirror is under a sheet of glass, the thickness of the glass itself lets you actually see under the subject! This can be a big problem if the underside of your subject is not pristine and well finished (a faucet fixture is a good example of this problem).

I have gotten around this problem by building a watertight dam around my subject using wood and silicone sealer and then filling the surface of the dammed mirror with about 1/4 inch (0.6 cm) of water. The water's surface just barely touching the base of the subject can create a beautiful effect all its own, but I've also blown a gentle stream of air over the water's surface during the exposure to slightly break up the reflection. The water solution works, but it is a lot of trouble, and you must remember that water and electric lights don't play together well! See the photo of the faucet, opposite, and the close-up of where the water and faucet meet (this page, top right) to get an idea of how this technique works in practice.

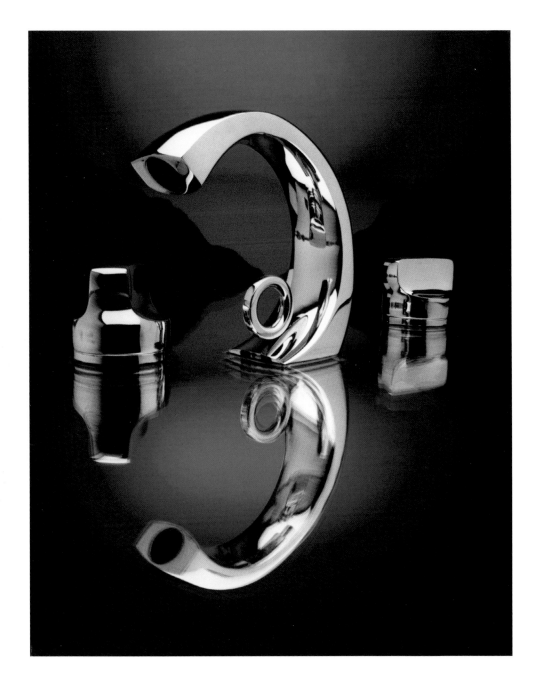

Material for Backgrounds

After you've exhausted yourself using seamless paper and acrylic sheets as backgrounds for your subjects, you might consider another whole variety of backgrounds made from pieces of fabric. Velvets and knits are passive fabrics, and satins are active fabrics. Silks, chiffons, and even tulle (netting) can be used too, as long as you use some pristine surface under them! Considering the range of surfaces, textures, and colors that are available, fabrics offer more variety than any acrylic supplier or seamless paper catalog can provide. Here are some ideas to help you work with fabrics.

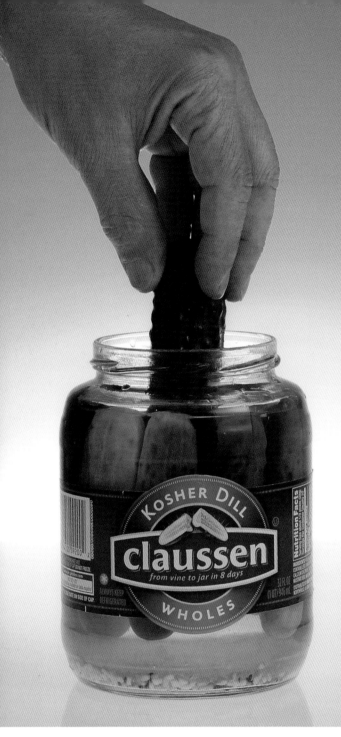

The Ellen Degeneres Pickle Grip with a Twist

Lucky for me I shoot weddings! A long time ago, one of my wedding photography mentors showed be how to bulk up a bride's train. When he was done, the acre (a slight exaggeration) of flat material that made up the bride's train was transformed into an 1/8 acre of material loaded with soft sensuous curves. Later, I saw an Ellen Degeneres comedy special where she described the hand grip need to remove a pickle from a jar, and I realized it was the exact grip my wedding photography mentor taught me eons before.

To use the pickle grip to bunch fabric, lay your piece of material on a 30x40-inch (76.2 x 101.6 cm) mat board on the floor or on a tabletop in your shooting room. The material can be wrinkled and even a bit creased. You are going to grab a bit of the material with your pickle grip, twist your grip, let go, and do it again and again, each time moving your hand from place to place on the material. The resulting background will have an interesting pattern of swirls that can support any lightweight subject.

The final trick is to use a large light source above or to the side of the material and use a second smaller source to skim the material's surface. The light source that skims the surface of the material will highlight the tops of the twists in the material's surface. This trick works best with a piece of satin, by the way. Do you know where the closest store to your studio is that sells material by the yard? You should!

Check out pictures A through G below to see the progression of using the Pickle Grip with a Twist.

A

B

C

Jamie AND *Benjamin*

DR. AND MRS. HOWARD ROSENBAUM
MR. AND MRS. NATHAN ASSOR
INVITE YOU TO SHARE IN THEIR HAPPINESS
AT THE MARRIAGE OF THEIR CHILDREN

Jamie Beth
TO
Benjamin Louis
SUNDAY, THE EIGHTH OF AUGUST
TWO THOUSAND TEN
CEREMONY AT FIVE O'CLOCK
· · · · · · · · ·
Seasons
Washington Township, New Jersey

BLACK TIE

This technique works best with a lightweight subject such as a piece of printed paper, but if you're careful, it can also work with heavier subjects.

D

E

F

G

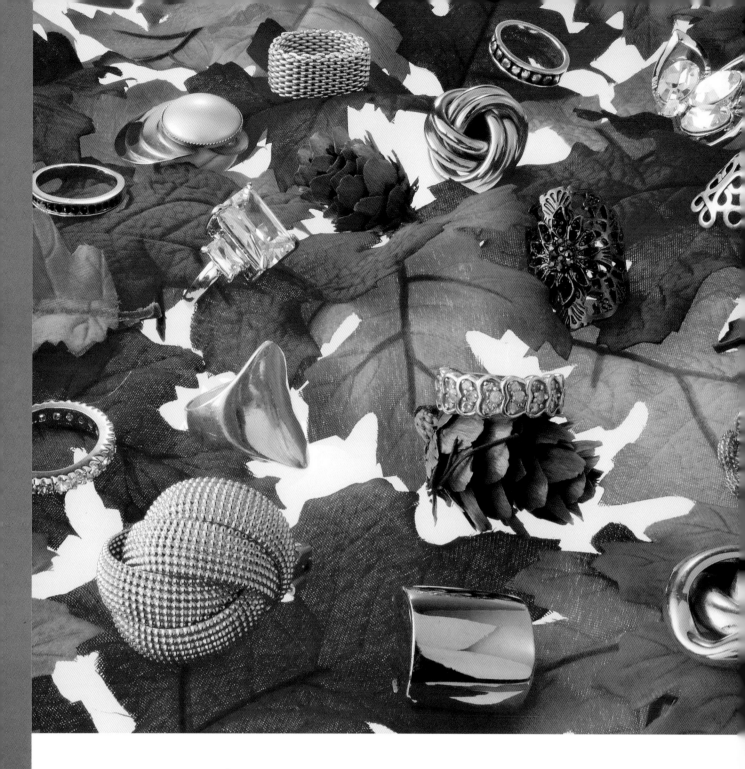

Build a Sandbox to Play In!

Sometimes, when faced with shooting multiple pieces of jewelry in the same image, you might find it to be a very trying exercise in frustration. Finger rings, earrings, brooches, and even decorative pins often don't balance well and won't stay in the exact position you (or your client) want them to so they can be photographed. Worse still, if you've gotten three of twelve subjects into a perfect position, and you accidentally bump the table top while positioning the fourth, the first three will all move or fall over. When this happens, I can tell you from sad experience, that it will become a time of lamenting, rending your garments, tearing your hair out, or just plain old tears—it really can be that frustrating!

To create the image at left, I tried to place about a dozen pieces of jewelry on artificial autumn leaves that were resting on a piece of translucent acrylic. Because the leaves were very lightweight, the acrylic was very slippery, and the jewelry pieces had high centers of gravity, positioning the subjects took over an hour! Too many times to count, I'd add one ring (or earring) and three others would move or fall over. And, did I mention my lower back was killing me by the time I was finished? It was. Things got so bad towards the end of the prep work for the shot that I actually gave up on getting every item into perfect position. Giving up is not a recipe for success in this field!

There is a way around this agony that works so well it will bring a smile to your face as you fly through the positioning of your subjects! The trick involves using a material that can support the bits of jewelry (or little electronic widgets for that matter) and keep them from moving around while you place other subjects on the set. The solution is sand!

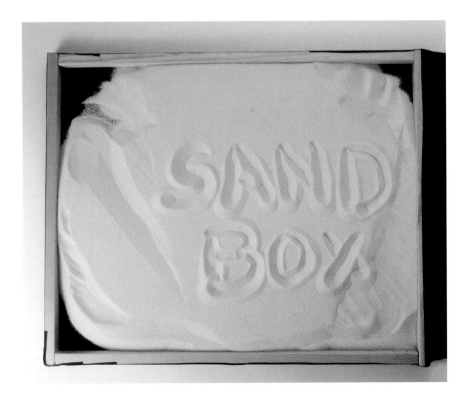

Unfortunately, however, you can't just pour a bag of sand on your tabletop and stick things in it. To contain the area where the sand is going to be, I build a small framework (about 16x20 inches / 40.6 x 50.8 cm) of 3/4-inch lumber gaffer-taped to a piece of foam core. You don't even have to screw the lumber framework together! Just use bits of gaffer tape to hold the pieces of lumber to each other and to the foam core base. Check out the photo above to see what your finished framework should look like.

The next step can be both messy and fun. Pour a pile of sand into the framework you've constructed. I can tell you from experience that, for a 16x20 inch, 3/4-inch-deep sandbox, you'll need about 10 – 12 pounds of sand. Then, you're going to take a 2-foot-long piece of 1x2 lumber, rest it on the edges of your framework, and drag it over the framework's top. This will spread out your pile of sand and you'll end up with a smooth surface.

The final step is to spread a piece of ironed velvet (hint: iron the back side of the velvet so you don't ruin the velvet's nap) over the sandbox and lightly push your subjects into the velvet that has the layer of sand below it. As if by magic, rings, earrings, pins, or other typically uncooperative subjects stay in position and won't fall over as you place another piece into your composition, or even if you accidentally bump the tabletop! Oh joy! Oh rapture unbounded!

What kind of sand should you get? I buy decorative sand from a handicraft store instead of using beach or play box sand from a home improvement store. It is obviously more expensive than beach sand (which is free) or play box sand (which comes in larger sized bags). It is worth the extra money, though, because it is cleaner, with no little dead (or worse, alive) critters in it; it is much finer-grained; and it comes in colors, which opens up the possibility of using it as a background by itself without a piece of material over it. You might call that thinking outside the (sand) box!

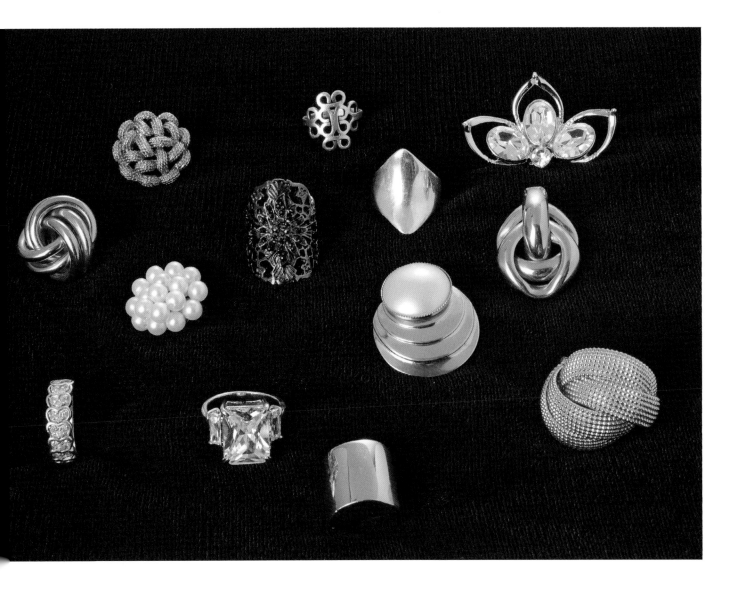

A Whole World of Possibilities

At the beginning of this chapter, I pointed out that there are almost as many background possibilities as there are products to photograph. Quite literally, I could almost write a whole book just about backgrounds and surfaces.

I know photographers that buy old barn board siding complete with peeling paint and rust-stained nail holes to use as surfaces beneath their subjects. Some buy sheets of marble from custom kitchen shops, or hexagonal terra-cotta tiles from flooring stores to use as surfaces.

Speaking of custom kitchen shops, sheets of Formica® come in a wide range of colors, reflectivities, and textures, and one can be flexed into a sweep using just a tabletop, two floor-to-ceiling poles, and a few spring clamps. Likewise, speaking of flooring stores, there are linoleums and rubber tiles with raised textures that are worth exploring (one such brand is Pirelli tile). The raised texture adds a clean, crisp look that really compliments high-tech products such as audio components or computer parts.

I personally have built a sandbox frame, filled it with moist red clay, smoothed the clay with a trowel, and baked it under two 1,000-watt quartz lights for a few days until it dried and cracked so I could use it as a background surface. If the subject you are photographing is small, and you are shooting straight down on it, a 12x12-inch (30.5 x 30.5 cm) square of background is often all you need of a unique surface, so don't overlook anything. The extent of what you can make into a unique background is only limited by your imagination, so use yours!

If you run into a dry spell and can't come up with an idea for a background, start looking around your neighborhood. I know of and have visited almost every hobby shop, handicraft store, art supply house, fabric store, plastic supplier, lumberyard, kitchen counter and bathroom tile showroom, and carpet store within a 15-mile radius of my office. I know where to find blocks of dry ice that I can use for smoke effects. I even know of a local taxidermist where I can get dried, posed butterflies from exotic lands in a variety of colors or glass animal eyes because, hey, you never know!

I mention all these items not to toot my own horn, but to give you food for thought. If you are going to be serious about still life photography, then part of your job description is to be aware of what possible backgrounds and surfaces are available to you. Maybe it's time you start looking around your area to get ideas of your own.

Fixtures

You might not know this, but when I described making a sandbox previously, what I really was describing was making a fixture. A fixture is something designed to hold a subject in a specific place, in a specific position, and at a specific attitude (tilt) without the fixture being seen by the camera. Because there is so much variety in what fixtures can be made of (after all, even a sandbox is a fixture), they are the kind of thing that is easier to explain by giving you specific examples of what they might be. Here are four kinds of fixtures I use.

This is what armature wire looks like when you buy it.

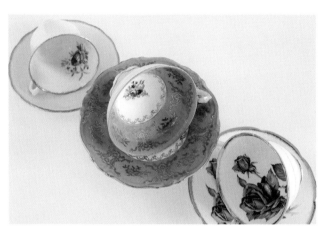

Armature Wire

Sold in art supply stores, armature wire is a solid (as opposed to braided) aluminum wire that can easily be bent into almost any shape by hand or (depending on its thickness) with two pairs of pliers, and it will hold the shape it is bent into. A spool of it is inexpensive, and it is available in a variety of different diameters. Armature wire was originally designed for use by sculptors to form a basic framework with and then cover with clay to flesh out the details of their sculpture. But, for a still life photographer who might be asked to float an antique teacup and saucer or some other lightweight item 4 inches over a surface, a piece of armature wire and a small blob of Fun-Tak® can seem like a miracle. Look at the photos below to see exactly what I'm talking about.

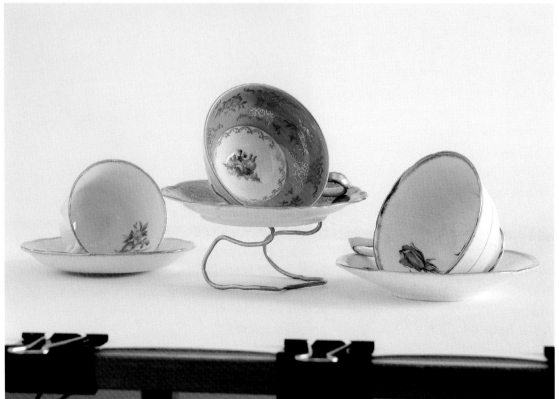

This is what armature wire might look like after a piece of it is bent into a fixture.

Monofilament

Sold in sewing shops and sporting goods stores (as fishing line), monofilament is an extremely thin, clear nylon thread that basically disappears once you are a few feet away from it. Let's say you have to photograph a pocketbook, and you want the handle to stand up instead of having it drape over the bag. You can string a piece of monofilament through the handle and tie it to something above the pocketbook and outside the frame of the photograph. I use a piece of 1x2 lumber supported by two light stands—one on either side of my tabletop set. Because the monofilament will be invisible, no one will ever know how you made that handle stand up. Monofilament to the rescue!

As another example, I had to do a head shot of a columnist who covered the world news. The concept given to me was him spinning a globe on his pointer finger like basketball stars do with a basketball. Needless to say, he couldn't do that, or at least not long enough to get a picture of it while he also looked at the camera and smiled. Although his face is cropped out of the image shown here because I don't have a signed model release, you can see I managed it.

I solved the problem by taping two pieces of monofilament from the globe, one running to a cross bar above the set and the second running from the bottom of the globe and taped to the floor. I spun the globe, he brought his finger up until it just touched the bottom of it, I dragged my shutter a bit to show that it was moving, and voilá, I had the shot. Monofilament to the rescue! For the record, now that we're in the digital age, it would be simple to clone out the monofilament altogether, but my original use of this image only ran 2x2 inches (5.1 x 5.1 cm), so the monofilament was invisible. I did not clone it out for use here, because I want you to see it for illustration purposes.

Last but not least, I wanted to float an orange slice over an arrangement of blue glass bottles, and I used a long piece of monofilament that was sewn through the orange rind so it exited the rind at the ten o'clock and two o'clock positions with the ends attached to an overhead crossbar with two bits of tape. I used two strands of monofilament so the orange slice wouldn't spin—monofilament to the rescue one more time!

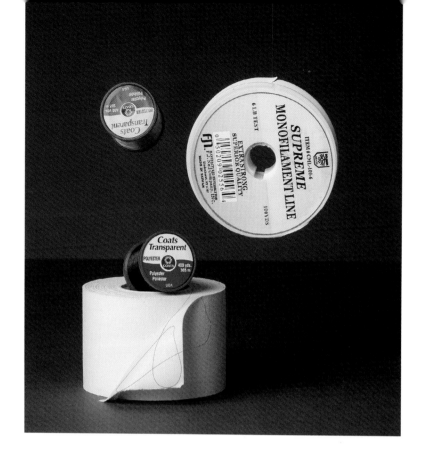

Here are three different examples of mono-filament. Even though they are very thin and almost invisible, any telltale signs of their use can be easily removed using Photoshop. So you can see just how thin monofilament can be, I attached some of the bottom spool to the turned-back piece of gaffer tape on the roll it is resting on. The clear monofilament seems to work best on white or lighter backgrounds, and black monofilament works best on dark backgrounds.

Odds and Ends

A fixture can be as simple as two blocks of wood nailed into your tabletop. On one assignment, I had to do 100 different teapots (for each style's box cover), but the monkey wrench in the assignment was that all the teapots had to be shot to exactly the same scale so that a small teapot looked smaller than a large teapot on the box cover. I nailed two very short pieces of 1x3 lumber arranged into a V shape into my tabletop and, once the perfect angle for the spout was decided upon and approved, I taped a pencil to the tabletop, just outside the photograph's frame, that lined up with the spout. I put a fixed focal length lens on my camera so I wouldn't be tempted to zoom in or out, and sandbagged my tripod until its legs creaked. After that, I could just push a teapot into the V, line its spout up with the pencil, blow off any dust on the pot, and push the shutter release button. In truth, after building that fixture, it took longer to unpack, repack, and cross the teapots' style numbers off the shot list than it did to shoot them.

Casting a Drop Shadow

Often, I'm asked to shoot an image of a thin box laying on its largest side, or even worse, a flat product with hardly any thickness at all. Boy, does a product like that create a boring image! One way to get away from the tedium of such an image is to create a drop shadow under it. I do this by hiding little blocks of wood or steel under the item I'm shooting so they can't be seen by the camera's lens. Now, I know this can be done in Photoshop quite easily but take a look at the picture of the drawer organizers, blotters, and coasters at left. In that image, there are six different drop shadows, and five of the items overlap other items in the photograph. The whole setup required only six little (different-sized) blocks of wood and six little Fun-Tak® blobs on top of my seamless background! It took me only 15 minutes to set it up before I made the exposure, and it was faster and easier than using software to do it.

Almost anything can become a fixture, so don't limit yourself to the few I mentioned. I sent a photographer friend my final image of the pliers (see page 180) and, after saying he loved the image, he asked me how I got them to all stand up at an angle. The truth is, I put a 5/8 bit in my drill and drilled five holes into a length of 2x4 lumber, each at an angle. I blew out the wood chips, and stuck a blob of Fun-Tak® in each hole. Then, I stuck one handle of each pair of pliers into the hole and the Fun-Tak® kept the little rascals in perfect alignment. I was able to do this because I had a pre-visualization of what I wanted the final image to look like. You should learn to pre-visualize your images too, and once you've got that image in your head, it's like I said—almost anything can become a fixture!

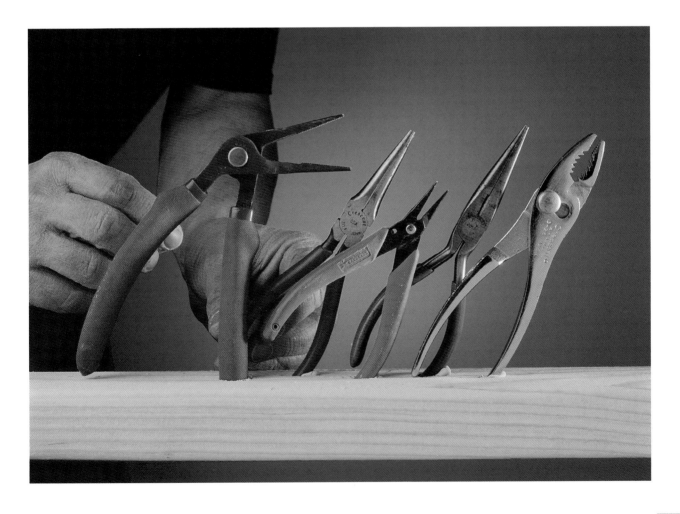

9

Portfolio Samples and Examples

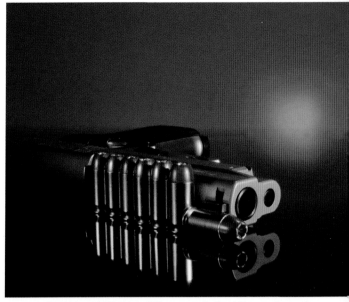

figure 1. Ugh! I hate it! Too busy! Too many bullets! You can't see the gun, and the background color is washed out. The horizon line is too high (see pages 192-195). In fact, my list of problems with this image is almost endless.

O f all the images you'll ever make, probably the most difficult, the ones that have to be the most perfect, the ones you'll agonize over the most, and the ones that will most show off your photographic skills, will be your portfolio samples. And, although they should be creative, it doesn't necessarily mean that creativity alone will rule the day. Clients will also want to see how well you can handle making images of the typical products that they are either producing or advertising. Of course you want the images you present to "wow" your potential clients, but the images should also prove to them you are able to show off to perfection what the subject of the photograph is. I will also add that if you stick to it, don't give up, and have a little bit of luck, eventually you could find yourself hardly ever having to show your portfolio at all. Your potential clients will know exactly what you can do before they even call you!

To this end, I created four new images to add to my portfolio specifically for this book. However, instead of just showing you the final images, I am going to show you how the images were lit, where, when, and why I added fill cards to my lighting design, plus the technical hurdles I had to jump to make them work. In other words, I am going to deconstruct the images so you can see exactly how they were done. I often feel as if every still life photograph is a journey, and my goal in this chapter is to take you along on the journey with me. So pack a notebook, and let's start out together.

The Gun and the Bullet: Simplify Your Subject

A friend of mine has a pistol. Although I'm not a big gun aficionado, he's a strong Second Amendment advocate, and he is in a profession that sometimes calls for defense and security. He brought his gun to my studio and asked if I would photograph it for him. Dutifully, I had him unload the magazines (that weren't in the gun) and prove to me there wasn't a bullet in the breech before he left the gun in my care to photograph it. I stored the bullets separately in a zip-lock bag and, honestly, I was a little uncomfortable that they were of the hollow-point, people-killer variety. But as I spent the day studying the gun, I kept checking out the bullets, which as it turned out, I found extremely beautiful.

I decided to shoot (ha, ha...get it?) a photograph of the gun and the bullets together but wasn't very happy with the resulting image. It was too busy, had too many bullets in the frame and, quite frankly, didn't show off the gun or get my message across. (See figure 1.) This was because, at that moment, I didn't have a message yet!

When looking for purity in a message, I have found that less is often more. How many bullets did I really need? How about just one? What were the most important parts of the gun? I thought the muzzle, the trigger, and the hammer seemed like the three things that were really important. Because the trigger and the hammer were close together and on the same face of the gun, and the muzzle was relatively far away and on a different face of the gun, I decided to limit my composition to the trigger, the cocked hammer, and a single bullet. Oh, and did I mention I wanted intense color? Now that I had simplified things, it was time to go at it again.

I set the gun back on a tabletop and set a bullet on top of it (held in place with a tiny blob of Fun-Tak®). Next, I framed it so only the three elements I wanted were included and started to experiment with getting a more intense background color. To make sure none of the spill from my two front lights hit the diffusion screen that I was using as a background, I put 20-degree grids on both of them to narrow their beams. One light (on the left) was diffused through an 18-inch (45.7 cm) square of translucent white acrylic (hard to notice because it's in front of Flag 1) and the other (on the right) was diffused with some Tough Lux. Doing this certainly helped to keep the background dark so the red-gelled light behind the background would be more intense, but I also introduced two flags into the set. I placed Flag 1 (so big I labeled it twice!) on the left side of the set and Flag 2, though smaller, blocked the beam of the right side light. (See figure 2.)

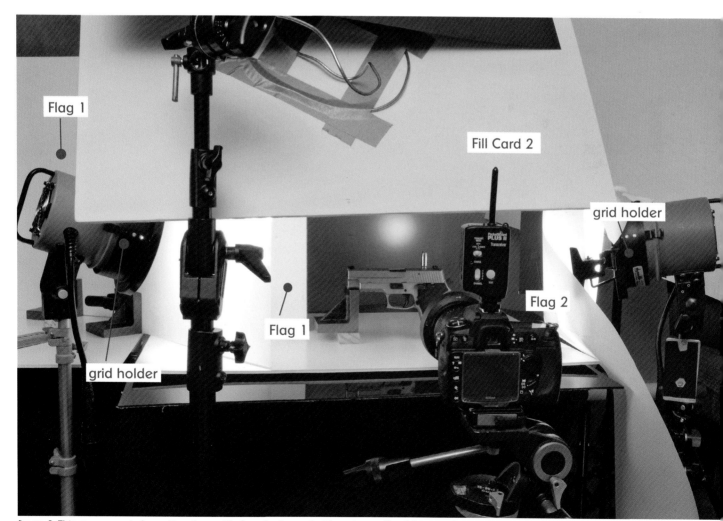

figure 2. This may seem to be putting the cart before the horse, but here is a pullback image of the final set with the flags, grid holders, and a fill card noted.

Three Lights, Added One by One

The first thing I worked on was getting the background light intense. I also made sure that the gun was positioned in such a way that some red highlights from the red gelled background light hit the inside of the gun's trigger guard and two little nubs on the underside of the barrel so that the red gelled light made those specific small parts of the gun more interesting. See figure 3 to see the effect of the red background light by itself.

Although this may seem counter-intuitive, the next light I added was from the left and wiped over the gun's front face. I chose to light from the left first because any light from the right would be blocked by the grip and would not hit the trigger, which was one of my three chosen subjects for the image. Furthermore, I wanted the light on the trigger to hit the front of it and not the back, plus I found the saw-toothed edge at the front of the trigger guard interesting, and I wanted to highlight it. (See figure 4.)

Lastly, I added a third light from the right side that was 1.5 f/stops hotter (three times more powerful) than the light on the left to illuminate the cocked hammer. I positioned the left and right side lights so their beams wiped across the surface of the gun to accentuate anything in low relief on the side of the gun (figure 5).

figure 3

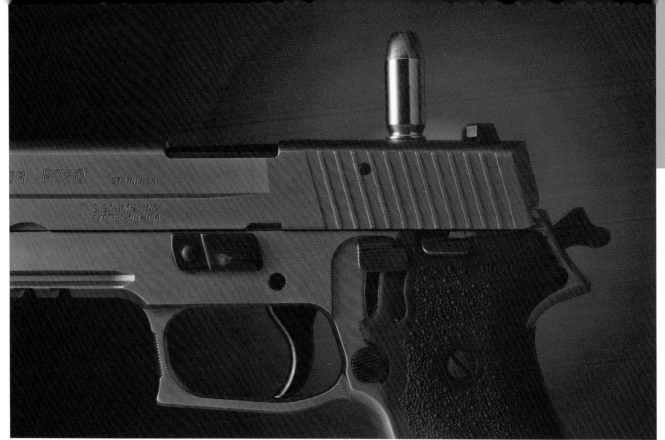

figure 4

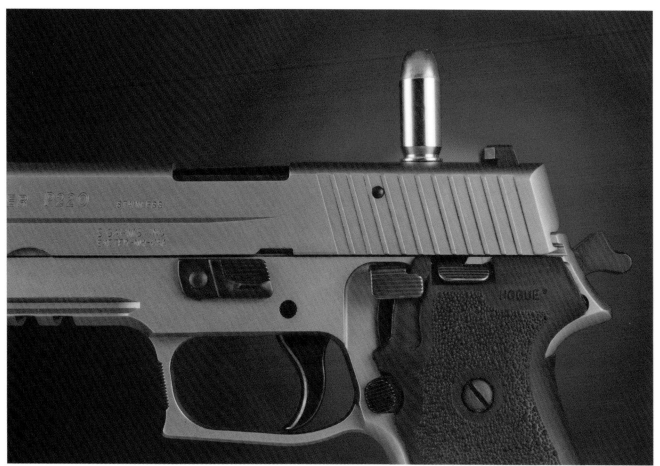

figure 5. The final "less is more" image, but now that you've seen the set, maybe you'll agree it sometimes takes more to get less!

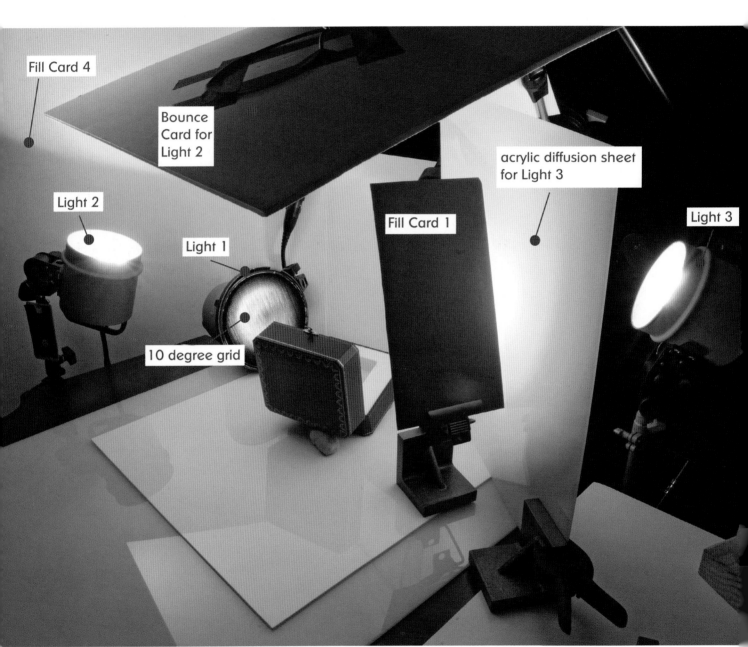

Fill Card 4

Bounce Card for Light 2

acrylic diffusion sheet for Light 3

Light 3

Light 2

Light 1

Fill Card 1

10 degree grid

figure 6. Study the notations on this image and the one on the opposite page carefully and refer back to them as you view the images that follow.

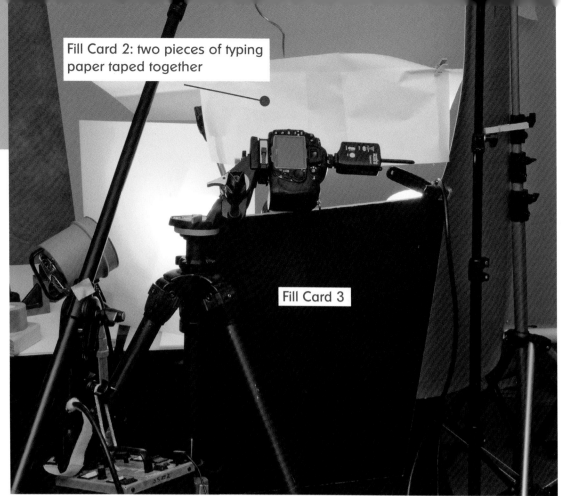

Fill Card 2: two pieces of typing paper taped together

Fill Card 3

figure 7

The Cartier Watch: The Anatomy of a Beauty Shot

Another friend bought his mom an antique Cartier watch and asked if I would photograph it for insurance purposes. Normally, this would be a simple record shot, but once I saw the presentation box it came in, and since I was writing this book anyway, I decided to do a beauty shot of it and deconstruct the image for you.

Again, I will start off a picture of the set. Actually, I'll start off with two pictures of the set. The first picture is called a reverse-angle view, which is shot from the rear of the set looking at the back of the subject and seeing the camera also. The second will be similar to the last picture's set shot, a pullback image so you can see what's happening from the front side of the scene.

I needed both pictures, because the final image required a complicated lighting scheme and I wanted to label all the lights, lighting accessories, and fill cards I used. (See figures 6 and 7.)

Often, when I use a complicated lighting design, I will place a light and then add a fill card (or two) to solve some of the problems the light's placement creates. That being the case in this instance, I will show you a series of images that represent the lights being added one by one and then I will remove the fill cards one by one so you'll be able to see exactly what that fill card did.

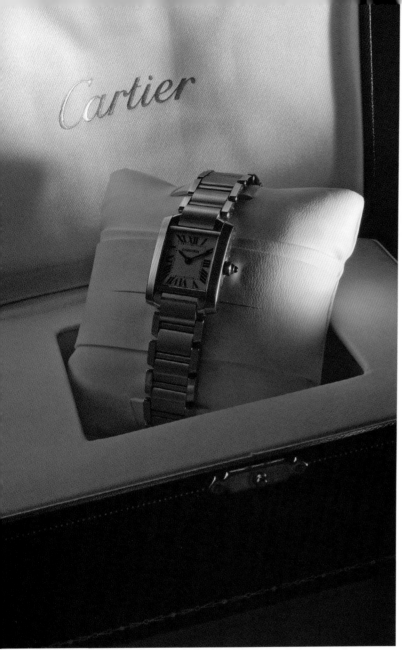

figure 8. This is Light 1 on the reverse-angle shot shown on page 220. I used a 10-degree grid on it to limit the size of its beam and keep it from hitting my primary subject. It's only job was to light the corner of the presentation pillow and the "C" in Cartier. As you can see, it also lit the "a" in Cartier, but I took care of that issue later using Photoshop.

Light 1: It may seem strange, but I often start off by adding any accent lights I'll be using on my subject. There's a reason for me doing this. Because my accent light(s) are usually the strongest one(s) I will be using in my lighting design, once I nail down the correct exposure for that light, I then know how strong I can make the other lights I add without losing the effect created by my accent light. (See figure 8.)

Light 2: Now it was time to light the watch itself, and to do so, I bounced Light 2 off a large (20x30-inch / 50.1 x 76.2 cm) foam core bounce card suspended on a boom arm over the set (figure 9). For the record, a bounce card is just a fill card that you bounce a light off of (see pages 164-165).

Light 3: Next, it was time to address the watch face and the band below the face, which I did using Light 3. To soften this light's beam, I placed it behind an 18-inch (45.7 cm) square of 1/8-inch-thick white translucent acrylic. Note that I tilted Light 3 upwards so that, in addition to lighting the watchband below the face, and the face itself, some of Light 3's beam also hit the bounce card that Light 2 was illuminating. (See figure 10.)

Fill Card 1: The first fill card I removed was Fill Card 1, shown in figure 6. To see exactly what Fill Card 1 was doing, compare figure 10 to 11.

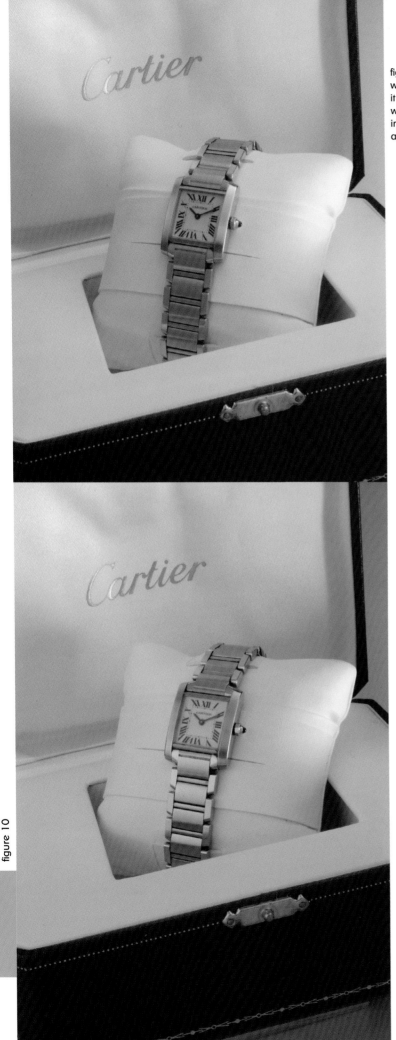

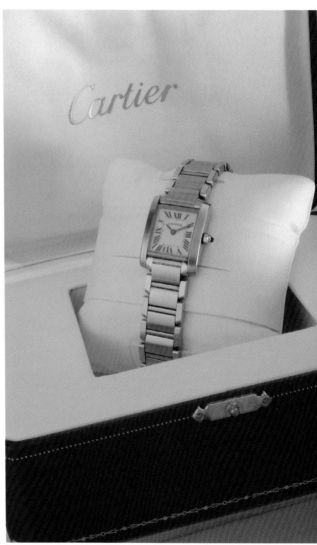

figure 9. Now I've added Light 2, which serves two purposes. First, it lights the watchband above the watch face; and second, it fills in the inky black shadows created by the accent light that I placed first.

figure 10

figure 11. Want to know what Fill Card 1's purpose is? Just look at the watch face's frame between IX and X.

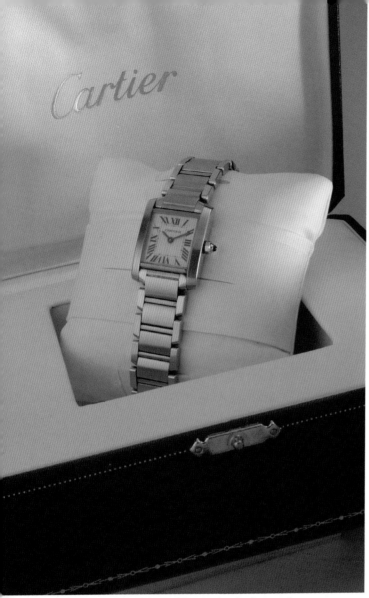

figure 12. Fill Card 2 was filling in the shadow on the watch face's frame between the III and V.

Fill Card 2: Next up, I removed Fill Card 2. Fill Card 2 wasn't really a fill card in the traditional sense. Instead, it was two pieces of typing paper taped together and attached to the bounce card floating over the set with a clothespin and a bit of tape.

I used typing paper, the clothespin, and the bit of tape as an improvised fill card instead of a more traditional cardboard fill card in this instance, because the improvised fill card I chose to use was lighter in weight, and I was attaching it to the bounce card already suspended from a boom arm. A heavier, more traditional, fill card would have required a heavier clip to hold it in place, and the added weight might have upset the balance of the carefully positioned bounce card.

It's important to note that almost any white surface can be used as a fill card, and sometimes, the lightest-weight possibility has distinct advantages over a heavier alternative. (See figure 12.)

Fill Card 3: Removing Fill Card 3, which is a large card beneath the camera's lens, makes the whole image a little darker and especially creates shadows along the right side of the watch, from the crown to the bottom of the band. (See figure 13.)

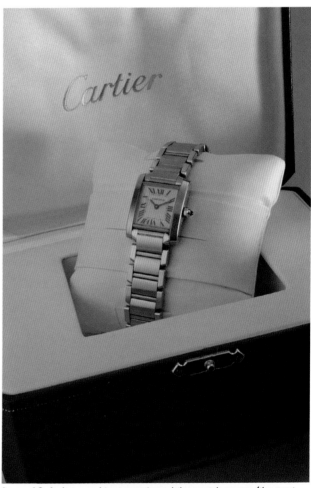

figure 13. As long as I just mentioned the watch crown (the part you wind), it's time that I shared a secret about shooting any analog watch. I was taught (and have found to be true) that you should always set any watch with hands to 10:10 before you photograph it. When you set the hour hand to 10 and the minute hand to 2, the hands frame the watch's name and usually don't block any secondary printing on the bottom of the face. I learned this the hard way and once had to reshoot 50 watches because I didn't think about the position of the watch hands first...so, just take this hint as a word to the wise.

Bounce Card for Light 2: When I removed Bounce Card for Light 2, the entire frame of the watch face just sort of died. (See figure 14.)

Fill Card 4: Finally, by removing Fill Card 4, we are about as far away from the smoothly lit visage we had in figure 10 as we can get. It has also become an image no client would be satisfied with and, quite frankly, neither should you! (See figure 15.)

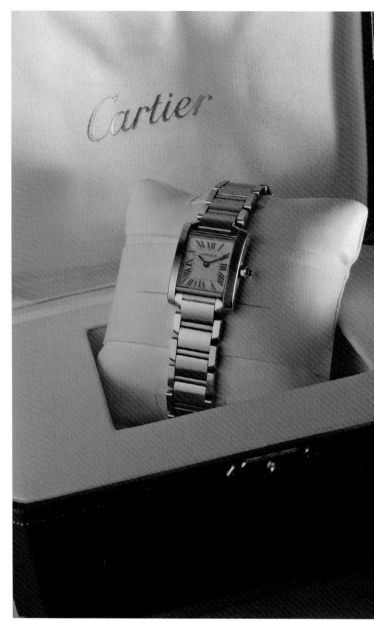

figure 15. Without sounding overly harsh, if this is the finished image you show to a client, they will probably head for the door of your studio and never be seen again.

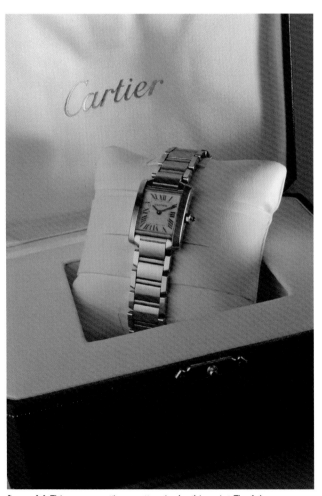

figure 14. Things are getting pretty grim by this point. That's because Bounce Card for Light 2 is not only a fill card, but a light source as well.

Now that we are in the digital imaging age, it is important to remember that we can ruin the flavor or feel of a subject in post-production work as easily as we can when we are photographing it. In my first go round at using Photoshop to improve this image, I was sure I wanted the face of the watch to "pop" more. Using mostly brightness / contrast (with a bit of help from a polygonal lasso tool), I did what I thought would be great, only to turn a $2500 classic watch into a cheap Indiglo®! (See figure 16.) While I have nothing against Indiglo watches, and in fact wear one every day, my Photoshop work was just too heavy-handed. I went back to my original image and once again brightened the watch's face and added more contrast to it, but this time to a lesser extent. (See figure 17.)

This leads me to my last, and possibly most important hint about this image in particular, and in general, all my images all the time. After spending an hour or two getting my lighting perfect, I never work on the original digital file when doing my post-production Photoshop work. Because a duplicate digital file is exactly the same as the original digital file, I always duplicate it before I start to work on it. That way, in the event I mess up the perfectly captured picture for any reason when I'm working on its digital file, I can always go back to the original and duplicate it again so I can have a second bite at the apple! This means my absolute rule is this: Before I do any (any!) Photoshop work on an image, I duplicate it and only work on the copy! If I find myself going back to rework an image two or three or more subsequent times, then I make a copy of the original each time before I start modifying it in Photoshop. I have found doing this is a habit well worth turning into a religion.

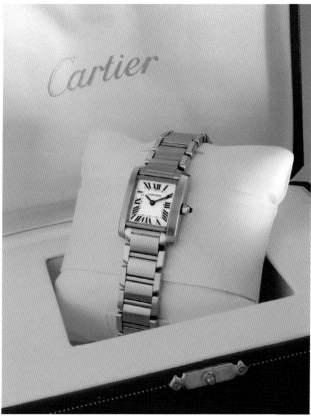

figure b16. Heavy-handed Photoshop work can ruin all the effort you've put into an image up to that point.

figure 17. This is my final image of the Cartier watch. I think it is good enough to be added to my portfolio.

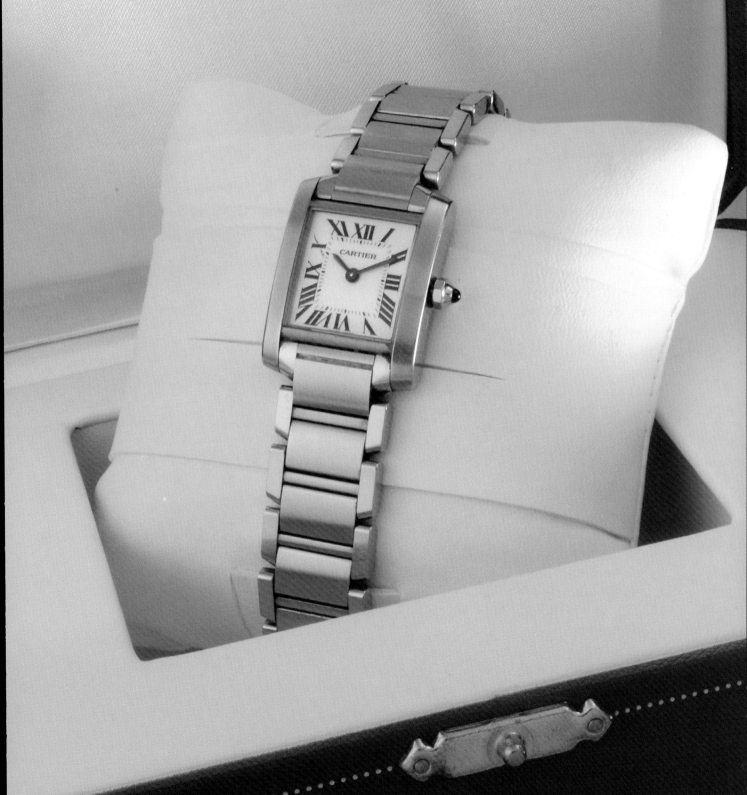

Hollow-Point Bullets and Cherry-Red Lipsticks

Chronologically, I created this image as one of the very last images I did for this book, over 300 images into the project. Even after I created the image of the gun and the bullet, days before this one, I was still intrigued by the hollow-point bullets. In a way, their deadly tips kept reminding me of hard little bronze-colored flowers. I kept standing them up on an acrylic sheet, and then it dawned on me: They might work with lipstick! So, the mental picture I envisioned was row upon row of alternating lipsticks and bullets—one row hard, bronze-colored, and metallic; the next row cherry-red with a soft, almost liquid sheen, both deadly, albeit in different ways.

The problem was that there would be technical limitations to overcome to make the image I had in my head. The bullets were barely an inch (2.5 cm) long, while the lipsticks, extended fully, were almost 3 inches (7.6 cm) long. Unless I shot straight down on the rows, the bullet tops would be lost in a sea of cherry red. OK, I thought, so I'd shoot straight down on them. To accomplish this, I'd use a side arm on my heaviest tripod (see page 253). However, a quick test with my macro lens proved to me that I still wouldn't have the depth of field necessary to cover the 2-inch height disparity between the bullet and lipstick tips, even if I stopped my lens down to f/32. I almost tabled the whole idea until I realized the lipstick caps were about 2 inches long. I did a quick mock-up with the lipsticks extended and the bullets standing on the lipstick caps. This resulted in failure. The lipstick's cases and caps were just too big—there was too much space between the rows of lipsticks and bullets for any meaningful correlation between them (figure 18). Maybe tabling the whole idea was the right way to go.

figure 18. Success denied!

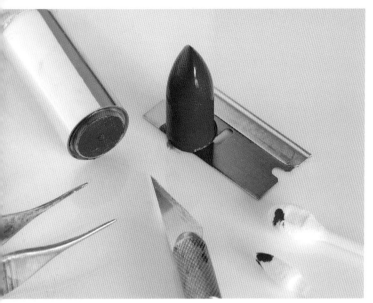

figure 19

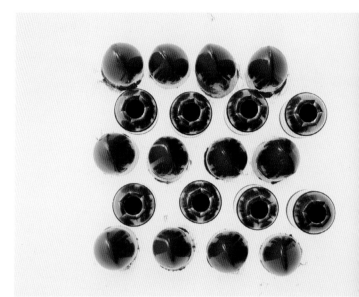

figure 20

figure 21

Lucky for me, I am tenacious! I took a break, walked around my studio for a few minutes, took a few deep breaths, cursed to myself a few times, and sat back down at the light table to once again stare at the bullets and lipsticks in front of me. Then, an old saying popped into my addled little brain: If I couldn't raise the bridge, maybe I could lower the water! The fully extended column of lipstick, not counting its tube, was just about as tall as a bullet.

Within a few minutes, I had gathered some single-edged razor blades, an XACTO® knife, a pair of tweezers, and some special cotton swabs used for makeup application. I proceeded to cut off each lipstick column with the single-edged blade and then I slid it off the razor blade with the side of the XACTO® knife blade (figure 19). I positioned it on my tabletop where I wanted it using the side of XACTO® again and the side of the tweezers' handle, being careful to only touch the side of the lipstick that the camera couldn't see. I used the swabs to clean up some lipstick that smeared on my acrylic because it turns out that a column of lipstick by itself is soft, messy stuff. I now understand why it comes packaged in retractable tubes! I did an arrangement of the lipstick columns and the bullets that was promising, but still not what I wanted (figure 20).

I gently rearranged the lipstick and bullets into tighter rows with less space between them and decided a more oblique angle, as opposed to shooting straight downward, would give the appearance of less distance between my subjects. Doing this had the added advantage of hiding all the messiness at the bottom edges of the lipstick. I used a 24mm lens on my DSLR as a sighting tool so I could explore many different possible camera positions quickly and easily using a hand-held

camera. I decided on my final, tripod-mounted camera placement before switching to a 24mm PC lens with a tilting capability (see pages 242-246) so that I could get the depth of field I needed to keep all my little subjects in focus.

My first try at this final arrangement resulted in an image with so many problems needing to be corrected that I made a little map of what had to be moved or rotated, which you can see in figure 21. Finally, I methodically made each change noted on the map until I got to the final image (figures 22 and 23).

figure 22

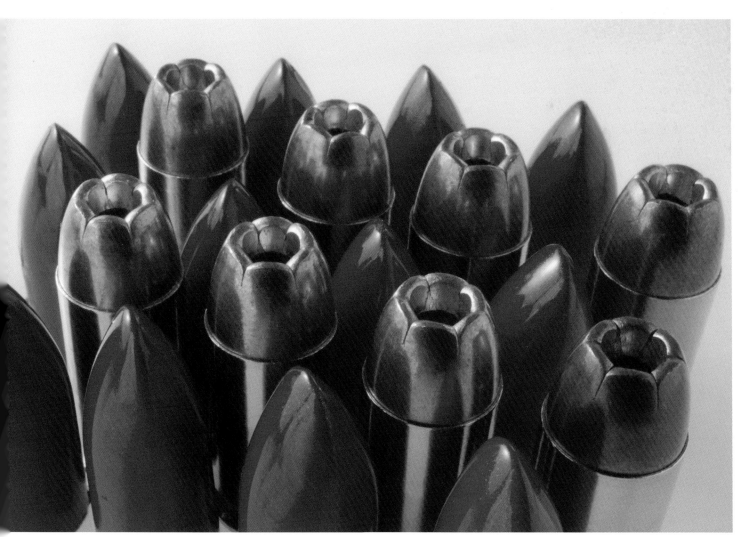

figure 23. This is the final image I came up with. One person who saw it wrote to me the following: "To me it's strangely erotic and disturbing at the same time. Nice light." If you remember how I'm always going on about creating an emotional reaction in my viewer, then you could say this image is a success!

White on White: Terror on the Set

Of all things that can strike fear into the heart of even a great a still life photographer, shooting a white subject on a white background is probably the scariest. But, probably because it is so scary, I feel it is a great addition to almost any portfolio. Furthermore, experienced and educated art directors and clients understand just how difficult it is to do it well, and therefore appreciate such an image when its done well and respect the photographer who pulled it off. Here are some ideas that might help you if you try to make a white-on-white image.

What exactly is going to be the white? This is an important decision you have to make. Even if the product is white, the surface it is resting on is white, and the background is white, there can only be one truly white thing in the image. If everything in your frame is truly white, then all the tones in the image will merge together, and you won't be able to distinguish one from the other.

Learn and understand the difference between flare and glare (see the lighting glossary, pages 116-121). This is especially important when working with white-on-white images.

The following are four variations (and one mistake) on an image of a bottle of mouthwash. The product is a white bottle with a white label placed on a piece of white translucent acrylic, and the background is a large piece of white diffusion material. For all four variations (and the mistake), the subject is lit with a single light source from its left (the camera's right) and a small V-flat reflector on the subject's right (the camera's left).

Figure 24 is a high-key rendition. By definition, a high-key image is one in which the background is brighter than the primary subject. While this can be very effective in certain portrait situations, I find it to be detrimental when shooting a white subject in a still life photograph. To my eye, it makes the white subject look grey, dingy, and lifeless.

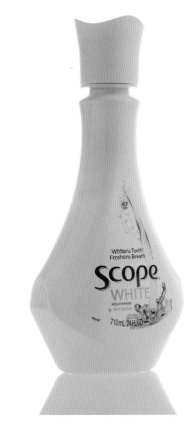

figure 24

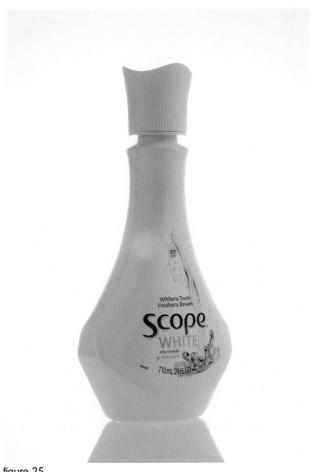

figure 25

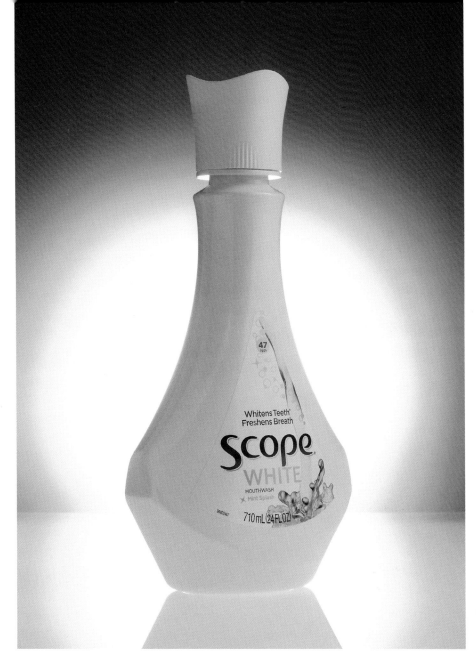

figure 26

One specific problem you face when shooting a high-key image is you are always on the verge of causing a flare. In this case, the flare presents itself as a green ball of color on the face of the bottle (figure 25). While I was able to retouch out the flare using Photoshop in this particular instance, a flare also creates a loss of sharpness and contrast, so I find it's often a better solution to decrease the intensity of the lights illuminating the background and under the acrylic table surface.

Figure 26 is a modified high-key rendition. I created it by adding a grid to the light behind the diffusion sheet background to narrow the beam of light shining through. Notice how the darkened top of the image keeps the viewer's eye from running off the top. I also like that the bottle seems less grey, dingy, and more "alive." While I still had an issue with a flare, it was much less noticeable, and once again, I eliminated it in Photoshop.

One thing I have noticed in recent published photographs is that some photographers are including light sources within their image's frame. Because I really liked the rim light effect in the image at left, but really disliked the blandness of the resulting grey background, I decided to bring the circular edge of the pattern created by my two back lights with grids into the frame. I did this in the hope that I could retain the rim light effect and, at the same time, use the circular edge of the lights with grids to accentuate the sensuous curves on the side of the bottle (figure 28). I think I accomplished that, and I'm happy with my final result.

The whole idea behind this chapter is not that you love the images I'm presenting. Instead, the goal is to give you ideas about how you would go about creating a portfolio piece for yourself. I have tried to be open and honest with you by showing you more images that were mistakes I made during each journey than final, perfected images. I think you should absorb my mistakes as well as the finished images because, in reality, learning from the mistakes I've shared is probably more important than just looking at the finished photographs. I hope the primary thing you come away from this chapter with is the realization that no still life portfolio image is going to be perfect the first time you push your shutter button. You've got to learn to be stubborn and not settle for anything less than a final image that you are 100% satisfied with. Sadly, when it comes to your portfolio images, "good enough" is just never good enough!

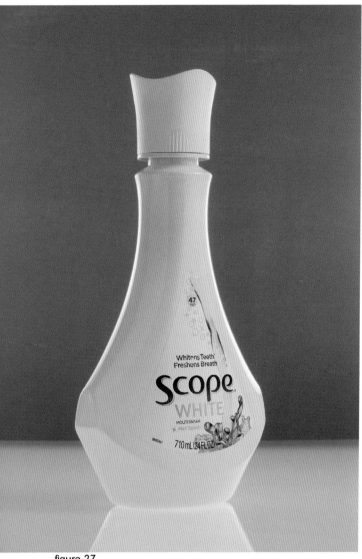

figure 27

For figure 27, I changed from a single light to two lights with grids shining through the diffusion sheet background, with each of the two lights placed just outside the camera's field of view. The two lights caused both sides of the bottle to be rimmed with light and that rim-lit area became the true white in my image. My only real objection to this image was that the background became grey and bland, but at the same time, it made the subject look more white.

figure 28. Notice how the bottle really looks white in this final image, even though the rim lighting is still brighter than the bottle's face. Part of this appearance of whiteness is an optical illusion. Because the bottle is framed in areas of grey, the bottle itself (even though the rim lighting is whiter than it) appears brighter by comparison.

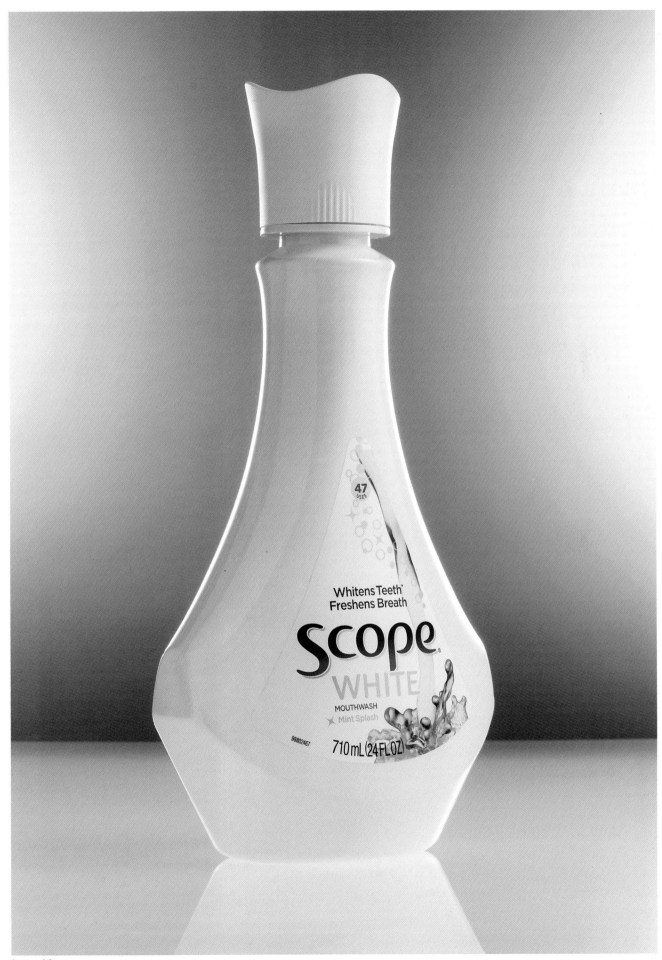

figure 28

10
Camera and Accessories

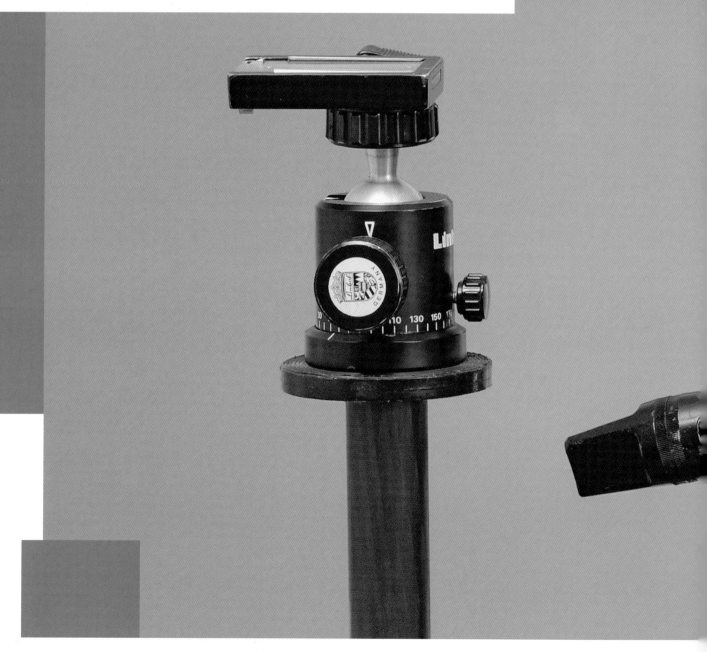

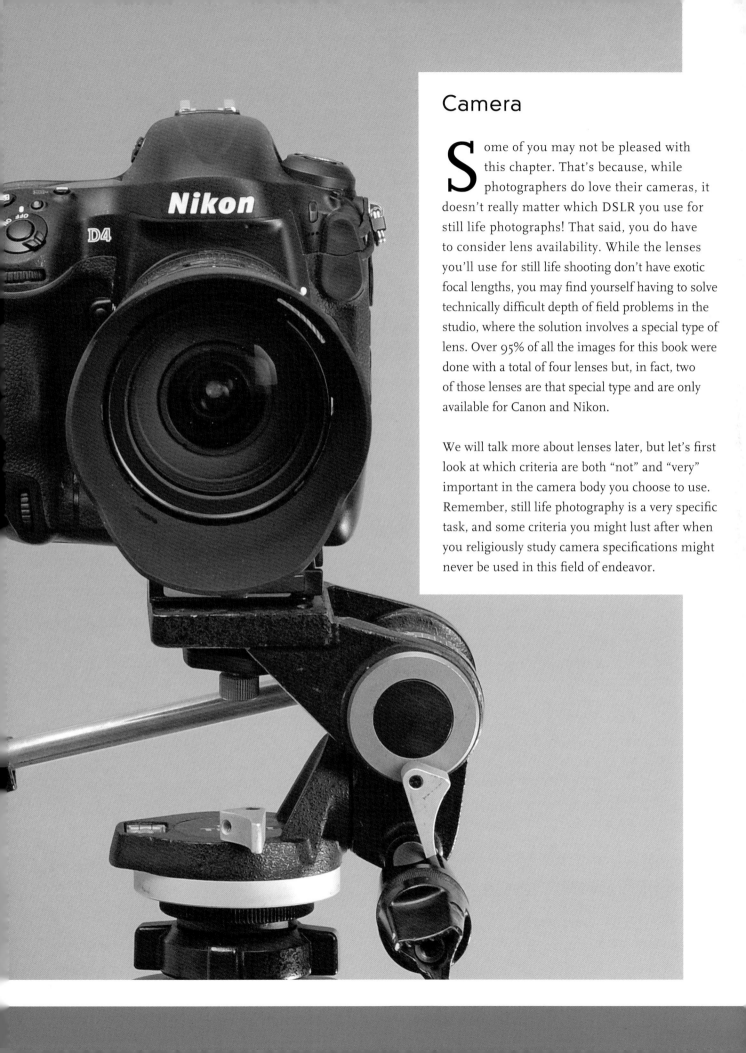

Camera

Some of you may not be pleased with this chapter. That's because, while photographers do love their cameras, it doesn't really matter which DSLR you use for still life photographs! That said, you do have to consider lens availability. While the lenses you'll use for still life shooting don't have exotic focal lengths, you may find yourself having to solve technically difficult depth of field problems in the studio, where the solution involves a special type of lens. Over 95% of all the images for this book were done with a total of four lenses but, in fact, two of those lenses are that special type and are only available for Canon and Nikon.

We will talk more about lenses later, but let's first look at which criteria are both "not" and "very" important in the camera body you choose to use. Remember, still life photography is a very specific task, and some criteria you might lust after when you religiously study camera specifications might never be used in this field of endeavor.

Exposure Modes

You don't need umpteen different autoexposure modes! The best exposure mode for still life photography is M—M as in Manual! Here's the scoop: Even if a photographer uses a handheld camera as a sighting tool to find the perfect camera position, successful photographers soon realize that if the subject doesn't move, there's no reason that the camera has to move either; so, a sturdy tripod or camera stand becomes the camera support of choice. That means that, for any given setup, a photographer can easily run off a string of slightly different, bracketed exposures. But, even with a dozen (or two dozen!) different exposures to choose from, if the range of brightness in the scene's highlights to the darkness in its shadow areas exceeds what the camera can record, then no amount of bracketed exposures can save the day. Still life photography is a slow, methodical game whose foundation is built on careful lighting technique, and autoexposure just isn't neccessary to play the game.

Framing Rate

There is no need to have a high framing rate for still life photography. Your subject is not going anywhere—it's not swinging a bat, jumping hurdles, or running for a touchdown. In fact, if you use professional-level flash units, the flash unit's recycle time will slow you down to one image at a time anyway. If you prefer to work with continuous light sources instead, the f/stops required for adequate depth of field will almost always require you to work on a tripod. A high framing rate is just not important when shooting a widget, a toaster, a knife, or a handbag. Generally speaking, none of the typical products you'll be tasked with shooting are going to wiggle or run away as you photograph them, nor can they change expression or even blink.

White Balance

I find that having the ability to set your white balance by Kelvin Temperature is extremely important. In fact for me, if a camera doesn't offer a Kelvin white balance setting, then that's a deal breaker (see pages 174-176 for more on white balance).

High ISO Capability

Like other supposedly important features, having the ability to shoot at very high ISO settings is just not that important for still life shooting. In fact, because you are most often shooting in a controlled environment and working on a tripod, you can usually shoot at low ISOs easily. I think you'll find that shooting at the lowest ISO setting your camera offers will reward you with the best image quality.

Resolution

This metric is a double-sized can of worms. The first half of the can is how many megapixels (MP) you are going to need, and that depends upon how the images are going to be used. If you are shooting for web use only, where your images will not likely be viewed much bigger than 5x7 inches (12.7 x 17.8 cm), an image with 1024 pixels in the long dimension contains more than enough information to look great when viewed at 72 pixels per inch (ppi). Conversely, if you are shooting an image of a product for a full-page national ad to appear on a glossy 8.5x11-inch magazine page, there are those who will argue that you need more than a 20MP capture to compete with other photographers doing these types of assignments.

Camera Type

This might sound like heresy, but if you are shooting still life or product images only for web use, you might not even need a DSLR! And, shockingly, you might not even need a camera with interchangeable lenses! There are high-end point-and-shoot cameras that can satisfy most if not all of the important criteria I've already listed. Further, these same cameras (almost universally) offer the close-focusing ability that is important in product photography.

On the other hand, the exact opposite of what I just said may be true: You might need a DSLR, though probably not for the reason you think. Not for the gain in image quality a DSLR can provide nor for the extra features, but to impress your client with your camera's presence instead! This concept may make you laugh, but I can't tell you how many times I've been asked what my cameras cost when I've opened my case. In fact, I think some clients justify the fees they are paying for my professional photography services based on the cost of the cameras and lenses I'm using. That being the case, I always inflate their value a bit when I'm asked the question.

Brand Name

Finally, as I said just before starting this list of requirements, the brand of camera you use is just not that important! This does not mean that any aficionado of a particular brand won't be willing to argue with you all day and into the night that their brand and type of camera is better than yours. Phooey! Nor does it mean that, when choosing a brand for yourself, you won't spend countless hours examining reviews, researching, and comparing things like pixel size and pixel count, price, various models in the brand's line, sensor size, and a host of other things that may or may not be relevant.

Every manufacturer will try to tout their brand as best (through advertising and endorsements), and every reviewer, no matter how objective they try to be, will have their opinions colored by their own preferences. This is true because it's the way that competition in the marketplace works, and interestingly enough, it's exactly the kind of force we are trying to exert when we make still life and product images for a client anyway.

Regardless of all the effort you put into making your camera choice, I truly believe that lighting and positioning your subjects (and the camera relative to them), background choices, the clarity of your vision, and your business skills are the most important tools you have available to insure your success as a professional photographer. No camera can accomplish any of these qualities without a knowledgeable photographer behind it and that last one doesn't even require a camera at all; they can only be learned and earned by you!

Now, let us not forget that there is one choice you make about the equipment you use that has a profound effect on the images you create, and that is not the camera itself, but the lens you choose to put on the camera; so let's talk about lenses!

Lenses

Unlike some other genres of photography, extreme focal length lenses aren't extremely useful for still life photography. Extreme wide-angle lenses, for example, capture such a wide angle of view that, even if you come in really close on the subject you're photographing, the background would have to be very wide. However, there are times when you might want to use a wide-angle lens to accentuate perspective distortion for an illustrative type of image. I have found that in those instances, a moderate wide-angle lens will suit my needs. So—and this is an opinion thing—the widest focal lengths I find useful are about 17 to 24mm on an APS-C DSLR (smaller sensor) or 24 to 36mm on a full-frame DSLR.

Likewise, extreme telephoto lenses require so much room to back away from the product I'm photographing and have such limited depth of field, even when used at smallish apertures, that I also find them superfluous for general still life and product photography. In fact, a short telephoto, often called a portrait lens, works very well. My opinion again, but something in the 70 to 90mm range for an APS-C camera or the 100 to 120mm range on a full-frame camera will serve you well. But wait—hold on a minute. Many of you, after considering my suggestions of 24 to 36mm on the wide end and 80 to 120mm on the long end, must be thinking that there's a zoom lens with just such a range available for your camera brand. Right you are!

More importantly, it's imperative that this lens is rectilinear, which almost all modern non-fisheye lenses claim to be these days (but aren't). That means the lens records straight lines as straight. There should be little or no barrel or pincushion distortion at the ends of the zoom range, because if you're shooting a box, and the camera's imaging plane is parallel to the box's edge, it is important the sides of the box should not bow outward or inward. From experience, I can tell you that most of the mid-range zooms I've used exhibit some barrel distortion at the wide end of their ranges and transition through being truly rectilinear at mid-range to exhibiting some pincushion distortion at the long end of their zoom range.

Also worth noting, while barrel distortion makes vertical lines bow outward, and pincushion distortion makes vertical lines bow inwards, there is a third type of distortion called "mustache." This is a truly weird one, in which vertical lines bow inward at the top and bottom of the frame and then outward at the middle of the frame. This specific type of distortion gets its name because it looks like a handlebar mustache. The real point of my mentioning all this is the fact that you should test your own equipment and know both its positive and negative attributes.

Close Focusing Lenses

A truly rectilinear zoom lens is even sweeter if it has a close focusing range (often called "macro"). (It's not truly macro, but that's OK. More on this shortly.) I use a 24-85 mm f/2.8-4 Nikkor as one of my four primary still life / product lenses and, in truth, it is so important to me that I own two of them! Need I mention that this lens also has a close focusing range? But, while I intended to help you by mentioning the specific lens I use, if you have or want to buy a 24-70mm, fixed-aperture zoom instead, the world won't end because it's 15mm shorter than my choice; just as it also won't end if you use a 24-105mm or a 24-120mm zoom instead. It is just important to know that any of the three lenses I just mentioned are all much more useful than a 14mm wide, a 300mm telephoto, or even the ubiquitous 70 (or 80)-200 f/2.8 zoom for this particular type of assignment!

Micro / Macro Lenses

Another lens I used to create a lot of the images in this book is a 60mm f/2.8 Micro Nikkor lens. (Canon calls theirs "macro.") Regardless of the brand I use, let's talk about the focal length I chose instead. Many photographers I know (especially those who shoot bugs and flowers) prefer a 100mm Micro lens instead, because it allows more working room between the camera and the subject, and this can be a definite advantage. In fact, I might have chosen a 100mm micro lens if not for three reasons: In the first place, when I bought my first normal focal length Micro Nikkor there was no 100mm choice available! Second, since I currently shoot with APS-C cameras, my 60mm lens frames the subject as if it were a 90mm lens because of my camera's cropping factor. Lastly, although the depth of field at any given aperture on lenses of different focal lengths is similar when shooting extreme close-up images, once you are shooting at longer distances instead, a shorter focal length lens has greater depth of field than a longer focal length lens.

Inexperienced photographers will immediately think they're going to be shooting extreme close-ups on their still life assignments, and they absolutely must have a micro (macro) lens, but that just isn't the case. Shooting at a 1:1 ratio means that if the subject is 1/2 inch across in reality, then its image on the sensor will be 1/2 inch across. Other than pharmaceuticals, gemstones, and some tiny electronic parts, there very few subjects a still life photographer will face that require all the performance (in terms of magnification ratio) a micro or macro lens can deliver. Furthermore, for every one of those truly tiny subjects, there are literally thousands of other, larger products that will make up the bulk of your assignments. To me, the primary reasons for owning a micro / macro lens are because they are more likely than other lenses to be perfectly rectilinear, and they are better corrected for close-up work at even modest reproduction ratios than lenses designed for general photography.

For most still life product photography subjects, you'll generally need a magnification ratio of between 1:10 and 1:20, which means a 10-inch-tall bottle of whatever will record as somewhere between 1 inch (1:10) and 1/2 inch (1:20) on the sensor. These are the more modest reproduction ratios I mentioned. The point is, until you get that assignment photographing 1000 pills, gemstones, or tiny electronic widgets, the 1:1 capabilities of a micro lens do not make it an absolute must-have purchase. But, do keep in mind that the very same lens' other attributes mean it will always earn its keep in a product photography studio.

Tilt-Shift and Perspective Control Lenses

If you find yourself getting a lot of still life or product photography assignments, you might want to invest in an expensive, special-purpose lens called a Tilt/Shift, or Perspective Control, lens. Generally speaking, these lenses are primarily made by and for Canon and Nikon. There is a similar lens line made by Schneider, but they too are only available in Canon and Nikon mounts at the time of this book's publication. The Nikon line includes 24, 45, and 85mm focal length lenses. The Canon line is bigger—their lenses that are best suited for still life product photography come in 24, 45, and 90mm focal lengths. The Schneider line includes the very useful 50 and 90mm focal lengths too.

Here are the 24mm and 45mm PC Nikkor lenses.

Normally, one part of image quality depends on a camera's lens plane (a plane that's perpendicular to the lens' axis) being perfectly parallel to the imaging sensor's plane and the lens' axis centered on the imaging sensor's plane. You pay a lot of money for high-end cameras to ensure that is the case. But, this same feature can be limiting at times, because an image's plane of subject focus will always be parallel to the lens plane; and since the lens plane is parallel to the sensor, that means the image's plane of focus is parallel to the sensor too. That works really well for some subjects, but not so well for others.

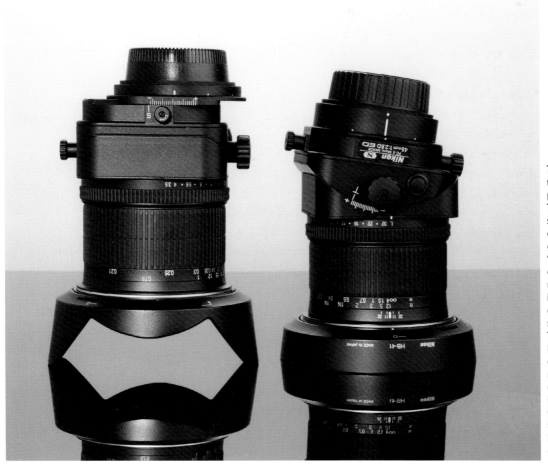

This picture shows the two special things these particular lenses can do. The type of movement shown on the left lens is called "shift" if it is done on the horizontal axis, and "rise" or "fall" if it is done on the vertical axis. Either movement is really helpful in architectural photography and for keeping a straight-sided subject's sides straight. These lenses also "swing" horizontally or "tilt" vertically, as shown on the lens to the right. Swings and tilts can extend your depth of field in close-up shots to infinity (even at wide-open apertures), making otherwise impossible photographs easy as pie.

Imagine a row of, oh, I don't know, let's say nail polish bottles. If they are set up in a row that goes straight across your set, parallel to your lens and sensor planes, then each one will be as in-focus as the next—great! But, what if you want to set them up diagonally across the set, no longer parallel to the lens and sensor planes? Depth of field, being shallow like it is when your camera is this close to the subject, will result in an image with a very shallow plane of apparent focus, because the subject now merely intersects the plane of subject focus instead of running along it as it did before.

The tilt part of a tilt/shift lens allows you to change the lens plane so that it is almost parallel with that diagonally placed subject. With the ability to do that, you can have a plane of subject focus that points any which way. Your subject no longer has to be parallel to the sensor to be in focus—you can follow it anywhere!

Here's the way this works. Before we start, I want you to imagine three individual planes floating in space. Let's say one of these planes represents the camera's imaging sensor plane. Now, imagine the second plane is represented by a group of subjects running diagonally from the front to the back of your set. If we were to extend both of these first two planes, they would intersect at some point in space because they are not parallel. Can you see all of this so far in your mind's eye? Good.

I am going to talk about that third plane now and, in honesty, it's the kind of information that can make your brain hurt, but try to stay with me because it's really, really important. The third plane is the lens plane, and the best way I can think of to describe it for you is to ask you to imagine that your lens is a full baloney or salami that you cut a thin slice from the middle of. I know this is sounding weirder by the moment, but stay with me, now! That slice of

meat is called the lens plane, and it is usually where the aperture of the lens lies and where all the light rays passing through it cross. That plane is usually at the nodal point of the lens.

Do you have the lens plane (slice of meat) in your mind's eye? Good. If you can swing that lens plane to the left or the right so that it intersects the point in space where the sensor plane and subject plane intersect then....wait for it....everything along the subject plane will be in focus! It doesn't matter if your lens is set to f/2 or f/22; if all three planes meet at the same point in space, then everything along the subject plane will be in focus!

What I just described to you, using planes floating in space and a slice of luncheon meat, is called the Scheimpflug Rule; and it is one of the most important tools in a still life photographer's arsenal! Furthermore, if the subjects (like the nail polish bottles) run from the front to the back of your set, and to get the three planes to intersect at the same point, you have to move the lens plane either left or right, that lens movement is called a "swing."

Stay with me for just a little bit more. If you were photographing a Persian rug from slightly above, or the tops of a bunch of pop top cans or bottle caps, or lipsticks and bullets, and you had to tilt the lens plane (that same slice of luncheon meat) forward or backward, that lens movement is called a "tilt." Now, I know that this book is being written for a bunch of photographers, and that photographers understand things better when they can see a picture, so look at the two pictures and one drawing at right that illustrates what I just wrote in words. Don't worry, I'll wait for you.

Look at the row of nail polish bottles. Notice how all of them are in perfect focus.

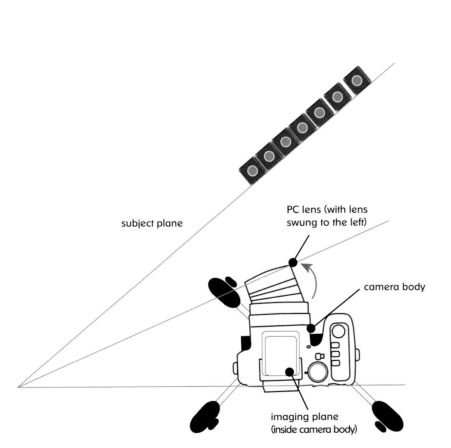

subject plane

PC lens (with lens
swung to the left)

camera body

imaging plane
(inside camera body)

This drawing is a bird's eye view of the Scheimpflug Rule. Notice how all
the planes involved meet at the same point in space. This means that
everything on the subject palne will be in focus!

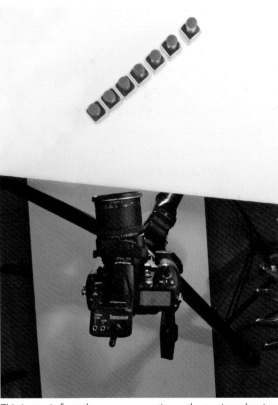

This image is from the same perspective as the previous drawing.

Are you ready to continue? Good. While the Tilt/ Shift lenses from Canon and Schneider and the Perspective Control lenses from Nikon only allow you to tilt or swing the lens plane (but not do both simultaneously), there was a time when studio photographers used a thing called a view camera that not only allowed you to tilt and swing the lens plane simultaneously, but also allowed you to do both of these movements on the imaging plane as well!

Knowledgeable photographers, who understood the principles I just explained like they understood the backs of their own hands, could bend their view cameras into pretzel shapes to extend depth of field to cover any subject, no matter how it was arranged. In fact, view cameras with full movements of both lens and imaging plane weren't even called cameras (by those in the know)—they were called "optical benches." To be able to be twisted like that, these optical bench cameras had the lens and imaging standards connected by a flexible leather bellows. In fact, today, there are even cameras built similarly to what I've just described, except they have a Canon or Nikon DSLR mounted to them—the DSLR's sensor is the imaging plane! You can see a picture at right of one such camera bellow made by Cambo (a Dutch manufacturer).

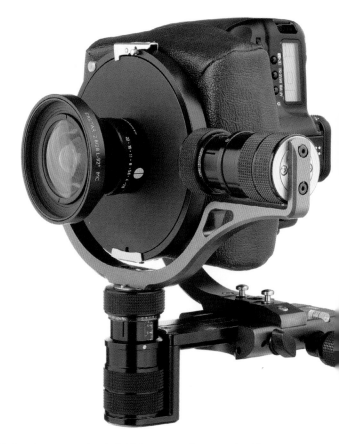

This Cambo camera is a hybrid that uses a lens standard (lens plane) with full movements and a DSLR with limited movements on the imaging standard (imaging plane).

The truth is, although I created the images in this book with a DSLR, for years, my "money camera" was a 4x5-inch or 8x10-inch view camera. I wrote a column in Modern Photography and then Popular Photography called Sint's View which was about... you guessed it—view cameras! This is not easy information to comprehend, and it requires dogged determination to learn and understand the principles involved, but before you dismiss it as not too important, let me tell you that I work in New York City, which is one of the imaging and advertising capitals of the world. The high-end photographers in my city, who shoot images for national print ads and earn big bucks, work with insanely high-resolution digital backs mounted on... you guessed it—view cameras! I am not suggesting that you have to do the same (it can be a goal though), but know that the photographers who work in the fabulous studios I showed you in Chapter 2 are getting the fees they command and the assignments they do because they have the knowledge to really control how an image appears to the viewer.

Alternatives to Lenses

In the beginning, you may not want to commit to buying specific lenses for close-up shooting—you might not know yet exactly what you need, or perhaps you don't have the capital to invest. Rest assured, there are some pretty good inexpensive alternatives.

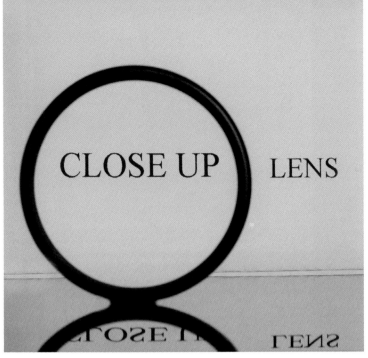

There will be some of you that will think I cheated by using a larger type size for "close up." The truth is, though, it's the same size as the word "lens" but, because they are being viewed through the close-up lens, they just appear bigger—the same way any product you'd be photographing with it would.

Close-Up Filters

If a lens you're interested in has the perfect focal length range but does not have a special close-up focusing range, there are other ways to allow a lens to focus closer than it was originally designed to. The first is a screw-in type of close-up lens (like a thread-mount filter) that is not unlike the inexpensive reading glasses you buy in drug stores for a few bucks a pair. In a nutshell, they make the subject appear bigger (or closer to the camera), which is exactly what you're after. Like those cheap eyeglasses, close-up lens filters come in different strengths (+1, +2, and +3), and I have found the lower magnification filters (+1 and +2) perform better than the higher ones (+3).

Throughout this book, I have pointed out places where you can save money by cutting corners that won't affect your image quality (and in some places doing so can even improve the quality you can achieve), but the truth is, when it comes to buying my glass (lenses and filters) I *never* cut corners! I have proven to myself that a $10 set of three close-up filters does not perform as well as a single close-up filter selling for $30.

Features that both lower the image quality and the cost of a specific filter are often little things you might not even think about. For example, image quality can be adversely affected by how carefully the glass is ground to the shape it has to be; or even how tightly the glass is mounted into its metal filter ring. If the glass part of the filter is held too tightly by the metal ring you screw onto the camera lens, over-tightening the filter ring when you screw it onto the lens can flex the glass part of the filter ever so slightly, and that flexing can lower your overall image quality. If you investigate them, you'll find that in the more expensive close-up filters, the glass is mounted slightly loosely (or using a flexible material between the glass and the ring), and that looseness or flexibility means the glass won't flex when you screw the metal retaining ring onto your camera lens. And lastly, there are photographers who will stack multiple close-up filters on the front of their lenses, but I have found the image quality suffers greatly when I've tried that technique.

Some will argue, rightfully so, that these close-up lenses lower your image quality. While I have found this to be true, it is offset by the fact that they are very easy to use, and image quality does not suffer significantly in the center of the frame, so if you use them wisely (by keeping your product in the center of your frame) and with smaller apertures on a primary lens, they can be a usable (not perfect, but usable!) solution to getting closer focusing distances.

Extension Tubes

A second (and better) way, that doesn't rob as much image quality as a close-up lens, is to use an extension tube (or ring) between the primary lens and the camera body. Using these often means giving up some of the automatic features (and infinity focus) available when the primary lens is attached directly to the camera body, but I don't find that to be a major hindrance in the slow methodical style used for still life photography. Furthermore, you can often stack and use extension tubes together (without image degradation) to magnify the image of the subject on the camera's digital chip even more.

However, one drawback of using extension tubes instead of close-up filters has to do with the fact that the light has farther to travel after leaving the rear of the lens to get to the imaging chip, and this means you'll have to compensate for the light loss when you decide on your exposure. The difference between the exposure for a 1:20 image and a 1:1 image equals a light loss of about 2 f/stops. You can easily compensate for this with ISO or aperture settings if you're using flash; or ISO, aperture, or shutter speed settings if you're using continuous light sources.

You can often buy a set of extension tubes that gets you all the way to a 1:1 magnification ratio using a standard 50mm lens, but that changes entirely if you use a lens of any other focal length, so this bit of information is not very helpful! If you buy a full set for your camera, I'd be willing to wager that, unless you are shooting the three specific products I mentioned above, you'll most often be using the shortest extension tube in any set you buy.

What to Do?

Over the course of my career, I have tried and used every solution I have offered here, and I have even had a microscope objective (a tiny lens) adapted to a 4x5-inch view camera a few different times to accomplish high-magnification images of tiny integrated circuit (IC) boards. Each and every time, it has required both research and trial and error to get the exact results my client was after. Thankfully, general still life product photography won't find you facing the issue of extreme close-ups too often. So what should YOU do?

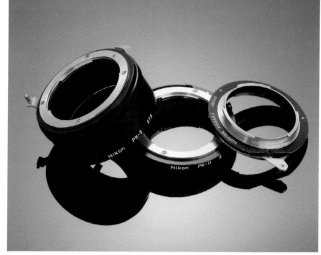

Here are three different sizes of extension tubes. The one on the right is a very short Nikon one that is now discontinued, but I still find it very useful. Mine is engraved with the words Nippon Kogaku (Nikon's original name) Japan F and the letter A. It is missing its lens locking button, but I still use it quite often. If you shoot with Nikon cameras, it's worth trying to find a used one for yourself (try KEH.com for older, discontinued items).

If you are just starting out, you have a limited selection of lenses in your arsenal, none of which have a macro (or micro) focusing mode, and you're on a limited budget, buy +1 and +2 screw-on close-up lenses. Choose a close-up lens diameter that fits the largest lens you'll likely be using them on, because you can always purchase a step-up ring to adapt that close-up lens to a lens with a smaller diameter (but you can't adapt a smaller close-up lens to a larger lens—it will vignette).

If you find yourself using your close-up lenses all the time, then invest in a set of extension tubes or at least a single short one, because extension tubes offer better image quality than close-up lenses.

If you find yourself constantly using your extension tubes, and enjoy the patience and methodical effort the world of close-up photography requires, invest in a micro (macro) lens that has a focusing range from infinity to 1:1. Be aware, however, that when you get into high-magnification photography, the demands on your lighting technique and the subject's perfection (and flaws) also require extra (sometimes super human) effort to get a perfect image your client will be satisfied with.

And finally, if not one of your clients ever requires extreme close-ups, but one day a potential client walks into your space and says he needs a photograph of a single pill to be used as a 4x6-foot poster... well, read on.

Reversing Rings

One lucrative specialty (because it is difficult to do well) within the still life / product photography world is shooting tiny products. Pharmaceuticals, gemstones, some cosmetics, and tiny computer components could become your business if you are located in a large metropolitan area (because you need big ad agencies to get these high-paying assignments).

Let's say you want to try your hand at this specialty, but have not yet invested in a micro (or macro) lens. Another way to get really close-up is to use an accessory called a lens-reversing ring. In use, you mount the ring on the camera body, then take a normal lens, turn it around backwards, and screw it onto the ring. In truth, using this method is a hassle. You lose autofocus and you can't set aperture from the camera body. The lens no longer focuses at all, in fact, and you have to move the entire camera in and out to achieve focus. However, on the plus side of the ledger, the ring is relatively inexpensive, and if you use a good normal lens, the image quality can be superb. Regardless, in a pinch, for extreme close-ups, it's worth knowing about.

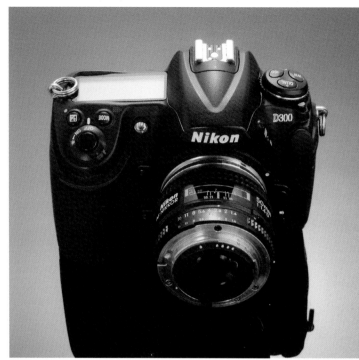

Here's what my 50mm f/1.4 looks like when it's mounted in reverse on one of my Nikon bodies.

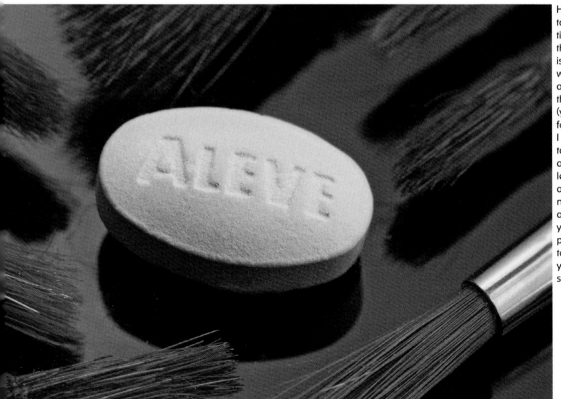

Here's an image of an Aleve tablet shot at more than 1.5 times life-sized (the image on the camera's recording chip is larger than the real pill) with my reversed lens, shown above. Note that even though the image quality is very good (you can tell by looking at the foreground paint brush bristles I used as props), the Aleve tablet's surface looks granular and coarse, while the recessed lettering on the tablet is not as sharp as it appears to the naked eye. This brings me to an interesting point: When you get into extreme close-up photography the limiting factor to image quality is not always your camera or lens, but the subject itself instead!

Other Essential Accessories

The Right-Angle Viewfinder

There is one viewing accessory that I find helpful enough to be worth mentioning. A right-angle viewfinder attachment is a bent viewfinder pipe (almost like 2/3 of a periscope) that screws into or slips onto the camera's eyepiece and lets you look down into the viewfinder from either above or the side (because the viewfinder can rotate on the eyepiece). In the image of the nail polish bottles on page 245, the tabletop was about 29 inches (73.7 cm) high and the center of my camera's lens was about 31 inches (78.7 cm) off the floor. If I had used the camera's standard eyepiece for this image, I would have been on my knees for about 30 minutes. After about 10 minutes of standing on your knees on a hardwood (or cement, eek!) floor, creativity goes out the window, and your primary concern is getting off your knees! But, I used my right-angle viewfinder, and that same 30 minutes was spent with me sitting on a stool as I created the image shown.

One of my first mentors was always interested in getting unique angles to photograph things from. When I showed him some landscapes that I had done, his comment was, "For interesting landscapes, either get down on your belly or up on a balcony." I thought about his comment for a while and eventually agreed, so I incorporated it into my style. But, the problem with getting down on your belly when shooting outdoors is when you finally get your eye next to the viewfinder, you end up with a mouthful of dirt, or worse, a bug climbing up your nose! So, a right-angle viewfinder became part of my kit. Now, even when I'm shooting in the studio, if I go for a low-angle perspective, I prefer to use a right-angle viewfinder—it's easier on my knees!

Still life images can be done outdoors too.

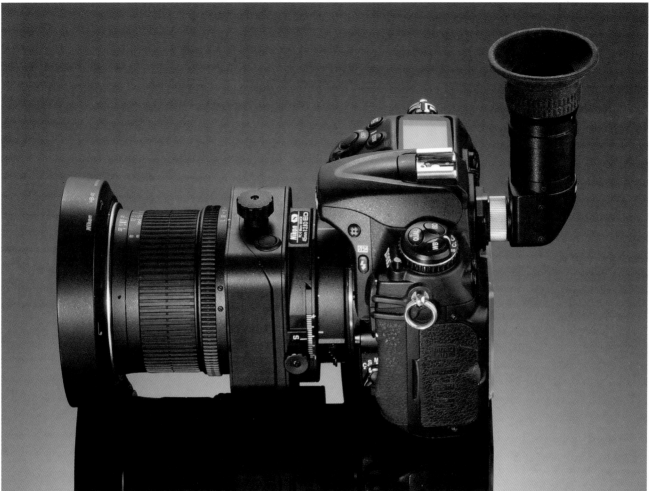

This is what a right-angle viewfinder looks like when it's mounted on a camera's eyepiece.

The Tripod Head

While amateur tripods often include a tripod head, many professional quality tripods don't. The reason for this is simple: Professional photographers prefer to use the type of tripod head that is best suited for the task at hand. Basically, there are two types of tripod heads. One is called a pan/tilt head; and the second, more-often-mentioned type, typically used for still photography, is called a ball head. If you consider the three planes that a camera's film or sensor plane can move through, the difference between the two types of tripod heads becomes easier to understand; so lets start there.

The first plane has to do with a camera rotating around on the tripod's center column. Both pan/tilt heads and professional-quality ball heads control this movement with a locking device that is independent of the ability to lock down the other two planes of movement. Those other two planes are tilting the camera left or right, and tilting the camera forward or backward. How a tripod head deals with these two planes of movement differentiates the two types of heads. While pan/tilt heads allow you to individually adjust and lock the left/right tilt and the forward/backward tilt, a ball head uses one lock to control both movements simultaneously. The independent adjustment and locking of the two planes, in my opinion, gives pan/tilt tripod heads a terrific advantage over ball heads for still life photography.

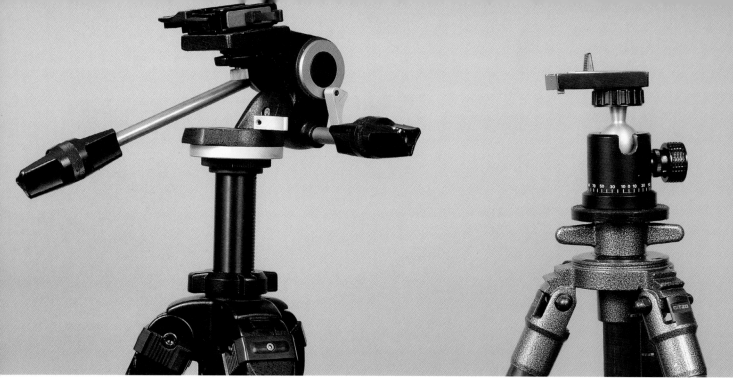

I find a pan/tilt head more in keeping with the slower methodical pace of still life studio photography than a ball head is. Unlike a ball head, the pan/tilt head has independently controllable tilt locks and holds your camera rigidly in position when you lock it down!

Here's why: When setting up a tripod, the first thing you must do is adjust its legs so the center column is perpendicular to the floor. At this point, some of you are saying, "Who cares? What's the big deal if the tripod's center column is not perpendicular to the floor?" Actually, it turns out to be a big deal, and you can prove that to yourself quite easily. Put your camera on a your tripod and extend your tripod's legs so that one is 6 inches (15.2 cm) shorter than the other two. Frame the front or rear edge of a tabletop so it's level (horizontal) from left to right. Now, rotate the tripod head (both pan/tilt and pro-grade ball heads have this feature) and see what happens to your level horizon line. It will skew wildly away from being level. Avoiding this frustration is why you start off with the center column perpendicular to the floor!

Once you've set up your tripod correctly, the next issue to be addressed is to tilt the camera (both left/right and forward/backward) so the product you are photographing is square and level. If you don't want it to be square and level for some creative reason, then adjust the two tilt axes of your camera so the subject looks the way you want it to. There it is! Notice that I just wrote "the two tilt axes."

The reason a pan/tilt head is useful in still life photography is because you can adjust and lock the two tilt axes independently of one another. Say you adjust the left/right tilt to exactly the way you want it, and then you want to adjust the forward/backward tilt to exactly the way you want it. Using a ball head, one locking knob releases both tilts at the same time. Releasing both tilts at the same time makes for frustration when you want to only adjust one tilt.

I have written six books on photography and, because those books dealt with photographing people, I always suggested using a ball head because it was faster to adjust. I love ball heads for photographing people and landscapes but not for still life photography, because of the issue I just mentioned above, and because they often sag a tiny bit and shift the camera's point of view slightly downward after they are locked down. Both limitations are a big drag when you are working on a tight still life composition.

As for actual tripod use in the studio, my answer is simple: I use one about 99% of the time. The worst thing is trying to do a bracketed exposure and finding out after the fact that the image with the perfect exposure isn't the image with the perfect framing!

A Tripod Side Arm

This last accessory, which is often very helpful when you have to shoot straight down on a subject, is called a tripod side arm. A side arm is like a tripod center column, except it is horizontal instead of vertical. In practice, the side arm is mounted where the tripod head would normally be fitted, and the tripod head is fitted to the end of the side arm.

Side arms are handy, but they are expensive, and you must use a sandbag on the open end to keep the whole thing from tipping over. There are ways to get around buying one, however. (See the illustration at right.)

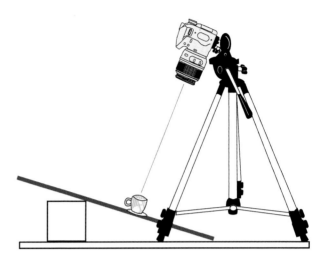

Another, less expensive way to produce an undistorted, accurate photo of a subject is to raise one side of the board your subject is lying on by propping it up with bricks, wooden blocks, or even a cinder block so that the subject's plane is parallel to the camera's imaging plane.

Once the board is at the angle you want (parallel to the camera's imaging plane), it might be hard to keep your subject from sliding off it. This frustrating experience can be avoided by using little blobs of Fun-Tak® (see page 75) to keep your subjects where you want them!

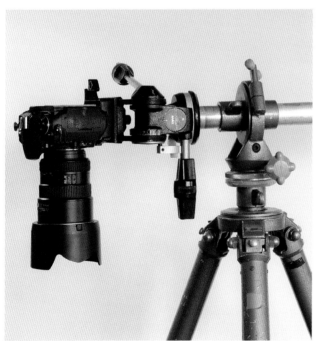

What a side arm looks like in use

11

The Business Side of Things

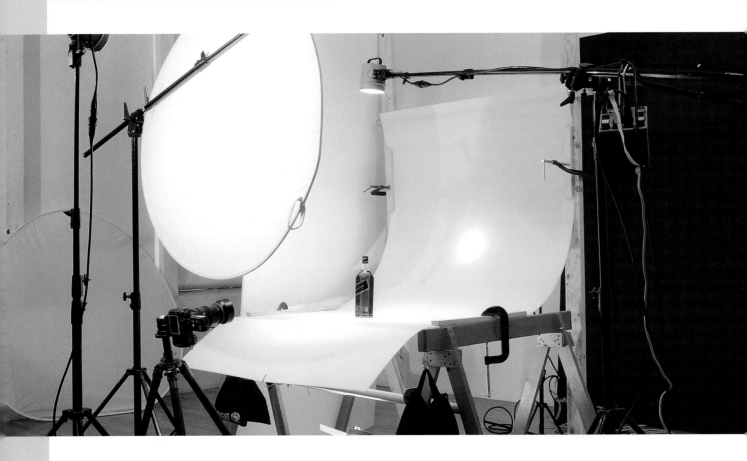

Let me kick off this chapter with a total fantasy: You scrape together all your pennies and assemble a sizeable amount of equipment that you then learn how to use, and then scrape together more pennies and put a down payment on a medium-sized building in an area you've carefully researched that is just filled to the brim with potential clients. You learn your craft well, constantly looking at and studying the work of others who are your peers as well as those that came before you.

You have taken small business administration and management courses at institutes of higher learning, and you create both a portfolio and a website packed with unique and exciting images. You constantly stand up to the agony of growing as an artist and a craftsman and manage to become world-renowned. Clients from all over beat a path to your door. You live a life shooting beautiful images for fees that make you giggle whenever you check your bank balance, and, toward the end of your productive and creative years, you sell your building for a huge profit and retire to a wonderful new life filled with joy, comfort, and reflection.

If most or all of that sounds a lot like your great expectations, in honesty, for almost all professional photographers except a very few lucky ones (yes, luck is a part of it!), they are nothing more than pipe dreams! Putting your pipe down for a moment, let's see what the other end of the spectrum might look like:

Because of advances in technology, you fall into the advertisers' traps of thinking it's the great camera that takes great images (instead of you!), so you are on a never-ending treadmill of desperately needing the newest camera, lens, computer, or software suite. You never make that down payment on a building because you keep throwing your pennies at

the newest stuff, so you rent space, don't establish equity, and only make your landlord much richer. Because you rely on automation, you don't feel the need to learn your craft well. You don't learn about small business administration and management because, quite frankly, it bores you. You create a portfolio and website filled with images whose uniqueness is based on having the latest (and greatest) stuff. You never stand up to the agony of growing as an artist and a craftsman because, well, it's agony. Since your images are based on mouse clicks and lenses that others can buy too, you join the constantly growing crowd of similar photographers all competing for the same assignments. You live a life shooting similar images trying to cut pennies off your prices to get enough assignments to avoid using credit cards and paying outrageous interest.

And, toward the end of your productive and creative years: You are forced into selling off your equipment for pennies because it is obsolete and getting a job driving a cab or shuffling around a Mickey D's cleaning tables and stacking trays. Later, you retire to a new life filled with the frustration of living on a bare sustenance existence and reflecting on where it all went wrong while waiting to die!

The difference between the two scenarios is much greater than the typical glass-half-full vs. glass-half-empty point of view. Almost like the plot of Frank Capra's *It's a Wonderful Life,* what I've just painted are two very extreme scenarios of what a photographer's life might be—one glorious and one pretty grim. One purpose of this book (in fact, all my books) is to give you some tools that might help you avoid ending up at the end of a career with a single pair of ratty jeans and eating dog food while scraping pennies together to buy another six pack. Although I have nothing against an occasional six pack, let's assume you'll end up somewhere between the two extremes and focus on specific things you might do to end up closer to "glorious" and farther away from "grim."

How Many Days a Year Can You Actually Shoot?

Before you can figure out how much you must charge for your time and images, you have to figure out what your fixed annual costs are and how much your assignment-specific costs are. While this might seem like a logical place to start, I feel strongly that you first must be able to figure out how much you must make every day you shoot and just how many days per year you can actually shoot! So, I'm going to start there.

While there are 365 days in every year, you might be surprised to realize, that no matter how busy and successful you become, you can probably only shoot about 100 days a year! What? "How could that be," you ask? Read on. Let's say you are willing and able to work six days a week. That makes the 365-day year 313 days long (365-52=313). Don't be too fast to say you're willing to work seven days a week. Between my wedding assignments and my commercial assignments I did exactly that for the first 10 years of my career, and I can tell you for a fact that my photography suffered. You need at least one day a week to chill out and refresh yourself.

Realistically speaking, you should also consider taking a two-week vacation every year. It doesn't have to be 14 consecutive days, but stretching a two-day weekend into a four-day extravaganza (although it is not extravagant to do so) a few times a year by taking the Friday and Monday that bracket the weekend is a worthwhile respite that can refresh your batteries. Since a two-week vacation includes two weekends, the end result is losing only 12 working days a year, and that brings our 313-day year to 301 days (313-12=301).

Finally, there are 10 days of official United States Holidays every year, and even if you want to work on those days, you'll find that almost all of your clients won't be willing to work even if you are! That brings our year down to 303 days (313-10=303), but to make the math easier, let's call it 300. So, you have 300 possible workdays per year.

Over a 40-year career, I have found that for every day I actually shoot, there is one day of pre-production and one day of post-production. Some of you might consider the pre and post-production days to include selling the job, negotiating and writing up the contract, renting props and possibly photographic equipment, booking assistants, setting up the studio, returning equipment to the rental houses, striking the set, downloading images, archiving images and cleaning them up in an editing program, and billing the client; but the reality is, there's more to it than just those specific, assignment-related things.

What about creating new portfolio images? What about an active program for finding new work? What about visiting prospective clients? Or, do you think that new clients are just going to stumble upon your website? Yeah, right. What about researching new equipment and software, learning how to use the photographic equipment you have, and learning how to use the software you choose? Furthermore, if a photograph is complicated, you often have to do a test run before the client even walks into the studio. Many times, the very set the subject is placed in has to be specially constructed. What about time used in searching for the perfect prop, or finding the perfect surface to place the subject on? While it's true that if you are billing a quarter of a million dollars a year, some of this work can be assigned to staff, at your beginnings, you will be both the chief cook and the (only) dishwasher! I can go on and on, but the reality is that for every day you shoot, you'll eat up two days on generating new business, servicing the business you already have, plus the pre- and post-production—it's just a simple fact of photographic life.

The real point of my mini tirade is this: 300 possible working days per year boils down to approximately 100 days of actual time spent shooting. So, in a nutshell, it pays to consider that a single shoot day has to pay for three days of your time. Inexperienced photographers might think that five or six hundred dollars for a shoot day is good money, but if you consider it your pay for three days, you'll realize that it only works out to $165 – $200 per day! Taking it a step further, that comes out to $20 – $25 per hour (and much less if you do longer than 8-hour days) and again, quite frankly, that's less than a manager at a fast food restaurant makes when you consider that they get health insurance. And, they don't have to spend thousands of dollars on equipment!

There is one exception to my 100-day approximation that is worth exploring. Sometimes, on assignments to shoot a large number of photographs on consecutive days, you might find yourself getting by with the same single day each of pre- and post-production, but between those two days, you have four to seven consecutive days of work. These assignments are plums that average out to a lot of income per day, even when you take into account pre- and post-production.

The last exception to this rule is the simple fact that if you're just starting out, you'll be hard-pressed to come up with 100 days of paying assignments per year! Even with a good portfolio, an active advertising program, and a studio location surrounded by potential clients, I think you'll be lucky to get 25 to 50 shooting days for your first few years in business. This should be a sobering thought to any young photographer just starting out. However, forewarned is forearmed, so if you expect the first few years to be very tough, at least you can prepare yourself for it by being very, very frugal.

The digital real estate to store your images on doesn't come free either!

Get What You're Worth

If you book 100% of the assignments you are offered, then chances are good you are not charging enough! It's no great feat to charge one dollar for something everyone else in the world is charging five dollars for. When you ask a prospective client for $50 per image, and they say they can get it for $10 an image, chances are very good they are being less than honest with you! When they say they only have a budget of $1000 dollars for an assignment, chances are very good they are being less than honest. If you allow the client to set the fees they will pay you, and at those prices you aren't making a profit, then your photography is just a hobby.

Have you ever walked into a store and seen a sweater you really liked? If the price tag on that sweater reads $75, would you then say to the salesperson: "I like this sweater. I'll give you $25 for it"? Do you think the salesperson would say yes? No! And, that applies to

almost anything else, from an aged filet mignon at a butcher shop to a new muffler at an auto parts store— the result would still be the same. Why do potential purchasers of photography think they can do it and get different results? Why would they even think of it at all?

Maybe it's because professional photographers have so much of their creative egos riding on getting an assignment that being accepted as an artist trumps being a successful businessperson. If that is the case with you, I can only suggest leaving your creative ego at the negotiating room door. Not everyone is going to love your images, regardless of how low you'll go. Worse still, when you do lower your prices to pennies a pound, your client is going to think of your images as low-cost, cheap commodities. Why would you want that? It is the antithesis of what you want a potential client to think about your images, or you!

Although this is just a suggestion, perhaps it's better to find peace and satisfaction with the quality of your work from someplace within yourself and totally separate that place from the business side of your life. I know, easier said than done, but it's something to at least aspire to.

Now, you must keep in mind that even some great clients will want everything they get for cheapest price possible, because that is just a part of doing business. In fact, for some of them, paying nothing is too high a price for photography of their products. Some even feel that just the honor of working for them and having their products featured as samples in your portfolio should be good enough. Try paying your rent or buying food with honor, or paying your bills with the image of their Super Duty Toilet Bowl Cleaner that's in your portfolio. Sadly, there are photographers who will agree with them, but you can't worry about the competition from those photographers. Why bother anyway? Unless they hit the Lotto Jackpot, they won't be around long enough that you should care.

Expenses

How much is needed per day of shooting to cover your fixed expenses?

There are so many fixed yearly expenses involved in opening and running a photography studio. The problem is identifying what they are, figuring out how much you must charge for each day of shooting, and how much you should budget for each expense. They include, but are not necessarily limited to, the following:

- Office or studio rent
- Phone (cell, office, and fax)
- Photo equipment
- Equipment repairs
- Computers (hardware and software)
- Internet (broadband, website, and email)
- Vehicle expenses (lease, insurance, and maintenance)
- Office supplies
- Photography supplies (fill cards, foam core boards, rolls of diffusion material, pieces of acrylic, colored gels, and anything else you use up)
- Postage and shipping
- Professional development (business and photography courses and workshops, visiting galleries and museums)
- Advertising and promotion (See pages 265-267 for more on this.)
- Subscriptions and dues
- Business insurance
- Health insurance
- Legal and accounting services
- Taxes and licenses (business, property, and self-employment)
- Payroll
- Utilities
- Retirement fund
- Travel
- Entertainment (meals with clients)
- Plus: Your own annual salary

You can cheat a bit here and there by forgoing some things such as a fax machine and a dedicated phone line for it (I gave up my dedicated fax line over ten years ago) or equipment repairs (if your equipment is new or you bought an extended warranty for it). You can drive an older car a few years longer, or even avoid hiring an office staff by doing all of your own paperwork and customer service, but generally speaking, that list is what you'll need in order to compete for assignments.

Through the magic of the Internet and the hard work of others that came before you, the NPPA (National Press Photographers Association) has an online calculator where you can plug in figures, list a desired salary, and the number of days per year you expect to be shooting. The result will give you exactly how much you must charge for each shooting day of your time to pay your expenses and make the salary you want. The NPPA calculator can be accessed at www.nppa.org > Education and Events > Business Practices. The NPPA website offers a wealth of other good information too. I recommend becoming familiar with it.

Before you spend time using the calculator, though, here is a quick word to the wise. All calculators only work well if you provide them with accurate information. Do not underestimate your expenses and overestimate the number of days you expect to be shooting each year! Plugging in pie-in-the-sky numbers is a recipe for disaster. To avoid this, I suggest you underestimate how many shooting days you expect to get and overestimate what your expenses will be. That way, if you are wrong (and estimates often are), you'll end the year being pleasantly surprised when your bank balance is higher than you thought it would be.

Assignment-Specific Expenses

One of the biggest breakthroughs in my professional life came when I added two little words to my pricing structure: "plus expenses." One day, my estimates and invoices read, "100 photographs at $50 per," and the next day they read, "100 photographs at $50 per, plus expenses." What a difference those two little words made to my bottom line!

For me, expenses are broken down into three categories: labor, rentals, and consumables. Examples of labor include assistants, fashion stylists, professional shoppers, food stylists, casting people (people in your studio who photograph potential models or go outside your studio and photograph potential props), hair and makeup professionals, dressers (people who help models into and out of clothes), location scouts, and delivery people—anyone you hire to help get a specific assignment accomplished. Examples of rentals can include higher-end cameras (maybe even a medium format camera and a large MP digital back), specialty lenses and lights, studio spaces, locations (from a gym to a mansion), wardrobe items (which are kept pristine and returned the next day), and props ranging from a desk and office chair to small accessories to a complete set of living room furniture. We'll get to consumables in a bit.

There are some general rules that are applicable to all three topics, so let's look at those first. Say you don't charge for your expenses and say you ask for a $4000 fee to photograph an item for a national advertisement. Here's the scoop: If you spend $2000 on a stylist, assistant(s), prop rentals, and consumables, and you didn't charge the client for your assignment related expenses, you didn't make $4000—you only made $2000! While this may seem to be obvious, it amazes me just how many photographers are absolutely convinced their expenses are pennies when in reality they are hundreds (or even thousands) of dollars!

It has been said that to be successful in business, every time money passes through your hands, some of it is supposed to stick to your fingers. What I can't understand is why photographers think this concept is somehow dishonest, dirty, or crass. In the first place, what your clients are paying you for is your knowledge. And not just the photographic knowledge used on the set, but the knowledge of how to put together all the pieces needed to complete an assignment.

Knowing where to find competent, reliable assistants and other staff (from food and clothing stylists, to chefs who know how to plate for the camera, to hair and makeup professionals, to model makers and other freelance creative types); or where to get the perfect prop or lens; or even where to find the right kinds of tapes, fill cards, seamless backgrounds, or fabrics you need to create a successful stopper image—all of this is valuable. In my city, people often say a professional photographer is only as good as his Rolodex! But a good Rolodex doesn't just happen overnight—most times, they take years to research, assemble, prune, add to, and keep updated so the information they contain is actually valuable.

So, the question then becomes, if assembling the information necessary to produce the final photograph takes a lot of time and effort, and that time and effort was expended long before the client asked you to produce the assignment, then how do you get paid for that effort? Before you answer that question, you should know that successful advertising agencies almost universally charge their clients a creative fee plus an additional fee of approximately 20% beyond all charges and fees they incur on their client's behalf. Obviously, advertising agencies understand that both time and knowledge have value, and maybe you should too. Do not (do not!) ever think it is dirty, crass, cheap, or unfair to make a profit! Businesses are supposed to make a profit; if they don't, then they are called hobbies.

Because of this, like advertising agencies, I also add a 20% charge on all fees I incur when producing an assignment for a client, ad agency, or publisher. Some of my clients accept this fee when I explain it, while others become adamant in refusing to pay it. However, if the assignment is very lucrative from a photographic fee standpoint, for that second group of clients, I am willing to offer a negotiated solution. I explain that part of the reason why I ask for the 20% markup on my expenses (in addition to my photographic fee) is that I do not feel it is my job to be my client's banker. The truth is, some clients won't pay you for 90 days past the date they were billed and even then you have to chase them to get your money, while you are paying the interest on the credit card you used to fund their shoot!

To avoid being a banker (and again, if the photographic fee for the assignment is very lucrative), I offer to waive my 20% surcharge on expenses if my client pays me 50% of my estimate upon signing our contract and the remaining 50% upon delivery of the images I produce. My goal is to change their adamant refusal into a negotiated solution instead. In honesty, some of my clients don't even know they are paying this surcharge. I also tell them my assistant gets $25 per hour, and I actually pay that assistant $20 per hour. Horrors! I just admitted I made a 25% markup on my assistant's time, but the reality is, I pick up the tab for my assistant's $10 – 12 lunch on my shoots, so my 25% markup is not really 25% after all.

Before you entertain the thought of not marking up your billable expenses (and if you are realistic about the numbers you plug into the NPPA calculator I mentioned before), consider this: If you can book 100 shooting days per year (probably hard to do), to make a salary of between $40,000 and $50,000 a year (not a life on easy street), your yearly expenses (including your salary) will be between $115,000 and $120,000. Your weekly expenses to be in business will be about $2300, and your expenses for every day you're shooting will be about $1300. That's $1300 a

day for your expenses, and only your expenses, so if that's what you are charging for a day of shooting, not a single cent of that money is yours to take home!

Charging for Consumables: Rental and labor expenses are pretty straightforward—you bill your client for the rental and labor costs you incur as part of their assignment. Consumables, on the other hand, can be tricky. Seamless paper, diffusion materials, yards of fabric, colored gels, to name but a few, are all items that get destroyed as you use them. Yet, there some photographers who do not charge for those expenses. To a certain extent, I can understand their rationale: You buy a roll of seamless paper that's 38 feet long, but only 10 feet of it is destroyed at your shoot. So, how can you charge the client for a full roll?

Taking just seamless paper as an example, while I might understand the argument for not charging the client for a full roll of white or grey seamless (you should have those anyway), what happens if the client wants a color not often called for (e.g., pink, purple, pea soup)? 9-foot SetPaper, for example, comes in about 50 colors. Between the price of each roll and the cost of shipping, your outlay to have all those colors available for your client to choose from will set you back close to $4000. Doing the same thing in the more economical half-roll sizes would still cost you close to $3000.

But wait, there's more! The end of each box of seamless paper is approximately 4x4 inches, or 16 square inches. That means that the 50 boxes would represent almost 6 square feet of floor space. Take a guess just who is paying the rent on those 6 square feet of space? The answer of course is you!

Here's another example: You buy two yards of velvet (at $20 per yard) and the product you plan to photograph on it has an LCD panel. The LCD panel requires the product to be plugged into a wall outlet to get it to light up, so you cut a small slit in the velvet to pass the plug through so the product's power cord is not seen. Do you think you can use that piece of velvet with the slit in it again? Maybe, or maybe not. Regardless of whether or not you can get a second use out of that piece of velvet, you have to charge your client for it.

Now, are you ready for what some might view as a shocker? If you do use that piece of velvet for another client, I believe you should charge that second client for the velvet, even if for no other reason than being consistent in your pricing structure. Otherwise, on another assignment for that second client, one where you do have to buy a piece of fresh material, you'll have to justify the new material's cost. Furthermore, I have found that after a few uses, almost any piece of material gets wrinkled and ratty looking. It's just a fact of life, and it's why things like seamless paper and fabric are called consumables!

Promotion

OK, let's assume you want to be successful, you want to be a professional photographer, and you're beginning to understand that making a profit is not only acceptable, but it is required. Way back when, in chapter 2, I said that the single most important thing that determines whether you are a successful professional photographer is getting assignments! I said it a number of times, in fact.

If getting the next assignment is so important (and it is), then you really should have a plan about how to go about it. In my portrait and weddings books, I describe opening a studio in an area catering to the carriage trade, forming relationships with wedding vendors and caterers, and even buying wall space in a high traffic mall.

Well, still life photographers deal mostly with companies, not individuals, so none of the prerequisites for a wedding or portrait studio location apply to a commercial photographic studio. In fact, for security purposes, many busy and successful commercial studios don't even have signs proclaiming their presence! They aren't looking for the general public to become their customer base, so they don't care about foot traffic. In my city, for example, most are located on the upper floors of buildings zoned for industrial or commercial endeavors. If that's the case, just how do they find the clients to beat a path to their door? Read on.

Many young photographers believe that all they need is a website, but I strongly disagree. There are billions (maybe trillions) of websites. But with all those websites, how does a potential client even know about, let alone find, yours? The reality is that, not only do you need a website, but you need very specific people (potential clients) to know, find, and visit yours.

While I feel that in today's world, having a constantly updated website is a necessity, I don't feel it will be the primary source of clients for a commercial studio. For commercial photography, I think a website should be viewed more as a way of intensifying the interest in a photographer's work, but the original interest has to be generated in other ways. While the greater New York area is a pretty intense place to build a name and reputation as a commercial photographer, the very fact that the competition is so fierce has led photographers to use creative ways to find potential clients.

To understand how one might go about promotion of a commercial photography studio, we should look at who makes up the clientele of such a studio. While having just one huge client can be considered the kiss of death (lose that one client and the business literally doesn't exist), successful commercial studios usually don't have a huge number of clients. What they don't have in numbers of clients is made up for in repeat customers who need photography services over and over again. Whether it's an advertising agency or publishing company whose art director services a variety of clients (each of whom need photography), or a manufacturer who is constantly developing new product lines, or a clothing manufacturer whose fashion lines change four times a year, each of these clients needs an ongoing supply of photographs. Between a dozen and two dozen of these types of clients can easily keep a commercial photographer busy 100 shooting days per year.

Word of Mouth

I've worked for two publishers of controlled-circulation magazines (mostly industry news), where each publisher had three art directors on staff, each of whom took care of three or four magazines. While the inside of the magazines was filled with advertiser-supplied articles and photography, each art director was responsible for the cover art on each of their three or four magazines every month. Assuming an average of three and a half magazines per art director, each one of them would be responsible for 42 covers per year. So, even if half the covers were illustrations, each art director was assigning 21 cover photography assignments per year. If just one of those art directors started to use you for their cover photography assignments, there was the possibility of getting 20 or so assignments just from him or her per year. Furthermore, art directors talk to one another, so doing a great job for one often means you can pick up any additional ones at the same company, thereby potentially increasing your work two- or threefold. That's not bad...not bad at all.

Third Parties

I worked for the New York office of a French perfume manufacturer. All the work we did for them kept my studio mate and I busy with about 40 – 50 days of shooting per year. Interestingly, the lead for this assignment came from a color lab manager who was always impressed with the cleanliness of our work, how close we always were on exposure and light control, and probably that we never complained about the quality of his lab's work! Dutifully, we treated him like our photographer's representative, and paid him 25% of the fees his assignments generated which, in turn, got him to recommend us to more clients.

There are probably some readers who are seething right now and thinking, "Ah-ha, kickbacks!" But the truth is, it's nothing more than a cost of doing business, and every photographer's rep in New York gets 25% of the fees he or she generates, so why shouldn't our color lab manger get the same fruits for his labor? Furthermore, for the record, when a photographer joins a picture agency (be it Magnum, UP, AP, or Reuters), the agency gets a percentage of that member's fees. Obviously, nobody can afford to work for you for nothing; and hey, think of it as paying for advertising, because all you're really doing is paying a third party to get your name out there!

Finding Your Own Clients

While you can buy lists of potential clients on the web, I feel that generating your own list of potential clients is more economical and helps you establish a database that you can grow yourself. Do Google searches for publishing companies, catalog printers (not as potential clients but as a potential source of new leads), magazine publishers, and advertising agencies in your area and surrounding areas. Run the same Google searches for your county and surrounding counties. When I started out, the web didn't exist, so I used the Yellow Pages, but I did basically the same thing. If your studio is near any population center, you might be shocked by just how many results you get! Because the number of resulting hits might be intimidating, break your results off in bite-sized chunks: Why not try for 50 a day? Go to every website that's available for the results you find. If the website seems to be a company that could be a potential client, check out the contact info page on their site and then you're going to call each of them.

I suggest you rehearse what you are going to say; but you don't want to sound scripted, nor do you want to rush through your words or mumble. Having an idea of what you are going to say makes you sound more comfortable saying it—actors rehearse their lines so why shouldn't you? Your goal is to sound friendly and businesslike at the same time.

Before you even think of picking up the phone, however, buy a loose-leaf binder, fill it with lined paper, and create a page in your notebook for each company you're going to call. Although there are a lot of software solutions for organizing contacts, I prefer doing it as a hard copy even though I'll enter them later into a database on my big Mac. Here's why: My database was created over a 40-year span, and my hard copy has survived five or six computers and about two dozen or so hard drives, not to mention floppy drives, Syquest drives, Iomega Zip drives, and USB jump drives, so I find it worthwhile to keep it as a paper document.

Here's how I make mine: On a separate sheet of paper in your binder, write down the company name, their address, and their phone number. When you call the company, introduce yourself to the operator and ask their name, then ask the operator (by name!) if they buy images from freelance photographers. If the answer is yes, ask who is their art director or art buyer and ask to be connected to him or her. As I get to know the people at a company, I make notes about their personal information—cell numbers, home addresses, spouses, kids—anything I think is pertinent, and I use that info to make small talk, send holiday cards, etc. By establishing this kind of relationship with clients, I have continued staying in touch and doing business with them, even as they move from publisher to publisher or agency to agency.

You might send a postcard to the creative director, art director, art buyer, or even the agency owner before you try for an appointment (more on that shortly) or you might send the potential client a "thank you" post card after you get the appointment. Regardless, you want to potential client to see your name and images more than once! In fact, without becoming a pain in the butt, you want the potential client to see your name as often as possible.

Since you don't need as many clients as a wedding or portrait studio to survive and be profitable, I feel the very best way to advertise is targeted direct-mail pieces. Whether it is an oversized postcard nicely printed on heavyweight glossy stock sent monthly to a select list of prospective clients (maybe 100-300), a poster sent every six months or so, a calendar sent yearly to current and prospective clients, or a combination thereof, you must do something to show off your freshest work and keep your name and images in front of both established and potential clients.

There are just a few points to keep in mind as you reach out to potential clients:

- You're going to be rejected a lot. That's OK, because you don't need that many clients anyway.

- This advertising plan, this searching for new clients, is not something you do once and then never do again. It is an ongoing project that you do forever! Because...

- The single most important thing that determines whether you are a successful professional photographer is getting assignments!

- Getting assignments is predicated on the fact that you have exciting, interesting, and technically proficient sample images to show.

Copyright Law and You

One of the most important concepts about the entire world of professional photography is that you really aren't selling anything tangible! This is especially hard for young photographers to understand. Even though portrait and wedding photographers might deliver prints or albums, and even though still life and other commercial photographers might deliver discs or downloadable photographs to their clients, all these different types of professional photographers still own the copyright to the images they create! The real truth is, professional photographers are licensing the right to use a photograph, that they've created and own the copyright to, for a client to use for a specific purpose. This concept of licensing the rights to use intellectual property was part of the copyright laws in the United States (and most foreign countries) long before photography was invented and certainly before the first photograph was ever published on the web, printed in a magazine, put on a poster, plastered on a billboard, or used on a book cover. This is because, without some form of protection for a creator's intellectual property, it would not be worthwhile for the creator to create it!

While a copyright exists the moment a photographer pushes the shutter button and an image is created, the protections for an unregistered copyright are relatively weak. Some photographers, who know that the copyright protection exists but have not really studied the complicated law nor read any books about it, are quick to claim that someone is violating their copyright! However, if you don't register the copyright of an image with the United States Copyright Office, the law limits the penalty for its unauthorized use to the actual damages incurred—that is, the fee that one would have received in a fair transaction in the current marketplace. The courts define actual damages as the amount a willing buyer would pay to a willing seller.

So, if a magazine publishes your image as a 1/4-page illustration without permission, and your copyright is not registered, you can only recover the fair market value for that use. If the image were registered, on the other hand, you could recover maybe three to five times that amount. In the rare case when the infringement is found to be willful (committed with full knowledge) the damages are usually much higher, as the court will use monetary damages to punish the infringer.

The punitive damages penalty for a willful violation of an artist's registered copyright is up to $150,000 for each infringement! While some of you might see dollar signs dancing before your eyes, it should be mentioned that to qualify for such statutory damages you would have had to establish a carefully and fully documented paper trail, discover the violation, and be dealing with an infringer that had deep enough pockets to pay such a fee. For better or for worse, today's professional photography marketplace is flooded with neophyte photographers who just aren't strong businesspeople, and even some established photographers are not organized enough to satisfy the stringent requirements needed for making such a case.

Lastly, both newcomers and established photographers, in the ongoing battle to compete for assignments, are willing to give up their copyright because they don't understand the ramifications of the copyright law. Others may give their clients a specifically limited copyright or ignore the issue altogether because they are afraid of losing an assignment. Additionally, a number of other factors have damaged the sanctity of a creator owning his or her work: the popularity of the web and electronic media, the ease with which a person can grab an image and drag it to their desktop, and a new breed of artistic students who believe all intellectual property should be public domain. Tell that last bit to big companies like Microsoft or Apple who understand the value of their intellectual property! It is, to use a cliché, a sorry state of affairs.

Although I still believe piracy is a dirty business (no matter how romantic and popular Johnny Depp's Jack Sparrow character may be), because of all of the above, I have developed a rather easygoing view of some copyright infringements. I no longer worry about the bride who scans a few of her wedding pictures to make a few extra prints for a grandma or aunt. I no longer bother to chase down every client who uses a 1024-pixel, 72 pixel-per-inch (PPI) image more than once. I have, however, adjusted my pricing structure upwards accordingly.

I also understand that some images are ephemeral in nature (such as a perfume manufacturer's Christmas sets), and their short life span makes them not worth protecting. But, when an image of mine is unique, part of a larger body of work (such as the images in this book), difficult to produce, or requested at the highest resolution I can create, I take the time to register my copyright to it and protect it from piracy to the best of my ability. Considering I create between 50,000 and 100,000 images per year that have limited appeal and are made for specific clients, the selective protection I work at insuring seems the only way to avoid bogging myself down in a mountain of paperwork.

For these special images that I create, the idea of leasing limited rights to prospective clients is a very appealing and worthwhile way for me to work, because it helps to give me a way to figure out how much to charge for a specific high-end assignment. Here's how it works: A client calls me and asks what would it cost for me to produce a photograph for them. I ask them what they want to use the image for. It's funny, but they always answer with the same words: "I want all rights, including the copyright to the image." At that moment, I inquire, "You want all rights including the copyright?"

They say, "Yes!"

I ask, "Do you want to put the image on a poster?"

They respond, "No."

I ask, "Do you want to use the image on a book cover?"

They answer, "No!"

I ask, "Do you want to use the image on a t-shirt?"

They exclaim, "No!"

I ask them if they want to use the image on a coffee mug.

They recoil, "Oh God, no!"

Finally, I say, "My apologies, but I have to ask—why do you want to pay me for rights you don't need?" And, while they ponder this, I ask them, "Tell me a little bit more about the image you are asking me to create, and then we can talk about rights you need later."

As that conversation begins, I ask some of the following questions: Where will the image appear? Is the image an advertisement? If it's an ad, how many different issues of the magazine will it appear in? How many different magazines will the advertisement appear in? How big will the image be? If it's for use in a high-end catalog, are they interested in the cover image or is it a 3x3-inch (7.6 x 7.6 cm) image inside the book? How many copies of the catalog do they plan on printing?

Let's look at a specific example to better understand this. If an image is to appear in one issue of a magazine as a full-page advertisement, and the magazine has a circulation of one million readers, if you were to charge one single penny for each person that you have stopped for three seconds while they look at your image, the fee that image could command would be $10,000! Although you might be satisfied with making a hundred or even two hundred dollars per hour of work, high-end clients know that such an image is worth much, much more! I know, that in today's world where consumers are bombarded with images, an image that stops people for three seconds is a very valuable commodity.

To get a better handle on the whole concept of licensing your photography, let me suggest you check out the following book: *Licensing Photography* co-authored by Victor Perlman and Richard Weisgrau. Although it was written in 2006, and it doesn't specifically deal with commercial still life photography, it will explain the concepts involved in licensing your photography. Consider it broccoli, something you might not like the taste of it, but it is good for you!

Reality Time

I wish I could guarantee that if you did everything I described in this chapter you would end up with a thriving photography business, but the reality is there are no such guarantees! The competition is stiff, and there are beginner photographers without an idea of what it takes to be in business, who buy a DSLR, print up some business cards, and declare themselves professional photographers. However, if they can just declare themselves some form of professional, they would be better off declaring themselves brain surgeons or even drivers of 18-wheel trucks, because those jobs are much more profitable! These same declarative photographers are so hungry for recognition and the thrill of getting paid anything to take photographs that they will charge 99 cents for something that costs them $5 to produce.

It is also true that even many good photographers are absolutely terrible at being businesspeople. They constantly underestimate what they must charge to make a profit and how long it will take to accomplish a specific studio photograph. With only a slight bit of tongue in my cheek, it's as if they look at the shutter speed setting on their camera and think the picture they just took really only took them 1/4 second (or 1/250ᵗʰ!) to make. Just keep in mind all the expenses you're incurring as you complete an assignment, and be sure to get what you're worth!

Now that we are in the automated digital age, there are manufacturers, who once bought tremendous amounts of professional photography, but have now decided to bring their photography "in house." They have carefully crunched the numbers and will buy a prefabricated studio lighting system (including a "product table") and a point-and-shoot digital camera to set up a photography studio in a tiny corner of their factory. These companies then take a relatively low-wage line or office staff worker and anoint him or her their official photographer! This is not sour grapes, but it is the reality of today's digital photography scene. Besides, the images many in house photographic studios need to create are very boring anyway. I mean really, how exciting is it to photograph 15,000 different buttons anyway? Personally, I'd rather drive a cab! There are plenty of clients, who appreciate the need for great photographs that are both visually interesting and technically demanding, who realize they must hire professional photographers to create them; and those are the clients you are looking for!

But You Still Want to be a Professional Photographer

Just saying you want to be a professional photographer will not make it happen, but there are some things you can do that will make it more than a fantasy doomed to failure. To conclude this chapter on a more positive note, here are some specific ideas that can help turn your fantasy into a reality:

Constantly study and learn about good business practices. I know, I know, you hate doing that, but like eating broccoli, it's good for you. Becoming a photographer who understands what it costs to run a business is not a joke: It's a necessity.

Constantly study and learn about the craft of photography. Doing so will allow you to create images that both the beginners and the anointed photographers can't do which, in turn, will make your images more unique and worth more.

Fight for perfection in everything you do. Oddly, in today's marketplace, "good enough" is hardly ever good enough!

Keep your overhead low. Don't fall into the trap of thinking that buying every latest DSLR, lens, or flash unit will make you a better photographer—it won't. Constantly think about ways to cut costs while never cutting quality.

Like a junkyard dog gnawing on his bone, become a marketing fiend! Constantly invest time and effort into finding more work. Don't do this now and then, do this all the time!

Diversify. Find joy in photographing any subject and always look to expand the types of assignments you are competent to accomplish. I shoot still life assignments, wedding assignments, and portrait assignments. I also lecture, write articles, write books, and I'm even starting to create videos and apps. None of these by themselves is enough to support me, but when I add them all together, my life is pretty good, and almost more importantly, never boring!

That's it! I have given you my heart, soul, and guts in this book. Almost everything I know about still life photography is contained within these pages. Try to apply what I've shared here and go make some outrageous images. Good luck, and may a warm sun and a strong wind always be at your back! But, if that's the case, remember to turn around and shoot the sunset!

Index